Contemporary Film History

William R. Foster

Pasadena City College

Kendall Hunt
publishing company

Dedication

To my beautiful wife, Donna Marie Carolan, whose help on this book was instrumental. To our son Vincent who is growing into a fine young man. And to Mingus and Mushroom, a good dog and a purrrfect kitty.

Contents

Hollywood and the Dawn of Television

1

INVENTING TELEVISION

Scientists began experimenting with a form of mechanical image scanning in the first years of the twentieth century. By the twenties the term television was being applied to these inventions. No doubt the fledgling movie industry was giving some impetus to this endeavor. Early in the decade two very different inventors began to make major breakthroughs in the development of electronic image scanning, Philo T. Farnsworth and Vladimir Zworykin.

Farnsworth was a farm boy from Utah who had won his high school science fair with a diagram for an instrument he called an image dissector. Due to his father's early demise, Farnsworth was not able to complete his college studies. He was able to interest a few financial backers in supporting his research and opened a small laboratory in San Francisco in 1926. The following year he applied for a patent for his invention of a primitive television picture tube.

Zworykin was an important member of the Russian scientific community when the revolution broke out in 1917. He managed to escape to Paris and, in 1919, settled in Pittsburgh to work in the Westinghouse research laboratories. He was fascinated by the possibilities of television and worked after hours on his own experiments with electronic image scanning. By 1923 Zworykin's work was sufficiently advanced that he applied for a patent for a camera tube device he called the iconoscope. Westinghouse was not enthused about his work because television was not one of the company's research priorities but Zworykin continued to labor late into the night after completing his workday for the corporation. In 1929 he demonstrated an improved device, the kinetoscope, to a major engineering convention and applied for a new patent. This prompted Westinghouse to arrange for his transfer to Radio Corporation of America (RCA) in New York which was operating a laboratory for the development of television. Happy in his new environment Zworykin completed work on a practical 230-line television system in 1933.

Along the way the RCA engineers and those of other members of the "television trust," General Electric and American Telephone & Telegraph, were stumped by the problem of getting their electron beams to properly scan images. RCA's

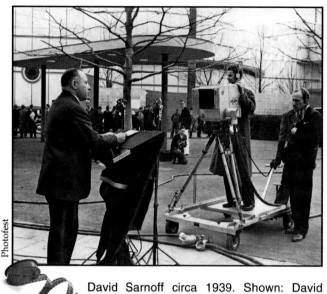

Photofest

David Sarnoff circa 1939. Shown: David Sarnoff, President of the Radio Corporation of America, makes the dedication speech at the World's Fair.

president, David Sarnoff, turned to the work of Farnsworth who had solved the scanning problem. He offered the young inventor a million dollars for his devices and patents. Farnsworth turned him down. Undeterred, RCA simply stole Farnsworth's work, setting off a patent lawsuit that lasted for years with the lone wolf inventor prevailing in the end.

Sarnoff correctly reasoned that the middle of the Great Depression was not a good time to be launching an expensive new home entertainment medium. He bided his time continuing to make improvements on the system and establishing a small network of experimental television broadcast stations. 1939 was chosen as the launch year for television. A world's fair was planned for New York City and RCA built a monumental television pavilion to introduce their wondrous new technology to the world. President Franklin Roosevelt addressed the opening day throng of dignitaries, becoming the first head of state to appear on television. Of course only a few RCA executives had TV sets to view the broadcast from the company's experimental broadcast station, W2XBS.

In 1940 the Roosevelt administration threw a monkey wrench into Sarnoff's plans for a television launch when he was informed that RCA's and the other electronic manufacturing giants production capacity was being commandeered for weapons production. Sarnoff was a sincere patriot and immediately went to work on an array of inventions, including radar, sonar, and television-guided bombs. Many historians of World War II believe that these devices were determinative of the war's outcome. As a member of the Army Reserves since 1924 Sarnoff was both flattered and eager to serve when General Eisenhower asked him to return to active duty as a Brigadier General to oversee wartime communications in 1944. He left RCA to serve and resumed his duties as chairman and chief executive officer following the war's end.

In 1946 RCA produced its first post-war model television set but there were not many takers. By the end of the next year there were only 44,000 television sets in America while the country was still listening to its 40 million radio sets. In spite of such slow growth, NBC launched new TV programs such as the Howdy Doody children's show. 1948 was not much better for TV sales. At the year end there were

350,000 sets. The next year Americans decided that TV was going to be around for the long run. The country boasted of two million TVs. Seven hundred twenty thousand were in New York City alone. In 1950 the TV tsunami arrived. In April the TV total reached 5.3 million and in October it was 8 million. Hollywood was in danger of becoming swamped by the upstart new medium.

Very quickly the three television networks (NBC, CBS, and ABC) transformed their successful radio shows into television programs. Jack Benny, Burns and Allen, Amos and Andy, Lucille Ball, and Arthur Godfrey were some of biggest shows in radio. Now they were removed from radio schedules and put on television. From outside the broadcast industry it looked like a huge gamble. But for people like Sarnoff and William S. Paley (chairman of CBS), it was a sure thing. They were hyper aware that America was about to undergo one of its biggest social and demographic revolutions since the opening of the frontier.

SOCIAL CHANGES

At the end of World War II President Truman was determined to make good on the country's debit of gratitude to the soldiers who fought the war. As an artillery captain in the First World War, he knew how badly his fellow veterans had been treated by their government which had promised repatriation bonuses, only to renege. As a result, many of those who fought in World War I returned to unemployment, poverty, and hopelessness. Truman made certain that the 12 million Americans who served in uniform would be treated better by instituting the GI (Government Issue) Bill of Rights. The Bill contained three promises: free college education, government-backed small-business loans, and government-backed home loans.

For a generation that had grown up during the Great Depression these promises were breathtaking. Before the war, the average American had an eighth grade education. Families simply could not afford to let children go to school when they could work. By 1960 the average American had two years of college. This incredible transformation had consequences for Hollywood. The audience was becoming more sophisticated. The old formulas and genres did not work any longer. The American dream of owning a home or a small business must have also been unbelievable to the Depression and war generation. Before the war their experience was foreclosure and dispossession. Now they were being handed their wildest dreams.

The war and its aftermath served to shift American demographics dramatically. There had not been much housing construction in America during the Great Depression. Suddenly there was an overwhelming demand for a lot of housing. Suburbs began to spring up around the American metropolises in places like Long Island in New York and Orange and Marin counties in California. Population was already shifting westward as a result of the Great Depression. After the war there was a mass exodus from the center of the country to its two coastlines. One reason

for this was cheap suburban land with expressways and freeways into the cities. Another reason was that everyone who fought in Europe or the Pacific or both left America through cities like New York, Boston, San Diego, Seattle, San Francisco, and Baltimore. For people who grew up on the farms of Nebraska, Kansas, and the Dakotas these brimming port cities seemed glamorous in comparison. For a young veteran who planned to open an auto garage or a construction company the prospects were much better in the new suburban America.

All of this migration away from the heartland of the country had a negative effect on the movie business. Small towns that had supported their local movie house since the twenties saw their theaters closed and boarded up. Big city theaters suffered too as people moved to the suburbs. One example was Los Angeles' glamorous movie district on Broadway. Picture palaces such as the Million Dollar Theater, the United Artists Theater, and the Los Angeles Theater that had served movie patrons since the twenties were reduced to all-night newsreel theaters where the homeless could sleep or swap meets full of trinkets. In 1950 there were over 19,000 theaters in America. In 1959 there were 16,000 theaters, and by 1963 the theater count bottomed out at less than 13,000.

The **Paramount Consent Decree of 1949** was another reason for the collapse of the theater industry. The major studios: Warner Brothers, Loews-MGM, Paramount, and Twentieth Century Fox had been forced to divest themselves of their theaters. This, in turn, relieved the studios of the necessity for making enough films each year to supply themselves. Consequently they reduced production. In 1951 644 films were released. By 1955 it was down to less than 400. Attendance had also taken a big hit. Between 1946 and 1949 average weekly ticket sales exceeded 90 million. By 1953 sales were down fifty percent and between 1958 and 1960 attendance bottomed out at forty million per week.

American lifestyles were changing. A baby boom had begun. In 1940 there were 2.5 million births. By 1950 the birth rate was 3.6 million. In 1955 over 4 million babies were born and the rate remained over 4 million until 1965. Returning veterans had wasted no time in starting their families and moving into their suburban tract homes. With a severe shortage of babysitters, people were staying at home instead of going out for a movie and a night on the town. The patio and the barbeque replaced restaurants and night clubs. Fraternal organizations like the American Legion and Elks provided a community refuge where veterans could share war stories and enjoy banquets and dances. Television became the new entertainment pastime.

HOLLYWOOD RESPONDS

The movie studios' first reaction to television was to dismiss it and fear it. MGM instituted a rule that TV sets would not be seen in their motion pictures. The rule was generally obeyed. During 1951 and 1952 four major strategies emerged.

TECHNOLOGICAL INNOVATION

One advantage the movies had over television was that TV broadcast standards were locked in by the National Television Standards Committee and to make changes was almost impossible. Additionally, the technology of the fifties was largely based on developments made in the thirties. The image was relatively low resolution with only 525 lines of information. The aspect ratio of the screen was 1 to 1.33, the same as 35mm film and the image was black and white. When primitive color television arrived in the late fifties, no further improvements were made in the technology for fear of making the millions of existing TV sets obsolete. For the studios, this presented an opportunity to transform motion pictures into something truly spectacular.

COLOR

Three-color Technicolor had been introduced in 1932. It was an excellent color system that employed a camera capable of exposing three strips of 35mm film simultaneously. Special optics separated the color spectrum so that the camera, combined with revolutionary film-processing technology, was capable of producing vivid color images. Initially there was a reluctance to embrace it because it was cumbersome and expensive and, during the Great Depression, movies were the only game in town. There was not much pressure to make the investment. As the economy came out of the doldrums in 1939, the studios began to lower their resistance to color and marvelous films like *Gone With the Wind* and *The Wizard of Oz* were the result. In the fifties TV provided the impetus for the studios to make a commitment to color. One problem with Technicolor was that the company was too small to keep up with the studios' demand for color. There were only enough cameras in existence to accommodate 15 productions at a time. This opened the door for other existing color processes such as Ansco, Cinecolor, and Trucolor. However, these alternative processes were all inferior to Technicolor.

The Eastman Kodak company realized the opportunity to capture the color motion picture market. It had released a single strip, "tri-pack" film stock called Eastmancolor in 1950. The film contained three separate layers of color dyes and was compatible with all existing 35mm cameras. The one drawback was that the quality was not as good as Technicolor. But Eastman Kodak was smart to license their "tri-pack" technology to other film manufacturers. This had the effect of swamping Technicolor with a variety of cheaper competing technologies. In 1954 Universal's film, *Foxfire*, was the last film that employed the three-strip Technicolor cameras and film. Thereafter, Technicolor concentrated on its laboratory business which was best processing facility in the motion picture industry. In 1959 Eastman Kodak introduced the legendary Eastmancolor 5250 film stock. It had all of the vividness of the three-strip color process and was much more light-sensitive than

its predecessors, thus streamlining the work of special lighting for color photography. Hollywood began to tout color as one aspect of the movie experience that was superior to television.

WIDESCREEN TECHNOLOGIES

In 1952 Merian C. Cooper, the man who made the 1933 spectacle, *King Kong*, introduced an amazing new movie format, Cinerama. The technology utilized three 35mm cameras harnessed together to produce an image that wrapped around the audience 120 degrees, filling the peripheral vision with movie images. This created the sensation of almost falling into the screen. The first release, *This is Cinerama*, had been a long time in the making. Fred Wall, head of special effects at Paramount, had been experimenting with multi-camera processes in his spare time since 1937. An early generation of the technology was demonstrated at the 1939 World's Fair. Another generation was employed for teaching aerial gunnery during World War II. Following the war Waller had several backers including Laurance Rockefeller, Time-Life magazines, and promoter Mike Todd. But Cooper, who had served as head of production at RKO, was John Ford's partner in Argosy Productions, and was an early proponent of color, had the perfect blend of technical knowledge and the heart of a visionary needed to bring Cinerama to the market. Cooper's creative partner in the enterprise was Lowell Thomas.

The film *This is Cinerama* opens with a spectacular sequence shot on the roller coaster at Coney Island and proceeds to present a pastiche of travelogue ideas. It ends with a patriotic rendition of "America the Beautiful" set to a coast-to-coast aerial montage of American monuments and natural wonders.

Converting a theater for Cinerama was an expensive proposition. The Stanley Warner theater company (formerly the Warner Brothers theater division) was one of the few companies with sufficient resources and theaters that were suitable for conversion. First a 120-degree wraparound screen needed to be installed. This meant removing the first several rows of seats and raising the floor at the front of the theater so that the seats could recline enough to

Cinerama/Photofest

This Is Cinerama (1952). Directed by Merian C. Cooper, Gunther von Fritsch. Shown: Rollercoaster image from souvenir book, *Rockaways' Playland*, Rockaways, New York.

see the screen without neck strain. Three projection booths with, at least, two projectors each were installed and a sound booth was constructed. Stereophonic speakers were installed and a projection engineer's booth was constructed and equipped with controls for feathering and matching the edges of the projected images and for synchronizing the projectors. The stereo soundtrack was played from a separate 35mm sprocketed magnetic tape. The Warners' 2800-seat Hollywood theater was the first to be so equipped. In its first two years Cinerama made $14 million in only 13 theaters. At its peak in 1959, 21 theaters around the world had been transformed for Cinerama. Only six films were made with the technology, *This Is Cinerama, Cinerama Holiday* (1955), *Seven Wonders of the World* (1956), *Search for Paradise* (1957), and *South Seas Adventure* (1958), all travelogues. One dramatic film was made with the technology, John Ford's epic western, *How the West Was Won* (1962). Thereafter, a new single-camera, single-projector Cinerama process was developed but it lacked the grandeur of its predecessor.

Cinemascope was a much more modest technology than Cinerama. It used special lenses to create widescreen images instead of a whole array of technologies. It was based on the work of French lens designer Henri Chrétien in the 1920s. The lenses were ground to be anamorphic. Camera lenses squeeze the width and stretch the height of the image. Projector lenses stretch the width and squeeze the height of the image. The result is a widescreen image that has been manipulated to fit standard 35mm film. Twentieth Century Fox's president, Spyros Skouras, purchased all of the rights for Chrétien's work in late 1952 and within nine months had enough of the lenses to accommodate every Fox production. Skouras also equipped all of his company's sound equipment to produce stereophonic sound. A demo reel was prepared for showing to theater owners to convince them to equip their theaters for the new technology.

The first two films made in Cinemascope were *The Robe* and *How to Marry a Millionaire* (both 1953). *The Robe* was a biblical epic about a soldier in the Roman army who takes part in the crucifixion of Christ and is so transformed by the experience that he becomes a Christian. It stars Richard Burton and Jean Simmons. It was by far the more successful of the two films. On a budget of $4.5 million it grossed an astronomical $30 million. *How to Marry a Millionaire* was also successful, taking in $7.5 million. It featured a cast that was a mixture of old and new Hollywood: William Powell, Betty Grable, Lauren Bacall, and the rising star Marilyn Monroe. Fox was so pleased with the results that the company announced that all future films would be released in Cinemascope.

After Cinemascope came a flood of new screen formats. Paramount introduced VistaVision, a format in which the film travels through the camera horizontally rather than vertically. The advantage of this approach was that there was no limit to the width of the image and no loss of resolution as was the case with the anamorphic lenses of the Cinemascope system. VistaVision was expensive. The Mitchell Company that manufactured most of the cameras used in American motion picture production had to entirely re-design their cameras for the new format.

Laboratory and projection equipment also had to undergo costly modifications. The cost of film stock increased, on average 75,000 dollars per picture. But in the race to make movies bigger and more spectacular, VistaVision was an unqualified success.

White Christmas (1954) was the first film made in VistaVision. It was successful but not in the same league with *The Robe*. Paramount decided to fight fire with fire and began work on their own biblical epic, Cecil B. DeMille's remake of his 1923 epic *The Ten Commandments* (1954). The story of the life of Moses featured an all-star cast led by Charlton Heston. It recreates the building of the pyramids of Egypt, the parting of the Red Sea, the burning bush, and Moses receiving the Ten Commandments from God. With the exception of a few location scenes, it is shot almost entirely on the stages and back lots at Paramount. More costly than *The Robe*, DeMille's film grossed $65 million domestically and many more millions abroad. The entire motion picture industry took note of the riches to be harvested from this bombastic style of motion picture. The one problem presented by this model is that a film like *The Ten Commandments* was so costly to make, failure at the box office could mean bankruptcy for the studio.

During the 1950s Paramount had Alfred Hitchcock, the great master of suspense, under contract. Hitchcock's style of directing was perfectly suited to the wide possibilities of VistaVision. A frustrated artist and complete control freak, he would create elaborate sketches for his camera crew to show them exactly what he wanted. *To Catch a Thief* (1955) was Hitchcock's first experience with the widescreen format. The film stars Cary Grant as a cat burglar on the French Riviera. Grace Kelly co-stars as his blonde love interest. Hitchcock exploits the format to capture the beauty of the location. His next widescreen film was a remake of his 1934 thriller, *The Man Who Knew Too Much* (1956). Shot on location in Marrakesh, it stars another Hitchcock favorite, James Stewart, with Doris Day playing the blonde. His last film at Paramount to be shot in VistaVision is *Vertigo* (1958), starring James Stewart and another blonde, Kim Novak. The film deals with one the director's favorite phobias, fear of heights, and uses the widescreen format to exaggerate the scariness of high places.

In 1959 Hitchcock moved to MGM to make the sensational *North By Northwest*. He took his VistaVision cameras with him. The film stars Cary Grant with the blonde role played by newcomer Eva Marie Saint. The film flawlessly combines studio trickery such as process shots, forced perspective sets, and enormous painted backgrounds with beautifully photographed second unit location work. Considered by many to be the first example of the action film, *North By Northwest* contains multiple chase scenes including an out of control sports car on a narrow mountainous road, a murderous bi-plane and a finale set on the faces of Mount Rushmore. The film was a critical and box office success earning over $14 million in the United States on an investment of 4 million dollars. At the end of the fifties VistaVision was discarded in favor of new and better anamorphic technologies for lower-budget films and large-film formats.

Sixty-five millimeter film formats were experimented with in the late twenties and early thirties but the Great Depression made commercial use of the format impractical. In 1952, after leaving the Cinerama enterprise, the flamboyant Mike Todd walked into the offices of the American Optical Company, put a check for $100,000 on the president's desk, and asked him to develop a lens that would create the 120-degree wraparound of Cinerama "out of one hole." Three years later the "bug eye" Todd-AO lens was married to a 65mm Mitchell camera and a new format was born. Twentieth Century Fox' adaptation of the successful Rogers and Hammerstein musical *Oklahoma* (1955) was the first film made with the majestic new technology. Since Todd-AO required theaters to install wraparound screens, the film was also shot in Cinemascope. In the ensuing years the format continued to thrive with many big budget films using Todd-AO including *Around the World in 80 Days* (1956 produced by Mike Todd), *South Pacific* (1958) and *Can-Can* (1959). In 1958 Mike Todd was killed in a plane crash and Fox took over stewardship of the format. In 1964 Todd-AO was modernized and renamed Dimension 150. Before his death Todd had consulted with legendary architects Buckminster Fuller and Frank Lloyd Wright to plan a domed theater design that would better accommodate the wraparound screen. The Cinerama company embraced the idea and decided to drop the three-camera, three-projector process in favor of Dimension-150. Pacific Theaters, using a Fuller geodesic dome design, built the first Cinerama Dome in 1963. Because of the efficiency of the radical new architecture, construction took only sixteen weeks. Ironically, when the theater was restored as part of the ArcLight Cinemas complex in 2002, a second and third projection booth were added to accommodate the original Cinerama process.

In 1959 the last widescreen format was introduced by the Panavision camera company, Super Panavision 70. As its name implies, the technology employs 70mm film, with four times the frame area of 35mm film. It was capable of producing images with a five-to-nine aspect ratio. Super Panavision was embraced by the theater companies because it made very large images without the need for a wraparound screen. Disney's film, *The Big Fisherman* (1959), the story of St. Peter, was the first film made in the format. Big budget films that are shot on film still employ Super Panavision today.

3-D

Stereoscopic photos date back to the 1850s. They were a popular entertainment in the later half of the nineteenth century. The View-Master, a popular children's toy, was introduced in 1939. When Hollywood began its search for technologies that would trump television, 3-D was inevitable. In June, 1951 the Natural Vision Company demonstrated a practical 3-D process to the motion picture industry. The system used lenses and beam-splitting optics to photograph and print two stereoscopic images on a single strip of film. When viewed through special glasses developed by the Polaroid Company the picture had real depth and could be made to "jump off the screen." The studios were reluctant to adopt 3-D at first but after the

success of the low-budget independent feature *Bwana Devil* (1952), there was an industry-wide race to develop 3-D movies.

Warner Brothers was the first studio to sign an agreement with the Natural Vision Company in 1953. Their big-budget color spectacle, *The House of Wax* (1953), did huge business. Other companies were competing to get their 3-D films into production but Natural Vision miscalculated and had only built one camera. Until others could be built, the studios would have to wait in line. The problem was solved in a few months and, by the end of the year, RKO and Universal were busy making their own 3-D movies. Warner Brothers had made the biggest commitment, even releasing a version of Alfred Hitchcock's *Dial M for Murder* (1954) in 3-D. However, by the end of the year the novelty had worn off as the studios focused on the pursuit of big screen technologies.

Over the years 3-D has continued to be used as a marketing strategy. In 1983 *Jaws* (1975) was re-released using the technology as was the second *Spy Kid* movie, *Spy Kids 3-D: Game Over* (2003) and *Beowulf* (2007). In 2009 Hollywood rediscovered 3-D and titles including *Final Destination, Monsters vs. Aliens,* and director James Cameron's *Avatar* were released in improved three-dimensional formats.

Directors of the Fifties

THE ANTI-COMMUNIST WITCH HUNT
AND THE MOTION PICTURE INDUSTRY

In 1938 the House of Representatives created the House Un-American Activities Committee (HUAC) to mollify the American Legion and right-wing politicians' charges that Roosevelt's many New Deal programs had been infiltrated by the communists. The committee's first target was the labor unions. In 1939 Congress passed the Hatch Act which barred communists, Nazis, and other political undesirables from working in government service. Other laws followed requiring communists to register as agents of foreign governments and making it a crime to teach or advocate the overthrow of the government. The witch hunt took a holiday for a few years when Germany invaded the U.S.S.R. in the summer of 1941 and the Soviets became military allies of the United States for the purposes of the war. However, the anti-communist right was ready to get back to work the minute the war ended.

Joseph McCarthy was by far the most opportunistic anti-communist senator in the immediate post-war period. As a graduate of Roman Catholic Marquette University Law School in Milwaukee, Wisconsin in the mid 1930s, he quickly became involved in politics and won an election for judge in 1939 at age 30. He took a leave of absence from the bench in 1942 to become a lieutenant in the Marines. He left the military in 1945 to successfully campaign for his old job. The next year he ran for U.S. Senate and was elected as one of the first of many World War II veterans who would take over Congress in the late 1940s. His Senate career was unremarkable until he made a speech to a group of Republican women in Wheeling, West Virginia in early 1950. He told the luncheon group that Secretary of State Dean Acheson had a list of 205 communists in the State Department. Later he claimed to have his own list of 57 communists and called for an investigation, thus placing himself in the middle of the hottest political issue of the day. The list proved to be worthless, but McCarthy had become a celebrity.

In 1947 HUAC gave in to the temptation to investigate the motion picture industry. This move guaranteed a tidal wave of publicity for Chairman J. Parnell Thomas and all of the committee members (including California Congressman Richard M.

Nixon) who delighted in posing as anti-communist warriors defending their country against the evil foe. The Screen Writer's Guild was a ripe target. The committee would show the world how these invisible agents of the U.S.S.R. had subversively planted pro-communist ideas into movie scripts.

The first people to testify before the committee were presented as "friendly witnesses." Jack Warner and Louis B. Mayer spoke on behalf of the captains of the industry, assuring the committee that no suspected communist would ever find work in Hollywood again. Gary Cooper and Ronald Reagan, representing actors, appeared next and were eager to "name names." Nineteen "unfriendly witnesses" were named who were believed to be communists. Eleven of these were called to testify. The first, playwright Bertolt Brecht, appeared, denied being a communist and promptly left America for his native West Germany. The remaining group who became known as the "Hollywood Ten," included director Edward Dmytryk and nine screenwriters led by Dalton Trumbo, Ring Lardner Jr., and Lester Cole. They were given three undesirable options. They could own up to being communists, in which case they would be forced to name other communists or be held in contempt of Congress. They could deny being communists and be prosecuted for perjury. Or they could invoke their constitutional right against self incrimination, which they did. The committee ignored the Fifth Amendment and threw them into prison for sentences between six months and a year. Later, Dmytryk lost his nerve and agreed to name other friends and acquaintances who might be communists. After their release from prison, the remaining "Hollywood Nine" found themselves blacklisted and unable to find work. Some used assumed names until a committee of 50 Hollywood executives, afraid the public would turn against the industry, announced that, henceforth, no one would knowingly employ a communist.

In 1951 the HUAC again turned its attention to Hollywood and a second wave of witch hunting was unleashed. A new committee chairman, John S. Wood, compiled a list of 324 names to add to the 1947 black list. Almost two-thirds of the people on the list were still working in motion pictures and when their names were released they instantly lost their jobs without appeal. With the assistance of HUAC research director, Raphael Nixon, Chairman Wood changed the focus of the hearings from rooting out individuals suspected of communist activities to examining the infiltration of Hollywood's major institutions by the Communist Party itself. This resulted in dramatic mass hearings with as many as 90 witnesses being called at a time.

A new group of "friendly witnesses" emerged including writers Budd Schulberg and Edward Dmytryk who appeared to reverse his 1947 testimony. Elia Kazan originally appeared before the committee in January 1952 as a hostile witness. He had been a member of the decidedly communist Group Theater in New York during the thirties. Kazan and most of his friends in those days were communists. He took the Committee's prying as an affront. Following this initial appearance, Kazan was approached by Spyros Skouras, president of Twentieth Century Fox, who presented the director with an ultimatum; name names or forget about ever working in the motion picture business again. Kazan returned to the House Un-American Activities Committee to name people he was involved with in the New York theater and motion

picture business. Kazan had been one of the founders of the Actor's Studio where many of the new generation of post-war stage and movie stars had studied method acting. Among those he named were his partners, Lee and Paula Strasberg, and Warner Brothers' star John Garfield. Hounded by the press wherever he went and refused employment by the studio he helped to build, Garfield was dead within a year, of a broken heart at age 39. Kazan would go on to become a rabid anti-communist and to direct several remarkable films but the stain of snitching his friends could never be eradicated.

Between 1951 and 1953 HUAC added over 200 names to the Hollywood blacklist. Another 100 names of communist sympathizers, people who were friendly with communists and people whose communism could not be proved appeared on a "grey list." Noted director and producer Stanley Kramer was on the list, along with playwright Arthur Miller and actress Judy Holliday. The end of the committee's investigation was only the beginning of the problems for those who had been swept up in the proceedings. Anti-communist organizations began to take up the cause in the early fifties. The American Legion with its 3,000 chapters was very effective in mounting boycotts against suspected individuals and films.

ESTABLISHED VETERANS

As Hollywood made more spectacular and expensive movies during the fifties to combat the smallness of television, it turned to veteran directors who were proven and could handle the pressure and complexities of big budget film making. For most of the older directors, this would be their last decade of greatness, their last moment in the spotlight. For many young directors, the fifties would represent a time of opportunity. As the studio system and the production code began to fade away, a new freedom to tell stories without compromise ignited the enthusiasm of the next generation.

JOHN FORD

He directed his first film, *Soul Herder* (1917), for Universal Studios less than two years after the facility opened. Early in his career he moved to the much more luxurious Fox Motion Picture Company where he learned expressionist style filmmaking from the likes of F.W. Murnau, one of the fathers of German expressionism. Ford developed a reputation for making excellent films with Fox' top talent, including Tom Mix, Janet Gaynor, Shirley Temple, and Victor McLaglen. The young director was also one of the studio's top directors of epic and action films. In 1924 he was handed the assignment to direct *Iron Horse*, the story of the construction of the trans-continental railroad. His natural leadership abilities were a great help in marshaling armies of extras, heavy equipment, and dangerous stunts. In 1935 he won the first of four Best Director Oscars (Academy Awards) for his film *The Informer*. Made at RKO, it is the story of a soldier in the Irish Republican Army who betrays his comrades for 20 pieces of silver. The

film stars Victor McLaglen who also won an Oscar for best actor. In 1939 Ford revived the western genre for adults and, in so doing, established John Wayne's position as a major Hollywood Star. Ford won two more Oscars for *The Grapes of Wrath* (1940) and *How Green Was My Valley* (1941). After this string of successes, Ford enlisted in the Navy to make wartime documentaries and training films. His most remarkable was *The Battle of Midway* (1942). He returned to Hollywood and picked up where he had left off in 1946.

When the fifties arrived the master director was still at the top of his game. In the late thirties he had joined forces with the RKO head of production, Merian C. Cooper, to found Argosy Pictures, an independent production company. Setting up residence at Republic Pictures Ford reeled off a string of commercially successful westerns including: *Wagon Master* (which was adapted as a hit television series in the late fifties starring Ward Bond) and *Rio Grande* (1950). In 1952 he made one of his greatest films, *The Quiet Man*, starring John Wayne as a prize fighter returning to his Irish homeland after killing an opponent in the ring and swearing to never fight again. In Ireland, he meets a beautiful young lass, played by Maureen O'Hara. The two want to marry but her brother (played by Victor McLaglen) refuses to put up the required dowry unless Wayne's character will fight him for it. The film was shot in Technicolor in the Irish countryside and wonderfully sketches life in an idyllic village. Ford was awarded his fourth Oscar for the film.

During the remainder of the decade Ford's production company drifted in and out of prosperity. In the mid-fifties he directed three different television programs to keep the venture afloat but he continued to turn out hit movies such as *The Long Gray Line* and *Mister Roberts* (1955), *The Searchers* (one of his best westerns with John Wayne) in 1956, *The Last Hurrah* (a political drama starring Spencer Tracy) in 1958, and another John Wayne western, *The Horse Soldiers* (1959). For a man who turned sixty in 1954, Ford's work was remarkable. As the sixties unfolded he still was making hit films at a time of life when lesser men would have faded into retirement.

HOWARD HAWKS

Like John Ford, Hawks had been around Hollywood since the twenties. He was Ford's contemporary at Fox but remained independent for most of his career choosing to use Warner Brothers as his home when he needed one. Through the thirties and forties, Hawks' reputation was for brilliance in a number of genres, including gangster films, screwball comedies, aviation films, adventure films, and westerns. In the fifties he sought new challenges, directing the Twentieth Century Fox motion picture adaptation of the Broadway Musical, *Gentlemen Prefer Blondes* (1953), a hit that helped establish Marilyn Monroe as a major musical star. In 1955 he directed the expensive and ambitious sword and sandal epic, *Land of the Pharaohs*. Shot on location in Egypt and at Titanus Studios in Rome, it was the most technically challenging project of his career. Today the film comes off as silly and is definitely not among Hawks' best work, but it was the kind of film that was being made to combat the competition from

television in the fifties. In 1959 Hawks returned to more familiar territory with a western, *Rio Bravo*. The cast was typical of Hollywood stunt casting during the decade. It starred ever-dependable John Wayne, Dean Martin (attempting to extend his singing career with a serious acting gig), Angie Dickinson (a television actress in the early fifties who was stepping up to film roles as a newly minted sex symbol), and Ricky Nelson (veteran of the Ozzie and Harriet Nelson television series who was becoming a teenage heart throb and rock 'n roll star).

Rio Bravo proved to be a very entertaining film and served to extend Hawks' career into the sixties.

BILLY WILDER

Wilder began his career as a journalist in Vienna in the mid-twenties when a chance encounter with the American band leader, Paul Whiteman, resulted in a move to Berlin where he became a successful screenwriter at the famed UFA studios. As Germany was falling under the spell of Adolph Hitler in 1933, Wilder began to plot his escape to Hollywood. Twentieth Century Fox sponsored his immigration in 1934. He wrote for the studio for two years without much success before moving on to Paramount where he was teamed up with New Englander Charles Brackett. The team wrote two very successful comedies *Bluebeard's Eighth Wife* (1938) and *Ninotchka* (1939) for Ernst Lubitsch, the German-transplant director who gave Paramount the "Lubitsch touch." His chance to direct came in 1942 with the comedy hit, *The Major and the Minor*. Following that, he reeled off a series of hits including *Five Graves to Cairo* (1943), *Double Indemnity* (1944), *The Lost Weekend* (1945), and *A Foreign Affair* (1948). As a writer/director, Wilder represented a new breed of filmmaker in the mold of Preston Sturges and John Huston, men who could both create a story and bring it to the screen. The result was a more nuanced finished product obviously more in synch with the writer's original vision.

In the fifties Wilder was one of the most successful directors in motion pictures. The decade begins with *Sunset Boulevard* (1950) a grotesque and noirish story about an aging silent movie star plotting her comeback while attempting to regain her youth in a relationship with a much younger failed screenwriter. The film stars Gloria Swanson as the actress, William Holden as her lover, and the great silent film director turned actor, Erich Von Stroheim as her ex-husband, butler, and caretaker. It is a wonderful commentary on stardom and the craziness that it can bring. Gloria Swanson's performance walks the razor's edge of self parody without ever losing its balance. Wilder and Brackett won the Oscar for best screenplay.

The following year Wilder wrote and directed *Ace in the Hole*, starring Kirk Douglas as a failed big city newspaperman who has stumbled on the story that will take him back to the big-time. The film is a cynical indictment about everything that was wrong about American journalism. Shot on location in Albuquerque, New Mexico, the film was an opportunity for the director to show that he could work outdoors. Although the screenplay was Oscar nominated, *Ace*

in the Hole was one of Wilder's few commercial failures. He referred to it as the "runt of his litter." He returned to form with *Stalag 17* (1953) a successful adaptation of a hit play. William Holden won the Best Actor Oscar for his performance. In 1954 Wilder changed writing partners with the production of the romantic comedy, *Sabrina.* It starred William Holden and Humphrey Bogart as two wealthy brothers competing for the affections of the chauffeur's daughter, played by the rising star, Audrey Hepburn.

The Seven Year Itch (1955) is a satire about a married man whose family is spending the summer in the country while he toils away in steamy New York City. When Marilyn Monroe moves into the apartment next door, the errant husband can barely contain himself. This is the film that contains the iconic image of Monroe's skirt being blown up around her head by the rush of air from a subway grating. *The Seven Year Itch* completed Monroe's rise to super stardom. Three more very good films followed and in 1959, Wilder topped off his greatest decade with his greatest comedy *Some Like It Hot*. The film stars Monroe as the leader of an all-girl band traveling by train to a gig in Florida. Two musicians, Tony Curtis and Jack Lemmon (who would work extensively with Wilder in the sixties) are being chased by the mob and go underground in drag as players in Monroe's group. When they arrive in Florida, Curtis poses as a wealthy playboy to win Monroe's affection while old-time comedian Joe E. Brown falls in love with Lemmon in drag. The complications pile up until the final scene when Lemmon responds to Brown's marriage proposal by taking off his wig and confessing that he is a man. Undeterred, Brown has the last word, "Well, nobody's perfect."

ORSON WELLES

He had become itinerant after the complete breakdown of his relationship with RKO over the editing of *The Magnificent Ambersons* in 1942. As the fifties dawned, Welles was living in Europe attempting to raise money for a film adaptation of Shakespeare's *Othello* in which he would play the title role and direct. With several starts and stops the project was completed in 1952. Afterward, he began raising money for a new project, *Mr. Arkadian* (1956), the story of a mysterious millionaire who attempts to murder everyone who had knowledge of his early life. Welles would work until he ran out of money, stop production to raise more money, and then continue filming. The result was a choppy film that never really expresses the director's artistic intent.

Actor Charles Heston, who had risen to stardom in two epic films by Cecil B. DeMille, joined forces with producer Albert Zugsmith to convince Universal to hire Welles and finance what would be his last great effort as a director, *A Touch of Evil* (1958). It is the story of murder and corruption in a Mexican border town. Heston plays a crusading district attorney and Welles is the hard-boiled and grotesque police captain. The medium-budget film is shot with the same lightweight European cameras and recorders that would enable the fluid style of the French New Wave films. In

Welles' hands this technology gives him the freedom to imagine shots and scenes that would have been prohibitively expensive with conventional studio equipment. Venice, California serves as a convenient and convincing location for the film. It is generally considered the last film of the classic film noir period.

ALFRED HITCHCOCK

Hitchcock arrived in Hollywood in 1940 after building a career and reputation as "the master of suspense" in England during the twenties and thirties. As the for-

Touch of Evil (1958). Directed by Orson Welles.

Universal Studios/Photofest

ties progressed, his reputation continued to grow. He made films that were dazzlingly experimental and films that were tremendous commercial successes. By the fifties, he was one of a handful of directors whose involvement could assure a film's creative and financial success. During the decade he became a celebrity director of unmatched notoriety, almost as famous for his television appearances as for his cinematic exploits.

In 1949 Warner Brothers was in the midst of reinventing itself. It was in the process of shedding long-term contracts with its established stars such as Bette Davis and Humphrey Bogart and developing new relationships with independent producers/directors. Hitchcock, who had formed his own independent production company in the forties, abandoned it to sign on to a four-picture deal with Warner Brothers. The deal was brokered by super agent Lew Wasserman (owner of MCA—Music Corporation of America) whose talent list included many of the stars Hitchcock worked with in the fifties. The director's first film under the contract was *Strangers on a Train* (1951). It is the story of two complete opposites, a conventional all-American type and a homosexual rich European living off his father's fortune. The two meet on a train and their musings about how nice it would be to get rid of people who pose a nuisance turn deadly. The film is full of the director's trademark macabre wit and stylish visuals. This film was followed by *I Confess* (1953) starring Montgomery Clift and the film noir classic, *Dial M for Murder* (1954), both for Warner Brothers. Hitchcock made his fourth and last film for the studio in 1956, *The Man Who Knew Too Much*.

In 1954 Hitchcock became infatuated with Paramount's new widescreen process, VistaVision. He made two films for the studio starring some of the best talent in the MCA roster. The first was *Rear Window* (1954), with James Stewart and Grace Kelly.

Over the years he had infused his films with bits of his personal psychology and quirks of taste. *Rear Window* is the story of a successful New York photographer who is laid up with a broken leg. He takes to spending his time spying on his neighbors in the next apartment house with binoculars and telephoto lenses. His beautiful blonde girlfriend is played by the future Princess of Monaco, Grace Kelly. When the photographer thinks he has witnessed a murder, the plot gets complicated. Voyeurism and blondes are two of Hitchcock's personal fascinations and the film gives him ample opportunity to explore both. His second Paramount film was *To Catch a Thief* (1955), starring Cary Grant as a former cat burglar jewel thief who had worked the French Riviera. Grace Kelly plays his love interest, continuing the blonde theme in Hitchcock's films made in the fifties.

In the late forties the MCA talent agency was granted a waiver by the then-Screen Actor's Guild president, Ronald Reagan, to branch out into the fledgling television production business under the name of Revue Productions. By 1955 television was a lucrative enough medium that Wasserman was able to convince the director to lend his name and personality to a program entitled *Alfred Hitchcock Presents*. It was a weekly mystery/suspense anthology series with no recurring characters or plot lines. Each show was like a short Hitchcock movie with a filmed introduction and wrap-up hosted by the show's namesake. The hit series aired until 1962 and made Hitchcock a celebrity, instantly recognizable to millions of TV viewers. Eventually, MCA would take over Universal Studios as its production facility, thus providing Hitchcock with a filmmaking home whenever he needed one.

In 1956 Hitchcock did a successful remake of his British film, *The Man Who Knew Too Much*. James Stewart plays the male lead and Doris Day is the blonde. In 1958 the director returned to making glossy films that explore his phobias with the production of *Vertigo*. In this film Stewart plays a police detective who must overcome his fear of heights to solve the mystery of a beautiful blonde, played by Kim Novak. With a luscious score by Bernard Hermann, Hitchcock weaves his visual magic into the film, creating a totally unsettling mood. By this point in his career he was completely in command of every aspect of the filmmaking process. As a young man, Hitchcock had aspired to become a painter. Using his skills as a graphic artist the director carefully storyboarded every camera angle until he achieved perfection. In 1959 he closed out the decade of the fifties with another masterpiece of art and entertainment, *North by Northwest*. This time Cary Grant stars as an advertising executive caught up in international spy intrigue. Eva Marie Saint plays the beautiful blonde who helps him escape when he has been wrongfully accused of the murder of a United Nations dignitary. Filmed at MGM in Culver City, the film is a wonder of process shots, scenic paintings, fanciful sets, and the highest state of movie magic possible at the time. Often regarded as history's first pure action movie, the film was considered too fast paced for 1959 audiences. Another masterful score by Bernard Hermann adds to the film's sense of urgency. Nonetheless, the film was a complete success both commercially and artistically, leaving just a few critics to long for Hitchcock's earlier, smaller films.

WILLIAM WYLER

A Hollywood veteran of many decades when the fifties began, Wyler had directed his first film for Universal in 1925. Over the next five years he made almost thirty films, many of them low-budget westerns. When sound arrived at the studio in 1929 he was given the opportunity to make the transition with his first talking picture, *The Shakedown*. He remained at Universal until 1935 when he left to make more prestigious films for The Samuel Goldwyn Company. At the new studio he made a series of very successful pictures including *Dodsworth* (1936), *Dead End* (1937), *Wuthering Heights* and *The Westerner* in 1939, and *The Little Foxes* (1941). When World War II began, Wyler enlisted in the Army Signal Corp to make wartime documentaries. His 1944 film, *Memphis Belle*, the story of a B17 bomber crew about to fly their 25th and last mission over Germany, is considered one of the best of its kind. Upon his return to Hollywood in 1946, Wyler made the definitive film about returning war veterans, *The Best Years of Our Lives*. Wyler's best known WWII documentary -

As 1950 began Wyler was one of the most highly regarded directors in the business. During the decade he made an amazing series of films that show the great range of his talent. In 1951 he moved to Paramount to make *The Detective Story*, an excellent adaptation of the stage play, starring Kirk Douglas with an strong supporting cast including character actors such as William Bendix, Gladys George, and newcomer Lee Grant. *Roman Holiday* (1953) was a big-budget film shot on location in Rome with the rising star, Audrey Hepburn, in the role of a royal princess on a state tour of European capitols. One night she escapes from her entourage only to fall into the arms of a dashing American journalist, Gregory Peck. The film won Hepburn a Best Actress Oscar and two others, as well. Wyler's next film *Desperate Hours* (1955) is a taut thriller about an escaped convict terrorizing a suburban household. Humphrey Bogart plays the convict and Fredric March is the middle class businessman who must do battle to protect his family. The pairing of Bogart and March gives the two great veteran actors a chance to show off their incomparable skills.

Wyler's next two films were with independent companies. In 1956 he made *Friendly Persuasion*, a charming film about a Quaker man and his family whose religion prohibits them from engaging in violence even though the American Civil War is raging all around them. An older Gary Cooper plays the head of the family and Anthony Perkins plays his son who is drawn to become involved in the war. The film was nominated for six Academy Awards including Best Director and Best Picture. Two years later Wyler completed work on the epic western, *The Big Country*, with an all star cast led by Gregory Peck, Charlton Heston, and Jean Simmons. Folk singer and actor Burl Ives won a Best Supporting Actor Oscar for his performance.

As the fifties were coming to a close, Wyler made the greatest film of his career, *Ben Hur* (1959). A remake of the MGM 1925 classic, it is the story of a Jewish prince who is sent into slavery, becomes a revered gladiator and, after winning his freedom in the arena, follows Christ to the crucifixion. The studio pulled out all the stops to make the

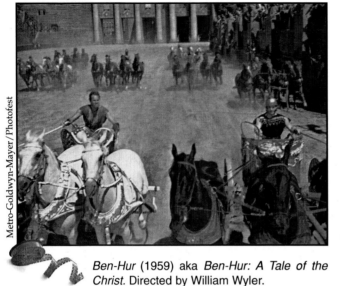

Metro-Goldwyn-Mayer/Photofest

Ben-Hur (1959) aka *Ben-Hur: A Tale of the Christ.* Directed by William Wyler.

film the grandest in its storied history. Charlton Heston who had performed so admirably as Moses in DeMille's *Ten Commandments* has the lead role. Great character actors like Jack Hawkins and Hugh Griffith (who won a Best Supporting Actor Oscar) give the film dramatic depth and credibility. *Ben Hur* exceeded MGM's expectations, racking up millions at the box office and eleven Oscars, including Best Picture, Best Director, and Best Actor.

GEORGE STEVENS

The son of middling successful stage and screen actors, got his first job in Hollywood in 1922 at age 17. He was hired as an assistant cameraman at Hal Roach studios, the comedy home of the great Harold Lloyd, the Our Gang Comedy serials, and Laurel and Hardy, one of the great comedy duos of the thirties. It was not long before Stevens was leading the camera crew and writing gags (visual jokes) for Roach's star comedians including Rex: The Wonder Horse. In 1933 after a brief stint at Universal, he moved on to RKO to direct comedy shorts with veterans such as Edgar Kennedy and Bert Wheeler. In 1935 Stevens broke out as a director with the assignment to helm the Barbara Stanwyck vehicle, *Annie Oakley*. The following year he was handed the challenge of breathing some fresh air into the great dancing couple of Fred Astaire and Ginger Rogers. Using his well-developed sense of visual style and camera technique, he guided the duo through their last (and one of their best) films, *Swing Time.* In 1939, the studio handed the young director his most challenging project thus far, *Gunga Din*, starring Cary Grant, Victor McLaglen, and Douglas Fairbanks Jr. Although the film seems politically incorrect today, it was a stirring adventure in its time.

In the early forties Stevens' reputation continued to grow. In 1941 he directed megastars Irene Dunne and Cary Grant in the very successful *Penny Serenade* for Columbia. By this time he had declared his independence from studio contracts and was making his deals on a picture-by-picture basis, with his compensation and power growing with each new deal. The following year he moved to MGM to direct the power couple Spencer Tracy and Katharine Hepburn in *Woman of the Year*. Also in 1942 he moved back to Columbia to make *Talk of the Town*, with Cary Grant and Jean Arthur. From 1944 to 1946 Stevens served in the Army Signal Corp and saw action filming the allied landing at Normandy, the liberation of Paris, and the liberation of

the Dachau concentration camp. His footage of Dachau was put into evidence at the post-war Nuremberg trials of the Nazi leadership.

As the fifties began Hollywood considered Stevens one of its greatest directors on a level with Ford and Hawks. With Paramount as his home for the time being in 1951 he directed Elizabeth Taylor (emerging from a career as a child star) and Montgomery Clift (one of the first actors to be appreciated for his neurotic method style) in *A Place in the Sun*. It is the story of a young social-climbing man (Clift) who is pursuing a sophisticated debutante (Taylor) while being stalked by a young, lower class, factory worker (Shelley Winters) whom he has impregnated. This style of melodrama with its sexual complications was very successful as counterpoint to television with its out-dated restrictions on indecency. In 1953 Stevens made one of the great modern westerns, *Shane*. The film stars Alan Ladd as the loner gunman who wanders into a community where the newly arrived settlers are being terrorized by the cattlemen who want the countryside for themselves. Shane decides to stay to protect the settlers. In the film Stevens deals with many of the issues modern westerns explored; the civilizing of the frontier, greed and evil versus the humanization of society, and the creation of a post-war American mythos in the character of Shane who could just as easily represent an America embroiled in a nuclear standoff with Russia.

Stevens followed up *Shane* with the biggest, most epic film of his career, *Giant* (1956). Based on a sprawling novel by Edna Ferber, the film stars Rock Hudson and Elizabeth Taylor as the Benedicts, leaders of a wealthy Texas cattle-ranching clan. Teen heartthrob James Dean plays Jett Rink, an outcast ranchhand who has been willed (by Hudson's father to his illegitimate son) a small plot of land (a few thousand acres) adjacent to Hudson's empire. All the local ranchers hold Rink in contempt as he toils away drilling for oil. When his well comes in, he uses his instant wealth to return the expressions of contempt and forces the cattlemen to become oil men too. The story takes place over three decades, giving the entire cast an opportunity to show their ability to age their characters. Dean easily wins the contest. Having begun his career in television in 1951, *Giant* was Dean's third and last film. During production he had wrapped his Porsche convertible around an oak tree on a lonely central California back road. Some of the unfinished scenes required filming Dean's stand-in from the back with a voice mimic providing the dialog. Stevens won another best director Oscar for his work on the film.

As the fifties came to an end, Stevens was also nearing the end of his career with the production of *The Diary of Anne Frank* (1959). The film is based on the true story of two Dutch-Jewish families who attempt to avoid detection during the Nazi occupation of Amsterdam by hiding in a factory attic. The thirteen-year-old daughter of the Frank family keeps a diary of their two-year ordeal which also serves to record her experience of growing to adulthood. With its tragic ending, the film is one of the best films of the fifties that attempt to document the Nazi Holocaust. Stevens would make two more films before retiring in 1970, neither very remarkable.

CECIL B. DEMILLE

DeMille was present at the birth of the motion picture industry. In 1914 he and his partner, Jesse Lasky, came to Hollywood to make movies far away from the meddling of the Edison Patent Trust on the east coast. Their first studio was a rented livery stable which has, since, been moved to a location across Highland Blvd. from the Hollywood Bowl where it serves as a film museum. Their first collaboration, *The Squaw Man* (1914), was the first full-length film made in Hollywood. By the late teens DeMille and Lasky teamed up with Adolph Zukor to create the Paramount, one of the first vertically integrated motion picture companies, owning production studios, theaters, and a distribution network. DeMille's role was to produce and direct films, which he did very well. He had directed 43 films between 1914 and 1920. He made another 18 films in the twenties including his 1923 epic, *The Ten Commandments*, and the equally ambitious *The King of Kings* (1927).

DeMille slowed down in the thirties and forties directing only 16 films. During the fifties he made only two films but both were so completely successful that they are counted among his best. The *Greatest Show on Earth* (1952) represents one of Paramount's early attempts to produce an epic-style film that would draw audiences away from their televisions and into the theater. It featured an all-star cast led by Charlton Heston and including several major stars of the previous decade such as Betty Hutton, Dorothy Lamour, and Gloria Grahame. The cast also includes well-known circus performers such as the great clown Emmett Kelly and John Ringling North. The film is infused with DeMille's trademark sense of pageantry and spectacle. It won the Oscar for best picture.

In 1956 DeMille completed his last production, a remake of his earlier film, *The Ten Commandments*. It is another attempt by Paramount to establish its dominance in the epic genre. Shot in widescreen VistaVision in Egypt and on the studio's special effects stages, *The Ten Commandments* is a perfect blend of DeMille's tableaux style of directing, great location work, great special effects, and kitsch. Charlton Heston as Moses leads a huge international cast including Yul Brenner, Edward G. Robinson, Anne Baxter, Yvonne DeCarlo, and veteran character actor, Sir Cedric Hardwick. DeMille recreates the building of the pyramids, Moses leading the Israelites out of Egypt, the parting of the Red Sea, God Speaking to Moses through the burning bush, and the handing down of the Ten Commandments. The great director/showman had clearly saved his best for last.

DIRECTORS OF THE FIFTIES: EMERGING TALENT

STANLEY DONEN

Born in 1924, Donen was a dance prodigy. He made his Broadway stage debut in 1941 at age 17. In 1949 at age 25 he teamed up with dancing star Gene Kelly to direct the MGM musical, *On The Town*. With a dream cast featuring Kelly, Frank

Sinatra, and Anne Miller, it is the story of three sailors on leave in New York. Largely shot on location, the film uses the city backdrops to great effect. Unlike the stagy, studio-bound musicals of the thirties and forties, this musical has a fresh everyman kind of exuberance. MGM was making a commitment to dominating the musical genre in the fifties and Donen was perfectly positioned to take advantage of that strategic direction.

In 1951 Donen was assigned by the studio to direct the great Fred Astaire and Jane Powell in *Royal Wedding*. Written and composed by Broadway veteran Alan J. Lerner, it is the story of the reunion of the two dancers for a royal performance before the Prince of England, played by future "Rat Pack" member Peter Lawford. In keeping with his previous work, Donen shot the film on location in London. In 1952 Donen directed one of the great musicals of all time, *Singin' In The Rain*. Staring Gene Kelly, Donald O'Conner, and Debbie Reynolds, the film is a satire on the period when sound pushed aside silent films. Unlike his previous films, *Singin' In The Rain* is shot almost entirely in the studio with just a few Hollywood locations. The studio gives Donen and Kelly an opportunity for complete control over their environment for the purpose of creating some truly amazing effects.

In 1954 Donen adapted the Broadway musical, *Seven Brides for Seven Brothers*, which won an Oscar for best music. In 1957 he made another successful adaptation, *The Pajama Game*, starring Doris Day and John Raitt. In 1958 Donen made a change of pace, directing Cary Grant and Grace Kelly in the romantic comedy, *Indiscreet*. Filmed entirely on location in London, the project gave the director an opportunity to show how brilliantly he could use locations without the encumbrance of a large musical cast and crew. His last film of the fifties was another adapted musical, *Damn Yankees* (1959). The film was another huge hit for MGM. During the decade Donen had dominated a genre as had no other director in history. He directed 14 films with some of the biggest stars in the business and did it with grace and style.

ELIA KAZAN

A fixture in New York dramatic circles in the thirties as a member of the Group Theater, Kazan was an early proponent of the Stanislavski method of acting. In the forties his reputation as a stage director began to grow as a result of his relationships with talented playwrights like Tennessee Williams and Arthur Miller. In 1945 Twentieth Century Fox invited him to direct *A Tree Grows In Brooklyn*. The film was an artistic success and led to other offers. In 1947 Kazan won the Best Director Oscar for his work on another Fox project, *A Gentlemen's Agreement*, a film about anti-Semitism in American business and society. In 1949 he made another "message film," *Pinky*, the story of a light-skinned black woman passing for white.

As the fifties began Kazan had gained a reputation for making films that dealt with difficult social issues and that contained vivid acting performances. *Panic in the Streets* (1950) is the story of a desperate effort to stem an outbreak of pneumonic plague that has

struck New Orleans. The following year Kazan made one of his greatest films, the screen adaptation of Tennessee Williams' *A Streetcar Named Desire*. The film stars Marlon Brando who had also starred in Kazan's Broadway production of the play. It was the actor's second film and it made him an instant star. The film won Brando's counterpart, Vivien Leigh, a Best Actress Oscar and Karl Malden and Kim Hunter swept the Oscars for Supporting Actress and Actor. In 1952 Kazan and Brando re-teamed to make *Viva Zapata*, the story of a Mexican bandit turned leader of the Mexican Revolutionary Army and president of the new republic. Brando received his second Best Actor nomination and Anthony Quinn won the Best Supporting Actor Oscar.

In 1954 Kazan and Brando joined forces to make one of the greatest films in contemporary film history, *On The Waterfront*. It deals with the issue of corruption and organized crime's involvement in labor unions. Shot on location on the New York docks, it is a hard hitting and moving film. It was nominated for twelve Oscars, winning eight, including Best Screenplay (Budd Schulberg), Best Actress (Eva Marie Saint), Best Actor (Brando), Best Director (Kazan), and Best Picture (producer, Sam Spiegel). In 1955 Kazan introduced another promising young method actor, James Dean, who became an instant star in *East of Eden*. Adapted from the John Steinbeck novel, it is the story of two brothers competing for the love and attention of their father. Dean is allowed to showcase his great emotional depth as an actor. His talent combined with his unconventional off-stage behavior made Dean a teen sensation overnight.

In 1956 Kazan brought another Tennessee Williams play to the screen, *Baby Doll*. It is the story of a middle aged cotton gin owner from the south (Karl Malden) who cannot wait for his wife's twentieth birthday so he can consummate the marriage. The 19-year-old wife (Carole Baker) is beautiful and sexy but she still sleeps in a crib and sucks her thumb. Then a rival (Eli Wallach) comes to town to steal the man's business and the affections of his wife. The darkly comedic film was nominated for four Oscars. Kazan's last film of the fifties, *A Face in the Crowd* (1957), was a departure from his earlier work. Based on a script by Budd Schulberg, it is the story of a hillbilly musician (Andy Griffith of television fame) who rises to become a media star and political kingmaker. The political satire genre was a little unfamiliar for the director as was the lack of a method actor in the leading role but the film still holds up.

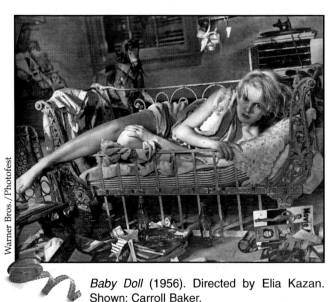

Warner Bros./Photofest

Baby Doll (1956). Directed by Elia Kazan. Shown: Carroll Baker.

OTTO PREMINGER

Preminger was born in Vienna Austria in 1906. He directed his first stage play in 1931 and came to New York five years later to continue his stage work. Fox brought him to Hollywood that same year to direct *Under Your Spell.* He made four other films for the studio until breaking through with *Laura* in 1944. It is a mystery about a young woman who has been murdered in her apartment in which a hauntingly beautiful portrait of her is prominently displayed. The detective investigating the case becomes obsessed with the victim, eventually falling in love with her. The film was made with such great style that Preminger became an instant directing star. Working as both producer and director, he made eight more films in the forties, becoming one of the studio's most prolific talents.

Beginning in 1950 Preminger made a series of mysteries including: *Where the Sidewalk Ends* (1950), *The 13th Letter* (1951), and *Angel Face* (1952). In 1953 he changed pace with the self-produced romantic comedy, *The Moon Is Blue*. The film is about two aging playboys pursuing the same woman who deflects their advances, claiming she wants to remain a virgin until she is married. The film was quite successful in spite of the fact that Preminger chose not to apply for a seal of approval from the Motion Picture Association of America (MPAA). Suspecting that he would not receive one, he decided to release the film sans seal of approval. Contrary to conventional wisdom, the lack of a seal had no effect on the film's box office. Inadvertently, Preminger had broken the code's 19-year stranglehold on the motion picture industry. In 1954, after completing another film for Fox, the producer/director undertook another daring independent project, *Carmen Jones*. It is a contemporized version of the Bizet opera, *Carmen*, with an all African American cast led by Harry Belafonte, Dorothy Dandridge, and Pearl Bailey.

In 1955 Preminger again went independent to make a film that the studio could not possibly release under its banner, *The Man With A Golden Arm*. The film stars Frank Sinatra as a heroin-addicted card dealer battling his disease against the backdrop of the Chicago underworld. Once again, Preminger was at odds with the MPAA and its longstanding rule that films were forbidden to portray drug use of any kind. This time it was the MPAA that relented. Fearing that the release of another film without the seal would undermine the power of the production code altogether, the Association decided to change the code to allow the film and it was granted certificate #17011, in a clear victory for the anti-censorship community. Throughout the remainder of the fifties Preminger continued to make groundbreaking films, including *The Court-Martial of Billy Mitchell* (1955), *Saint Joan* (1957), *Porgy and Bess* (1959), and *Anatomy of a Murder* (1959).

ROBERT WISE

He could have easily have passed into movie history known as the man who edited *Citizen Kane* (1941). But after Welles walked off the set of *The Magnificent Ambersons* (1942), Wise directed a few un-credited finishing scenes. He caught the directing bug

and never lost it. During the remainder of the forties he worked for Twentieth Century Fox, directing a number of B pictures in the film noir style. In the fifties, after making three good but unremarkable films for the studio, he was assigned to direct the science fiction classic, *The Day the Earth Stood Still* (1951). It is the story of an alien space ship that lands on the capitol mall in Washington DC. Klaatu (Michael Rene) and his robot companion are on a mission to tell Earthlings that they had better become more peaceful or the galaxy is going to wipe out civilization. Of course the Earthlings react with characteristic stupidity. The film is extremely well written and Wise's direction makes the story both entertaining and believable. The director made two more films for the studio in 1952 before being assigned to make *The Desert Rats* (1953). Set in World War II, Richard Burton plays a British tank commander who prevents the Germans under Field Marshal Erwin von Rommel from capturing the Suez Canal. It is a first-rate war film with excellent battle scenes and many daring stunts. After *The Desert Rats* Wise made one more film for Fox before becoming an independent director for hire.

In 1954 Wise moved to MGM to make *Executive Suite*, starring William Holden in a story of boardroom intrigue at a big corporation where the boss has died without naming a successor. It is a very adult drama with an Oscar-nominated performance by Nina Foch. Next Warner Brothers hired Wise to direct his first big screen epic, *Helen of Troy* (1956). Shot at the huge Cinecittà Studios facility outside Rome, the film demonstrates the director's ability to work on a complex and technically challenging film. Wise followed *Helen* with a quickie western before making the bio-pic, *Somebody Up There Likes Me* (1956). Paul Newman stars as Rocky Graziano, the young gangster-turned prize fighter and middle weight champion of the world. Newman's performance is characteristically charming and the film won Oscars for cinematography and art direction. Always one to stay busy, Wise made two films in 1957 before tackling the tense submarine drama, *Run Silent, Run Deep* (1958). The film stars Clark Gable as a submarine commander obsessed with sinking a Japanese destroyer that had destroyed his previous sub. Burt Lancaster co-stars as the executive officer who doubts his boss's sanity. The film is the most realistic depiction of sub warfare of its time. It shows Wise's ability to handle difficult detail.

Wise's next film was a big departure from his war films. *I Want To Live* (1958) stars Susan Hayward as the real-life party girl, Barbara Graham, who was sentenced to death in the San Quentin gas chamber for her part in the murder of an elderly woman from Burbank. Hayward's performance won her the Best Actress Oscar. Wise was nominated for Best Director. His painstaking recreation of the execution makes *I Want To Live* seem almost like a horror film. His last and eighteenth film of the fifties was *Odds Against Tomorrow* (1959). It is the story of a diverse group of criminals masterminding a bank heist. A superb cast, including Harry Belafonte, Robert Ryan, Shelley Winters, Ed Begley, and Gloria Grahame, breathe life into this crime procedural. Once again, the director's ability to make detail interesting turns what could have been a rather ordinary film into something special.

As the decade reached its end, Wise was poised to be offered some of the most important films of the next two decades.

VINCENTE MINNELLI

Minnelli's career peaked in the fifties. After working on Broadway for several years, he got his start in movies at MGM as an art director, designing several Busby Berkeley musicals. In 1943 he was assigned to direct an all African American cast in the production of *Cabin in the Sky*. The film features amazing performances by Lena Horne (who sings "Stormy Weather), Louis Armstrong, Eddie "Rochester" Anderson, and Ethel Waters. The following year he was assigned to direct his future wife, Judy Garland, in the Technicolor spectacular, *Meet Me In St. Louis*. The film was a major success and helped cement Minnelli's reputation as an excellent director of musicals at a studio that took great pride in its mastery of the genre. In all he directed ten films in the forties including hits such as *The Pirate* (1948) and *Madame Bovary* (1949).

Minnelli began the decade helming one of MGM's 1950 prestige films, *Father of the Bride*, starring Spencer Tracy and Elizabeth Taylor. The following year he reunited with Producer Arthur Freed's MGM musical unit to make *An American In Paris*. Gene Kelly both stars in the film and choreographs the ballet made for cinema based on George Gershwin's musical suite. The film was received as a great work of art, winning a total of six Oscars including Best Picture. In 1952 Minnelli was given a chance to show his versatility with *The Bad and the Beautiful*. The noirish film is the story of a Hollywood mogul and the people who he has helped and betrayed along the way. Kirk Douglas is the mogul. Lana Turner, Dick Powell, and Walter Pidgeon lead a colorful cast of veteran character actors. The film won six Oscars. In 1953 Minnelli had three films released, the last being *The Long, Long Trailer*, an uproarious comedy starring the king and queen of television sitcoms, Desi Arnaz and Lucille Ball. His sole 1954 film was another Gene Kelly musical, *Brigadoon*. 1956, Minnelli changed directions once again with the biopic, *Lust for Life*, starring Kirk Douglas as Vincent Van Gough and Best Actor Oscar winner Anthony Quinn as Paul Gauguin.

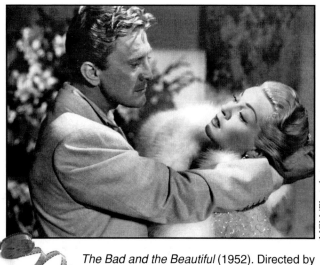

The Bad and the Beautiful (1952). Directed by Vincente Minnelli. Shown (from left): Kirk Douglas and Lana Turner.

In 1958 Minnelli finally won his long overdue Best Director Oscar for his work in the musical, *Gigi*. With Leslie Caron in the title role and the venerable Maurice Chevalier as her costar, the film is a warmhearted romance. In all the film won nine Oscars including another Best Picture for Arthur Freed. As the fifties were nearing an end, Minnelli changed styles once more with *Some Came Running* (1958) starring "Rat Packers" Frank Sinatra and Dean Martin as two brothers adjusting to post-war life in a small Indiana town. In all Minnelli made 18 films during the fifties. This would have been an amazing output for a journeyman studio director working on B-picture programmers. But Minnelli was making some of the most prestigious motion pictures Hollywood produced during a decade when the emphasis was on making big, complicated pictures. Both the quality and quantity of his work stand out as remarkable achievements.

FIFTIES GENRES

During the fifties much of what came out of Hollywood reflected America's conscious and sub-conscious obsessions. The possibility of a nuclear holocaust, the threat of spreading communism, changing morality, and emergence of teenage counterculture presented sensational subject matter for a motion picture industry that was, itself, threatened and in need of change. The rise of independent film production and the decline of studio hegemony created an atmosphere that was much more open to new ideas and approaches than the top-down world of the studio system. New genres were created to appeal to an audience that was becoming more sophisticated through education and the window on the world that television was becoming. Old genres were updated to reflect the need to lure back the restless audience to the movie house.

SCIENCE FICTION

In the thirties, science fiction was pretty much limited to Saturday matinee serials such as Flash Gordon and Buck Rogers. In the fifties, two new strains of sci-fi emerged to deal with the twin threats of nuclear annihilation and communist invasion. Films that deal with the nuclear threat often involve horrible creatures that mutated through exposure to the testing of atomic and hydrogen bombs or some other scientific meddling with nature. Those that deal with communism typically have plots that involve alien invasion.

The growth of the science fiction genre was also aided by other factors including great sci-fi writers such as Ray Bradbury and Robert Heinlein and the availability of better special effects technology. Advances in model making, prop making, make-up, and cinematography resulted in more vivid and visually believable films. Producer and special effects master George Pal created much of the technology for the genre. As a veteran of famed UFA studios in Germany and the producer of dozens of stop-animation Puppetoons in the forties, Pal had the perfect experience to meet the challenges of sci-fi. In the fifties Pal headed the special effects unit at

Paramount. Not only did he create many new technologies, he trained the next generation of special effects wizards.

Nuclear-Inspired Science Fiction

Rocketship XM (1950)

The Beast from 20,000 Fathoms (1953)

Them (1954)

The Creature from the Black Lagoon (1954)

Tarantula (1955)

The Incredible Shrinking Man (1957)

The Attack Of The 50 Foot Woman (1958)

Alien-Inspired Science Fiction

The Day the Earth Stood Still (1951)

When Worlds Collide (1951)

The Thing (1951)

It Came from Outer Space (1953)

Invaders from Mars (1953)

The War of the Worlds (1953)

This Island Earth (1955)

Earth vs. Flying Saucers (1956)

The Invasion of the Body Snatchers (1956)

The Blob (1958)

I Married a Monster from Outer Space (1958)

Others Two outstanding films that do not fit neatly into categories deserve mention in this section, *Forbidden Planet* (1956) and *The Fly* (1958). *Forbidden Planet* was conceived as a big-budget Technicolor and Cinemascope epic by the executives at MGM. Based on the Shakespeare play, *The Tempest*, the film is the story of space travelers sent to rescue a prior mission to the planet Altair IV. On arrival they discover that the only survivors are the mysterious Dr. Morbius, his daughter, Altaria, their robot man-servant, Robby, and a mysterious shape-shifting monster. The film is made with impeccable detail and remains as one of the great films of the decade. *The Fly* was Twentieth Century Fox studio's entry into the color, Cinemascope sci-fi genre. Vincent Price stars as a scientist who has created a teleportation machine that allows him to break down living creatures into streams of atoms and send them through the airwaves instantly. The experiment goes awry when the scientist decides to test it on himself and his atoms get mixed up with a fly's that has hitchhiked a ride in the teleportation chamber. The film is a very successful mixture of science fiction and horror.

TEEN FILMS

This was a genre that came into its own in the fifties. In post-war America many families could afford to send its teenagers to high school and even to college. Kids were staying in the home longer and, given the tremendous prosperity of the time, they were able to develop a culture of their own that centered on fast cars, drive-in coffee shops, and drive-in theaters. In 1954 a new kind of movie company, American International Pictures (AIP), was created by Samuel Z. Arkoff and James S. Nicholson to appeal to the teenage market. Their approach was to make low-budget double pictures and distribute them as doubles to drive-ins and "grind houses" (theaters that had seen better days and were hanging on by appealing to teenagers). The success of AIP was noted by other studios that quickly began to serve the new market. United Artists was on the brink of bankruptcy when a new management team took over in 1951 and quickly added the production of low-budget teen films to the studio's output.

Teen films took on several forms. Science fiction, rock 'n roll, motorcycle gangs, juvenile delinquents, fast cars, sex, and out-of-touch parents became the subject matter for films in which the stories were told from a teenager's point of view and the main characters were teenagers. Many successful actors got their start in teen films including Jack Nicholson, Dennis Hopper, and Peter Fonda. Roger Corman, AIP's production chief and lead director, had a particular talent for making teen films with unproven talent on both sides of the camera. In the mid-fifties major studios began to see the potential in teen movies. Upon seeing the first week of dailies from *Rebel Without A Cause* (1955) Warner Brothers executives ordered the director, Nicholas Ray, to stop production and start all over so that the film could be shot in color and Cinemascope. Increasing the budget turned out to be a good decision. The young actors starring in the film, James Dean, Natalie Wood, and Sal Mineo, were creating something very special. In the end the film became a classic.

Teen films tend to fall into three categories: Schlock films that are sometimes unintentionally funny for their poor level of craftsmanship; films that have wonderful moments or really good performances but are not particularly good overall; and some films that were good when they were made and are still must-see classics.

Rock 'n Roll Films

Rock Around the Clock (1956)

Don't Knock the Rock (1956)

Rock All Night (1957)

Elvis Presley Films:

Love Me Tender (1956)

Jailhouse Rock (1957)

King Creole (1958)

Juvenile Delinquent Films

Crime in the Streets (1956)

Crybaby Killer (1958—featuring Jack Nicholson)

Daddy-O (1959)

Live Fast, Die Young (1958)

Riot in Juvenile Prison (1959 with a coed prison)

Classics

A Place in the Sun (1951)

The Wild One (1953—Brando's biker movie)

Blackboard Jungle (1955)

Peyton Place (1957)

Stakeout on Dope Street (1958)

A Summer Place (1959)

Blue Denim (1959)

Gidget (1959—the original surfer movie)

Schlock—So Bad It Is Good

I Was a Teenage Werewolf (1957—with Michael Landon)

I Was a Teenage Frankenstein (1957)

Earth vs. the Spider (1958)

Teenage Caveman (1958)

Teenagers from Outer Space (1959)

FILM NOIR

Film noir began as a genre with the production of John Huston's *Maltese Falcon* in 1941. The people who made films in the noir style were not conscious of it at the time. Film Noir is a description that the French New Wave critics gave to a particular body of films made between 1941 and 1958. The basic characteristics of Film Noir are the following:

1. The use of expressionistic visual style.
2. Heroes and anti-heroes who do not adhere to society's conventional sense of morality.
3. Villains who are often more colorful and interesting than the good guys.
4. Femme Fatales—literally "deadly women" who control men with their sexuality and are perfectly open to the idea of homicide.
5. Pessimistic stories that rarely have happy endings.

The genre was heavily influenced by great detective writers such as Dashiell Hammett and Raymond Chandler. Pulp fiction (fiction of a low-brow lurid quality was often printed on cheap pulp paper) was another influence. Many of the works of pulp fiction writers Jim Thompson and Cornell Woolrich were adapted as Films Noir. Fritz Lang, a pioneer German expressionist, had created noir classics like *Scarlet Street* (1945) and continued working in the genre in the fifties. *The Big Heat* (1953) is the best of his later day noirs but *Clash by Night* (1952) and *Human Desire* (1954) are also very worthy of notice. Orson Welles' *Touch of Evil* (1958) is generally considered the last Film Noir of the classic period. This does not mean, however, that the noir genre ended there. Over the years directors have continued to revive and adapt its principles. Films such as *Blade Runner* (1981) and *L.A. Confidential* (1997) have continued the noir tradition.

ACTORS: ESTABLISHED STARS

FRED ASTAIRE

Astaire had been in show business since 1904 when he became a five-year-old vaudeville performer. During the thirties he became the greatest dancing star in movie history. However, as ballroom dancing movies began to go out of style in the forties, Astaire began to put as much emphasis on his acting talents as on his dancing. In 1945 he decided to retire but it was only two years before he was back before the cameras. In the fifties he appeared mostly in musicals opposite several different dancing partners. In *Royal Wedding* (1951) he worked with Jane Powell. In the 1953 MGM musical *The Band Wagon* his partner was Cyd Charisse. His opposite in *Daddy Long Legs* (1955) was Leslie Caron. By this time Astaire was becoming too old to play romantic leading men. Between 1957 and 1959 he appeared on the television program *General Electric Theater* to showcase his acting. This led to his best-acted film of the fifties, *On the Beach* (1959), the story of the last survivors of the nuclear holocaust, slowly dying of radiation poisoning.

HUMPHREY BOGART

Bogart's career would come to an end when he lost his battle with throat cancer in January 1957. Even though he knew he was dying, Bogart created some of his most vivid roles in those last few years. In 1950 he played a daring test pilot in *Chain Lightning* and a screenwriter suspected of murder in *In a Lonely Place*. The following year he starred in three films including one of the most colorful roles of his career, Charlie Allnut, opposite Kathryn Hepburn in John Huston's *African Queen*. The film, set in wartime Africa, features Bogart as a broken down riverboat captain who rescues a missionary woman who has aroused the suspicions of the local garrison of Nazis. During their daring escape the two engage in an improbable romance.

Bogart made just one film in 1952, *Deadline U.S.A.*, in which he plays a crusading newspaper editor. In 1953 he re-teamed with Huston on another African adventure,

Beat the Devil. That year he also appeared on the Jack Benny television show and starred in a big-budget war film. In 1954 Bogart played the paranoid Captain Queeg in *The Caine Mutiny.* That year, he also made *Sabrina* and starred as a washed-up movie director whose career is revived by the beautiful Ava Gardner, in Joseph L. Mankiewicz', *The Barefoot Contessa.* In 1955 Bogart continued the feverish pace of his work with three films and a television project. His last film was the 1956 production of *The Harder They Fall,* a prize fight drama.

HENRY FONDA *worked with John Ford, Hitchcock, Sidney Lumet, Anthony Mann.*

He left the New York stage for Hollywood in 1935 when he signed with Twentieth Century Fox. Fonda made twenty films in the 1930s and achieved star status in John Ford's 1939 classic, *Young Mr. Lincoln.* The following year he played Tom Joad in Ford's adaptation of *The Grapes of Wrath*. He received a Best Actor Oscar nomination for the role. Between 1940 and his enlistment in the Navy in 1942 Fonda appeared in fourteen films including the classic screwball comedy, *The Lady Eve* (1941), and *The Ox-Bow Incident* (released in 1943). He resumed his career in 1946 in *My Darling Clementine,* the story of the mythical frontier lawman, Wyatt Earp. During the remainder of the decade Fonda played leading roles in another five films.

In the early years of the fifties Fonda returned to New York where he combined television acting with his starring role in the long-running Broadway hit, *Mr. Roberts.* He appeared on dramatic shows such as *General Electric Theater* and *Producers' Showcase.* In 1955 he returned to Hollywood to reprise his stage role in John Ford's adaptation of *Mr. Roberts.* The following year he starred opposite Katharine Hepburn in King Vidor's ambitious adaptation of *War and Peace.* Fonda's other remarkable fifties movies include Alfred Hitchcock's *The Wrong Man* (1956), Anthony Mann's sophisticated western, *The Tin Star* (1957), and Sidney Lumet's *Twelve Angry Men* (1956). During the remainder of the decade and beyond, Fonda continued to give his stage work equal time with his movie career. He also raised two children, Peter and Jane, who would go on to have significant movie careers on their own.

CARY GRANT

Grant had been a circus acrobat in England, named Archie Leach, before Paramount signed him as a romantic leading man in 1932. He went on to make 39 films during the remainder of the thirties and became one of the greatest stars in film history. During the forties he made another 20 films. As the fifties began, Grant was beginning to work less and become more selective in the roles he took. In 1950 and 1951 he made only two films, *Crisis* and *People Will Talk* (1951). He was making the transition to playing older characters and played a doctor in both films. The following year he made the light comedy, *Room for One More,* and played yet another doctor in Howard Hawks' screwball comedy, *Monkey Business.* Grant made one uneventful film in 1953 and took off almost a year before going back to work on Alfred Hitchcock's *To Catch A Thief* (1955).

In 1957 Grant made one last film with the director who taught him how to do comedy, Leo McCarey. *An Affair to Remember* (1957) was not a comedy, however. It was a serious romantic drama. Grant played opposite Deborah Kerr as two people who have a brief affair aboard an ocean liner and agree to put it on ice for one year and if they are still interested they will meet at the Empire State Building. It all goes wrong when Kerr has a disfiguring accident on her way to the rendezvous. Grant made two other films that year including the Stanley Kramer epic, *The Pride and the Passion*, and Stanley Donen comedy, *Kiss Them for Me*. His next film, *Houseboat* (1958), was also with Donen. In 1959 Grant and Hitchcock got together to make the action-suspense classic, *North by Northwest*. Even though Grant was 55 when he made the film, he shows off his vitality and athleticism as well as his ability to be believable in a romance opposite an actress 20 years younger, Eva Marie Saint.

JAMES STEWART

Stewart was among the group of actors who came to Hollywood in the thirties after having graduated from college. He received a degree in architecture from Princeton in 1932. After a period of stage acting in New York, he came to Hollywood in 1934 and was signed to a contract by MGM. He began by playing the younger brother roles in family pictures. Because he was tall and had never lost his Indiana drawl, he projected a kind of sincerity that was very appealing. In 1936 he appeared in nine films as the studio was preparing him for lead roles. The following year he got his first starring assignment opposite Simone Simon in *Seventh Heaven* (1937). Throughout the remainder of the thirties he became one of Hollywood's biggest stars. Two of his most memorable roles were as the young senator in *Mr. Smith Goes to Washington* (1939) and as a reporter in *The Philadelphia Story* (1940). After the attack on Pearl Harbor, MGM released Stewart from his contract to enlist in the Army Air Corps where he became a bomber pilot, serving until the end of the war in 1945.

Stewart's career blossomed in the fifties. As an actor for hire without a studio contract, he started to get roles that were much more challenging than his earlier career. His collaboration with Alfred Hitchcock during the decade included *Rear Window* (1954), *The Man Who Knew Too Much* (1956), and *Vertigo* (1958). Other important films include *The Glenn Miller Story* (1954), *The Spirit of St. Louis* (1957), and *Anatomy of a Murder* (1959).

JOHN WAYNE

Born Marion Morrison, he got into movies working as a prop man for John Ford who gave him his name and taught him how to walk, fight, and act. In the early thirties Wayne signed with Republic Studios to make low-budget westerns which were very popular with younger audiences. His career reached a rough spot in 1939 when no studio wanted to hire him. Ford came to the rescue and made the film *Stagecoach* (1939) to renew his appeal. From that moment on, whenever Ford needed him, Wayne made himself available.

The fifties were Wayne's greatest decade. He made 21 films during that period, among them are some of the actor's best roles. He began the decade making the last of the films in Ford's Cavalry Trilogy (*Fort Apache*—1948 and *She Wore a Yellow Ribbon*—1949, and *Rio Grande*—1950). One of Ford's and Wayne's greatest collaborations is *The Quiet Man* (1952), the story of an American prize fighter who returns to his roots in Ireland. Wayne has the best fight scene in his career and Ford virtually caresses the Irish landscape with his camera. Most of the best World War II films and films about the military life were made in the fifties and Wayne was in many of them, *Flying Leathernecks* (1951), *Island in the Sky* (1953), *The High and the Mighty* (1954), *Blood Alley* (1955), *The Wings of Eagles* (1957), and *Jet Pilot* (1957).

BETTE DAVIS

She was, by far, Warner Brothers' greatest star during the thirties and forties. She made 60 films during that time. As the fifties arrived, Davis was beginning to play older women and choose her roles carefully. *All About Eve* (1950) is a perfect example. She plays the aging stage actress, Margo Channing, who uses and is used by the ambitious young actress-to-be, Eve Harrington. In 1955, Davis played one of her greatest roles, Queen Elizabeth I, in *The Virgin Queen*. In the mid-fifties Davis began to work extensively in television, including the *General Electric Theater* and *Alfred Hitchcock Presents*. Her last great film of the decade was the historical epic, *John Paul Jones* (1959), in which she played Empress Catherine the Great.

KATHARINE HEPBURN

Hepburn began the fifties playing one of the most colorful roles of her career, Rose Sayer, in John Huston's classic, *The African Queen* (1951). She had gracefully slipped into playing older women in the forties by appearing opposite her real-life partner, Spencer Tracy, in a number of films. They continued the collaboration with *Pat and Mike* (1952) and *Desk Set* (1957). Other great roles of the decade include Jane Hudson, the lonely American tourist who finds love in Venice in *Summertime* (1955), and the old maid, Lizzie Curry, who is romanced by Burt Lancaster in *The Rainmaker* (1956).

ACTORS: RISING STARS

Television created a tremendous amount of opportunity for actors, writers, and directors in the fifties. With its insatiable need for new programming, an actor could get a year's worth of experience in a matter of weeks working on TV shows. Those who already had movie experience saw their careers accelerated in much the same manner in which careers were rushed in the early days of sound.

Doris Day

Born Doris Mary Ann Von Kapplehoff in Cincinnati, Ohio in 1922, she began singing with local bands in the early forties. In 1946 she was screen tested by Warner Brothers who liked her sunny screen persona and signed her right away. She made her screen debut in *Romance on the High Seas* (1948). During the fifties she became one of the studio's leading musical performers beginning with *Tea for Two* (1950). Other musicals include *Lullaby of Broadway* (1951), *April in Paris* (1952), *Calamity Jane* (1953), and *The Pajama Game* (1957). In all, she appeared in 10 musicals during the decade. She also was cast in a few dramatic and comedy roles including Jo Jordan in *Young Man With a Horn* (1950), *Storm Warning* (1951) a film noir with Ronald Reagan, and *Teacher's Pet* (1958) opposite Clark Gable. During the sixties Day would be cast opposite Rock Hudson in a series of romantic comedies beginning with *Pillow Talk* (1959).

Grace Kelly

Kelly was born in Philadelphia in 1929 to a very wealthy family. She was educated in private schools and, upon graduating from the Stevens School, she left for New York City and the American Academy of Dramatic Arts. She made her stage debut in 1949 in *The Father*. Her first film performance was in *14 Hours* (1951), directed by Henry Hathaway. In 1952 she was cast opposite Gary Cooper as his wife in Fred Zinnemann's western classic, *High Noon*. Her next role was in *Mogambo* (1953) a John Ford film set in an African safari. Her co-stars were Clark Gable and Ava Gardner. With her cool demeanor and shimmering blonde hair, Kelly was the perfect Hitchcock heroine. She appeared in three of his films, *Dial M for Murder* (1954), *Rear Window* (1954), and *To Catch a Thief* (1955). It was while shooting *Thief* on the French Riviera that she met her future husband, Prince Rainier III of Monaco. After completing work on *High Society* (1956) Kelly retired and married the Prince.

Marilyn Monroe

Nee Norma Jean Baker, she was a "Hollywood brat." Her mother was a film cutter at RKO (her father's identity is unknown) until her mental health forced retirement. Baker was placed in an orphanage when her mother was institutionalized. In 1942 she got married to escape the orphanage. When her husband was sent to work in the merchant marines during the war, Baker worked in an aircraft factory and did modeling jobs to support herself. She signed a contract with Twentieth Century Fox in 1946. The studio gave her a new name and blonde hair and cast her in a number of supporting roles until she broke through in Howard Hawks' *Gentlemen Prefer Blondes* (1953). From that role on, the studio marketed her as a "blonde bombshell." *How to Marry a Millionaire* followed in 1953 in which she was teamed up with Betty Grable and Lauren Bacall. The great writer-director Billy Wilder should be credited with really

"getting" Monroe and understanding how to make her shine on film. *The Seven Year Itch* (1955) was their first collaboration. In 1959 they teamed up to make her best comedy film, *Some Like It Hot*.

DEBBIE REYNOLDS

Reynolds was born in El Paso, Texas in 1932. She signed an MGM contract after winning a beauty contest when she was sixteen. Her first big break came when Gene Kelly picked her to be his dancing partner in *Singin' in the Rain* (1952). She was not really a dancer before getting the role but, with Kelly and Donald O'Connor in the cast, she had two of the best teachers in the business. Reynolds became a regular in MGM musicals following *Singin'*, appearing in seven musicals during the next three years the last of which was *The Tender Trap* (1955) opposite Frank Sinatra. *The Catered Affair* (1956), directed by Richard Brooks, was her first non-musical comedy role. In 1959 she did a string of four films including a musical, *Say One for Me*, and three comedies, *The Mating Game*, *It Started with a Kiss*, and *The Gazebo*.

ELIZABETH TAYLOR

A child actress at MGM in the forties, she was still playing teenagers as the new decade began in Vincente Minnelli's *The Father of the Bride* (1950) with Spencer Tracy in the title role. She was finally allowed to grow up in 1951 when she played a new mother in the sequel to *Father of the Bride*, *Father's Little Dividend*. Her first serious role came that same year when she played opposite Montgomery Clift in George Stevens' *A Place in the Sun*. As proof of the studio's faith in her stardom, MGM put her in the leading role in the big-budget epic, *Ivanhoe* (1952). George Stevens cast her again in his adaptation of Edna Ferber's epic, *Giant* (1956). She plays opposite Rock Hudson in a role that requires her to age 30 years. She was up to the challenge. Next, Taylor played two sultry southern belles in *Raintree County* (1957) and *Cat on a Hot Tin Roof* (1958). Her last film of the fifties was the very disturbing adaptation of Tennessee Williams' *Suddenly Last Summer* (1959). She plays opposite Montgomery Clift and Katharine Hepburn in a role that establishes her reputation as one of the great film actresses in history.

KIRK DOUGLAS

Born Issur Danielovitch Demsky in Amsterdam, New York in 1916, his father was a "rag man." Douglas was an excellent wrestler and received a scholarship to attend St. Lawrence University. He soon transferred to the American Academy of Dramatic Arts and appeared in a few plays on Broadway before joining the Navy during World War II. In 1946 he was screen-tested by Warner Brothers for a part in *The Strange Love of Martha Ivers* and got the role. In 1950 he won the role of Jim O'Connor in the movie

adaptation of Tennessee Williams' *The Glass Menagerie*. The demanding role established him as a talented and serious actor. The following year, Billy Wilder cast him as the scheming reporter in *Ace in the Hole* which led to William Wyler casting him in *The Detective Story* (1951).

Douglas' reputation for playing hard-bitten characters was growing in the early fifties, spurred on by his performance as the egotistical producer in Vincente Minnelli's inside-Hollywood film, *The Bad and the Beautiful* (1952). One of Douglas' most charming early roles was Ned Land, the accordion-playing sailor in Walt Disney's *20,000 Leagues Under the Sea* (1954). In 1956 he played the tortured artist, Vincent Van Gough, in the well-respected biography, *Lust for Life*. His biggest action spectacle of the fifties was Richard Fleischer's *The Vikings* (1958). In all Douglas made 23 films during the fifties.

WILLIAM HOLDEN

Born in O'Fallon, Illinois in 1918 as William Franklin Beedle Jr., his family was very wealthy. They moved to Pasadena, California when he was young. Holden was studying chemistry at Pasadena Junior College in 1939 when he was signed to a contract by Paramount to appear in *Golden Boy*. He enlisted in the military in 1942 and did not return to acting until 1947. His first great role was Joe Gillis, the cynical writer, in Billy Wilder's *Sunset Boulevard* (1950). George Cukor was impressed by the performance and cast Holden as the newspaper man hired to tutor a rich man's girl friend in manners and social skills in *Born Yesterday* (1950). Holden won a Best Actor Oscar for his role in Billy Wilder's *Stalag 17* (1953). In 1955 his performance in Joshua Logan's *Picnic* was controversial for its mature sexuality. Kim Novak was his sultry co-star. In 1957 Holden stared in David Lean's masterpiece about life as a prisoner of war in *The Bridge on the River Kwai*, which won seven Oscars including Best Picture. He is credited with 25 film appearances in the fifties.

BURT LANCASTER

Lancaster was born in New York in 1913. He had an early interest in gymnastics and became a circus acrobat until an injury ended his career. While serving in the Army during the war, he became interested in acting through the USO. His first film role was the lead in Robert Siodmak's *The Killers* (1946). In 1951 Siodmak cast the actor in the role that got his career rolling, Captain Vallo in the swashbuckling *The Crimson Pirate*. The role gave Lancaster a chance to show off his athleticism as well as his acting. In 1953 Lancaster won the role of a lifetime. Colombia had acquired the screen rights to one of the best books about life in the military at the outbreak of World War II, James Jones' *From Here to Eternity*. Every actor in Hollywood wanted to be in a film that was certain to be the biggest movie event of the year. Lancaster received the lead role of Sgt. Warden, who is having a torrid affair with his Captain's wife, played by Deborah Kerr. Their make-out scene in the surf is a classic. *Trapeze* (1956) gave the actor another role in which his acrobatic abilities could shine, but his acting was

front-and-center in *The Sweet Smell of Success* (1957). In it he plays J.J. Hunsecker, a gossip columnist who is willing to destroy people to get a good story. The role was based on the feared Walter Winchell, and Lancaster is at his steely-eyed best in it. Lancaster appeared in 22 films in the fifties.

JACK LEMMON

The quintessential Billy Wilder actor: he is intelligent, charming, and vulnerable. Lemmon was born into a wealthy family from Newton, Massachusetts in 1925. He attended boarding school before enrolling at Harvard where he majored in drama. He served as a junior officer in the Navy during the war, after which he worked in live television dramas in New York City. He continued his TV career in Hollywood and had appeared on 16 different shows (often in multiple episodes) before breaking into movies in 1954 in the strangely titled *Phffft*. Lemmon's big break came when John Ford cast him in the comedic role of Ensign Pulver in *Mister Roberts* (1954). Lemmon won a Best Supporting Actor Oscar for his performance in a cast that included such high-powered acting talent as James Cagney, Henry Fonda, William Powell, and Ward Bond. He continued to work predominately in film until 1959 when Wilder cast him as the cross-dressing Jerry–Daphne in *Some Like It Hot* (1959).

Revolutions in International Cinema

3

As was the case with many American industries in the post World War II era, American movie companies had grown and thrived during the war. There was no immediate need to reinvent the industry, only to keep up with the times. Conversely, international cinemas had been either completely wiped out by the war or were so disrupted that a return to business as usual was unthinkable. American films were soon in heated competition with television. It would not be until the mid-sixties that foreign movie companies would need to respond to TV, and, even then, television was as much an ally to the motion picture business as a competitor. The result was that as the indigenous film industries of Europe reawakened, one by one, film revolutions in style, theory, and technique burst forth, each broadening the vision of what a movie could be.

THE NEW ITALIAN CINEMA: NEOREALISM TO PERSONAL CINEMA

Almost from the moment Benito Mussolini became the Fascist dictator of Italy in 1922, he played an active role in the Italian cinema. He certainly understood the propaganda value of film and its power to sell his image and politics to the citizenry. He was, no doubt, drawn to the glamour of the medium and clearly enjoyed the company of its stars. The dictator's second son, Vittorio, wrote and produced films in the thirties and the Mussolini regime operated an active and effective film commission for the purpose of encouraging promising young filmmakers to create Fascist films. In 1937 the dictator further rewarded and encouraged the Italian cinema by opening Cinecittà outside Rome, the largest studio production facility in the world. As a result, a new cinema began to emerge in Italy that followed Fascist ideals in celebrating the lives of common people and depicting their stories realistically. Roberto Rossellini's *A Pilot Returns* (1942) (written by Vittorio Mussolini) is a good example of Fascist cinema. It was clearly a propaganda film but it offers a realistic portrayal of an ordinary soldier attempting to cope with life as a prisoner of war. In the end, his suffering serves no real purpose and is only heroic on a personal level.

In 1942 Luchino Visconti's film, *Ossessione* (Obsession), pointed the way for the new generation of **neorealists**. Based on the American novel, *The Postman Always*

41

Rings Twice, the film is the story of a woman and her lover who conspire to kill her husband and live off his fortune. Once the deed is done the two devolve into an orgy of lust and recrimination. The film is set in a dry barren location which serves as a metaphor for the couple's passions. Visconti's work proved to be too unorthodox even for the relatively freewheeling Fascist cinema and was denounced and withdrawn from theaters. However, by the time this was done, young Italian directors and writers had already seen the possibilities the film presented.

The first important post war film to emerge from Italy was **Roberto Rossellini's** *Roma: Città Aperta* (Rome: Open City—1945). Italian audiences had always been fed a healthy diet of escapism and they loved it. But the originality and audacity of Rossellini's work made it a great financial and critical success. In *Città Aperta,* the director incorporates all of the stylistic and narrative elements of neorealism. It is set in a working class neighborhood of Rome during the Nazi occupation of the city (1943–1944). The people do not have enough bread to eat and must raid the bakery to survive. Many of the men are actively involved in the communist-led resistance movement. The neorealist sense of moral ambiguity is presented in the relationship between the parish priest, Don Pietro, and the atheistic resistance. The priest aids them in every way in a direct contradiction of his vows. The resistance leader's lover is addicted to opiates that she gets from an evil lesbian Nazi. This leads to his and Don Pietro's capture and torture by the Nazi commander who is also gay. The ensuing scenes of torture are still some of the most graphic in film history. In addition to the realistic treatment of sex and violence, the film also employs many non-professional actors, whose authentic faces heighten the sense of realism.

Rossellini continued to work in this new style twice more, completing his postwar trilogy with *Paisà* (1946) and *Germania, Anno Zero* (Germany, Year Zero—1947). *Paisà* is a series of six small films that take place during the invasion of Italy by the Allied Armies. After the Nazi occupation, Italians were more than ready to welcome the Americans and English enthusiastically. The film shows the growth of camaraderie between the people and their liberators while never letting the audience forget that death is always at stake during war. *Germania, Anno Zero* is dedicated to the director's son who died in 1946. Rossellini poured all of his grief into the film which was set among the ruins of Germany in defeat. It is the story of a young man, his sister who survives through prostitution, and his father who is dying. Of the three films that comprise the trilogy, the last is the bleakest and least hopeful. Rossellini continued to write and direct films into the seventies. But his greatest contribution is to the creation of neorealism. His daughter, Isabella Rossellini, was one of three children born to Ingrid Bergman and Roberto during their seven-year marriage.

VITTORIO DE SICA

If Rossellini created neorealist cinema, Vittorio De Sica perfected it. He began his film career as an actor, appearing in over 36 films (mostly comedies) before directing himself in the comedy, *Rose Scarlatte* (Red Roses—1940). In 1944 De Sica met the screenwriter,

Cesare Zavattini, while working on *The Children are Watching Us*. The two men began to develop films that were closer to the neorealist style than their previous work. In 1946 they made *Sciuscia* (Shoeshine), a film about the lives of two boys who shine shoes at the horse racing track and become tragically involved in selling goods on the black market. This is De Sica's first truly neorealist film.

The director's next neorealist film was *The Bicycle Thief* (1948), his masterpiece. Using non-professional actors in the principal roles of the father and son, De Sica is able to create an almost oppressive feeling of reality. It is the story of man who has been unemployed for a long time. He finally gets a job posting bills because he has a bicycle to take him to his assignments all over Rome. Tragedy strikes when the bicycle is stolen. The man and his son search the entire city constantly being told by police and bureaucrats that there is no hope of recovering the bicycle. In desperation the man steals one and in so doing loses the respect of his son. The film is a passionate depiction of life among Rome's poor. It was seen by many critics as an argument for communist rule.

The last film in De Sica's neorealist trilogy was *Umberto D.* (1952). As with the other two films, Zavattini wrote the screenplay. It is the story of a retired university professor who suffers the humiliations of old age. Accustomed to being respected, he is treated like any other aged pensioner. The film is the director's least sentimental. By the early fifties neorealism had reached the end of its run. De Sica accepted an invitation to work on an American production for Columbia Pictures. *Stazione Termini* (1953) stars Montgomery Clift and Jennifer Jones as a married woman who gets involved with Clift while visiting family in Rome. As conceived and executed, the film is as far as possible from neorealism. De Sica continued to work both as an actor and director until his death in 1974 at age 72.

The next generation of Italian filmmakers included directors such as Michelangelo Antonioni and Federico Fellini. Their films were focused on the intimate aspects of human nature, particularly sexuality. This new style of film earned the title: **personal cinema**.

MICHELANGELO ANTONIONI *wrote the script for Rossellini's A Pilot returns.*

Antonioni began his career writing scripts for neorealist directors such as Rossellini's *A Pilot Returns* (1942) and Giuseppe De Santis' *Tragic Pursuit* (1947). He was also a contributor to the respected film journal, *Cinema*, where his essays on the documentary genre led to the opportunity to make documentaries beginning with *The People of the Po* (1947). Antonioni made ten more documentaries over the next two years, gaining a reputation for cool style and the interesting use of music. His first dramatic feature was *Story of a Love Affair* (1950) which he both wrote and directed. As a director he became fond of elaborate tracking shots and he encouraged his actors to underplay their emotions, resulting in films with a cool, detached attitude. Another departure from neorealism is Antonioni's choice of narratives that involve middle class and upper middle class characters rather than the underprivileged common man.

The director also assumes in his films that the audience is educated enough to follow a complicated or ambiguous narrative. In many ways this is the most revolutionary aspect of his work in the fifties and sixties, the period when the European and American motion picture establishment were highly averse to making films that would "go over the audience's heads."

Antonioni's first film to have success in America was *Il Grido* (The Cry—1957). Shot in Italy, the film features an international cast including American actors Steve Cochran and Betsy Blair. It is the story of a man who is spurned by his lover and begins to travel the countryside in search of a replacement. He ends up in the industrialized Po Valley region where the environmental desolation serves as a metaphor for emotional emptiness. In 1960 Antonioni began work on a quartet of films that would define his style and lead to his reputation as one of the great post-war filmmakers. The first was *L'Avventura* (1960). It is the story of a group of rich kids on a deserted island. A young girl is missing and the others begin an unsuccessful search that is more important for the formation of relationships among the searchers and their libertine attitudes about sex. The director's decision not to let the characters find the girl is an example of his growing belief that classic film conventions were too confining. In this film and his next, Antonioni concentrates on his cinematic technique, delivering shots and compositions that are a delight unto themselves. His next film, *La Notte* (1961) delves deeper into the idea of characters who live meaninglessly. *L'eclisse* (1962) moves away from abstract nature of the two earlier films into a style that is more straightforward. In it, Monica Vitti plays a woman who has just escaped a bad relationship. The next day she meets a materialistic young stock broker. His frenetic life in the trading pit is contrasted with her quiet self absorption. They seem to have nothing to say to each other but are attracted anyway. The last of the four films, *Il Deserto Rosso* (The Red Desert—1964) is Antonioni's first color film set amidst the industrial waste of Ravenna, Italy. It stars Monica Vitti as a bored housewife who is having a mental breakdown. Irish actor Richard Harris plays her husband, the manager of the local factory. While he is out of town she meets another man at a sex party. When she confides in him about her unhappiness, he takes advantage of the situation, then abandons her. The physical wasteland she inhabits becomes a metaphor for her emotional wasteland in which communication with others is almost impossible. Throughout the film Antonioni emphasizes his editing technique with disorienting jumps in time. With the completion of these four works, Antonioni created a new kind of motion picture in which the story became subservient to mood and the old notions of happy endings and neat plots were made absurd.

FEDERICO FELLINI

Although Fellini wrote neorealist masterpieces such as *Roma: Città Aperta* and *Paisà*, his own films as a director were far removed from realism. Even as a student at the University of Rome, his imagination ruled his decisions. After seeing a number of American movies portraying the adventurous lives of newspaper reporters, he

decided to become one himself. His articles and cartoons (Stan Lee's Marvel Comics were one of his early influences) were published in the Italian humor magazine *Marc'Aurelio* when he was 19. At age 22 he penned the first of 51 scripts that he would write in his career, an adaptation of *I Cavalieri del Deserto* (1942). His directorial debut came in 1950 with *Luci del Varietà* (Lights of Variety), the story of a group of wandering vaudeville performers. From the beginning, the focus of his films was on character. Having worked briefly as a circus clown he was particularly interested in the lives of entertainers. His first autobiographical film, *I Vitelloni* (The Young Bulls—1953) tells the story of four young men coming of age in an Italian country village. The protagonist is witness to the failures of his boyhood friends and, in the final scene, leaves on the morning train bound for his new life in Rome.

La Strada (The Road—1954) begins the development of Fellini's signature style. The film stars American actors, Anthony Quinn as a circus strongman and Richard Basehart as the tightrope walker. The director's wife, Guilietta Masina, plays Quinn's waiflike companion. Because of the international cast, the dialogue had to be recorded after filming was complete. Although this method is technologically challenging, Fellini gets everything to synch up excellently. As a result, it was relatively simple to translate the film into English and other languages for export, thereby increasing its value in the marketplace. In *La Strada* the director brings his characters into sharper focus than in his previous work. His love for presenting the audience with grotesque images also emerges in this film. The music was written by Nino Rota, beginning a collaboration that would last more than two decades.

Fellini's next two films, *Il Bidone* (The Swindle—1955) and *Le Notti di Cabiria* (The Nights of Cabiria—1957) were well made and well received but they lacked the greatness of *La Strada*. In 1960 Fellini captured the imagination of the motion picture world with his breakthrough film, *La Dolce Vita*. Marcello Mastroianni , Italy's biggest male star at the time, plays a journalist who is reporting on the lives and lifestyles of the "Jet Set" celebrities of Europe. The deeper he digs into these people, the shallower they get. Fellini's protagonist is not just collecting gossip, he is searching for meaning and there is not any to be found. A statuesque Anita Ekberg becomes the focus of a halfhearted orgy at the end of the film. Even the promise of carnal delights cannot awaken these characters from their comas of self absorption. A revolution of

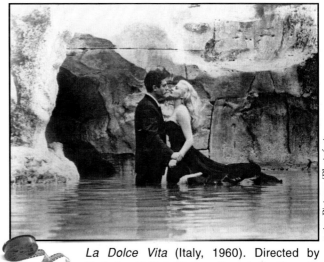

La Dolce Vita (Italy, 1960). Directed by Federico Fellini. Shown (from left): Marcello Mastroianni, Anita Ekberg.

Astor Pictures/Photofest

epic proportions was about to overtake the world's motion industries in the sixties and *La Dolce Vita* was one of the films that announced its beginning.

During the remainder of the sixties, Fellini made two more wonderful and important films, *8 1/2* (1963) and *Juliet of the Spirits* (1965). In *8 1/2* Marcelo Mastroianni plays a director very much like Fellini who is trying to finish one film and get another started. In a dizzying and disorienting series of flashbacks and fantasy sequences, he encounters his lover, his wife, his producer, his friends, and critics. Are they the reason for the freeze in his creative process? Or is he using them to stay frozen or to thaw? The narrative is non-linear like the process of creation itself, drawing the viewer into the same state of disorientation as the filmmaker. Through all of this the director is undergoing some sort of self analysis, exploring the reasons he does or does not do the things he believes he should. Actress Claudia Cardinale plays several of the female characters in the film. Perhaps the sum total of her parts equals the director's idealized woman. At last Fellini devolves into one of his favorite motifs, the circus. Once again he reminds us that even his sincerest attempts to create and explore meaning in film may be nothing more profound than the circus parade going through town.

In *Juliet of the Spirits* Fellini returns to his fractured narrative technique. This time his wife, Giulietta Masina, stars as a woman whose husband is being unfaithful. She must sort through her notions of the church, family, tradition, and society to find the direction she must take in confronting her situation. In real life Fellini claimed to have taken LSD in a clinical setting just prior to making *Juliet*. It is his first color film and he seems to have infused it with his notion of psychedelia. The decade of the sixties ended for Fellini with his film *Satyricon* (1969). Some critics are dismissive of the film and some see it as a serious attempt at bringing Petronius' book, *Satryricon*, to the screen. The author had the bizarre job of being the advisor to Emperor Nero on all matters of luxury and extravagance, including, of course, gluttony and sex. Fellini uses the text as a blueprint and an excuse for filling the screen with fantastical and grotesque images of sex, suffering, perversion, and everything else that can be related to the topic. All of this is set against the backdrop of first century Rome. Taken seriously or not, in *Satyricon* Fellini is giving full voice to the extremes that were the result of the cultural revolutions and liberations of the sixties. At the very least the film is a visual feast even if some of the dishes are a bit distasteful.

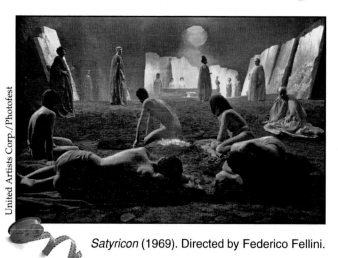

United Artists Corp./Photofest

Satyricon (1969). Directed by Federico Fellini.

THE BRITISH NEW WAVE AND WORKING CLASS REALISM

Great Britain was economically drained by the Second World War. Many of its industries lay in ruin, the result of nightly bombing by the German Air Force. In London, block after block of burned out roofless brick row houses stretched out for mile after mile across the city, once homes for the working class. Returning veterans of the war found an economy in shambles. Across the Atlantic in America the cousins of the British were busy building new colleges and universities to prepare the war generation to become the best educated, most technologically advanced workforce in the world. Home in England there had never been much in the way of public institutions for higher learning and there certainly was not money in the post-war economy to build them. For many of those who had served so valiantly in the jungles of Asia and the deserts of North Africa, not to mention the battlefields of Europe, what awaited was the dole and days spent in the pub nursing pints and a deep resentment for the lack of opportunity.

The British motion picture industry still existed but much of its best talent had taken refuge in Hollywood during the war. The studios were struggling to get back to normal and those who had remained at home provided a sufficient workforce for the small amount of production that existed. The Rank Organisation and London Films were the two remaining significant studios. Rank focused on making comedy series including the *"Doctor in the House"* films with Dirk Bogarde. London Films was busy trying to make movies for export to America. The tiny Ealing Studios struggled to make comedy classics such as *The Lavender Hill Mob* (1951) and *The Lady Killers* (1955). In 1958 Ealing shuttered its doors. Upstart Hammer Studios was struggling for survival, but would later hit on a successful formula for low-budget horror films. The few work opportunities that existed for the next generation of British filmmakers came from television work at the British Broadcasting Corporation (BBC) or on stage. During the period of the middle to late fifties three filmmakers arise who represent the rebirth of the British cinema while giving expression to the disappointments of their generation. Tony Richardson, Karel Reisz, and Lindsay Anderson all spent the early parts of their filmmaking careers creating documentaries and short films for television and as program fillers for movie theaters.

TONY RICHARDSON made the film, Look Back in Anger

He spent 1955 directing hour-long dramas for BBC Television. The following year he made a TV adaptation of John Osborne's play, *Look Back in Anger.* The television program attracted a lot of controversy. Many hailed it as an example of the new British theater with plays about the working class and disaffected middle class as opposed to comedies of manners by older writers like Noel Coward. In 1958 the play was adapted into a motion picture, directed by Richardson and starring Richard Burton, a ruddy-faced newcomer who was equally at ease playing blue collar ruffians or Shakespeare's Hamlet. Burton plays a character trapped in a job and a marriage that are going nowhere. He is too smart and too educated to fit in but does not know how to escape.

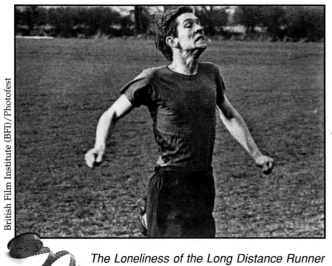

The Loneliness of the Long Distance Runner (1962). Directed by Tony Richardson. Shown: Tom Courtenay.

The result is a constantly frothing anger. Audiences reacted enthusiastically to Burton's rage at a government and society that were denying an entire generation the opportunity to succeed.

Richardson's next film, *The Entertainer* (1960), was also based on an Osborne play. In it Sir Laurence Olivier, the king of the British stage and Hollywood movies, plays a music hall performer desperate to keep his career going while all the signs point in the opposite direction. Osborne saw the play as an allegory for Britain's decline as a country and an empire. The next year the director made *A Taste of Honey* (1960) featuring a pixie-like Rita Tushingham as a homely 17-year-old girl who gets pregnant and is forced to fend for herself. As the film unfolds she learns how to take care of herself and her baby leading to a hopeful ending. The director's style in the film is much lighter and less argumentative than his previous work. He was clearly evolving away from the negativity of his earlier work. The film also represents an early depiction of women's liberation. The last film of Richardson's realist period is *The Loneliness of the Long Distance Runner* (1962). It stars a young Tom Courtenay as a working class boy who has been sentenced to reform school for robbing a bakery. In the reformatory, the boy discovers that he is a talented long distance runner. He uses the sport to rise above his class and past and achieve his ambitions.

KAREL REISZ

Reisz' entrance into fictional film came with *Saturday Night and Sunday Morning* (1960) the film adaptation of a book by Alan Sillitoe (the author of *The Loneliness of the Long Distance Runner*). Young Albert Finney plays a factory worker with two girlfriends one of whom is married and carrying his baby. His rebellion and his sexual self indulgence give form to the protagonist's anger, but nothing can sooth it. Reisz' next film as a director (he took off time to produce *This Sporting Life* in 1963) *Night Must Fall* (1964), also starred Albert Finney again as a working class fellow but this character just happens to be a serial killer. The part gives Finney the opportunity to show his many sides as an actor.

His next film was a significant departure from the working class hero genre. *Morgan: A Suitable Case for Treatment* (1966) stars David Warner opposite Vanessa

Redgrave. Warner plays Morgan, a gifted artist who has become the toast of the elite of swinging London. He is obsessed with his wife (Redgrave) who is leaving him to marry a rich art dealer. Morgan is dedicated to his old mum who loves her gin and Karl Marx. The mother and her boyfriend, a retired wrestler, agree to help Morgan win back his wife with a series of funny but misguided stunts aimed at getting her attention. The problem with the stunts is that they become increasingly dangerous and crazy. Even as the film depicts the artist's descent into madness it manages to remain comedic. In many ways *Morgan* is the perfect bridge between working class hero and the swinging London films that were to follow.

LINDSAY ANDERSON

From 1948 to 1957 Anderson spent his time making documentary films. In 1956 he took a job directing episodes of the *Adventures of Robin Hood* for television. He worked at odd jobs for the next few years before directing Richard Harris in *This Sporting Life* (1963). Whether it was intentional or not, the film is generally considered to be the film that killed the working class hero genre. Harris plays a talented rugby player from the north of England. He should be getting promoted to better teams and he should have better luck with the women he pursues but his behavior is so boorish and self destructive he gets nowhere. In some respects the film takes the convention of the young man faced with the hopelessness of existence and turns it back on itself. If he were just a little smarter and better behaved, life would not be such a drag.

As the sixties unfolded, both in Europe and America a new spirit of rebellion and the possibility of changing the world for the better began to emerge. For Great Britain the focus of pop culture was increasingly on new music. In America it was known as the British Invasion. New groups like The Dave Clark Five, Herman's Hermits and, later, the Beatles and Rolling Stones were transforming rock 'n roll with an upbeat positive spirit. British film was changing too. Tony Richardson had progressed from angry young man pictures to comedies such as the sexual romp, *Tom Jones* (1963), and a dark satire about the mega cemetery, Forest Lawn, *The Loved One* (1965). Karel Reisz had moved from *Morgan* to *Isadora* (1968) a biopic based on the life of the great dancer, Isadora Duncan. Anderson, likewise, had changed his style with the film, *If* (1968), the story of a rebellious boy trapped in the stultifying atmosphere of an English boarding school. In 1962 the James Bond franchise was established with Sean Connery playing the legendary spy in *Dr. No*. Peter Sellers started the *Pink Panther* comedy franchise in 1963. Audiences completely forgot about the old grievances of the working class hero movies in the midst of this new torrent of positivity.

NOUVELLE VAGUE: THE FRENCH NEW WAVE

Of all the post-war cinematic revolutions, the most influential and enduring is the French New Wave. Led by an academic, André Bazin, the French movement began as a loosely knit cult of movie theorists who wrote about movies and studied movies for

years before putting their ideas on the screen. In 1959 24 French directors made and released their first films. Not all were part of Bazin's intrepid group but many were. The world had never and would never again experience such a convulsive outpouring of cinematic invention.

ANDRÉ BAZIN

Born in Angers, France in 1918, Bazin studied to become a literature teacher as a young man. Due to a speech impediment, he was unable to pass the oral examinations required for a credential. Instead, he turned to his other love, the cinema. In 1942 he established a cinema club at the Sorbonne University which became a sensation with young movie lovers from all over Paris. Cine clubs were popular in wartime Paris which was occupied by the German army who heavily censored films shown in regular theaters. The clubs were able to obtain prints of banned films and became the refuge of serious students of film. Bazin began writing about film the following year and was soon published in journals such as *L'Espirit* and *Le Parisien libéré*. He was interested in exploring film as art and in using art critical approaches to analyzing movies. Some of his early work explores the films of the great French pre-war directors including Dryer and Jean Renior.

In the years following the war, Bazin helped establish several other film clubs throughout Europe and began writing for an experimental film journal, *La Revue du Cinéma*. He was becoming a minor celebrity among film scholars. In 1949 Bazin met a 16-year-old juvenile delinquent named François Truffaut. He was engaged by the boy's knowledge and love of film. Before long he took the boy under his wing and acted as protector when young François got into trouble, which was often. The boy introduced his mentor to other young cineasts (film people) including Jean-Luc Godard, Éric Rohmer, and Jacques Rivette. Later this group would form the French New Wave. That same year Bazin established a new film event, the "Festival of Accursed Films" which was organized around the principle of discovering overlooked treasures.

In 1950 Bazin teamed up with his friend, filmmaker Jacques Doinol-Valcroze, to create a new film journal, *Cahiers du Cinéma*. Truffaut and his friends were joined on the writing staff by another cineaste, Claude Chabrol. The first issue included Bazin's classic essay, "The Evolution of the Language of Cinema." He went on to write at length about Orson Welles and *Citizen Kane* and Chaplin. His greatest work is a 1957 collection of essays titled, *Qu'est-ce que le cinéma?*, later published in English under the title, *What is Cinema?* Bazin who had fought ill health, including tuberculosis, his whole life, died at age 40 in 1958. To compound the tragedy of his early death, he never got to see the brilliant work of his young "New Wave" disciples beginning with Truffaut's 1959 breakout film, *The 400 Blows*.

French New Wave theories are too numerous for a work of this nature; however, some of the major theories are described below.

one advantage of long take : spontaneity .

The Long Take Bazin and his followers were critical of the Russian theory of montage editing which puts much emphasis on the way the film is edited. Furthermore, in the thirties, the Hollywood studios had adopted a method of filming known as the continuity style. It emphasized shooting every scene from several points of view to ensure that the dialogue would be completely covered. This was done for the practical reason that the director could move on to another project and leave the editing to the people in the editing department. The result was often artificial. The new waves believed that filmmaking should be more honest and that scenes should be filmed in one long take if possible. This accomplishes several purposes. First the actors are freer to concentrate on their performances rather than on being able to repeat their performances from several different angles through many takes. This allows for spontaneity and, when appropriate, improvisation. The use of long takes requires the cinematographer to compose the scene in deep focus (a technique that was held in high regard by the new waves) so that the actors move naturally around the set rather than focusing on hitting their marks.

Cinema Verité Literally translated, cinema verité means the cinema of truth. This theory was heavily influenced by Italian realism but it entails more than realistic methodology. Cinema verité is a value that the new waves held in common. They sought to make films that did not rely on trickery and to tell stories about life as they experienced it in a lifelike manner. Some of the new waves believed that films did not have to contain action in the cinematic sense and all of them rebelled against the "happy ending" orthodoxy of Hollywood. The new waves revered the documentary genre and were pleased when their fictional films attained a documentary-like feeling of truth. Cinema verité suggests the use of unknown actors so that audiences would not place expectations on a film simply because of who was in it. In Hollywood no one would dare cast John Wayne as a coward or Cary Grant as the second fiddle who does not get the girl in the last act. Cinema verité distinguishes between images that are made by hand and those which are made photographically. When we encounter a painting in a museum we are acutely aware that it is the work of a particular artist and that it is depicted through the artist's point of view. When we encounter photographic images we accept them as documents that are not so much depictions of reality but reality itself. Therefore, the filmmaker has an ability to manipulate images both through photography and editing to fool the audience. It is called movie magic. The theory of cinema verité commands the filmmaker to be honest with the audience and to avoid, wherever possible, the use of tricks.

Mise en Scène A term borrowed from French stagecraft, mise en scène means the elements of the scene. On stage this includes the art direction of the sets, props, wardrobe, and lighting. Acting and directing are also elements. In film we add the elements of photography and editing. One of the unique properties of the camera

is to change the audience's point of view. When we watch a stage play our point of view remains constant; it is determined by the seat we purchased. In film the director and photographer have the ability to control what we see and how we see it. Cinematic mise en scène is dynamic because the camera moves. It is the filmmaker's responsibility to attend to and balance all of the cinematic and dramatic elements.

Auteur Theory The Auteur theory did not originate with the cineastes. In fact they probably borrowed it from their favorite directors such as John Ford, Howard Hawks and Alfred Hitchcock. All of these directors and others had attained such stature in the film business that they were in complete control of every aspect of the films they made. The auteur theory holds that the director should be the author of the film. Even though all films represent the work of many individuals, the finished product should be a reflection of the director's artistic vision and intent. The result is a unified work of art that has the desired quality of verité.

FRANÇOIS TRUFFAUT

Truffaut was born in Paris in 1932. His father was an architect and his mother was an office manager. They were indifferent parents and sent their son to live with his grandmother until he was eight years old. By the time he returned to his parents, Paris was occupied by the Germans and the city was experiencing a serious problem with juvenile delinquency. Many Parisian men had gone to North Africa to join General Charles De Gaulle and the Free French Army. Others had taken to the countryside to join the French insurgency. This left many women alone in the city to fend for themselves. Those who could not find work to support their families often turned to prostitution, leaving their children to run wild in the streets. It did not take young François long to join in. He was indifferent about school but passionate about movies and chose to spend his days in movie theaters and cine clubs instead of school.

By the time Truffaut became teenager he had a few brushes with the law. However, it was his decision to start a film club in 1948 that got him into real trouble. In developing his enterprise the young man piled up enormous debts for the films he rented and the theaters in which they were screened. His father was furious about the money and had Francois committed to a reform school where his bad behavior earned him a seven-month stay in solitary confinement. The institution's psychologist, Mademoiselle Rikkers, took an interest in Truffaut's case. She was friendly with André Bazin and convinced him to see the boy and help in speeding up his release from prison. Bazin was more than willing to help and so began what would become a father-son relationship over time.

In 1953 Truffaut enlisted in the French army. At the time France was fighting a war in Viet Nam. Truffaut decided to desert on the eve of being sent to Asia. The penalty for desertion could have been death before a firing squad. But, with the help of Bazin

and Mademoiselle Rikkers, the authorities were convinced that Truffaut was mentally unstable and should not stand trial for his misdeeds. Instead he spent six months in a prison mental hospital and was discharged from the service. At this time the young man turned his passion toward writing for *Cahiers du Cinéma*. One of his essays titled "A Certain Tendency of the French Cinema" was a notorious scathing criticism of everything and everyone in the French film establishment, especially the Cannes Film Festival. It should have gotten him blackballed from the motion picture industry forever but, instead, even some of the people he criticized thought that his observations were noteworthy.

In 1955 Truffaut made his first film a 16mm short entitled *Une Visite*. His collaborators were fellow new wave filmmakers, Jacques Rivette and Alain Resnais. The following year Bazin helped arrange for Truffaut to work for the father of Italian neorealism, Roberto Rossellini. He served as the director's assistant for two years working on three different projects while learning the technique of motion picture pre-production. In 1957 Truffaut married Madeleine Morgenstern whose father was a noted film producer and distributor. In 1958 he made his second short film, *Les Mistons*, the story of a group of young brats (mistons) who spy on and stalk the woman of their fantasies. Following that project, he teamed up with Jean-Luc Godard to make *Une Histoire d'eau*. Truffaut entered *Les Mistons* in the Brussels film festival and it won an award but he was banned from Cannes for the nasty things he had written about it.

In 1959 Truffaut made his first feature film, *The 400 Blows*. It is the autobiographical story of young Antoine Doinel struggling to escape adolescence and become an adult. It is also the portrait of the artist as a young man. Antoine is played by Jean-Pierre Leaud who would appear in many of Truffaut's films, including his other autobiographies, *Love at Twenty—Antoine and Colette* (1962), *Stolen Kisses* (1968), *Bed and Board* (1970), and *Love on the Run* (1979). *The 400 Blows* became an instant international sensation. It was accepted into the Cannes Film Festival where it received the best director award, the British Academy Awards (BAFTA) gave it its best picture award, and it was also nominated by the American Motion Picture Academy for the best foreign film Oscar.

Truffaut's 1960 film, *Shoot the Piano Player*, is a slight departure from the pure cinema verité style. It stars French pop singer, Charles Aznavour, as a pianist in a dive bar frequented by

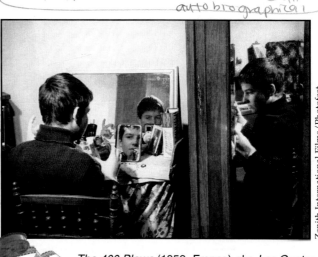

The 400 Blows (1959, France) aka *Les Quatre Cents Coups*. Directed by Francois Truffaut. Shown: Jeanne-Pierre Leaud.

Zenith International Films/Photofest

prostitutes even though he was a world famous classical pianist in his earlier life. Important parts of the story are told in flashback, The film adheres slightly to the gangster and mystery genres, and it depends a great deal on editing. But Truffaut captures a sense of cool and aloofness in his protagonist that is both appealing and mysterious and hip enough to keep the critics from complaining about the lack of adherence to doctrines of the new wave.

The next Truffaut film, *Jules and Jim* (1961), was immediately hailed as a new wave masterpiece. It stars Jeanne Moreau as the central figure in a complicated love affair with two men. The relationships are depicted over a long period of time including the World War I. Truffaut completed two more films before making *Fahrenheit 451* (1966) a future fiction film, based on a story by the American science fiction writer, Ray Bradbury. By this point Truffaut was not exactly ignoring the theories of the new wave but he was incorporating those that fit and finding other devices to suit his needs. The very fact that *Fahrenheit 451* is speculative fiction breaks the cardinal rule of cinema verité, that films should be realistic or, at least, tell stories about real people in real situations. The film's cast also defies the rule against the use of well-known actors for fear that audiences would not accept them if they were cast against type. Oscar Werner was a big international film star in 1966 and Julie Christie was one of the two or three most in-demand women actors of the sixties and early seventies.

The following year Truffaut made his homage to Alfred Hitchcock, *The Bride Wore Black*. It stars Jeanne Moreau as a young bride whose husband has been killed by accident by five local men. She tells her mother that she is leaving town but stays and dons elaborate disguises as she plots to kill all of the men. Like many of Hitchcock's films, *Bride* is a study in suspense and surprise. Truffaut even went so far as to hire Bernard Herrmann, a composer associated with some of Hitchcock's best films, to write the music. In 1970 the director made another film that does not fit neatly into the new wave canon, *Wild Child*. It is the story of a group of hunters who find a boy, approximately ten years old, who was abandoned as a baby to be raised by the creatures of the forest. Truffaut plays Le Dr. Jean Itard, a doctor to whom the hunters take the boy. The doctor decides to keep the boy in his custody to attempt to civilize him. The film contains many scenes of the doctor lovingly and patiently teaching the boy manners and educating him. Bazin had always encouraged Truffaut to act as well as direct. It is interesting that the director chose this role of caring father, given the complete lack of fathering he received in his own youth.

In 1973 Truffaut made a beautiful and romantic film, *Day for Night*. It is his valentine to the movie business. He stars as the patient and long-suffering director of a big scale movie production with lots of complications. The film opens with a long tracking shot of the director on a crane shooting the complex opening scene of his film. To add to the complexity of the shot, Truffaut employs a crane to shoot the crane creating a dance-like sequence. British born Jacqueline Bisset stars as Julie, a famous movie star recovering from a breakdown. Jean-Pierre Leaud plays

himself playing the leading man. Truffaut treats his audience to all of the love affairs and near disasters and small victories that comprise the movie making process. He gives himself one of the great lines in movies about movies, "Shooting a movie is like a stagecoach ride. At first you hope for a nice ride. Then you just hope to reach your destination."

In 1978 Truffaut directed himself again in *The Green Room.* It is a period piece set in the 1920s and concerns a man who is still grieving his deceased wife ten years after her death. He builds a shrine to her in his home (a green room), but the house burns down and he must find another place. In his search for a new location he meets a beautiful woman who falls in love with him but he is dead inside and cannot return her affection. The last Antoine Doinel film was *Love on the Run* (1979). In it Doinel is over 30 and divorcing. He must begin to face life's unpleasant realities but Doinel can never lose his romanticism completely. The film contains many flashbacks from the earlier Doinel works. Truffaut's penultimate film as a director is *The Last Metro* (1980). It is set during the German occupation of Paris during World War II and deals with the travails of a Jewish couple struggling for survival. In 1983 Truffaut appeared in a major role in Steven Spielberg's science fiction epic, *Close Encounters of the Third Kind.* That same year he made his last film, *Finally Sunday*, a Hitchcockian suspense comedy. As he was completing the film, Truffaut received a diagnosis of an inoperable brain tumor. He spent most of his final months in and out of hospitals and died in 1984 at age 52.

JEAN-LUC GODARD

The most consistently revolutionary of the new wave directors, he was much more committed to the precepts of cinema verité than Truffaut and his other contemporaries. Born in Paris in 1930, Godard came from a somewhat well-to-do Swiss-French family. When it became apparent that the Germans would eventually occupy Paris in 1939, the family escaped to Switzerland. They returned after the war and Godard continued with his studies. When it was time for him to attend university at the Sorbonne, he majored in sociology, which he would come to detest. He began to gravitate toward the Cine-club du Quartier Latin and to write about film. After two years he left the university for good, at which time, he was completely and permanently disowned by his parents. In 1951 when *Cahiers du Cinéma* began publication, Godard became an early contributor. He was particularly interested in films by Howard Hawks and Hitchcock. He left Paris to travel and make a documentary film about the building of a dam in Switzerland in 1952 and did not return to Paris until 1956.

In his absence Godard's opinions and observations about film had changed considerably. He had developed a new pantheon of film heroes, Roberto Rossellini, Ingmar Bergman, and Nicholas Ray. He wrote about them with great passion and admiration. He also began to direct and edit a series of short films in preparation for his first feature. In the watershed year of 1959 he made the feature, *À bout de souffle.*

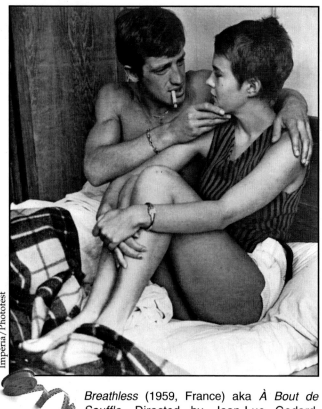

Impéria/Photofest

Breathless (1959, France) aka *À Bout de Souffle*. Directed by Jean-Luc Godard. Shown: Jean-Paul Belmondo, Jean Seberg.

It was brilliantly photographed by Raoul Coutard (much of it hand-held) at 15 different locations in Paris, Marsielle, and Orly Airport. Godard's technical inexperience resulted in an almost unusable sound track. He and his editor, Cécile Decugis, were forced to abandon the rules of film construction and make up their own, replete with jump cuts and other transitions that would normally be considered mistakes. Jean-Paul Belmondo stars as a hip and cool car thief who has, accidently, killed someone. As the police close in, he tries to seduce a woman he had met a couple of weeks earlier into letting him hide in her apartment. Played by the beautiful young star, Jean Seberg, the woman is a hip American student studying at the Sorbonne. She is reluctant to go along with the plan but she is also attracted to Belmondo.

Breathless was a big and unexpected commercial success. It sold 259,000 tickets in Paris alone. Godard and Belmondo became instant stars. The film won Godard the best director award at the Berlin International Film Festival, the French Film Critics Association gave it their Best Motion Picture prize and it was nominated for the BAFTA. The critics were especially taken by the film's rejection of the "tradition of quality" and by its emphasis on style over story. After *Breathless*, Godard made two short films and an anti-colonialism diatribe about France's evil doings in North Africa. In later years, he more or less disowned these early films as learning experiences. He considers his 1961 film, *Un femme est une femme* (*A Woman is a Woman*), his first real film. It stars Dutch actress Anna Karina as a stripper-cabaret singer who wants to have a baby. When her boyfriend will not go along she turns to his best friend, Alfred Lubitsch, (an homage to legendary directors Alfred Hitchcock and Ernst Lubitsch) played by Jean-Paul Belmondo. The film defies categorization but it most closely represents Godard's take on the Hollywood musical. It also is the next step in the director's development of a theory of style. Many of the scenes are shot and edited in unconventional ways that seem to work.

Godard's next feature was the 1963 film, *Les Carabiniers* (The Riflemen), about two men who fight in a fictional war and the letters they write home about their adventures. Neither the director nor his critics believed that the film was successful. That same year he made a film about movie making, *Le mépris* (*Contempt*). Released in English, French, and German, it is an attempt at international filmmaking. Michel Piccoli and Brigitte Bardot play a screenwriter and his wife who is hired by a horribly mean American movie producer to rewrite a script. The great director, Fritz Lang, plays himself. The movie depicts the slow destruction of the writer's marriage. In 1964 Godard made a more playful film that was also an homage to Hollywood. *Bande à Part* (*Band of Outsiders*) is a caper movie about two petty thieves who adore American gangster movies and try to emulate them in their lives of crime.

In 1964 Godard and his wife, Ana Karina, founded an independent production company, Anouchka Films. The following year both *Alphaville* and *Pierrot le fou* (*Pierrot Goes Wild*) were released. *Alphaville* represents a huge departure from new wave theories and rules of cinema verité. It is a science fiction spoof and does not fit neatly into Godard's body of work except as a prank (Godard had a reputation in his younger days as a prankster). *Pierrot*, on the other hand, is a daring experiment in film style. Belmondo and Karina star as a man bored with his marriage and the babysitter with whom he runs away. Their adventures are not so much the point as the way the director reveals them. *Pierrot* is one of Godard's masterpieces. In 1966 he followed up with *Masculine-Feminine: In 15 Acts.* It stars Jean-Pierre Leaud as a veteran recently released from service involved with a pop singer whose career is beginning to take off. Once again Godard hit the mark with a highly regarded film. Later in the sixties and into the seventies Godard would become known as a director who caught the political zeitgeist. His films reflect the post-war generation's flirtation with Maoism and its rejection of the Viet Nam War and the forces both cultural and political that led to it. *Weekend* (1967) is an example of this development in Godard's work. It begins as a depiction of a happy trip to the countryside and ends up as a challenge to the audience to endure a very uncomfortable story.

By the end of the sixties Godard was beginning to move toward television. In France the new wave had reached its conclusion. However, French television was still a welcoming home for experimenters. Between 1970 and now, Godard has been involved with 50 film and television projects; some of them uncredited. It is testimony to his passion for filmmaking that he continues to make films well into the new millennium, including a 2010 project, *Socialisme*.

INGMAR BERGMAN

Bergman was considerably older than many of the participants in European film revolutions. He was born in Sweden in 1918, the child of a strict Lutheran minister. He was raised in conditions that would constitute child abuse today, often being

banished to hours locked in a lightless closet for breaking one of his father's many rules. At a very young age he saw his first play and was so captivated by it that he created his own puppet theater for which he wrote original plays. Bergman attended Stockholm University from 1938 through 1940 where he studied literature and stage. Upon graduation he became an assistant director at a Stockholm theater.

In 1941 Bergman got his first work in film as a script doctor, a job at which he worked until he was assigned his first original script in 1944 for the film, *Torment*. Based on the success of the project he was given the opportunity to write and direct his first film *Crisis* in 1946. From that year until 1955 Bergman made a total of 14 films. The earlier works are not remarkable except that they demonstrate the growing ambition and style of master writer-director early in his career. By 1951 his films were becoming more complete and had the quality of finished work. His major themes were philosophical: the existence of God, man's relationship with God, death, and alienation. His first film to be seen outside of Sweden was *Smiles of a Summer Night* (1955). It is a witty and sexy comedy that deals with the issue of how relationships get complicated when sex enters the picture. It was nominated for the Palme d'Or at the Cannes festival and was awarded the prize for best poetic humor.

Bergman's breakout film was *The Seventh Seal* (1957) starring Max Von Sydow as a medieval knight engaged in a game of chess with the angel of death. The chess scenes are intercut with scenes of a journey the knight takes in search of the meaning of life and the existence of God. Bergman's visual is strikingly sparse and the characters he meets along the way are engrossingly grotesque. The French New Wave critics were particularly affected by the film. Even though it was almost the opposite of cinema verité, stylistically, it was original and clearly the work of an auteur. The Cannes festival awarded it a special jury prize. The same year the ever prolific Bergman made *The Wild Strawberries* as well as a television project. Like many of the director's films *Strawberries* is organized around a journey, in this case a disillusioned professor of medicine is traveling back to his university to accept an award. He begins to examine his mortality through a series of disturbing nightmares. In the end he experiences healing through reuniting with his family.

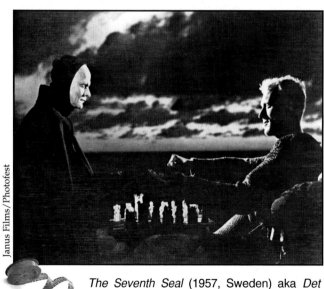

Janus Films/Photofest

The Seventh Seal (1957, Sweden) aka *Det sjunde inseglet*. Directed by Ingmar Bergman. Shown (from left): Bengt Ekerot, Max von Sydow.

In the decade following 1957 Bergman continued to make

ambitious films but none were the equal of *The Seventh Seal* or *Wild Strawberries* until the release of *Persona* in 1966. Starring the two principal actresses in his stock company, Bibi Anderson and Liv Ullman, the film is a psychological drama about a successful film actress who has chosen to quit speaking and her nurse-companion. The nurse fills the silence with her conversation, eventually exposing her innermost secrets and fears. Through the process the two women's personalities merge together. *Persona* represents a point in Bergman's career when he ceases to make films that deal with philosophical issues and

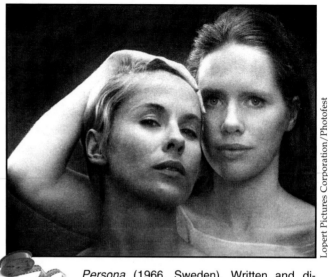

Persona (1966, Sweden). Written and directed by Ingmar Bergman. Shown (from left): Bibi Andersson, Liv Ullmann.

Lopert Pictures Corporation/Photofest

begins to make films that explore the psychological realm. In 1976 Bergman experienced a psychological trauma of his own. He was unceremoniously arrested by the Swedish government for tax evasion. He had a nervous breakdown and was hospitalized for depression. Upon recovery Bergman left his homeland for Hollywood, vowing never to return. In America he made two very good films, *The Serpent's Egg* (1977) and *Autumn Sonata* (1978). By the end of 1978 he had become more forgiving about Sweden and returned to his home where he settled in to work mostly in the theater and in television.

Bergman's last great film *Fanny and Alexander* was released in 1982. It was by far his least pessimistic film and was a commercial success in both Europe and America. The title characters are children who are blessed to have colorful parents and acquaintances. When the father dies, the mother marries a local clergyman and moves them into his cold and forbidding home. Obviously, Bergman is recalling his own childhood but with a sense of hopefulness rather than his usual gloom. The film won four Oscars including best foreign film and was feted by every other major film festival and organization. Bergman continued to work in theater and television until 2003 when his health forced retirement. He died in 2007 at age 89.

AKIRA KUROSAWA

Asian cinema was introduced to American and European audiences in the early 1950s by Kurosawa. His tales of Samurai warriors wandering the countryside in search of a

cause to which they might lend their lethal skills reverberated with audiences raised on American westerns. Kurosawa was born in Tokyo in 1910. One of ten children, his father was a school teacher who enjoyed the movies and encouraged his family to learn more about western culture through film. At age 18 the young man applied for art school but was not accepted in spite of the fact that his paintings were already being exhibited. For the next eight years he struggled to make his way as an artist. He finally decided to find steadier work and applied for a position as a third assistant director at Photochemical Laboratories Studio in 1936 where he worked under Kajiro Yamamoto. By the end of the following year Kurosawa was promoted to first assistant director.

By 1943 Kurosawa was ready to helm his first picture. With the war at full pitch, Japanese films, like their American counterparts, were required to receive government approval and were expected to be supportive of the war effort. Rather than make a run of the mill war movie, Kurosawa chose to make a film about the history of the martial art, Judo, *Sugato Sanshiro* (1943). It was big success, earning the young director the reputation of a new genius. His next six films did not live up to this reputation; but in 1948 he rediscovered his talent with *Drunken Angel*. It is the story of a doctor battling malaria and tuberculosis in the slums of post-war Tokyo. He encounters a young gangster who has been wounded in a gun fight and tries, futilely, to help turn his life around. *Drunken Angel* began a winning streak for Kurosawa that would last into the seventies.

Rashamon was released in 1950. Its structure was so unorthodox that Kurosawa's assistants begged him not to make the movie when they first read the script. It is the story of three travelers: a woodcutter, a priest, and a commoner who take refuge from a storm in a Buddhist temple in the countryside. The woodcutter begins to tell the story of a Samurai who was killed by a local bandit who also raped the victim's wife. In flashback sequences the story is told from four points of view that are so contradictory that they do not seem to be the same story. In many ways the narrative reflects John Ford's *Stagecoach* (1939) and *Citizen Kane* (1941) but it is also uniquely Kurosawa's invention. *Rashamon* was accepted with great enthusiasm in Europe and America, winning the grand prize at the Venice Film Festival

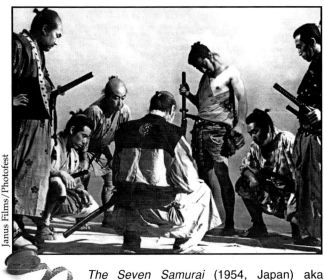

Janus Films/Photofest

The Seven Samurai (1954, Japan) aka *Shichinin no samurai*. Directed by Akira Kurosawa.

and a Best Director nomination from the Director's Guild of America. Kurosawa had become an international star.

Kurosawa's 1954 film *The Seven Samurai* was a major hit abroad. It was so admired in America that it was remade as a western, *The Magnificent Seven*. In 1957 Kurosawa turned the tables by adapting Shakespeare's *Macbeth* into *Throne of Blood*. It is considered one of the best-filmed versions of the play in any language. *The Hidden Fortress* (1958) was the director's next period film. George Lucas, one of Kurosawa's greatest admirers, borrowed the story of the film for his 1977 masterpiece of new mythology, *Star Wars*.

Once again the great director provided inspiration for imitators with his 1961 film, *Yojimbo*. Toshiro Mifune reprised his role of the wandering samurai. This time he happens on a village where a civil war rages between the clan of the sake brewer and the clan of the silk merchant. The samurai sells his services to the highest bidder while playing the two sides against each other. The film contains some of the best choreographed sword fighting yet. In 1964 the story was borrowed by Sergio Leone to make his first "spaghetti western" *A Fistful of Dollars*, starring an unknown, Clint Eastwood. In 1994 *Yojimbo* was remade again, as *Last Man Standing*. In 1962 Kurosawa extended the saga of the wandering samurai with *Sanjuro*. This time Mifune's character teaches a group of impetuous young men the samurai way. The last of the Mifune samurai films was *Red Beard* (1965). By this time Mifune's character is no longer the quickest sword fighter alive. He must defeat his opponent with his wits. Following *Red Beard*, Kurosawa experienced a career slump that lasted until the midseventies when he would reinvent himself as a modern filmmaker.

EASTERN EUROPEAN FILM REVOLUTIONS

The countries of Eastern Europe were either occupied or dominated by the Soviet Union in the post-war period. Poland, Yugoslavia, East Germany, Albania, Hungary, Romania, Bulgaria, and Czechoslovakia all had communist governments that exercised some form of movie censorship. The approved film style was socialist realism, an artifact from the Stalinist era. Filmmakers were required to praise the benefits of communism and celebrate the working class. The result was usually predictable and dreadful. A few exceptions did emerge, however. The Czech part of Czechoslovakia was an industrialized, educated, and sophisticated society that remained free for three years after the war's end, until the communist takeover in 1948. Likewise, Poland and Hungary had their own well-established film traditions that were impossible to quash entirely.

ANDRZEJ WAJDA

Polish filmmaker Andrzej Wajda started the post-war era making films that were squarely within the socialist realism canon. However, in 1958 he made *Ashes and*

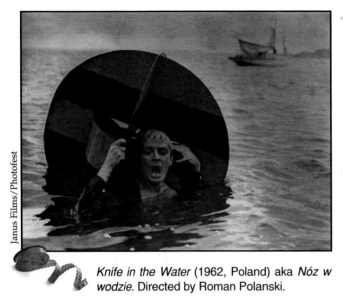

Janus Films/Photofest

Knife in the Water (1962, Poland) aka *Nóz w wodzie*. Directed by Roman Polanski.

Diamonds, a film that broke from the convention forcefully. Set in the final days of World War II, it is the story of an assassin from the anti-communist resistance sent to eliminate a heroic communist leader. What would otherwise be a conventional story is switched up by the casting of a Brando lookalike in the role of the assassin. He is so cool and romantic that it becomes obvious that the audience is supposed to find him much more attractive than the nominal hero. The government censors struggled over the film fitfully before giving it its release. It was sent to the 1958 Venice Film Festival but not entered into the competition. It was not allowed to be entered in the 1959 Cannes Festival where the French New Wave exploded.

Wajda's next film was entitled *Innocent Sorcerers* (1960). One of the roles was cast with a young Polish film student who had just made a very good student film, *Two Men and a Wardrobe* (1958). The young film student was **Roman Polanski**. Once again the government film board disliked and distrusted Wajda's work. But the release of the film proved to be highly profitable. In 1962 he was invited to contribute an episode to *Love at Twenty* along with Truffaut and Rossellini. This gave him the freedom to work outside of Poland just as the government was beginning to crack down on press and artistic freedom. Meanwhile Polanski had made his first feature, *Knife in the Water* (1962), a brilliant debut. But the young director also sensed that his homeland had ceased to be an inviting place to work. He soon left for Paris and on to America, effectively ending the brief renaissance in Polish film.

Unlike Poland, Czechoslovakia had undergone its governmental oppression in 1958. By 1963 the country was liberalizing in a dramatic fashion. A group of young filmmakers emerged during this period that would eventually comprise a small new wave of their own. Among them were **Milos Forman** and Ivan Passer. None were members of the communist party. Nor were they under any pressure to follow any stylistic orthodoxy. *Konkurs* (1963) was Forman's first short film after film school. It is an unremarkable documentary about singers auditioning for a show. *Peter and Pavla* (1964) is about a working class boy who hates his job as a security officer and flirts with a girl from his neighborhood. The socialist officials hated the slacker quality of the film but there was no specific reason to withhold it, so the

film was released. *Fireman's Ball* (1967) was Forman's breakthrough. The film was co-written by Ivan Passer and it is a satire on the blindness and stupidity of Soviet-style bureaucrats. A fire breaks out during the annual fireman's ball and the department is too disorganized to put it out. Pranksters use the fire call as an opportunity to steal the prizes from the ball and the whole affair ends in a mess. The film was permanently banned. Forman made one more film in Czechoslovakia, *Loves of a Blonde* (1968) before the Soviet invasion of 1968 and the end of all freedoms for years to come. What had been a promising new wave was over. Forman left for America and the others soon expatriated also.

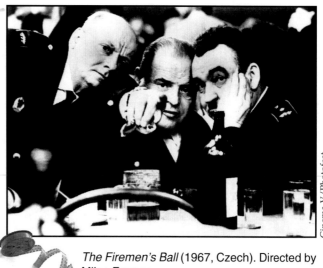

Cinema V/Photofest

The Firemen's Ball (1967, Czech). Directed by Milos Forman.

American Cinema in the Sixties

4

The sixties have become notorious in American popular history. In many ways the sixties was the decade when America became grown up and cosmopolitan. It was the decade in which the baby boomers first asserted their influence on popular culture and was also the decade in which old Hollywood finally lost its grasp on power. With the birth of counterculture and the protest movement in the second half of the decade, the idea of America as the last, best hope for mankind would give way to darker images of the country. Whatever the sixties were or were not, the decade still has a profound effect on who we are today and the way we see ourselves.

The decade began in the sunny aura of Eisenhower era complacency and hegemony. Untouched by the war, the American economy had swept almost everyone into the middle class. Factory workers earned enough to own vacation homes and send their children to college. The cold war and its imperative to be the best-armed nation on earth further stimulated the American industrial and technological juggernaut. Always considered among the most provincial of nations, Americans began to travel the world and drink up its cultures. Kennedy began the decade challenging the country to get involved in the world. He started the Peace Corps and announced the mission to the moon inspiring the new baby boom generation with his cultured movie idol ways. He also botched the invasion of Cuba and brought the country to the absolute brink of a nuclear holocaust.

Just three years into this new hope-filled decade an assassin's bullet ripped through President Kennedy's brain and the country's belief in its essential goodness. The war in Viet Nam kept getting bigger. Increasingly young men were being torn from their happy lives of Saturday night high jinks and dropped into the deadly jungles of South East Asia, and for what reason? The birth control pill arrived in the middle of the decade and changed the rules of sexuality that parents had so carefully impressed on young people. New African American heroes began to emerge. Martin Luther King, Jr., Malcolm X, Muhammad Ali, and many others would give voice to the black diaspora of separate but equal America. In 1965, Los Angeles, America's capitol of hedonism and moviemaking, would erupt into deadly race riots that lasted a week and killed hundreds. The America of *Happy Days* was turning dark and brooding.

1967 was the summer of love in San Francisco. At any time that year over 100,000 kids from all over the country were camped out on the Golden Gate Park panhandle near Haight and Ashbury streets. That same year the anti-war effort had escalated to match the growth in the war. Hundreds of thousands took to the streets to show their discontent with the increasing death toll in Viet Nam. The Monterey Pop Festival introduced Janis Joplin and Jimi Hendrix to the world of rock. The Beatles' "Sgt. Pepper's Lonely Hearts Club Band" introduced complexity and sophistication to the world of rock 'n roll. At the same time, kids and their parents were engaged in the "generation gap," talking over each other not with each other, disagreeing on everything. Alternate youth culture was emerging to speak the truth about Viet Nam, the government, and the stale platitudes that mom and dad spouted like a broken record.

In 1968 the national mood grew morose. First Martin Luther King, Jr. and then Robert Kennedy were assassinated, robbing the country of its last hope for leadership that could unite the people. The Beatles' *White Album* was released. Gone was the exuberance and love vibe in their music. In its place were songs like "Helter Skelter" that homicidal cult leader Charles Manson claimed convinced him it was time to "kill the piggies." The Tet offensive in Viet Nam proved that a U.S. victory was not inevitable and President Johnson sent an additional 206,000 troops. In November Nixon won the election that should have been Robert Kennedy's for the taking.

1969 certainly had its positive moments. Neil Armstrong was the first man to set foot on the surface of the moon in July. The music festival at Woodstock, New York proved that half a million kids could gather peaceably for three days. But there were other darker omens. College campuses all over the country were shut down by the protest movement. The Mai Lai massacre proved that, under the extreme pressure of combat, American soldiers stepped over the line that separates civilization from barbarism. Near the end of the year, Charles Manson unleashed his LSD-crazed gang of murders on Los Angeles. Society was coming apart at the seams.

Hollywood in the sixties began with the studio system in decline. Anti-trust lawsuits, the Paramount Consent Decree, and television had the industry reeling a decade earlier. Now the old

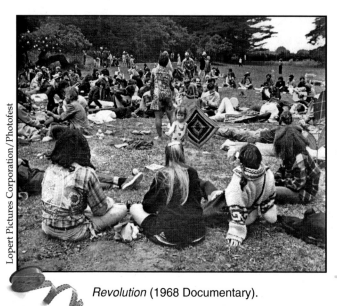

Revolution (1968 Documentary).

guard management was in its last days, often bereft of ideas for winning the audience back into the theaters. Louis B. Mayer was forced out of MGM by Nicholas Schenck and Dore Schary in 1951, only to see themselves forced out in 1955 and 1956 respectively. Eventually the studio would fall into the hands of Las Vegas hotelier Kirk Kerkorian. Harry Cohn had died in 1958, leaving Columbia leaderless and directionless for over a decade. Daryl Zanuch had stepped down at Fox to install his son, Richard, at the helm of the studio in 1962. That same year Universal Studios (which was already in the hands of Decca Records) was purchased by the Music Corporation of America (MCA) to be converted to a television production facility. In 1966 the Gulf + Western holding company took over Paramount and installed novice studio executive Robert Evans as chief of production. Jack Warner had out-maneuvered his brothers to gain a controlling share of his company in the fifties, but in 1967, he too gave in to the inevitability of age and sold out to the Seven Arts Company which in turn sold out to the Kinney Company (a New York funeral home and parking lot company) in 1969.

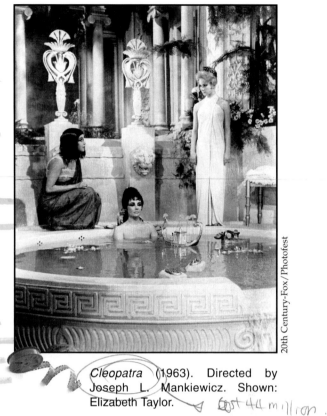

Cleopatra (1963). Directed by Joseph L. Mankiewicz. Shown: Elizabeth Taylor.

20th Century-Fox/Photofest

Never before had Hollywood so keenly felt the competition from Europe. American production fell to an all-time low in 1961 with only 121 films in release. The following year 361 foreign films were released in America compared to only 142 domestic productions. As if the competition were not enough of a threat, Hollywood was beginning to shoot itself in the foot with regularity. The Fox production of *Cleopatra* in 1963 was a perfect example of out of control production. It starred Elizabeth Taylor and Richard Burton whose on-set affair resulted in divorces for both. Tales of their drinking bouts filled the tabloids. Filmed at locations in Spain, Egypt, Rome, Naples, Malibu, and Pinewood Studios in London, it was the very definition of a runaway production. Taylor's costume budget was $200,000 but the actual expenses were double that. Director Joseph Mankiewiez never had control of the movie from the first day of shooting. When it was all over, Fox had spent $44,000,000 (a record) for a four-hour-plus 70mm flop. The studio was forced to sell its back lot to developers for what would become Century City. The proceeds of the sale still would not have been enough to keep the studio afloat were it not for a

small film in its production pipeline that became a big hit, *The Sound of Music* (1965). Clearly the expensive epic film had had its day. Old Hollywood was fading out to be replaced by a new generation that was in touch with the new audience and the spirit of revolution that was beginning to sweep America.

NEW FILMMAKERS

The vacuum that was Hollywood in the sixties presented opportunities for the next generation of directors, actors, and writers. Some would be content to make commercial films with broad audience appeal across generational lines. Others would focus on reinventing the American cinema bringing to it some the excitement and originality that was emerging from Europe with regularity.

BLAKE EDWARDS

Edwards was one of the most commercial of the new crop of sixties directors. He was born into the movie business. His step-grandfather was a director during the silent era and his stepfather was a production manager. Born in 1922, he began his career as an actor in the early forties. When television arrived Edwards became a writer on *Four Star Playhouse* (where he also directed) and on *The Mickey Rooney Show* (1954). Between television projects he directed a series of low-budget romantic comedy features. He did his last major stint in television directing the very stylish detective series *Peter Gunn* (1958–1959).

In 1961 Edwards broke through directing the movie adaptation of Truman Capote's novel, *Breakfast at Tiffany's*. The film starred Audrey Hepburn who had begun the fifties playing adolescent parts and advanced to adult roles in the sixties. Her costar in the film is George Peppard who was just making the transition from television to film. *Breakfast at Tiffany's* is the story of an eccentric aspiring New York café society girl who suffers from neuroses and depression but masks it with her upbeat attitude. The film was a major commercial success and received five Oscar nominations, winning two. The musical score by Henry Mancini received particularly high praise and the film's song, "Moon River" became a hit record for several artists.

Edward's next big film was *The Days of Wine and Roses* (1962). Jack Lemmon stars as a public relations man who performs miracles for his clients while consuming astonishing amounts of alcohol. He meets an innocent young teetotaler played by the beautiful Lee Remick. Lemmon teaches her to drink and the two descend into the depths of alcoholism. The film is an unflinching examination of the disease with heartbreaking performances by both actors. Lemmon and Remick were both nominated for Oscars. Henry Mancini won for his musical score featuring the movie's title song which became another major hit on the record charts.

The next year Edwards hit comedy pay dirt with British comedian Peter Sellers and the first of the *Pink Panther* (1963) series of films that would eventually stretch into seven films. In the films Sellers plays a bumbling Paris policeman, Inspector

Jacques Clouseau. Sellers uses his pitch-perfect talent for dialect comedy in creating a character who is completely clueless but always manages to stumble on the solution to the mystery. The following year Edwards made the first sequel in the series, *A Shot in the Dark* (1964). The downside of the *Panther* films was that the director was becoming typecast as a maker of commercial comedies in spite of the fact he had two great dramas on his resume. His next film, *The Great Race*, (1965) featured an all-star cast and was funny but completely lacked depth. This was followed by a very pedestrian World War II comedy, *"What Did You Do in the War, Daddy?"* (1966) and a very creditable movie adaptation of the *Peter Gunn* television series, *Gunn* (1967).

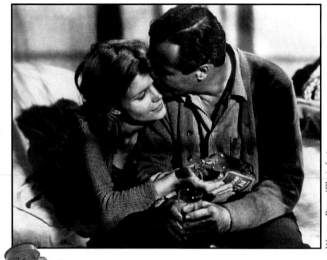

Days of Wine and Roses (1962). Directed by Blake Edwards. Shown (from left): Lee Remick, Jack Lemmon.

Edwards ended the sixties by reuniting with Peter Sellers in one of the actor's finest performances in *The Party* (1968). Sellers plays Hrundi V. Bakshi, an Indian actor who has been fired from the movie he is working on but mistakenly believes he is being invited to an A-list Hollywood party. Again Sellers has an opportunity to show off his dialect skills. But it is his physical comedy that steals the show. By the time he has befriended the drunken butler and the pot smoking band members, he is disoriented enough to become a one-man wrecking crew. At the end, the party and host's home are a shambles. Edwards wrote and directed the film. In the decades to come, he would both remain commercial and current with changing times.

STANLEY KUBRICK

Born in New York City in 1928, Kubrick and his family lived in the Bronx where his father and uncle had medical practices. Kubrick received his education in public schools and by the time he enrolled at Taft High School it was clear that the young man was not college material. He preferred to spend his days playing chess in Greenwich Village over pursuing his studies. Kubrick's other passion was photography. His father had given him a professional photographic rig and had equipped the home with a dark room. Young Kubrick contributed some photos to the high school newspaper but he was more interested in capturing more adult subjects with his camera.

He became staff photograph for "Look Magazine"

In the 1930s, 1940s, and 1950s, two magazines dominated photojournalism in America, *Life Magazine* and *Look Magazine*. They were weekly publications that endeavored to document all of the important news events, both domestic and foreign. The also specialized in photo essays, series of photographs that tell the story of an individual or an event. Each had circulations in the millions. When he was 16 Kubrick sold a photo to *Look Magazine*. At the end of his senior year at Taft High, *Look* made Kubrick a staff photographer. Barely 17 years old, he rented himself an apartment in Greenwich Village and devoted himself to photography. One of his early essays was entitled "The Day of the Fight." In it he follows a prizefighter from the moment he awakes, through his pre-fight preparation, the fight itself, and the aftermath. He invested his own life savings into making a 16mm documentary film based on the photo essay. *The Day of the Fight* (1951) was sold to RKO and became part of its *This is America* series of documentaries. Around this time Kubrick married Toba Metz, the niece of a New York art theater operator and, sometimes, producer. Metz encouraged her husband to pursue his filmmaking dreams and helped whenever she could.

Soon RKO assigned Kubrick to another documentary project for its *PatheScreenliner* documentary series. *The Flying Padre* (1952) was the story of a pastor, Fred Stadtmuller, who used a single-engine Piper Cub airplane to provide Sunday services for his New Mexico parish that encompassed 400 square miles. The following year the Seafarers International Union hired the young filmmaker to make his first color film, a 30-minute documentary titled *The Seafarers* (1953).

During this period of his life, Kubrick was trying to further his education. He audited classes at Columbia University, often supporting himself with the winnings from chess matches. In 1935 the New York Museum of Modern Art declared film as modern art by creating its first film library and department. By the fifties the museum was conducting weekly seminars on film topics ranging from film history to the avant-garde experimental film. Kubrick was a regular at these presentations. At the same time, Truffaut and Goddard were also immersed in their film studies.

In 1953 Kubrick decided it was time to make his first fictional feature film. He raised a budget of $13,000 with most of it coming from his father. Because he had so little money, Kubrick needed to do as much as possible of the production work himself. With a crew that never exceeded ten (including him and his wife) Kubrick shot the film *Fear and Desire* in the San Gabriel Mountains overlooking Los Angeles. It is the story of four soldiers shot down behind enemy lines in an unnamed war and how they deal with their predicament. The finished product was little more than a student film, but with the help of his wife's uncle, the film had a booking in New York City sufficient to qualify it as a real film release. Somehow Kubrick managed to convince his family to bankroll his second film, *Killer's Kiss* (1955). With a bigger budget he was better able to pull off the production of the melodramatic gangster film. It was good enough to be sold to United Artists at a time when the company was developing a reputation as a good place for young, hip filmmakers to work.

In 1954 Kubrick joined forces with James B. Harris, the son of a Broadway producer, to form a production company, Harris – Kubrick Productions. Their first project was *The Killing* (1956). Co-written by Kubrick and the great pulp fiction writer, Jim Thompson, it is the story of a race track heist. It stars Sterling Hayden as the gang leader. It is a classic B-movie noir film and serves as the young director's first successful feature. MGM's production chief, Dore Schare, was a great admirer of *The Killing*, and offered the young director and his producer a development deal at the studio. Kubrick's first studio project was never produced, but while at MGM, he met Kirk Douglas, who was a major star with his own production company at the studio. Kubrick and Thompson wrote the screenplay for *Paths of Glory* (1957), an anti-war film set in the French Army in World War I starring Douglas. Kubrick deftly managed the direction of the film and the star.

After *Paths of Glory*, Kubrick began to work on another project with Douglas that never got made. Douglas moved on to appear in the film *Spartacus* (1960) and Kubrick signed on to direct Marlon Brando in the western *One Eyed Jacks* (1961). Just before *One Eyed Jacks* was ready to begin shooting, the ever-eccentric Brando decided that he would direct himself and summarily fired Kubrick. Meanwhile Douglas was in Rome shooting *Spartacus* and he was very unhappy with his director, Anthony Mann. Douglas fired Mann and called for Kubrick to direct the film. It was a huge undertaking. It is the story of a slave revolt in Ancient Rome. Douglas stars as a gladiator turned general of the slave army. For the young director the $12 million project meant filming scenes involving thousands of extras and other technically difficult production elements including the recreation of Rome. Kubrick rose to the challenge and the film was quite successful, earning four Oscars, including Best Supporting Actor for Peter Ustinov.

In 1960 Kubrick began preproduction on the most controversial project imaginable, a movie based on Vladimir Nabokov's novel, *Lolita*. It is the comedic story of a man who is infatuated with his 13-year-old stepdaughter. When her mother dies in a traffic accident, he is free to consummate his love for the girl. The novel was notorious in America and its reputation made it impossible to raise money for the production. Kubrick took the project to England where attitudes about the book and subsequent movie

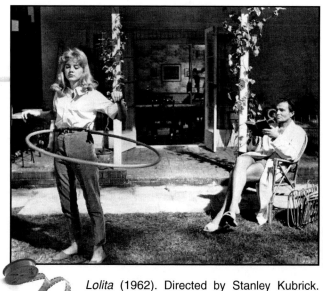

Lolita (1962). Directed by Stanley Kubrick. Shown (from left): Sue Lyon, James Mason.

MGM/Photofest

were more relaxed. James Mason was cast in the role of the lovesick college professor and Peter Sellers played his rival for the girl's affections. Upon its release in 1962, *Lolita* was well-received by the critics, less so by audiences. Kubrick remained in England where he and his second wife, Christine Susanne Harlan, would reside for the rest of his life.

Kubrick's next film, *Dr. Strangelove* (1964), was equally controversial as *Lolita*. It is a comedy about the accidental unleashing of nuclear armageddon. In the early 1960s the United States and the Soviet Union were locked in a death struggle to achieve dominance in nuclear warfare. Both sides had built up arsenals capable of killing every living thing on earth several times over. The name for this military doctrine was "mutually assured destruction." It was the idea that only mad men would start a nuclear war with the inevitable outcome being certain destruction. Kubrick's film is dark satire about such a group of mad men. Peter Sellers is brilliant in multiple roles including the ineffectual American president, Merkin Muffley, Group Captain Lionel Mandrake and Dr. Strangelove. George C. Scott plays General Buck Turgidson, a hawkish Air Force advisor to the president. Sterling Hayden plays General Jack D. Ripper, the Air Force base commander who has a breakdown and orders a nuclear attack on the Soviet Union. For baby boomer audiences who had been raised on "duck and cover drills" and other cold war civil defense strategies, the film was an explosive release comedy about a subject that had terrorized them since birth.

Always a slow worker, Kubrick made only one more film in the sixties, but he left his imprint on the decade as much as any other filmmaker of the time. *2001: A Space Odyssey* was released in 1968. Like *Dr. Strangelove*, it is a masterpiece of painstaking technical virtuosity. In the late 1960s the American Apollo space program was nearing man's first moon landing. Science fiction movies about space travel were extremely popular as a result. Working with many of the same technicians who had so successfully recreated a B-52 bombing mission in *Dr. Strangelove*, Kubrick gave *2001* a perfect sense of realism. Its famous light show ending was considered a marvel in 1968 but seems a little quaint by today's special effects standards.

RICHARD LESTER

Lester enjoyed successful career as a British director despite the fact that he was born in Philadelphia in 1932 and did not set foot in England until he was 22. As a boy he was a scholastic genius and graduated from the University of Pennsylvania at the age of 19. He was an accomplished piano player and got a job at a fledgling television station, WCAU, working as a stagehand and playing musical interludes between programs. Within a year Lester had progressed to directing live broadcasts including news, sports, and a puppet show. During this period he spent much of his spare time writing a stage musical. In 1954 Lester left for Europe, eventually settling in Britain where he played jazz piano in coffee houses while trying to sell

his play. It did not sell but he was offered a job directing a jazz show at an independent television station. He talked the management into letting him create his own program. *The Dick Lester Show* was a surreal comedy show loosely based on Peter Sellers' wildly successful radio series, *The Goon Show.* It only lasted a few episodes but that was long enough to be brought to Sellers' attention. The two went on to collaborate on a few comedy TV specials including *Idiot's Weekly.* In 1959 Lester produced his first film, an 11-minute comedy short, *The Running, Jumping and Standing Still Film.* It became a cult classic and brought him to the attention of the Beatles.

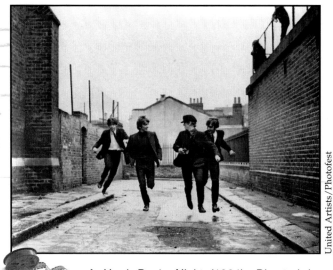

A Hard Day's Night (1964). Directed by Richard Lester. Shown: The Beatles (from left): Paul McCartney, George Harrison, Ringo Starr, John Lennon.

During the early sixties Lester continued to work in television and directed two small features, *It's Trad Dad* (1962) featuring American rock artists including Chubby Checker, and *Mouse on the Moon* (1963). In 1964 United Artists was contemplating making a film about an up and coming British rock band and asked Lester to develop and direct the project. By the time he got started, The Beatles had blown up into the biggest attraction in show business. *A Hard Day's Night* (1964) kicked off the "Swinging England" movie craze. The film was budgeted for $650,000 and with the band's popularity, became a hit, making the studio a fortune. It is a combination of Marx Brothers surreal comedy filmed in a hand held documentary style. Critically, it was well received.

Lester's next film, *The Knack and How to Get It* (1965), stars Rita Tushingham in a story about the sexual revolution. She plays a country girl arriving in London to take part in the youth scene. She encounters two boys, one who has the knack of attracting women, and the other who is trying desperately to get it. The film was a hit and won the Palme d'Or at the Cannes Film Festival and secured Lester's reputation as a director. He directed the next Beatles film, *Help,* which was released almost simultaneously with *The Knack. Help* is a send-up of the James Bond films with action sequences shot in cities around the world. The plot involves Ringo being chased by an Asian cult that wants to make a human sacrifice of him, and gives the band a chance to show off their natural comedic talent.

Lester's last successful film of the decade was the screen adaptation of *A Funny Thing Happened on the Way to the Forum (1966)*. The director removed several songs and scenes from the original play to better showcase Zero Mostel's amazing high energy comedy performance. His supporting cast included legendary comedians Buster Keaton and Phil Silvers. After *Forum*, Lester made an anti-war satire, *How I Won the War* (1967). It was so dark that it never took off as a comedy. This was his first big setback as a director. In 1968 Lester directed *Petulia* with Julie Christie as a kooky socialite in the swinging San Francisco of the sixties. Her husband takes offense at her affair with a married doctor and the film turns dark. Lester's last film of the decade was *The Bed-Sitting Room* (1969), a post apocalyptic comedy starring Rita Tushingham. Once again audiences rejected Lester's sense of humor and his insistence on infusing his films with surrealism. In the decade to come, he would change styles and win back the affection of his audience.

MIKE NICHOLS

He made two of the most important films of the sixties, *Who's Afraid of Virginia Woolf?* (1966) and *The Graduate* (1967). They were also the only films Nichols made during the decade as he split his time between Hollywood and the New York stage. Nichols was born in Berlin, Germany in 1931. His family immigrated to Chicago in 1938 as Germany was becoming too dangerous for Jews. His father died when he was 12, leaving the family in desperate financial straits. He entered the University of Chicago after high school, supported by scholarships and part time jobs as a janitor, a hotel night clerk, and a stable hand. Academic life did not suit him and, after a couple of years, he moved to New York City to study acting under Lee Strasberg at Actor's Studio. After completing his studies he returned to Chicago and joined an improvisational cabaret group of actors who called themselves The Compass Group.

Comedy partner in 50s.

Nichols began a relationship with another performer in the group, Elaine May. In 1956 they began to perform two-person comedy improvisations that satirized dating, marriage, sex, and American life in general. Their shows were legendary for stretching the boundaries of comedy subject matter. Nichols, however, was growing unhappy with the partnership because his focus was on trying to perfect their material while May was more interested in concentrating on the jazz-like riffs that made each performance unique. The act broke up in 1961. Nichols turned to directing on the stage in 1963 when he helmed Neil Simon's *Barefoot in the Park*. He directed two more plays in 1964 and teamed up again with Simon in 1965 on *The Odd Couple*.

Nichol's reputation had reached such heights in 1966 that there was no question that he could handle the challenges of saving the screen adaptation of Edward Albee's play, *Who's Afraid of Virginia Woolf?* Nichols was in and out of Hollywood between plays in 1964 trying to get his film project, *The Graduate*, into production. It was finally set to begin production at Embassy Pictures in the summer of 1965. That March fate

wrote the play Mike's 1st feature film based on.

intervened when Jack Warner paid $500,000 for the rights to the Albee play. Richard Burton and his wife, Elizabeth Taylor, expressed interest in the project and Warner rushed to sign them. Burton had become acquainted with Nichols when was appearing on Broadway in *Camelot* in 1961. They became friends and, when Burton and Taylor told Warner they wanted Nichols to direct, there was no further discussion of other directors. *The Graduate* would have to wait.

The production was challenging for everyone. Nichols hired Haskell Wexler to photograph the film. Wexler was well-known for his documentary–like cinema verité style. Over the studio's objections, Nichols planned to shoot in black and white and with a hand held camera whenever possible. The director pushed his stars to the limit with Taylor often breaking into tears at the end of a scene. Burton was insecure that the film was showing off his pockmarked skin. But there was no question who was in charge. Burton remarked of the young director, "He's bland as butter but as brilliant as diamonds." The film was a triumph for all involved. It was nominated for eleven Academy Awards, winning five, including Best Actress for Taylor, Best Supporting Actress for Sandy Dennis, and Best Black and White Cinematography for Wexler. The nominations included Burton for Best Actor, George Segal for Best Supporting Actor, Best Director, and Best Picture. With his very first film, Nichols had established himself as a top director.

THREE GREAT FILMS OF THE SIXTIES: *THE GRADUATE* (1967) *Anne Bancroft played Mrs. Robinson*

During the filming of *Who's Afraid of Virginia Woolf?*, Nichols became acquainted with a brilliant young comedy writer, Buck Henry, who at the time was writing the television show *Get Smart*. Henry was fully aware of the pending production of *The Graduate* and convinced Nichols that the script needed a rewrite. He believed that the lead character, Benjamin Brabbock, as written in Charles Webb's novel, was not consistent and that the author had failed to milk as much comedy from him as was possible. The two men threw themselves into the new draft. Benjamin became the iconic sixties character, distrustful of adults and other authority figures, but willing to break the rules and although uncertain about the future, ultimately willing to rush into it.

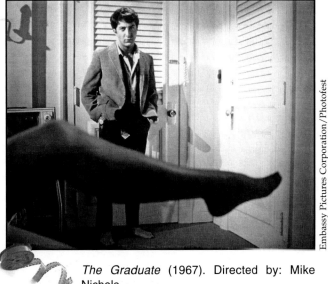

The Graduate (1967). Directed by: Mike Nichols.

Embassy Pictures Corporation/Photofest

The part of Benjamin was originally offered to Robert Redford but he felt the character was too weak and bowed out. Mrs. Robinson, the middle aged woman who Benjamin has an affair with and wife of Benjamin's father's law partner, was proving equally difficult to cast. Doris Day and Jean Moreau were among the actresses considered for the part. At one point Nichols was close to signing Charles Grodin for the lead role but it did not feel right to him. Dustin Hoffman had recently opened a new play, *Eh?*, to rave reviews. He was sent a script for *The Graduate*. Hoffman agreed to come to Hollywood to test for the part. The test was a disaster. Nichols directed the actor through take after take as he became more and more tense. Finally it was over and Hoffman went back to New York and the director went back to trying to think of who to cast in the roll. A day or two later Nichols went to the screening room to watch the test on screen. He was transfixed. Hoffman had a quality that brought the Benjamin character to life. Katherine Ross who had done the test with Hoffman was also cast in the role of Mrs. Robinson's daughter, Elaine. Anne Bancroft was finally signed for the Mrs. Robinson part. She had done a lot of television work, but was best known for her performance in *The Miracle Worker* (1962). William Daniels had been cast in the small role of the hotel clerk who is "on to" Benjamin and Mrs. Robinson's affair. He convinced Nichols to let him have the role of Benjamin's father and Buck Henry was given the clerk part.

One of the things Nichols wanted to capture in his film was the sociology of new wealth in California and how money was eroding social order. He wanted the sets to reflect the easy spending ways of his characters. Special attention was paid to the design of the sunroom bar in the Robinsons' house. Nichols' crew gave it a boozy jungle motif. When Mrs. Robinson takes Benjamin home for the first time she wearing a tiger-striped dress. With the background of the tropical garden, Bancroft is like a beast of prey, stalking her victim. As their forbidden relationship unfolds, we see Benjamin becoming more relaxed about it, accepting it as an easy way to pass the summer. It is ironic that the critics marveled at the film's hard edged modernism when the cinematographer was the 61-year-old Robert Surtees, veteran of 65 films. Nichols, as the director, had a strong vision and a great cinematographer was able to realize it regardless of age.

Film writers were obsessed with the idea of portraying a relationship between a middle aged woman and a boy just turned 21. In real life there was not that much difference in the actors' ages. Bancroft was 36 and Hoffman was 29. Yet there was a lot of concern about what the censors would do. The National Catholic Office for Motion Pictures was in the process of liberalizing its censorship code to fit the new liberalism of the motion picture industry. Nichols was fortunate to be making his film at that particular moment. In effect he was making up the new rules more than the censors were.

One last touch was the film's music. Nichols favored using the folk music of Simon and Garfunkel. It had a wistful quality and their song, "The Sounds of Silence" could easily be the music that Benjamin had in his head, allowing his thoughts to be expressed without the need for dialogue. The duo had also been working on a song

about declining morality titled "Here's to You, Mrs. Roosevelt." It did not require much tailoring to change it to "Mrs. Robinson" to make it a commentary on the characters in the film. When *The Graduate* was released, it was dismissed by important critics like *The New Yorker*'s Pauline Kael and *Time Magazine*. However, Bosley Crowther, the *New York Times*' highly respected critic, opened the door to acceptance by recognizing the film's brilliant satire. Audiences were less ambiguous. Baby boomers immediately understood the critique of their parents' shallowness and the affirmation of the need for them to find meaningful and unconventional lives to lead. When it came to the Oscars, Nichols won his well-deserved Best Director statuette among the film's eight total nominations.

Dennis Hopper

In all reality, Hopper probably does not belong on a list of great directors of the sixties. In fact, in his entire career to date, he has directed only eight films while he has over two hundred credits as an actor and an equal number of television commercial appearances. However, he did make one film that belongs on the list of the great films of the decade.

Born in Dodge City, Kansas in 1936, Hopper wanted to be an actor from childhood. He was 19 when he got his first television role on the *Medix* series. In 1965 he had a small role in *Rebel Without a Cause* and the next year he had a more substantial role in George Stevens' epic, *Giant* (1956). Hopper worked in television to pay the bills throughout the sixties. He had one memorable performance on *The Twilight Zone* in 1963 and was a regular in the TV western *Big Valley* in 1968. What really intrigued Hopper was the growing edginess of teen movies in the sixties. Along with Jack Nicholson, he had been part of Peter Fonda's psychedelic experiment, *The Trip* (1967) and had starred as the ruthless gang leader in the 1968 biker film, *The Glory Stompers*. That same year he joined forces with Fonda in an attempt to make a biker movie unlike anything ever attempted.

THREE GREAT FILMS OF THE SIXTIES: *EASY RIDER* (1969)

In 1968 Hopper had convinced his friend and colleague, Peter Fonda, that the time was right to update the biker movie genre with something truly artistic. They enlisted the help of novelist and screenwriter Terry Southern and began to create a film that they believed would define their generation. Hollywood was in the midst of another revolution in 1968. Two young men, Bert Schneider (the son of Columbia Studio's chief, Abe Schneider) and TV director Bob Rafelson, had literally walked into the offices at Screen Gems (Columbia's television division) and demanded that they should make a television show based on the Beatles' *Hard Day's Night*. With very little discussion, the television show, *The Monkees*, was born. Older management knew that the young filmmakers held the secrets to reaching the youth audience and paid complete deference to their demands. Schneider and

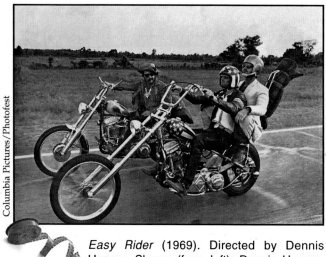

Columbia Pictures/Photofest

Easy Rider (1969). Directed by Dennis Hopper. Shown (from left): Dennis Hopper, Peter Fonda, Jack Nicholson.

Rafelson formed a company, BBS productions. It was funded by Columbia which would give over complete control of production for six features as long as none cost more than a million dollars.

The script for *Easy Rider* was as unconventional as the people who were making it. It consisted of the basic outlines of a road trip across southwestern America to Mardi Gras in New Orleans. Some scenes were to be completely improvised while others were conventionally written. Hopper insisted on directing when the project was presented to Roger Corman at American International Pictures (AIP). AIP was interested but not overly enthusiastic. Hopper and Fonda took the film to BBS and got $400,000 in financing just by asking. Hopper wanted and got $40,000 up front so they could get to New Orleans in time to shoot Mardi Gras. With only a week to prepare, Hopper grabbed some 16mm cameras, Fonda, Karen Black, and Toni Basil (who played two prostitutes the boys pick up in New Orleans) and took off. Hopper had envisioned Mardi Gras as a big acid trip. The shoot lasted five days and ended up in a cemetery with everyone tripping on acid. Hopper was pushing his actors to do a kind of psychotherapy on themselves. He wanted Fonda to explore the very sensitive issue of his mother's suicide. At first Fonda refused but then gave in to emotion. The entire sequence has scary realism to it even though it is filmed like a drug experience.

Schneider had looked on the Mardi Gras shoot as a sort of test of Hopper's ability to direct and Fonda's to act. They passed the test and got the rest of the financing, but the script still was not ready. Fonda had gone to New York City to motivate Southern and ended up partying with him instead. Hopper took matters into his own hands and flew east in a rage. Finding them in a hip New York restaurant, he confronted the two and actor Rip Torn who was scheduled to play the role of George Hanson, an eccentric lawyer the boys meet along the way. Hopper pulled a knife on Torn and shoved Fonda to the ground. Fonda was accustomed to Hopper's outbursts but Torn was not and withdrew from the project to be replaced by Rafelson's good friend, Jack Nicholson.

Hopper claims that after the New York fiasco, he holed up in Southern's office and wrote the script himself in two weeks. Finally the production got underway. It was much more professional than the Mardi Gras shoot had been, but Hopper still insisted

on using non-professional actors they met along the way and on keeping improvisations as part of the plan. The rest of the shooting took seven weeks. After the wrap party, Hopper realized that he had forgotten to shoot the last campfire scene in which Fonda famously says, "We blew it, Billy." Characteristically, Hopper was just as manic in the editing room. He cut and recut the film for months. Finally, after a year, Schneider told Hopper to take a Christmas vacation to Taos. Hopper agreed and Schneider and the editor finished the film. Meanwhile Fonda got the new supergroup, Crosby, Stills & Nash, to write music for the film, a much-needed added dimension. *Easy Rider* opened July 14, 1969 at the Beekman Theater on Third Avenue in New York City. Hippies lined up for days to see it. BBS' investment of $500,000 made over $19,000,000 in rentals. More importantly, American youth had a film that spoke to the paranoia and disorientation they were experiencing as the Viet Nam War was dragging on to a new decade. Jack Nicholson would emerge as a major star of the future, Fonda would go on to have a somewhat successful, if troubled, acting career, and Hopper would proceed to direct one of the great movie disasters in motion picture history, *The Last Movie* (1971).

GREAT ACTORS OF THE SIXTIES

WARREN BEATTY

Beatty was born in Richmond, Virginia in 1937. His mother, a drama teacher, had already sent his older sister, Shirley MacLaine, to pursue a stage career in New York City and on to Hollywood. After high school, Beatty went to Northwestern University for a year but grew impatient for his own stardom and dropped out to study acting with Stella Adler at Actor's Studio. His pedigree, good looks, and a string of successful performances in TV dramas landed him a role in one of the best television situation comedies of the late fifties, *The Many Loves of Dobie Gillis*. Sitcoms did not suit him, so Beatty went back to New York and won a Tony Nomination for his role in *A Loss of Roses*.

His first major film role came in 1961 when he was cast opposite Natalie Wood in *Splendor in the Grass*. The film is a cautionary sex tale set on the eve of the Great Depression. Beatty plays a rich boy who is pursued by Wood. Class differences and sexual taboos keep them apart. Eventually she has a breakdown and ends up in an institution. Beatty's performance gained him instant "heart throb" status with the teen magazines. In his next film he was cast as a gigolo in *The Roman Spring of Mrs. Stone* (1961), opposite Vivien Leigh (who was 24 years his senior). The following year he, again, played a womanizer in *All Fall Down*, this time opposite Eva Marie Saint (13 years his senior). His next role in *Lilith* (1964) failed to break the handsome boy image that had begun to cling to him. Beatty was dismayed and began to look for material that would allow him to show more range as an actor.

Beatty's break came with *Mickey One* (1964), directed by Arthur Penn. He plays a comedian who has gotten in trouble with the mob for reasons he does not understand.

He escapes to Chicago and changes his name to Mickey One and begins to unravel the mystery. Beatty's next film was a lightweight comedy, *Promise Her Anything* (1965), followed by a competent caper film, *Kaleidoscope* (1966). He was frustrated at this point, believing that his career was going nowhere. It was time to take affairs into his own hands, perhaps even becoming his own producer.

FAYE DUNAWAY

Known as the greatest neurotic leading lady of the seventies, Dunaway did star in some of the best films of the great decade. Her emergence in the late sixties was so spectacular, however, that she deserves credit for putting her mark on that decade as well. She was born in Bascom, Florida in 1941. After high school she majored in drama at the Boston University and joined the prestigious Lincoln Center Repertory Group in New York City in 1962. She remained in New York for the next five years, distinguishing herself in many stage productions including the off-Broadway play, *Hogan's Goat*. After seeing her in the play, Otto Preminger, the great independent producer, signed her to a contract with his company. Her first film appearance was a small role in *Hurry Sundown* (1967), a southern gothic tale of intrigue and race set in the post World War II era. Her next film was another supporting role in the hippie comedy, *The Happening* (1967).

THREE GREAT FILMS OF THE SIXTIES: *BONNIE AND CLYDE* (1967)

In 1963 Robert Benton was working as the art director for *Esquire Magazine* and David Newman was on the magazine's writing staff. Both men were film lovers and had become fanatical about the French New Wave, particularly Truffaut. They had been sneaking away during lunch hours to attend screenings at the Museum of Modern Art where they were introduced to a book by John Toland about the Great Depression era gangsters including the Texan bank robbers Bonnie and Clyde. Benton had grown up in Texas and was aware of the legend. With no knowledge of screen writing the two decided to spend the summer writing a film treatment about the two gangsters. Brazenly they had decided that they were writing specifically for Truffaut to direct the film. The finished outline was very detailed and cinematic. Benton and Newman met two novice producers, Elinor Wright Jones, and her brother, Norton Wright, who picked up the project and got it into the hands of Arthur Penn who was a successful television and film director. (His credits include: *The Left Handed Gun* [1958], *The Miracle Worker* [1962], and *Mickey One* [1965].)

Penn had grown tired of Hollywood by that time and like Mike Nichols he had maintained a thriving New York stage career that he could return to when he needed to escape Hollywood. He had no interest in the *Bonnie and Clyde* project when he saw it. Jones and Wright wasted no time in getting the treatment to Truffaut who was interested enough to have it translated and began to question who owned the project and to mildly pursue it.

At the time, Truffaut was also interested in making a film based on Ray Bradbury's *Fahrenheit 451*. He met with Benton and Newman in March 1964. In September that year Truffaut was given a finished draft of the script and liked it, but he had already committed to the Bradbury project. Undaunted, Benton and Newman took the script to United Artists in the spring of 1965. The studio executives hated the complicated sexual sub plot and rejected it out of hand.

Warren Beatty had just finished up *Promise Her Anything* and was looking for his next role. He had heard about *Fahrenheit 451* and approached Truffaut about playing the role of Montag but the director was already set on Oscar Werner for the part and suggested that Beatty check out the *Bonnie and Clyde* project. Not long after, with his project delayed, Truffaut began to talk

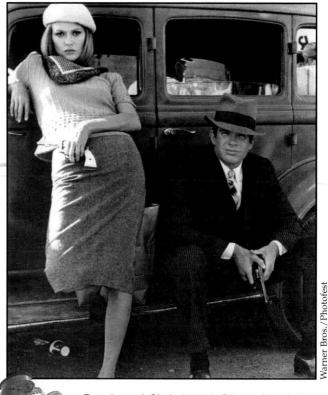

Bonnie and Clyde (1967). Directed by Arthur Penn. Shown: Warren Beatty, Faye Dunaway.

about the gangster movie again. Beatty was not wasting time. He called Benton's house and insisted on coming over to get a copy of the script. An hour later he called back and said he wanted to do it. What he meant was he wanted to produce it, but upon further reflection he decided he wanted to play Clyde too. Finally the movie was going to get made but with Beatty attached, Truffaut pulled out for good, not wanting to work with an actor he believed was temperamental. Beatty convinced Benton and Newman that they needed an American director.

The first director Beatty approached was George Stevens—one of the great veterans still working. But Stevens was too busy suing Paramount and NBC over a bad television edit of one of his films and passed. Beatty discussed several other possibilities but decided to try Arthur Penn who had already passed on the project twice. Beatty's persuasive talents are legendary and Penn agreed with Beatty insisting that they have an argument over the film every night so that they would always be finding a way to make it better. Penn had no problem keeping up that side of his bargain. With Penn on board, Beatty met with Jack Warner and was persuasive in getting the legendary studio boss to agree to finance and distribute the film. The only remaining question was who would play Bonnie?

Faye Dunaway was still under contract to Otto Preminger but he had abused her so badly on *Hurry Sundown* that she rushed back to Hollywood and insisted that her agent get her out of the contract at any expense. Within a few days, Dunaway was available and both Beatty and Penn were interested. At the time Beatty lived in a suite of rooms at the Beverley Wilshire Hotel and Penn was staying there too. Shuttling back and forth between the two rooms in a marathon interview, she won over both men and they agreed that she would be their Bonnie. One last detail needed to be pinned down. Benton and Newman had been on the project so long that they were burned out and had moved on to other endeavors. A writer was needed to look at the script with a fresh perspective and give it one last rewrite. Robert Towne had already been advising Beatty in the background and Penn agreed that he would be good for the job. Towne was able to fix the basic problem with the story which is that everyone knows what is going to happen to the lead characters in the end. Towne managed to make the end unimportant and to focus the film on getting there.

The production team, including art director Dean Tavoularis and veteran cinematographer Burnett Guffey, assembled at the North Park Motor Inn in Dallas. Every day they would leave for the location early in the morning, shooting in almost-deserted, forlorn hamlets in the countryside that still looked as they did during the Great Depression. As producer, Beatty was technically in charge, but Penn also had the director's customary control of the set. Almost every day's shooting began with a discussion between the two men, often mediated by Towne. Beatty did not have time to fret much over his performance but Dunaway was quite insecure, so much so that when she saw herself on screen for the first time watching dailies, she went into a three-day depression. After that, Penn closed the dailies.

Gene Hackman, who had appeared in *Lilith* with Beatty, was cast as Clyde's brother and Estelle Parsons, a favorite of the director, was cast as the sister-in-law. Michael J Pollard was cast as C.W. Moss, the gang's car mechanic and accomplice. Dean Tavalouris had found such authentic locations that it was ordinary for people who actually knew Bonnie and Clyde to show up on the set to watch and comment on the goings on. As production proceeded, Penn continued to work on the issue of Clyde's impotence, framing the camera at Clyde's waist level, showing scenes of failed lovemaking and creating scenes that hint at C.W. Moss acting as Clyde's sexual stand-in with Bonnie. The portrayal of violence was also an issue of aesthetics. Both producer and director agreed to depict the violent scenes as realistically shocking as possible. When it came time to shoot the climactic ambush of Bonnie and Clyde, Penn devised a scene that included sixty different shots and several different film speeds that give the scene a sense of grace.

Beatty had always wanted to remain true to Benton and Newman's cinema verité vision for the film. While they were shooting the scene of Bonnie's reunion with her family, one of the local women that had come out to watch was pressed into service as Bonnie's mother and did a very credible job. Locals were also used in a scene shot at a migrant labor encampment where Moss has taken Bonnie and Clyde after they

were shot up in the ambush that killed Clyde's brother. When the production returned to the Warner's stages in December to film all of the automobile interior shots, which required rear projection photography, they were three weeks over schedule. Back on the lot Jack Warner finally asserted his control and ordered the film to wrap immediately requiring Penn to shoot the stills that are the opening credit sequence at the wrap party.

Beatty and Penn decided to take the film to Manhattan for the edit to avoid any more interference from the 74-year-old Warner. Dede Allen was the editor. Film school students study the cutting of the last scene as a textbook on montage style editing but the entire film is infused with wonderful moments that she added during the cutting. Authentic period music was added by the banjo player, Earl Scruggs, who performed Foggy Mountain Breakdown as an accompaniment to the chase scenes. To save his studio money on the film, Warner had made a bargain with Beatty to give him forty percent of the grosses in exchange for foregoing his $200,000 producer's fee. It was a good deal for Beatty. By 1973 the film had made over 70 million dollars. The release was a critical success and, as the filmmakers had wished, audiences saw Bonnie and Clyde as two kids fighting the establishment rather than as bloodthirsty criminals.

SEAN CONNERY

Connery was born in 1930 in Edinburgh, Scotland. His mother was a cleaning lady and his father was a truck driver. As a young man he had several different odd jobs and joined the navy only to receive a medical discharge. At age 23 he decided to take up acting. His first uncredited screen performance was in 1954. After that, he moved back and forth between small movie and television roles. 1957 was his breakthrough year with a total of three television roles and four feature film appearances. From that point on he was constantly working, mostly in television. In 1962 Connery became an instant star when he was cast as James Bond in *Dr. No*. Upon seeing Connery on screen, Ian Fleming, the creator of the series of spy books, exclaimed "he *is* James Bond."

In 1963 Connery reprised his Bond character in *From Russia with Love*. This was followed by two more features in 1964 including Alfred Hitchcock's *Marnie*, opposite Tippi Hedren as the habitual thief with psychological problems. Connery's character has some psychological depth in the film, giving him an opportunity to showcase his acting skills. The gravitational pull (and the money) of the Bond films drew him back to *Goldfinger* (1965). The film contains one of the most memorable scenes in Bond lore with the super spy strapped to a table and a laser beam about to cut him in half. His escape is considered by many to be the best in any of the Bond films

Connery was extremely productive during the sixties. He starred in nine films, appeared in four others, and did television work in England as well. After appearing in the prison drama *The Hill* (1965), he did another Bond, *Thunderball* (1965).

Thunderball is particularly noteworthy because much of the action takes place under water which was a considerable technical feat at the time. In 1966 Connery showed off his comedy talent opposite Joanne Woodward in *A Fine Madness* (1966). Connery's last appearance as Bond was in *You Only Live Twice* (1967) which features the best gadgets of any of the previous Bond films. The series continues today long after Connery's exit but he defined the genre and will always be the greatest James Bond of them all.

PAUL NEWMAN

Most of the fifties Newman spent working in television and developing a reputation as a competent young actor with matinee idol good looks. His big break came in 1958 when he was cast in *The Long Hot Summer* based on southern gothic short stories by William Faulkner and directed by Martin Ritt. Newman plays opposite his real-life wife, Joanne Woodward, and Orson Welles plays the head of the Varner clan, a rich southern family. Newman was propelled into starring roles forever afterward. He made another excellent film that same year, *The Left Handed Gun,* in which he plays the great western outlaw, Billy the Kid.

Newman began the sixties starring in one of the biggest films of the early decade, *Exodus* (1960), the story of the war between the Jews and Palestinians over the founding of the Jewish state of Israel. It was a big-budget Otto Preminger spectacular and Newman lives up to the picture's demand that he appear bigger than life. The following year he gained even more respectability as a serious actor in *The Hustler,* the story of a young pool hustler and his troubled rise to the top of his shady profession. In 1963 Newman teamed up with Martin Ritt again to make the neo-western masterpiece, *Hud*. Based on a story by Larry McMurtry, *Hud* is the story of a Texas cattle rancher (played by Melvin Douglas) who is trying to stave off turning his ranch and his way of life into an oil field. Newman, in the title role, is the rancher's derelict son who cannot wait to take over and has a total lack of sentimentality about ranch life. The film won three Oscars and Newman was nominated for Best Actor.

Over the next few years Newman appeared in seven films including one of Hitchcock's last, *Torn Curtain* (1966). It would not be until 1967 that he would fine another role strong enough for him to show off his acting talents. *Cool Hand Luke* is one of the definitive Newman roles. It is a prison drama set in the chain gang camps of the Deep South. Luke is originally put into prison for smashing parking meters off their poles but he is so ill-behaved in his rejection of prison authority that his sentence is extended indefinitely. The role calls for comedy, action, and high drama and Newman handles it all with perfect authority. In a decade that introduced anti-authority anti-heroes to the movie lexicon, Luke is one of the best examples of this type of character. His last film of the sixties was the wildly successful *Butch Cassidy and the Sundance Kid*. It is an action-comedy western and a buddy

picture combined. It is the film that began Robert Redford's career and con[...] Newman's stay at the top of his profession.

SIDNEY POITIER

The greatest African American actor of the 1960s, Poitier began the decade playing an underprivileged son fighting for his family's dignity (*A Raisin in the Sun*, 1961) and ended it creating grown-up, dignified role models.

Born in 1927, Poitier grew up in the Bahama Islands, the son of a peasant farmer. He had almost no formal education and was sent to live with his brother in Miami, Florida when he was 15. At 18 he moved to New York City to find his fortune. He worked at menial jobs and barely subsisted. On an impulse, he auditioned for the American Negro Theater. He was so bad that he was kicked out of the audition. He went away and vowed to lose his accent and six months later came back to audition successfully. He was so good on stage that he worked steadily over the next three years until Daryl Zanuck offered him a role as a black doctor treating a white bigot in *No Way Out* (1950). His early years in Hollywood sustained him but progress was slow until Stanley Kramer cast him in a leading role opposite Tony Curtis in *The Defiant Ones* (1958), an excellent anti-racism allegory.

In 1961 Poitier was cast in a strong role with Paul Newman and Joanne Woodward in Martin Ritt's *Paris Blues*, a film about the beatnik jazz scene in Paris. In 1963 he became a true star as Homer in *Lilies of the Field*. Homer is an out-of-work construction worker whose car breaks down near a farm being operated by a group of European nuns in the Arizona desert. The sister superior is convinced that he has been sent by God to build them a church. The film was made at the height of the civil rights struggle in the South and Poitier's positive image of a black man won him a Best Actor Oscar. After three not-so-great film projects, he scored again in *A Patch of Blue* (1965) playing opposite Elizabeth Hartman as a blind girl whom he befriends and helps out of her abusive environment.

In 1967 Poitier created another iconic role in *To Sir, With Love* as a black school teacher

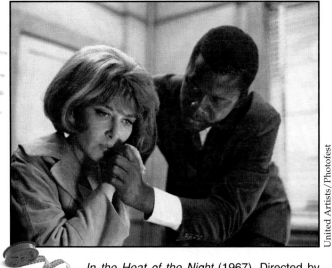

In the Heat of the Night (1967). Directed by Norman Jewison. Shown (from left): Lee Grant, Sidney Poitier.

United Artists/Photofest

of white working class kids in the East End of London. He has
nd, eventually, their love. That same year Poitier played oppo-
the Heat of the Night. Steiger is a racist southern small-town po-
Philadelphia homicide detective who just happens to be visit-
murder is committed. He ends up teaming up with Steiger and
ect and friendship. Steiger won a Best Actor Oscar and the film
ier's last great film of the sixties is the Stanley Kramer classic,
Guess Who's Coming to Dinner? (1967). Katherine Hepburn and Spencer Tracy play
the parents of a girl who has become engaged to a black man and is bringing him
home to meet her parents, challenging their liberal philosophies. It was Tracy's last
film and he looks frail but gives a spirited performance with the love of his life,
Hepburn, at his side. Poitier is suitably dignified and deserving.

ch. 5

1. George Lucas direct American Graffiti

2. Al Pacino played Michael Corleone in The Godfather.

maybe not's (3). Dennis Hopper directed Dustin Hoffman in Little Big Man

4. Peter Bogdanovich wrote extensively about Orson Welles.

5. Steven Spielberg directed Jaws

6. Patton earned Francis Ford Coppola his first Oscar for Best Screenplay

7. Liza Minnelli won Best Actress for Cabaret

8. Martin Scorsese direct Taxi driver

9. William Peter Blatty wrote bout "The Exorcist"

10. Robert De Niro stared in Taxi Driver

The Great Decade of the Seventies

<div style="text-align: right">**5**</div>

In all of film history two decades stand out for the number great films that were made and new talent that emerged. The 1930s is the first and several forces were responsible for making it happen. The studio system was fully evolved and infrastructure for filmmaking on a mass scale was in place. Thomas Ince's industrial method of film production had led to a lot of specialization in the film industry to the point that every department of a good studio had brilliant technicians and artists from which to draw. The advent of sound at the beginning of the thirties had caused the industry to revolutionize. A new generation of writers, directors, and actors brought a fresh point of view into play. The economic hardships of the Great Depression certainly served to motivate those who were lucky enough to have a job in the film business. Certainly one ingredient of greatness is effort and there was no want for effort during the decade.

The second great decade is the 1970s. Some of the same factors and some new developments gave rise to this period in film history. During the sixties most of the remaining major studios were in the hands of transnational corporations. Movie making was just one part of a larger financial picture. Gone were the movie moguls of the studio era who had involved themselves personally in the production process. In their place were business people who did not perceive themselves as filmmakers. This created a vacuum that independent-minded young auteurs were more than happy to fill. Even studios that had active production management understood that the new breed of directors expected to have and usually got creative control over their films once the production deal was made.

Like the thirties, the seventies were a decade when a wave of new talent entered the industry. The great writers, directors, stars, and cinematographers of the past had finally reached the end of their careers making way for a new generation schooled at film schools and universities as opposed to the apprentice system of the studio era. The members of this new generation, like the European cineasts of the previous decade, were students of film history with a reverence for the past and a fresh take on the future. The new filmmakers were in touch with the changing cultural landscape of America. They understood how to make films that appealed to youthful audiences

who, like themselves, were raised on television and its continual stream of old movies and new popular entertainment.

As in the thirties, the movie business was in financial distress at the beginning of the seventies. Unemployment in the industry reached forty percent by 1970. Things were so bad that the federal government stepped in to subsidize motion picture production by granting two different kinds of tax breaks. Movie makers were allowed to receive tax credits for their losses. This led to the creation of tax shelters as a new method of financing. The tax laws were also changed to grant a seven percent tax credit to movies made in the United States and movie companies were allowed defer taxes on their profits if they were reinvested in film production. This policy change stimulated film production but other problems beset the industry during the decade including the post Viet Nam War recession and runaway inflation of the second half of the decade. In 1970 film budgets averaged $1.9 million. By the end of the decade the average had swollen to $8.9 million. This put tremendous pressure on filmmakers to make hit movies and they often did.

Movie technology changed dramatically during the seventies. The Panavision Company, manufacturer of the most commonly used studio cameras, developed smaller, lightweight cameras that allowed operators to hand hold their shots, rather than using cumbersome and time consuming camera mounts. Multi track tape recorders and wireless body microphones became available in the late sixties and early seventies, giving directors much more flexibility in recording dialogue scenes. This freed directors to conceive of shots and effects that would have been impossible in the past. In 1976 the Steadicam body mount was introduced. This device made it possible for camera operators to literally wear the camera and its stabilization technology made it easy to create smooth and controlled camera movements. The Louma Crane was introduced in the late seventies allowing for remotely controlled, precision crane shots. George Lucas organized the Industrial Light and Magic Company in 1976 to create special effects for his production of *Star Wars* (1977) introducing the first computer technology to the movie industry. A vast array of new lenses, film stocks and laboratory technologies also came on line during this time.

The movie theater business experienced its biggest transformation since the building of the great picture palaces of the twenties. Stanley H. Durwood had created the "Multiplex" theater concept when he opened a facility consisting of two side-by-side theaters with a single ticket booth, popcorn counter, and projection booth in 1963. It was located in a shopping mall in Kansas City. In 1967 he created the first four-plex theater and in 1969 he opened a six-plex theater with automated projection booths. He went on to head the AMC Entertainment Company, a leader in developing multiplex theater complexes in the new shopping malls that were springing up at the edges of every city and hamlet in America. With their safe, heated and air-conditioned environments, shopping malls became the favored new hang-out for America. For the most part, the old one-screen movie theaters were a thing of the past as many went under the wrecking ball during the decade.

A new alternative to the theater experience was created in the mid-seventies with the introduction of the Sony Betamax and JVC VHS home videocassette systems. Videocassette stores cropped up, seemingly on every street corner. For the motion picture business, this meant a new, highly profitable revenue stream. There was no need to promote and market the product because the theatrical release of the films had already accomplished that. Home video did become competition for the theater industry. Further competition was also coming in the form of cable television. In September 1975 Home Box Office channel was beamed by satellite to cable television systems all over America. Free unedited, commercial movies shown on cable television meant another revenue stream for the movie business and the opposite for theater owners.

External events were also making their impact on the motion picture business. Richard Nixon began his first term as president in 1969. During the campaign, he had promised to end the Viet Nam War but, instead, he escalated it and, in so doing, added energy and anger to the protest movement. In May 1970 four students were murdered by the Ohio National Guard at Kent State University. The following May (1971) hundreds of thousands of protesters gathered for a four-day demonstration in Washington DC. In the resulting melee 13,400 arrests were made. During his 1972 campaign for reelection, Nixon's operatives had bungled a burglary at the Democratic Party headquarters at the Watergate complex. The investigation of the affair began in 1973 and lasted over a year with Congress moving toward impeachment. Nixon resigned, under fire, in August 1974. Distrust for public officials and authority figures reached an all-time high in the wake of the Watergate scandal. America's presence in Viet Nam came to an ignominious ending on April 30, 1975 when the last American personnel and Vietnamese refugees were evacuated by helicopter from the roof of the U.S. Embassy in Saigon under fire from the advancing North Vietnamese Army. In its wake the war left more than 58,000 Americans and over 900,000 Vietnamese dead and countless hundreds of thousands with shattered lives. America was bankrupt both economically and spiritually.

At the beginning of the decade Hollywood was reveling in its new freedom. The Motion Picture Association ratings system had freed the new film school generation to make movies on their own terms and great films were the result. But, in the summer of 1975, the seeds of this new freedom's ending were sown with the release of Steven Spielberg's *Jaws*. This became the first summer blockbuster movie in film history. Historically considered a slack time for the movie business, the summer season was when lackluster films were released. *Jaws* proved that if a film had the right ingredients to appeal to a broad audience, summer business could be better than the other seasons. This made for high expectations on the part of motion picture executives for what a summer movie could do financially, and led movie companies to follow the formula for success. It also led the business away from movie experimentation into the corporate era that is still with us today.

TEN GREAT FILMS: 1970—*M*A*S*H* BY ROBERT ALTMAN

ROBERT ALTMAN

Altman was born in 1925 in Kansas City, Missouri where he enjoyed a very normal childhood. In high school he began to experiment with tape recorders and other sound equipment, an interest that would remain with him throughout his professional life. When Altman graduated from high school his greatest ambition at the time was to fly in the war that was already raging. His only hope was to accelerate his flight training and college work. He enrolled in the Wentworth Military Academy where both needs were accommodated. In 1945 he graduated with his Associate Degree and soon was a co-pilot flying B-24 bombers over the Pacific. This early determination to achieve a goal is something that Altman would exhibit for the rest of his life.

After getting out of the military Altman became fascinated by movies and moved to Hollywood with his first wife. He did a little acting and writing, even penning a musical, but success eluded him. Altman decided to return to Kansas City to work for the Calvin Company, a producer of industrial, educational, and documentary films. This was the perfect training ground for a young filmmaker. Budgets were very tight which meant that directors were often their own producers, writers, sound operator, camera operator, and editor. In short, at one time or another, Altman needed to learn every technical aspect of production. Furthermore, he seldom had the benefit of working with experienced actors. Working with amateurs required great patience and ability to communicate about performances with specificity. Altman worked for Calvin from 1951 to 1957 and had a hand in making 65 films. During his time at Calvin he also directed one feature film, a low-budget project, *The Delinquents* (1957). It became his calling card when he returned to Hollywood.

Altman's first Hollywood assignment was to make a documentary for Warner Brothers about the short, colorful life of James Dean. *The James Dean Story* (1957) is a feature-length biography in which the director slyly manages to comment on the cult of celebrity as much as he details the life of the young actor. Thereafter, Altman became a television director. In the late fifties the studios were just waking up to the fact that television was the business of filmed entertainment, not much different from movies except the budgets were smaller and the schedules were incredibly tight. It was a fortuitous time for the movie business. Just as it was slumping, television arrived to keep the production facilities active and keep employment high. For Altman, who never gave up on his ambition to direct features, the caste system that relegated television directors to a lower status than feature directors was particularly galling. The studios preferred it this way. There was always a plentiful supply of young and eager directors, writers, and actors waiting to take the place of feature film workers if they became too difficult to work with. Also, with movie production at an all-time low, television replaced the B-picture as a developmental league for

new talent and, best of all, the television networks were taking all the risks. The studios got paid for their services and their overhead whether or not a show was a hit or a flop.

Altman's first television job was briefly directing *Alfred Hitchcock Presents* at Republic Studios. He made ten episodes of *The Millionaire* at CBS, nineteen episodes of *Whirlibirds* at Desilu Studios (owned by Lucille Ball and Desi Arnaz), and eight episodes of *Bonanza* for NBC at Warner Brothers. In all, Altman directed 107 television episodes, almost all hour-long dramas, between 1957 and 1965. During that period he developed a reputation for being very good with actors, technically competent, and a bit of a maverick. Some executives really liked and trusted him, while others found him impatient and difficult, but clearly those who worked with him on a set were usually eager to repeat the experience. He finally got a shot at a feature when Warner Brothers tapped him to direct *Countdown* (1968). It was the year before Neil Armstrong's "first step for mankind" on the surface of the moon. Excitement about the coming real-life space adventure was spawning a lot of movies about space travel. This one stars James Caan and Altman regulars Robert Duvall and Michael Murphy, in the story of a mad dash between the Americans and the Russians to get to the moon first. The director does a great job of making this low-budget space opera exciting and suspenseful.

In 1969 Altman was chosen to direct Sandy Dennis in *That Cold Day in the Park*. Having won a Best Supporting Actress Oscar for her performance in *Who's Afraid of Virginia Woolf?*, Dennis was now being offered starring roles despite her reputation for being difficult. It is possible that some people in the film industry were looking for Altman to meet his match in Dennis and falter. But he charmed an excellent performance from her and the finished product is quite good. Altman had finally won acceptance into the fraternity of feature film directors and had escaped the stigma of television.

*M*A*S*H* (1970)

Otto Preminger had been a fixture on the Twentieth Century Fox lot since the late forties, well known for his many duels with the irascible studio chief, Daryl Zanuck. His younger brother, Ingo, kept a much lower profile until he purchased Ring Larnder Jr.'s script for *M*A*S*H* in early 1969. Years earlier Otto dared to disobey the anti-communist black list by working with Dalton Trumbo, one of the infamous "Hollywood Ten" blacklisted screenwriters. Now his little brother was doing the same. Lardner had actually been sent to prison for contempt of Congress during the House Un-American Activities Hearings of the later forties and early fifties. On its surface the script for *M*A*S*H* is a comedy set during the Korean War. But everyone who read it instantly understood that it was an anti-Viet Nam War film at a time when it was not politically or professionally safe to make that kind of movie. The job of directing it was offered to Arthur Penn, Mike Nichols, Stanley Kubrick, Franklin Schaffner, George Roy Hill, Bob Rafelson, and at least ten others. To a person, everyone either had an excuse or

just did not want to do it. It was a hot potato with the potential to derail someone's career.

When *M*A*S*H* was finally offered to Altman, he jumped at it. He needed to make a major film at a major studio and he needed to prove he could direct comedy. Plus, unlike the others, he had nothing to lose. If it flopped, he had television to fall back on. Fox had defined the film as low budget and everyone agreed that the script was not suitable for movie stars because it was an ensemble piece. They would find a bunch of fresh faces and save a lot of money. At first Altman lobbied to take the production to the Philippines or Puerta Vallarta to give it the jungle look of Viet Nam and, more importantly, to get away from the studio where he could build his ensemble into an improvisational group and where he could make a film as subversive as possible. Preminger vetoed the idea and insisted that it would be shot at the Fox movie ranch in the Malibu Mountains. In effect they might as well have been in Asia because in 1970 the freeway system did not reach far enough west for the cast and crew to commute. They ended up staying in a trailer village adjacent to the set as if on location and Altman was allowed to create his happy movie family after all.

As planned the cast was full of fresh faces. Some were becoming Altman regulars like Michael Murphy, Robert Duvall, and René Auberjonois. Elliot Gould who played Trapper John would star in two other features for the director, as would Sally Kellerman and Duvall. Other young cast members included Donald Sutherland, Tom Skerritt, Fred Williamson, Gary Burghoff (the only cast member to reprise his role in the television series), and seven others. *M*A*S*H* was a seminal film with almost every actor involved in the film going on to have a long and successful career.

Altman was experimenting with multi-track recorders during preproduction. Their use, combined with wireless body microphones, made it possible to mike eight or more actors in a scene. No screenwriter writes scenes with that many characters having dialogue but Altman's plan was to rely on improvisation. Every night he would invite the entire cast and crew to view the dailies. He made it a party. After the screening he would begin to discuss the next day's scenes with his cast and ask the actors who did not have lines in the script to create improvisations among themselves. Whenever he was asked what he wanted, his reply was, "I don't know. Surprise me." This resulted in very lively and lifelike group scenes because all of the actors are actually acting as opposed to being background players. Often the director would redirect the camera and the soundtrack from the central characters in a scene to a more interesting improvisation. Using long takes, this technique comes off like a particularly American cinema verité. Tom Skerritt estimates that some scenes contain as much as eighty percent improv. Altman would use this technique often during the remainder of his long and prolific career.

It was little touches that made the finished film subversive. It is a war film without a battle scene. All of the conflict is between the military lifers, of "Army Clowns" as Hawkeye calls "Hot Lips," and the anti-war draftees, who do their

duty, not out of some sense of loyalty to America, but because they are doctors. They have taken an oath to mend the ravages of war and they do not really care if they are ministering to soldiers on our side or to the enemy. The other preoccupation the draftees share is making the best of a bad situation. Whenever there is an opportunity, there is a party. They are men and women together and if romance happens, it happens. The draftees have long hair, sideburns, and facial hair more indicative of Viet Nam than Korea and the camp public address system is a constant reminder that we are making fun of the Korean War period, not portraying it. Altman always liked to say that "*M*A*S*H" wasn't released. It escaped." And it did fly so low under the radar that it was already a hit before the studio paid it much attention. *M*A*S*H* was made on a budget of $3.5 million and to date has returned over $81 million.

THE REST OF 1970

Jack Nicholson finally got a well-deserved starring role in a serious motion picture, Bob Rafelson's *Five Easy Pieces*. Nicholson plays Bobbie Dupea, who comes from a family of concert musicians and has been a concert pianist himself. But he has turned his back on his former life and chooses to "slum around" working on oil rigs in Bakersfield, California. His girlfriend, Rayette, (played by Karen Black) is not particularly bright, which causes Bobby to abusively take out his frustrations on her. Inevitably he must return home to the family estate in the Pacific Northwest to confront his past and his demons. Nicholson gives a complex and nuanced performance, proving that he deserves to be considered an important actor. The film received Oscar nominations for Best Actor, Best Actress, and Best Picture.

Arthur Penn and Dustin Hoffman teamed up to make an epic revisionist western, *Little Big Man*. Hoffman, playing 100-year-old Jack Crabb, narrates his life story, beginning with being kidnapped and raised by Native Americans. He becomes a drunk and a gunslinger. He meets Wild Bill Hickock and witnesses the mindless slaughter of his tribe, including his wife, by General George Armstrong Custer (colorfully played by Richard Mulligan). Crabb gets some sort of revenge for his tribe in witnessing Custer's end at Little Big Horn. Faye Dunaway has a supporting role as an older woman who takes in the young Crabb but has her eye on him as a bed partner. Chief Dan George plays Crabb's tribal grandfather with a coy sense of humor. In addition to the political statement the film makes about the historical treatment of Native Americans, it can also be analogized to Viet Nam and the dehumanization and senseless killing of the enemy.

Francis Ford Coppola won an Oscar for his screenplay for the film *Patton*. In the title role, George C. Scott is both the physical and emotional embodiment of the great, but complicated, American tank commander. The film captures his genius, his arrogance, his temper, and his pettiness, particularly in his need to compete with his ally, the British general, Field Marshal Montgomery. The film won an incredible seven Oscars including Coppola's, Best Actor, Best Director (for Franklin Schafner), and Best

Film. *Patton* is an interesting mix of old and new Hollywood elements. The writer was 31 and on the verge of becoming one of the greatest directors of his time. The 50-year-old director was a television veteran whose big movie credit leading up to *Patton* was *The Planet of the Apes* (1968).

Woodstock would have won the Oscar for best documentary whether or not it was a good movie, simply because it was such a great event. What was planned as a three-day rock festival for 50,000 paying customers became a quasi-political demonstration when over 400,000 hippies showed up for the weekend. Reportedly, the camera crews became too involved in the revelry and failed to capture some of the best performances but did get lots of interviews with pretty hippie chicks. Editor Thelma Schoonmaker, and her assistant Martin Scorsese, managed to craft the miles of footage into a coherent film. She received the Best Editing Oscar for working miracles in creating a historical record of one of the iconic moments of the seventies.

OTHER REMARKABLE FILMS INCLUDE

Love Story—The romantic blockbuster that saved Paramount from bankruptcy, introducing Ali McGraw and Ryan O'Neal as the young lovers.

Performance—Nicolas Roeg directs the Rolling Stones' Mick Jagger in a surrealistic noir.

The Private Life of Sherlock Holmes—Billy Wilder's last great film.

Women in Love—Ken Russell interprets D.H. Lawrence's novel as an exploration of human sexuality.

Zabriskie Point—Irony of ironies. Michelangelo Antonioni got MGM to lavishly finance this critique of American capitalism and the rise of hippie culture, with music by Pink Floyd.

TEN GREAT FILMS: 1971—*THE LAST PICTURE SHOW* BY PETER BOGDANOVICH

ROGER CORMAN

He became the movie father to an entire generation of talent that emerged in the late fifties through the early seventies, including Peter Bogdanovich. Corman was born in Detroit, Michigan in 1926. He received a degree from Stanford University in mechanical engineering in 1953. He has often attributed his ability to make films cheaply and quickly to the principles of engineering. Corman decided that he was more interested in movies, however, and took a job as a messenger at Twentieth Century Fox in an attempt to learn the ropes of the movie business. He was soon writing low-budget features and directed his own, low-budget film, *Swamp Woman* (1955). He went on to make several other low cheapie movies, primarily aimed at the drive-in movie business. American Releasing Corporation (owned by Samuel Z. Arkoff) distributed

Corman's work. Later in the fifties Arkoff changed the name of his company to American International Pictures and began to finance as well as distribute Corman's films. As a producer he is responsible for 386 films. Corman managed to shoot *The Little Shop of Horrors* (1960) in two days and one night. Until later in his career he rarely took more than a week to shoot a film.

PETER BOGDANOVICH

Bogdanovich was born in up-state New York in 1939 where his family had briefly settled after escaping Europe and the Nazi holocaust. His father was an eccentric Serbian painter and his mother came from a wealthy Jewish family. He grew up in Manhattan and began to study acting with Stella Adler of Actor's Studio when he was 15. Like Truffaut and Godard, he was a movie kid, spending all his spare time at the local cinema soaking up masterpieces by John Ford, Howard Hawks, and Hitchcock. He kept a file of three-by-five inch cards with his observations about every film he saw from age twelve to thirty. The file contained 5,316 cards. In his early twenties he got a job programming the New Yorker Theater which led to a job at the New York Museum of Modern Art in the film department, programming film series. During this time he began to publish articles about film in *Esquire* magazine. In 1962 he married Polly Platt, a production designer and fellow cineaste. Two years later *Esquire* offered Bogdonavich a job as their Hollywood film writer. He accepted and he and his wife were more than happy to move to Hollywood to get closer to their movie heroes and write about them. Not long after his arrival, Bogdanovich was introduced to Roger Corman and began to lobby him for a job.

Bogdanovich's first job for Corman was as an un-credited writer on *Wild Angels* (1966). Two years later Corman produced his protégé's directorial debut, *Voyage to the Planet of the Prehistoric Women* (1968). Actually, to describe what Bogdanovich actually did on the film as directing is misleading. He started with footage of a Russian science fiction film, *Planeta Bur* (1962) which had been dubbed in English and re-edited it with a different story, much of which the young director narrated himself. Following that effort Corman handed Bogdanovich a script for a film about the Texas University massacre. Boris Karloff (the actor who played *Frankenstein*—1931) owed the company a few days work and was written into the script as was existing, but unused, footage of Jack Nicholson from *The Terror* (1963). The young director managed to weave all of these disparate elements into a coherent story about a Viet Nam veteran who shoots up a drive-in movie theater. Bogdanovich wrote himself into the film and had a few scenes with Karloff which clearly show his affection for the old, down on his luck movie star.

In 1970 Bogdanovich was working on an article about Orson Welles and was able to interview him at great length. The two became fast friends and Bogdanovich is largely responsible for bringing Welles' genius to the attention of the film world. Around the same time he became involved with BBS productions and its principals, Bob Rafelson and Burt Schnieder. They had purchased the rights

to Larry McMurtry's book, *The Last Picture Show*, which tells the story of a small Texas town slowly dying out during the Korean War era. Rafelson was in charge of producing it and asked Bogdanovich to direct. He accepted, assuming that the book was about movies, a subject about which he was quite knowledgeable. When he actually got around to reading the book, the director was shocked to learn the true subject of the film he was about to make. Polly Platt, on the other hand, understood the book very well. Having grown up as the daughter of father who was career Army, she was raised in military towns in the middle of nowhere. She reassured her husband that they would get it right. She would give him great sets and costumes and he would tell the story.

THE LAST PICTURE SHOW (1971)

Bogdanovich's first inspiration was to cast Ben Johnson as Sam the Lion, the man who owns the pool hall and the shabby little theater in the movie's town. Johnson was a character actor and a veteran of many of John Ford's best films. He was reluctant until the young director (who had written extensively about Ford and the two had become friends) got Ford to convince him to take the part. With that part of the casting accomplished, Bogdanovich could proceed to find the young actors to play Duane and Sonny, the two best friends at the center of the film, and Jacy the femme fatale, who destroys their friendship. The director and his wife had seen a girl on a magazine cover who looked perfect for Jacy, Cybil Shepherd (Shepherd began her career as a fashion model). Rising star Timothy Bottoms was cast in the role of Sonny. Jeff Bridges was perfect for the part of the feckless Duane.

Established actors filled out the cast. Ellen Burstyn played Jacy's mother, with Clu Gallagher as her boyfriend, and Cloris Leachman was cast as Mrs. Popper, the coach's wife with whom Sonny has an affair.

The director wanted to make a film that had the look and feel of a classic. He convinced BBS to let him film in black and white. He was also inspired by John Ford's sense of visual composition and paid a lot of attention to how the scenes were organized. Robert Surtees, who was 65 when he was hired to photograph the film, had worked for Hawks, Sturges, and other directors from

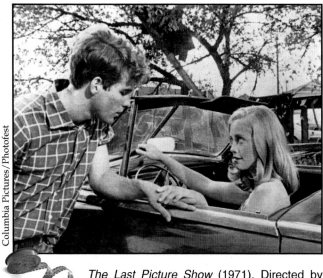

Columbia Pictures/Photofest

The Last Picture Show (1971). Directed by Peter Bogdanovich. Shown (from left): Timothy Bottoms, Cybill Shepherd.

the classic era. He was conversant in the films that the young director wanted to emulate and was able to give him what he wanted. Unlike other films of the time, *The Last Picture Show* is not anti-establishment. In fact, Sam the Lion is clearly the person the boys look up to for approval. Easily the film could have been made in the period it depicts.

The *Last Picture Show* opened at the New York Film Festival. Bogdanovich arrived with Shepherd on his arm. During production, he had left Polly Platt and began an affair with Shepherd. The whole affair was scandalous but the publicity only served to raise interest in the film. The critics were blown away by the film with one *Newsweek* writer calling it a "masterpiece." BBS was riding a string of hits. *Last Picture Show* would eventually take in over $29 million on a budget one tenth of the gross. It won Best Supporting Actor and Actress Oscars for Johnson and Leachman. It was nominated for six more including Best Cinematographer, Best Director, and Best Picture

THE REST OF 1971

Harold and Maude, maverick editor turned director Hal Ashby's "cult film" has a disturbing relationship at its center. Harold, played by Bud Cort (who was in *M*A*S*H*) is a disturbed teenager who keeps faking his own suicide to get the attention of his socialite mother. It does not work. She is on to him. Ruth Gordon (who was in *Rosemary's Baby*) plays a 70-something free spirit who befriends Harold. The two discover that they enjoy each other's company so much that the relationship turns into a romance. Ashby keeps it from getting creepy by successfully playing up the quirkiness of his characters, but it almost goes over the line. The music by Cat Stevens is a classic folk score that helps make the movie work.

Klute stars Jane Fonda in a follow up to her critically acclaimed role in *They Shoot Horses, Don't They?* (1969), and Donald Sutherland is fresh from his role in *M*A*S*H*. Fonda plays Brie Daniels, a high-priced call girl, and Sutherland is Klute, a small-town detective on the trail of a missing friend, and the trail runs through Daniels. While he has her under surveillance, he discovers that someone is trying to murder her. Romantic involvement ensues. At the time Fonda's role in the picture was seen as a feminist statement in respect to the film's exploration of women's sexuality.

The Tragedy of Macbeth is Roman Polanski's very witchy updating of Shakespeare's play. The director's wife, Sharon Tate, had been brutally murdered by the Manson Family a little more than a year earlier. Here he explores the theme of murder and betrayal with a graphic realism, no doubt influenced by the horror he experienced in real life. Polanski portrays murder and battle scenes on screen that are off stage in most productions of the play, adding to the power of the story.

McCabe and Mrs. Miller gives Robert Altman a chance to do to the western genre what he had already done to the war genre: flip it. The hero, McCabe, played by Warren Beatty, is a not too bright gambler who arrives in a new mining town in the

Northwest to set up a saloon and whorehouse. Julie Christie is Mrs. Miller, the madam, who has enough brains and initiative for both of them.

The film becomes a meditation on capitalism when a big corporation gets wind of the mining deposits and decides to force McCabe out. A great folk music score by Leonard Cohen and beautiful low-light photography by Hungarian cinematographer Vilmos Zsigmond lend the film a haunting quality.

Play Misty for Me is Clint Eastwood's debut as a feature film director. He also stars as a disc jockey who has a fling with one of his fans who turns out to be deranged. She begins to stalk him and call him when he is on the air, trying to get him to play the very romantic Johnny Mathis song, "Misty," for her. The film is a very convincing example of reverse feminism with Eastwood playing "the damsel in distress."

BLAXPLOITATION

Two films were released in 1971 that started a trend in African American filmmaking. For years black actors were cast in subservient roles such as butlers and chauffeurs. Black actresses were cast as maids, mammies, and sex objects. Melvin Van Peebles' *Sweet Sweetback's Baadasssss Song* and Gordon Park's *Shaft* gave African American audiences heroes they could cheer for. In the first film Van Peebles is writer, star, and director as he portrays a man on the run from the police because he has come to the aid of a Black Panther (an Oakland, California-based group of African American liberationists who believed in the use of violence to defend their communities) who has run afoul of the law. *Sweet Sweetback* is decidedly psychedelic. Sweetback is brought back to life at one point by a chorus of voices from The Community. His sexual prowess is so great that he can drive women wild without even touching them. The quality of filmmaking leaves much to desire but that is not important. What is important here are images of an African American superhero.

Shaft is a hip and cool private detective in Harlem. He is a lady killer and he fears no man. Richard Roundtree plays the title character, a role that would come to define his career. The film was made on a substantial budget by MGM. The risk paid off for the studio. The white mafia has kidnapped the daughter of the black mafia chief who has hired Shaft to get her back. A black political group also figures in the action. The movie is a run of the mill detective story except for the fact that it is a black man playing the detective and he is so cool. The funk musical score also adds to the movie's appeal. Both films served as a point of pride for African American audiences and crossed over well enough with young white audiences to prove that commercial success was possible in this new genre. MGM followed with two sequels, *Shaft's Big Score* (1972) and *Shaft in Africa* (1973), and a Shaft television series that also starred Roundtree.

The Blaxploitation genre resulted in literally dozens of movies in the seventies and as many new careers were begun as well. Football legend Jim Brown became *Slaughter* (1972), a Green Beret who comes home to avenge the murder of his family by the mob.

He is so effective that the government enlists his help as a secret agent. The following year Brown reprised the role in *Slaughter's Big Rip-Off*. Pam Greer made her debut in 1974 as *Foxy Brown*, a woman out to get revenge for the murder of her boyfriend who was a CIA agent. Music was an important element in these films and soundtrack albums were a common approach to extending the franchise value of these films. Stax Records' artist Isaac Hayes did the music for the *Shaft* films. "The King of Soul," James Brown, did the score for *Black Caesar* (1973) and Marvin Gaye did the music for *Trouble Man* (1972).

TEN GREAT FILMS: 1972—*THE GODFATHER* BY FRANCIS FORD COPPOLA

FRANCIS FORD COPPOLA

He was literally born to direct two of the greatest films of the seventies, *The Godfather* (1972) and *The Godfather: Part II* (1974). Born in Detroit in 1939, Coppola was the son of a symphony musician and an actress. The family moved to New York City in 1940 so that Carmine Coppola could take a job as first flute with the prestigious NBC Symphony Orchestra. At the age of ten Francis Coppola was stricken with the polio virus which paralyzed his left leg. He was bedridden for months during which time he watched hundreds of old movies on television and made puppet shows.

By the time he was high school age, Coppola was sufficiently recovered to become an expert tuba player. He was first sent to the New York Military Academy but hated it and ran away. When he went back to high school he added play writing to his tuba practice and distinguished himself enough to win a scholarship to Hofstra University where his brother had attended. Coppola majored in drama and became friendly with another student in the department, James Caan. About the time he received his bachelor's degree, Coppola saw the Sergi Eisenstein film, *Ten Days That Shook the World* (1928), and was inspired to become a movie director. He enrolled in the Master of Fine Arts program in film studies at UCLA in the fall of 1960. Before graduating he went to work for Roger Corman. With Coppola's ability to work with equipment and actors and to write, it was not long before Corman began to rely on his young assistant for everything. He even directed parts of four films when the senior director could not be on set. His big break came when the company was in Ireland to make horror films in old Irish manor houses in 1963. As usual, Corman finished the scheduled work early. There was enough time left that Coppola was offered the chance to direct his own film, *Dimentia 13*. It is not a classic but it is a credible first film, especially considering that it was shot in nine days.

When he returned to Hollywood, Coppola took a job with the Seven Arts Company in the writing department where he adapted (un-credited) *Reflections in a Golden Eye* (1967) as a starring vehicle for Marlon Brando. During this time he worked on other projects including an adaptation of Tennessee Williams' *This Property is Condemned* (1966) for Paramount and assisted Gore Vidal with the screen adaptation of *Is Paris Burning?* (1966) for MGM. That same year he adapted and

directed his second film, *You're a Big Boy Now* for Seven Arts. The coming of age film was shot in New York City and features Elizabeth Hartman as the woman who helps the boy become a man. Although there is some controversy about the subject, most sources report that Coppola submitted the film to UCLA as his thesis film for the purpose of finally getting his degree. An influential film critic, Charles Champlin, pronounced Coppola's effort as the work of a true auteur, thus, anointing him as a young director on the rise.

By 1968 the Seven Arts Company had acquired Warner Brothers. Coppola was tapped by the new company to direct Fred Astaire in what would be his last movie, the screen adaptation of the Broadway musical, *Finian's Rainbow*. The production did not go well. There was a reason the play had been shuffled around Hollywood for 20 years with no takers. It was not good film material. Veteran choreographer Hermes Pan was hired to do the dance numbers but Coppola fired him halfway through shooting and resorted to shooting and editing the dance numbers montage style to give them some sense of rhythm. The $3.5 million budget was too small but the director made it do; however, the final results were lackluster. The film flopped at the box office and was panned by the critics.

In 1969 Coppola and his friend, George Lucas, established American Zoetrope, realizing their dream to have their own production company. Coppola's first film for the company was *The Rain People* (1969) starring James Caan with Shirley Knight and Robert Duvall. It is a road picture with Knight's character picking up a hitchhiker who is a brain-damaged football player (Caan). Duvall plays a lonely motorcycle cop they meet along the way. Lucas' first film for Zoetrope was a feature-length remake of his thesis film *THX1138* (1971). In 1970 Coppola struck Oscar gold for coauthoring the screenplay for *Patton*. He and his writing partner, Edmund H. North, won Best Story and Screenplay Academy Awards for their work. The film dominated the Oscars that year with ten nominations and seven wins. Coppola was beginning to add to his reputation that he was bankable. He could deliver the goods when called upon.

THE GODFATHER (1972)

Mario Puzo had written a book about the Mafia in 1969, *The Godfather*. He had been a magazine writer in New York City and started collecting material for a book about organized crime families. In the late sixties Puzo had some health problems, got into debt, and needed money fast. He decided to write his crime book. *The Godfather* is much less of a story than the film. What Puzo did manage to capture was the day-to-day operations of a crime family and how they were organized. He also had a few real characters in mind while writing to book, including a singer who resembles Frank Sinatra. The book struck a chord with the reading public and became an instant success and stayed atop the best-seller list for months. Prior to the publication of the book, Puzo had sold the rights to Robert Evans at Paramount to keep his family going while he wrote. Given the success of the book, Evans knew he had a sure hit movie on his hands and prepared to go into production.

As *The Godfather* went into pre-production, Paramount was controlled by the Gulf+Western Company in New York City. The president and chairman was a brilliant and eccentric businessman named Charlie Bluhdorn. This film project was so important to the fortunes of the studio that Evans did not have complete control over it but shared decision making with his boss in New York. Evans wanted to make the film as authentic as possible. He believed that he needed an Italian director to achieve that goal and there was only one person in

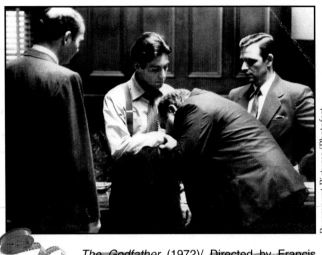

The Godfather (1972)/ Directed by Francis Ford Coppola.

Hollywood that fit that description, Francis Ford Coppola. Evans chafed at working with the brash young genius, knowing he could expect Coppola to go over his head whenever he pleased. But above all else, Evans wanted to make a good movie.

Coppola was signed to co-write and direct the film for $150,000, not a princely sum, but knowing how great it could be, he was eager to get his hands on the project. Writing began with Coppola doing a draft, then sending it to Puzo to get the factual touches right. Then Puzo would send it back to his partner for dialogue and story elements. From the beginning Coppola insisted that *The Godfather* was not to be a gangster film in the classic sense of the genre. His vision was that he was making a film about a great American family and that was the central unifying principle. Thus, the film's structure is organized around two weddings, a funeral, and a baptism, common Roman Catholic family rituals.

One of the director's first decisions was to hire Gordon Willis as his cinematographer. Willis was a young but good New York style photographer. He knew how to shoot in the city and was expert at the high key, expressionist lighting that both he and the director envisioned. He had just finished shooting *Klute*. Coppola's next difficult decision was who to cast in the role of Don Vito Corleone, the Godfather. Marlon Brando had convinced himself he was perfect for the role and had been lobbying the director all through the script writing period. He had even devised new make-up to make himself appear to be older (he was 48 in 1972). Evans was against it. Brando was more expensive that the budget would allow and he had a reputation for being extremely difficult on a movie set. Coppola made a film test with Brando in make-up using the whispery voice he had created for the part. The director showed the test to Bluhdorn in New York and got the okay to cast Brando.

Paramount Pictures/Photofest

Other casting decisions were less difficult with James Caan playing the hot-headed brother, Sonny; Robert Duval as the adopted family member, Tom Hagen; and Diane Keaton as Michael's love interest. Richard Conte, a veteran of gangster films, got the part of Don Barzini and Coppola's sister, Talia Shire, was cast as Connie Corleone. With the script finished, the director moved his headquarters to New York to finish casting with local actors including Richard Castellano as fat Clemenza. One interesting bit of casting was Lenny Montana, a former wrestler and sometimes mob enforcer, in the role of Luca Brasi. Finally, it came down to deciding who would play the pivotal role of Michael Corleone. Coppola had settled on an unknown Broadway actor named Al Pacino but the screen tests were so bad Evans objected. Again the director went over his boss' head to get approval from the top.

Al Ruddy was the very experienced line producer charged with the responsibility of shooting a film about the mafia in their own backyard. It was not unusual for the real mafia to show up at the various locations where the film was in production and behave in a threatening manner. Ruddy was perfectly adept at co-opting his interlopers, telling them how perfect they were for the scene that was being shot that day and sending them down to wardrobe and make-up to get ready for their moment in front of the camera. Before shooting began the Italian-American Civil Rights League had raised $600,000 at a Madison Square Garden rally attended by thousands. Faced with this kind of pressure, Coppola agreed not to use the words mafia or cosa nostra in the film.

From the outset, Hollywood was not happy with the dailies. In his first scenes, Pacino looked weak on camera. How could he ever carry off Michael's transformation from clean-cut war hero to cold-blooded mobster? And Willis' camera work was even more of a problem. He was not using enough light. Nobody could see Brando's eyes. Why did they spend all that money and you could not see the actor's eyes? How would they show such a dark film in drive-in movie theaters? Coppola knew what he was doing. They had purposely lit Brando with a high key light to put his eyes in shadow so that the audience would not know what Don Vito was thinking, to maintain his mysteriousness. As for Pacino, the director was secure that he could coax a nuanced performance out of his young star to be. As for the drive-ins, this movie was going to be the event film of the year. It would only be seen in the best theaters in America.

When it was all over, Coppola had made the masterpiece he started out to make. He had been judicious with his budget and had finished pretty much on time. The first cut of the film was weak, however, and this time Evans got his way—sending his director back to the edit room to put in material he had left out to bring the film in with a shorter running time. The final three-hour version was perfect reserved-seat, limited-release strategy. An intermission was added which only contributed to the film's epic quality. Paramount launched a media-blitz style sales campaign and *The Godfather* became one of the top-grossing films in history, at the time. It made almost

$135 million domestically and did $110 million overseas. Not only was Coppola now a certified genius, he was on his way to becoming very rich. The film won the Best Actor Oscar for Brando, Best Picture, and Best Screenplay. Coppola was nominated for Best Director.

THE REST OF 1972

Cabaret is a musical about an American girl stranded in Berlin between the two world wars. She sings and dances in a cabaret to get by. Liza Minnelli was born to play the part which requires a lot from a performer and she has a lot to give. Michael York plays her bi-sexual love interest in a story that explores the decadence of Berlin at this time and the dawning of the Nazi regime. Joel Grey is magnificent as the androgynous master of ceremonies. Bob Fosse, a veteran Broadway choreographer, skillfully directed the adaptation. His dance designs are both sexy and over the top and he captures the forced hilarity of the cabaret beautifully. The film won eight Oscars up against *The Godfather* including Best Supporting Actor for Grey, Best Actress for Minnelli, and Best Director for Fosse.

The Candidate was directed by Michael Ritchie who had broken through a few years earlier in his film *Downhill Racer* (1969) starring Robert Redford. In this film Redford plays the handsome son of a former Governor who is running to be governor of California (Governor Pat Brown and his son Governor Jerry Brown are clearly the role models for this film). It is a biting satire of what it takes to succeed in politics. Ritchie has a highly improvisational style and it is refreshing to see Redford working in a more liberated manner. The film has a great ending scene in the back of a limo after the title character, Bill McKay, has just won the election. As he sits there savoring the moment, a cloud of awareness sweeps over him and he says forlornly, "Now what?"

Deliverance is director John Boorman's rural horror film about what can go wrong when four city guys decide to have an adventure in the wilderness. Jon Voight, Burt Reynolds, Ned Beatty, and Ronnie Cox are the city slickers who decide to go on a rafting trip on a river that is about to be dammed up. The further they get into the wilderness the scarier it gets. A group of locals, played by amateur local actors, besets the city guys and begins to torment them. The film is a true test of the city guys' survival skills and the viewer's ability to stand the incredible tension Boorman manages to create.

What's Up Doc? Ever the film historian, Peter Bogdanovich is determined to recreate the hilarity of thirties screwball comedies. Barbra Streisand and Ryan O'Neal (she is the Katherine Hepburn character and he is the Cary Grant character) star as a free-spirit college drop-out and a college professor who meet, by chance, at a musicology conference in San Francisco. Intrigue ensues when stolen jewels, top secret papers, and O'Neil's scientific research all go missing in identical pieces of luggage. The director succeeds in updating the genre.

TEN GREAT FILMS: 1973—*THE EXORCIST* BY WILLIAM FRIEDKIN

William Peter Blatty's 1971 novel, *The Exorcist*, was a best seller and destined to become a movie. Warner Brothers acquired the rights in a feverish bidding war with other studios and producers. Blatty was a veteran screenwriter himself, having written *A Shot in the Dark* (1964) and *What Did You Do in the War, Daddy?* (1966) among other films. The novel was based on material he had collected 20 years earlier about the exorcism of a 14-year-old boy. He had been in contact with the priest who conducted the ritual and had been allowed to read the priest's account of the ordeal. Blatty began writing the book in 1969 and the finished book has the feel of being a movie already. Blatty both wrote the screenplay for the film and produced it.

William Friedken, who had won a Best Director Oscar for *The French Connection* (1971), was brought on to direct. Warner Brothers had set the budget at a more than ample $12 million. The decision was made up front to avoid casting established movie stars but to use New York stage actors so that the audience would never be sure what to expect of the narrative. Ellen Burstyn was cast as the possessed girl's mother. Max von Sydow, a veteran of several Bergman films, was cast as Father Merrin, an old priest/archeologist who is expert at the rite of exorcism. Jason Miller is the younger priest who assists him and is experiencing his own test of faith. Lee J. Cobb plays the police detective who gets involved in the affair, and a national talent search resulted in the casting of 14-year-old Linda Blair as Regan, the girl who is possessed by Satan.

A special effects team created a series of increasingly horrifying illusions. As the demon gains control of Regan's body there are scenes of grotesque projectile vomiting. At one point her head rotates 360 degrees. The demon has the power to throw people and objects around the room. Blair was required to endure a great deal of physical discomfort during the shooting. She was often placed in a body harness to appear to be levitating. At one point the set cooled to below freezing, and the make-up sessions could take hours. As news of this near-abuse leaked outside the production, the film was roundly criticized by children's rights activists.

Filming locations included Iran where Father Merrin unearths a demon, and Georgetown, adjacent to Washington DC, where Regan's actress mother is working on a film. Friedkin employed the services of a sound designer, Christopher Newman, to create a

Warner Bros./Photofest

The Exorcist (1973). Directed by William Friedkin. Shown (from left): Linda Blair, Max von Sydow, Jason Miller.

soundtrack that conjures up the tortured noise of hell. The narrative is completely unconventional with scenes beginning and ending abruptly and characters suddenly appearing and vanishing. Friedken used subliminal flash frames of the image of a demon. All of this was intended to make the audience ill at ease and to increase the shock value of the story.

Warner Brothers released the film in a mere 26 big city theaters just before Christmas. At every location lines formed around the block for every showing. Scalpers were demanding ridiculous prices for tickets. The studio started ordering new prints and booking the film into new theaters immediately. *The Exorcist* was more than just a good horror film; it was the scariest movie ever. It was so shocking that people routinely became physically ill in the theater. It was also so shocking that it spawned protests insisting that it deserved an X rating, not the R that the Motion Picture Association had given it. By the end of its run, *The Exorcist* had grossed over $230 million domestically and $208 million overseas. Given the success of *The Godfather* the previous year coupled with the grosses for this film, Hollywood was beginning to awaken to the potential riches of the global movie market.

THE REST OF 1973

American Graffiti was planned to be George Lucas' breakout film. His close friend, Francis Ford Coppola, was the producer and took an almost fatherly interest in making sure that his young partner had a big success. The script by Lucas and Gloria Katz, another UCLA product, tells the story of two high school buddies who are set to leave their small town for college in the morning. It is their last night of cruising and hanging out. The setting and many of the scenes are based on Lucas' own experiences growing up in Modesto, California before attending the USC School of Cinema.

The film features a dream cast. Richard Dreyfuss and Ron Howard are the two buddies. Cindy Williams is Howard's girlfriend and their clueless follower, Terry the Toad, is played by Charles Martin Smith. Candy Clark is the Toad's object of desire. The local hot rod king is Paul Le Mat and Mackenzie Phillips is the teeny bopper who stalks him. Harrison Ford is a hot rod driver from another town and DeeJay Wolfman Jack appears as himself and provides the top forty radio soundtrack. Legend has it that on the eve of production Lucas wanted to back out, concerned about directing an ensemble of young actors. But Coppola gently convinced his friend that everything would be all right and it was.

Last Tango in Paris teams director Bernardo Bertolucci (*The Conformist*—1970) with Marlon Brando who plays a middle aged expatriate living in Paris and mourning the recent suicide of his wife. He has a chance encounter with a young girl (Maria Schneider) while looking for an apartment. The two fall into a rough lovemaking episode and instead of ending it there, they continue to meet in the afternoons for anonymous sexual encounters that become more disturbing over time but seem to help him deal with his grief and help her steady her resolve to marry her fiancé.

Brando gives a wonderfully tortured performance which garnered a Best Actor Oscar nomination.

Mean Streets is young Martin Scorsese's first personal film after having a hand in editing *Woodstock* and having made *Box Car Bertha* (1973) for Roger Corman. Scorsese wrote the screenplay with his long time collaborator, Mardik Martin. Robert De Niro and Harvey Keitel star as Johnny Boy and Charlie, two hoodlum pals from Little Italy. Charlie works for his uncle and is making his way in the arcane world of an Italian crime family. Johnny Boy aspires to become a made man too, but he is too unstable and not trustworthy enough to be given responsibility. As Charlie moves up the ladder he must decide where to place his loyalties.

Scorsese shot the film in and around authentic locations he had known since childhood. Many trademark elements of his style are evident, including a vivid color palate, careful attention to wardrobe, improvisational acting, and long, intricate tracking shots. The script was nominated for best drama by the Writer's Guild of America and Scorsese's direction received enthusiastic critical reaction, earning him the "auteur" label.

The Sting is the follow-up to *Butch Cassidy and the Sundance Kid* reuniting Paul Newman and Robert Redford in a comedy buddy picture. They play two con men who are planning to pull off the ultimate con to revenge a partner's murder by a mob boss, played by Robert Shaw. George Roy Hill also returns to direct a well crafted period piece set in 1930s Chicago. The film was nominated for ten Oscars and won seven including Best Director and Best Picture.

TEN GREAT FILMS: 1974—*CHINATOWN* BY ROMAN POLANSKI

After *Godfather* Robert Evans tired of working for a studio salary when the producers who worked for him at Paramount were making ten times as much. He organized a deal to become an autonomous producer with offices at the studio and financing and distribution as well. The emerging young screenwriter Robert Towne had pitched an idea over lunch one day that Evans loved. He made a deal for the writer to come on board for $250,000 and five percent of the gross. Evans knew that Towne was a notoriously slow writer, so to speed him up Evans started to put together the other elements of the film. Jack Nicholson was already committed to the project out of friendship with the producer and respect for the writer's talent. Evans wanted Roman Polanski to direct but he was happy living in Rome. Polanski was still in mourning following his wife's murder and was not anxious to return to Los Angeles but Nicholson interceded and the director was won over.

Towne's final script was an amazing, intricate, 300-page tale of murder, corruption, and degradation set against the backdrop of L.A. water politics in the thirties. Nicholson plays Jake Gittes, a private detective hired by Faye Dunaway as Evelyn Mulwray to investigate the disappearance of her husband, the head of Los Angeles' sprawling water department. John Huston plays a mysterious millionaire, living in a huge estate on Catalina Island with his fingers in seemingly everything in L.A.

Towne's script was great but Polanski needed to put his touches on it too. So they spent a couple of months on a new draft that changed the writer's original ending and added a part for the director to play.

Once production began, the dynamics changed radically. Polanski believed that the director should be in complete control of the set and every other aspect of production, including the actor's performances. Nicholson went along with it with a mild sense of amusement. He and the director were pals and, by this point in the

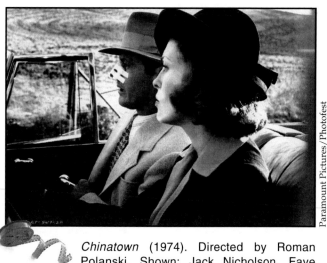

Chinatown (1974). Directed by Roman Polanski. Shown: Jack Nicholson, Faye Dunaway.

actor's career, he had seen and done it all. Faye Dunaway, on the other hand, was appalled by the director's dictatorial demeanor, which often resulted in a dash to her dressing room in tears. By way of contrast, the actress was so abusive to the teamsters that several of them walked off the set too. It turns out that with the actress, being in a constant state of agitation actually served the purpose of the film. In the story Evelyn Mulwray is a high strung bundle of emotions. She is hiding an awful secret and believes her life and her daughter's life are in danger. It would not have been the first time that a director manipulated an actor's emotions to get a better performance.

By the spring of 1974 Polanski had left Chinatown to direct an opera. This left Evans and Towne (who was not allowed on set in Polanski's presence) to finish editing the film. For Towne it was like getting his revenge because he was able to shape the story more to his liking and he and Evans seemed to agree on most story issues including the film's very dark and frustrating ending. When it was screened for the studio executives and the critics at the Director's Guild Theater, the business people thought it was awful but, the next day, the reviews broke enthusiastically in favor of the film. Evans had succeeded in making a great film, proving he belonged in the producer's chair. Chinatown was a modest box office hit. It made $30 million on a 6 million dollar budget but, artistically, it was much more successful. It received eleven Oscar nominations with Towne deservedly winning for his script.

THE REST OF 1974

The Conversation was one of two films Coppola released that year. It is a modest, French-inspired, closely observed character study. The other film, *The Godfather II*, was

an American epic. This would become a pattern for the duration of the director's career, alternating small, well-crafted films with very ambitious and risky projects. In the context of the paranoia of the mid-seventies from the war, Nixon, and Watergate *The Conversation* rings very true.

Gene Hackman plays Harry Caul (caul is the word for the protective membrane the covers a child's head at birth) a loner private detective who specializes in audio surveillance. He is so good that the government hires him. He takes pride at being the best in the business until he records a conversation for the mysterious "Director" that gets somebody killed. Then he focuses his obsessive nature on the challenge of finding out who did it, all the time struggling with guilt, alienation, and the reality of living life as a voyeur. Hackman is excellent as the single-minded, tormented detective. Coppola produced, wrote, and directed the film in true auteur style. John Cazale plays Caul's assistant who is constantly frustrated because the boss will not teach him anything and Teri Garr plays his girlfriend who is frustrated because her lover will not communicate with her. They both leave with the assistant going to work for the competition. In the end, Caul is alone and, ironically, is the object of the Director's surveillance team. Sound editor Walter Murch adds a complex soundtrack that gives believability to technical aspects of Caul's character. He received an Oscar nomination for sound and Coppola was nominated for Best Picture and Best Screenplay.

The Godfather (Part II) is the greatest sequel in movie history. Actually it is both a prequel, with Robert De Niro as the young Don Corleone establishing his crime family in New York City of the twenties, and a sequel with Al Pacino as Michael Corleone growing his gambling empire and descending into the depths of evil. Once more, Coppola and Mario Puzo collaborated on the screenplay, which begins with the confirmation of Michael's son and ends with Michael alone and emotionally alienated from humanity.

Robert Duvall returned to the cast as did Diane Keaton and Talia Shire. John Cazale's role as Fredo, the remaining Corleone brother, is greatly expanded over the original film. Lee Strasberg joins the cast as Hyman Roth the aging crime boss of Cuba, literally carving up his empire on the eve of the Cuban revolution. Where *The Godfather* is about the fight to keep the family intact and the succession of generations, *Part II* is about the disintegration of the family and Michael's vanity. Coppola directs his ensemble masterfully and Gordon Willis' camerawork makes it seem as if the two films were made at the same time. In fact, versions of the films have been released with the two edited together in chronological order. The result is arguably the greatest motion picture epic in film history. *Part II* received eleven Oscar nominations. Coppola's father Carmine and Nino Rota won for Best Music, Dean Tavoularis who did *The Godfather* and *Bonnie and Clyde*, won for Best Art Direction and De Niro won Best Supporting Actor. Coppola finally won his well-deserved Best Director Oscar as well as Best Screenplay and Best Picture. *Part II* did not make the kind of money the first film did (but it deserved to), grossing $134 million worldwide.

Lenny teams up director Bob Fosse with Dustin Hoffman to explore the life of the great improvisational jazz comedian, Lenny Bruce. For Hoffman playing a tortured and addicted genius was a big departure from his work in *The Graduate* but when put in the context of *Little Big Man* and Ratso Rizzo in *Midnight Cowboy* (1969), *Lenny* stands as proof of the actor's versatility and greatness. Valerie Perrine is wonderful as Bruce's long suffering wife and Fosse captures the ambience of smoke-filled night clubs and furtive junkies perfectly in black and white. All three were nominated for Oscars.

Young Frankenstein is Mel Brooks' pitch-perfect spoof of the thirties classics *Frankenstein* (1931) and *Bride of Frankenstein* (1935). Brooks' other 1974 film was the western spoof, *Blazing Saddles*, with Cleavon Little playing a black law man in the midst of the dumbest bunch of white bullies and crooks in movie history. *Frankenstein* stars Gene Wilder as the mad Dr. Frankenstein who thinks he can play God in his laboratory. Peter Boyle is hilarious as the monster who can do song and dance numbers with his creator. Bug-eyed British comedian Marty Feldman is Igor. Cloris Leachman is the demented housekeeper, Frau Blucher, and Teri Garr is Dr. Frankenstein's fiancée while Madeline Kahn plays the monster's man-made bride. Brooks always had an unerring, if sometimes over the top, sense of satire. Here, he chooses to remain behind the camera and the result is his most disciplined film and, therefore, one of his funniest.

TEN GREAT FILMS: 1975—*JAWS* BY STEVEN SPIELBERG

Jaws is by no means the best film of the year (although it is an exquisitely made entertainment) but, in retrospect, it is the most historically important for the impact it had on the motion picture industry. In the seventies Hollywood had discovered how to make the right mix of pictures. It did not stop making the overblown epics of the sixties, but it made fewer of them to decrease the risk. Studios and independents also made smaller films for art house audiences, youth, and mature audiences. The marketing practice with important films was to put them in limited release and let word of mouth do the selling. With films that were not deemed serious, the policy was to book them into as many theaters as possible and saturation advertise to sell as many tickets as possible before word of mouth had a chance to kill sales.

Jaws changed the way movies are marketed and established the concept of the summer blockbuster. Customarily, summer had been seen by the industry as a slack season. With families vacationing or at the baseball park, summer was time to release teen pictures and family entertainment, but not a time to release serious films. *Jaws* was the first serious film to receive the saturation booking (464 screens in America and Canada) and advertising with big ad flights on television included. The result was $260 million in domestic box office and another $210 million overseas. At the time it was the biggest grossing movie ever. This changed the industry view of summer as a time to release films that had high entertainment value and to spend more on summer releases. It also showed that the wide-release strategy worked for films that

might stay in theaters for an extended length of time so that a larger-than-usual audience could be accommodated, as well as people who wanted to go back and see the film another time.

Steven Spielberg was a movie kid from the beginning. Born in Cincinnati, Ohio in 1946, his father was an electrical engineer who worked on early generation computers and his mother was a concert pianist. When he was very young, the family moved to Scottsdale, Arizona. Some biographies claim that the young man was a victim of Asperger's syndrome, a mild form of autism that results in obsessive behavior that, sometimes, manifests as genius. At the age of twelve he started a tree-planting business to finance his first eight-minute film, *The Last Gun*. He set up a theater in his home and sold tickets to the movie and popcorn. At age 14 he made a 40-minute film, *Escape to Nowhere*. All the while he was working to become an Eagle Scout.

After high school, Spielberg tried, in vain, to get accepted into the USC School of Cinema. Rebuffed, he attended California State University, Long Beach instead. While at Long Beach he made a small film, *Amblin*, that became his Hollywood calling card. The little movie got him work directing television, which he did from 1969 to 1974. One of his television projects, *Duel*, a TV movie about a big rig truck that terrorizes a mild mannered commuter, created much buzz about the young director in Hollywood. It led to his first serious feature film, *The Sugarland Express* (1974). Following that his big break came with *Jaws*.

Peter Benchley's novel, *Jaws*, had been one of the best-selling summer reads of all time. Richard Zanuck acquired the movie rights to the book for his company at Universal Studios for the modest sum of $175,000 before publication. After the book became such a hit, it was expected that the movie would be too. But a film about a man-eating shark big enough to eat a boat was going to be difficult to pull off. Spielberg had a deal to produce and direct at the studio and was developing a script for a science fiction movie, *Close Encounters of the Third Kind* (1977) but he was not making enough progress to satisfy himself. He asked Zanuck and his partner, David Brown, to let him do *Jaws*. They agreed. The first problem was that the young director did not like Benchley's script. It did not have any really sympathetic characters. He got Carl Gottlieb to do a rewrite that was more to everybody's liking.

Casting was the next issue to be resolved. The director had been impressed by the look of the casts in Coppola's *Godfather* films. He wanted to use unknown and amateur actors in *Jaws* to keep the audience guessing about who would be the next victim. Spielberg wanted to give the film a *Moby Dick* quality and he saw the Quint character as his Ahab. Zanuck suggested Robert Shaw, who turned out to be an excellent fit as the weathered old ship captain. Richard Dreyfuss turned down the film three times until he saw himself in *The Apprenticeship of Duddy Kravitz* (1974) and thought he was so bad, he had better get his next role soon. He called Spielberg who was glad to have him on board as the shark scientist. Roy Scheider rounded out the cast as the chief of police. Actually, there was one other very important character to work out, the shark. There were three mechanical sharks.

The *Jaws* production team set up at their location, Martha's Vineyard, in the spring with a ten-week shooting schedule that would end before the summer rush and the tripling of rental rates for the cast and crew's quarters. The schedule turned out to be a complete fiction. Shooting in a small boat on water was particularly challenging for cinematographer Bill Butler and his operator, Michael Chapman. It required hand holding every shot so the audience would not become sea sick. The script was a mess. Every night Spielberg would meet with Gottlieb who was only able to stay ahead of the production by a day or two. The sharks did not work. The shark the crew called Bruce was prone to crossing his eyes at inopportune times. All three sharks broke down with regularity causing delay after delay. Back in Hollywood the studio chief, Sidney Sheinberg, was in a panic every time he saw new dailies. Finally he went to the location to see for himself. He reminded Spielberg that things would be much easier back home in the tank. The director insisted on the location for realism. Sheinberg offered to let the director quit but he insisted on finishing.

Shooting ended in September 17, 1974, 104 days behind schedule. Whereas the original budget had been $3.5 million, the final cost was $10 million. Furthermore, the first cut of the film was awful. The shots did not match and the shark looked like a big rubber thing. Editor Verna Fields came up with the idea of delaying the shark's first full appearance until the third act. Showing the results and reactions to the shark proved to be much scarier than the original plan. The film was edited to be like the horror classic, *The Thing* (1951), in which the monster is not shown until late in the film.

Jaws previews began in the spring of 1975. On March 26 it was added to a screening of *The Towering Inferno* at the Medallion Theater in Dallas. Spielberg waited in the lobby. About the time of the scene of the boy in the boat getting attacked by the shark, a man came running out of the theater, threw up, and went back in. At this moment, the director knew he had a hit. Television had rarely been used to advertise movies. Columbia had experimented with it on a couple of B pictures and it worked very well. Universal created a 30-second TV ad and spent the unheard-of sum of $700,000 buying primetime spots. The movie, the ads, and the releasing strategy all worked beautifully, to make *Jaws* a smash success. Spielberg was disappointed in being passed over for the director's Oscar, but he was a rich man and a director who could now do as he pleased.

Barry Lyndon is Stanley Kubrick's story of an Irish rogue who joins the military, becomes the assistant to a famous gambler, then marries a rich woman and settles down until his past catches up to him. Ryan O'Neal plays the title role but the real star is Kubrick's painstaking recreation of life among the wealthy in the eighteenth century. Cinematographer John Alcott and production designer Ken Adams both won Oscars for their work on the film. The director insisted on using the actual manor house locations to film interior shots and on lighting with the candle light that would have been used in that period. With the help of some very special cameras and lenses from the Warner Brothers' legendary camera shop, the results are stunning. It is a truly beautiful picture.

Dog Day Afternoon is TV director turned movie director Sidney Lumet's high powered follow-up movie to his successful cop drama, *Serpico* (1973). Both films star Al Pacino. Here he plays a desperate man who robs a bank to get the money for his lover's sex change operation. Once inside the bank he discovers there is not much money to steal and that he is surrounded by the entire Brooklyn Police Department. The robber begins to bargain for his safe exit and a helicopter to escape in. Lumet directs the film with the amazing energy of a breaking news story. Pacino is equally high voltage and the result is heart pounding action.

Nashville is Robert Altman's satire on the country music industry and so much more (including an examination of the outpouring of patriotism, both phony and sincere, that was unleashed by the American bicentennial). Set in the country music capital, the film has 24 characters, each with a well-developed storyline (written by long time Altman collaborator, Joan Tewkesbury). Inevitably, the stories intersect and diverge like themes in a symphony. In keeping with the director's collaborative style, many of the actors were encouraged to write and perform their own music. Karen Black plays a Tammy Wynette-like character. Henry Gibson is Haven Hamilton, politically conservative and politically influential, who performs a song titled "We Must Be Doin' Something Right to Last Two Hundred Years." Ronnie Blakely is heartbreaking as Barbara Jean, the frail, fading queen of country. Altman is also meditating on the role of assassination in American politics which gives the film a surprisingly dark under tone.

One Flew Over the Cuckoo's Nest is Jack Nicholson's greatest performance. Producer Michael Douglas had taken over the rights to Ken Kesesy's iconic book from his father Kirk, who had purchased them years earlier. The great Czech director, Milos Foreman, does an excellent job of blending his cast of unknowns and amateurs with his two stars with a subtle touch. Louise Fletcher as Nurse Ratched plays opposite Nicholson's Randal Patrick McMurphy. He is a ne'er do well who has escaped the county jail by playing crazy to get into the mental hospital. She is the rigid embodiment of everything we hate about institutions. The result is like an immovable object meeting an irresistible force. The film is both hilarious and heartbreaking. It won the Oscars for Best Actor, Best Actress, Best Director, and Best Picture. It is an all-time classic.

Shampoo was written by Robert Towne and Warren Beatty as a satire of the sexual revolution, incorporating people they knew into many of the characters. Beatty plays a hairdresser with dreams of having his own salon and becoming a star. The problem is that he is sleeping with the wife, daughter, and mistress of his financial backer. Set in a 24-hour period, it all catches up with him in the end. Hal Ashby directed this classic send up of vanity with his customary disdain for pettiness.

TEN GREAT FILMS: 1976—*TAXI DRIVER* BY MARTIN SCORSESE

Paul Schrader's script for *Taxi Driver* had been at Columbia since 1972. The son of strict Calvinist parents, he had attended Calvin College Seminary before escaping to the UCLA film program. He was a disciple of the very influential film critic

Pauline Kael before deciding to become a screenwriter. His breakthrough came when director Sydney Pollack paid $350,000 for his script for the Japanese crime thriller, *The Yakuza* (1974). Producer Julia Philips had optioned *Taxi Driver* for $1,000 before the writer got hot. The script had been passed around quite a bit until Martin Scorsese, who had recently arrived in Hollywood, got a look at it. He wanted to do it the first time he read it, but Philips and Schrader were not so sure. All they had ever seen of Scorsese's work was *Boxcar Bertha*, which did not give them much confidence. *Mean Streets* was in its

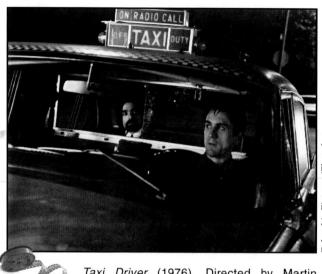

Taxi Driver (1976). Directed by Martin Scorsese. Shown (from left): Martin Scorsese (Director), Robert De Niro.

Columbia Pictures/Photofest

final stages of post-production at the time. When the writer and producer saw it, they became convinced that Scorsese was their director, with the caveat that he had to get Robert De Niro to star in it. At first Scorsese was a little insulted by the idea that he was not enough on his own. Besides he wanted Harvey Keitel to star. But the director demurred and called his friend De Niro who accepted and the deal was on.

Taxi Driver is the story of a Viet Nam veteran, Travis Bickle, who is suffering from what is now called post traumatic stress disorder (PTSD). He cannot sleep at night so he gets a job driving a taxi in New York City. He is very suspicious of others and has a hard time forming relationships. He obsesses on things. First it is Betsy, played by Sybil Shepherd, a beautiful volunteer working on the senate campaign for a politician named Charles Palantine. Betsy agrees to have lunch with Bickle but when he takes her to a porno movie on their second date, the relationship is over before it begins. His next obsession is guns. He buys them and plays with them until he is a skilled gunman. Next Bickle hatches a plan to assassinate Palantine, but before he does he comes upon a black robber sticking up a grocery store and shoots him. His obsessions shift to cleaning up the streets of New York when he befriends a 12-year-old prostitute played by Jodie Foster. His focus is her pimp, Scout, played by Keitel. The film reaches a climax in a bloody shootout between Bickle and Scout.

Taxi Driver was shot on the streets of New York in the sweltering summer of 1975. Scorsese had hired Michael Chapman as his cinematographer. Chapman had been Gordon Willis' operator on the *Godfather* movies and had filled the same role

on *Jaws*. He was ready to advance plus he loved Godard. He and the director could talk endlessly about Godard and tried to infuse *Taxi Driver* with a new wave look and feel. They decided to shoot in super saturated color and to use the technique of over-cranking (variable speeds of slow motion) to create a subjective point of view.

When *Taxi Driver* was finished, the studio heads started to become nervous about the extremely graphic quality of the violence. A great deal of pressure was put on Scorsese to cut some of it. He refused but compromised by de-saturating the color of the blood in the final scene. This served to appease the MPAA which issued an R rating. The film was much more of an artistic than a commercial success. Pauline Kael saw it as a neo noir revival of fifties B pictures, with its dark musical score by Bernard Hermann, its use of narration, the fetishism of objects, and Bickle's pessimistic worldview. Other critics viewed the film as a metaphor for a powerless America in the wake of the Viet Nam War, an America beset with social problems and cynical about solutions in the wake of Watergate. For Scorsese, the film was validation that he was a true auteur who would make other great films.

All the President's Men has a "ripped from the headlines" quality as it tells the real-life story of two intrepid *Washington Post* reporters, Robert Woodward and Carl Bernstein, who brought down the Nixon Administration with their reporting of the Watergate affair and cover-up. Dustin Hoffman plays Bernstein and Robert Redford is Woodward. Veteran stage and screen actor Jason Robards plays the colorful *Post* editor, Ben Bradlee. Alan J. Pakula, the director of *Klute* and *The Sterile Cuckoo* (1969) is at the helm. Respected screenwriter William Goldman adapted Woodward and Bernstein's book for the screen.

The story begins during the run-up to the 1972 presidential elections. A group of burglars get caught breaking into the Democratic Party national headquarters at the Watergate hotel and apartments in Washington DC. Woodward is assigned to cover what seems to be a small story only to discover that the burglars are connected to top Republican fundraisers. Bradlee assigns Bernstein to assist in the investigation which leads to the Whitehouse. Along the way they develop a secret source they dub Deep Throat, who keeps them one step ahead of the President's men. The film won Oscars for Robard's supporting role and Goldman's adaptation.

Bound for Glory is the biography of legendary folk singer/composer and political activist Woody Guthrie. David Carradine stars as Guthrie and the politically liberal Hal Ashby directs. The film follows Guthrie as he leaves his home in drought-devastated Texas of 1936 to travel the country writing songs about working people and the Great Depression. The music is the real star in this film. Guthrie is a great composer and Ashby knows well enough to let the songs do the talking. Haskel Wexler's Oscar-winning photography recreates the thirties wonderfully. Leonard Rosenman also won an Oscar for his score which complements the songs beautifully.

Network is former television writer Paddy Chayefsky's biting satire about the banality of television. Sidney Lumet directs and the star-studded cast includes

Peter Finch as Howard Beal, the network anchorman who flips his lid on air one day and starts a TV revolution. Faye Dunaway plays Dianna Christensen, an ambitious young executive who is willing to turn the nightly news into a circus. William Holden is Max Schumacher, a grizzled veteran of the news business who still takes it seriously. Robert Duvall is Christensen's boss and ally, Frank Hackett. Ned Beatty is the chairman of the board of the company that owns the network, Arthur Jensen.

One day Howard Beal wakes up to realize his life as an anchor is over. His ratings are in an all-time slump. His wife has died. He has become such a heavy drinker that the network has just fired him. He goes on the air one last time and does a rant to end all rants about the deplorable state of life in America and the more desperate state of affairs in television. He gets his audience to go to their windows and yell, "I'm mad as hell and I'm not going to take it anymore." The entire nation responds. Chayefsky's dialogue is wonderfully overwritten. Everyone sounds like a poet. Soon Beal is the host of a new kind of news show that includes a soothsayer and other elements in addition to his own rants. When Beal starts to attack capitalism, the chairman, Jensen, calls him into the boardroom for the most delicious dressing down in movie history. Who would have guessed that Chayefsky and Lumet's over the top satire would fall short in predicting the laughable state of television news today. Finch won the Best Actor Oscar, Dunaway won Best Actress, and Chayefsky won Best Screenplay.

The Outlaw Josey Wales was directed by Clint Eastwood, who stars as a man who is trying to live the peaceful life of a farmer in the years following his Civil War service. When his house is burned and his family murdered, he turns into a revenge machine. He joins a band of guerilla fighters who continue to make war on behalf of the Confederacy. Bit by bit Wales' anger recedes and he begins to dream of rebuilding his life. Eastwood is his usual stoic self, at his best in the film's many action scenes.

Rocky was written by Sylvester Stallone who also wanted to direct it. Unfortunately he had no experience as a director and only a little more as an actor except for one good performance in *The Lords of Flatbush* (1974). He had to settle for being the star of this seminal boxing film about a thug who beats people up for the mob but dreams of being the heavyweight champion. Talia Shire costars as his love interest, Adrian. Character actor Burgess Meredith plays the colorful trainer, Mickey Goldmill, with Bert Young as Rocky's manager and Carl Weathers as Apollo Creed, the current heavyweight champ. The film predictably shows the lovable mook, Rocky, training himself into top shape for his big fight. Creed is expecting another victim to extend his string of wins and gets much more than he bargained for.

Rocky ended up being much more than the producers, Irwin Winkler and Robert Chartoff, bargained for. It was a runaway hit, grossing over $117 million on a miniscule budget. There was something about the underdog story that resonated with audiences hungry for happy endings. When Oscar time arrived, the film shocked Hollywood with wins in the Best Picture, Best Director (for John Avidson), and Best Editor.

TEN GREAT FILMS: 1977—*STAR WARS* BY GEORGE LUCAS

After *American Graffiti*, George Lucas knew he was on the right track, making films that had positive messages, rather than the anti-establishment filmmaking of his contemporaries. He decided to make films for younger kids while everyone else was targeting the older critics' taste and those of the baby boom generation. And he had always wanted to do a science fiction movie. He started writing the treatment for *Star Wars* in early 1972. One problem: Lucas did not want to make the film at Universal, where he was obliged to take any project first. He did not like the negativity of the studio head, Jeff Berg. Meanwhile Alan Ladd Jr. at Fox had seen a screening of *Graffiti* and had immediately called Lucas. Lucas wanted to be in business with Ladd instead. Lucas pitched his idea to Ladd and he loved it. Just before the 30-day option period was about to lapse, Universal vetoed *Star Wars*, leaving the young director free to go to Fox.

Lucas worked on the script for almost three years. He would show drafts to Coppola and others who would react negatively and tell him that he should be making art house films not *Flash Gordon* (a thirties comic book and serial space traveler). In March 1975, Fox still had not committed to making *Star Wars*. Time was running out when Ladd gave a one-paragraph description of the film to his boss, Dennis Stanfill, and asked for $8.5 million to make it. The board of directors said yes.

Now the hard part began. Lucas' vision of space fighters and death stars had to be brought to life. It called for such complex model shots that the only way to create them was to have a computer-controlled camera, which did not exist at the time. Lucas gathered together special effects wizards, including Jim Nelson and John Dykstra, who had worked for the great Douglas Trumbull on *2001: A Space Odyssey*. They called their new company Industrial Light and Magic (ILM) and rented a vacant warehouse in Van Nuys. ILM started to chew up the budget. By the time the last draft of the script was finished over $4 million had been spent on technology that had yet to produce a single acceptable film element.

In keeping with the fashion of the time, Lucas decided not to cast actors that were well known. Instead he searched for fresh faces. He joined forces with Brian De Palma who was casting his film, *Carrie* (1976), and was also looking for young actors. Carrie Fisher, daughter of actors Debbie Reynolds and Eddie Fisher was cast as Princes Leia, Harrison Ford, who had worked on *Graffiti*, was given the comic relief and lead man role, Hans Solo. Mark Hamill was Luke Skywalker.

Lucas chose to shoot the film at London's Elstree Studios to save money and avoid any meddling by the studio. Accustomed to being treated with kid gloves in Hollywood, the director was not prepared for the treatment he got from his British crew. Lucas was always awkward socially and now it had cost him the respect of the cast and crew. But he slogged on. By the end of the London phase of the production, the budget had swelled to over $10 million and there was still much to do. The British editor was trying to "camp up" the film too much. So Lucas fired him and brought the editing home to the Bay Area.

By March the director was ready to show a rough cut to Ladd. The effects were not ready yet so footage of World War II dog fights was inserted as place holders. The screening was a disaster. Lucas' editor-wife, Marsha, was in tears. They left with De Palma and a few friends for dinner and a post mortem. Lucas took notes as the others tore the film to bits. Only Spielberg disagreed. He thought it was great. Lucas went back to San Francisco to continue editing. ILM was finally producing usable footage and Dolby stereo was added to the sound track. Finally, another screening with sound and effects was arranged for the executives. The result was very different this time. By the end of the film, the audience was cheering and stomping. The film opened on March 25, 1977.

Star Wars (1977). Directed by George Lucas.

Star Wars made motion picture history. On a budget of $11 million its domestic gross was $460 million and overseas it did over $314 million for total of $775 million—more money than the entire Fox Studio was worth. Lucas was richer than any other director in movie history. He even pondered buying the studio, but he had a better idea. When it came time to make the deal for the sequel, he decided to finance it himself, and demanded and got 77 points (77% of the gross after the film reached a certain threshold). At Oscar time, the film swept the technical awards but, otherwise, struck out. It did not matter. The audience voted with their wallets, with people seeing the film over and over again. *Star Wars* had shown that movies could be the new mythology. If the creative people could dream it, it could be put up on a screen. From now on, anything would be possible with the new computer technologies. It proved that foreign audiences would flock to American-made films that had great technical effects, plots that were easy to follow, and characters that were easy to understand. In time this would become the new global box office formula and it would spawn a new kind of corporate filmmaking that would come to dominate the industry.

Annie Hall represents the culmination of Woody Allen's comedy ambitions. Born in Brooklyn in 1935, Allen developed a reputation as a comedy savant from an early age. He was 15 when he got a job writing jokes for a local newspaper for $200 per week (enough to support a middle class family in comfort). Two years later he joined the cast of Sid Caesar's *Your Show of Shows*, a weekly, 90-minute, live, sketch comedy television program. It was the blueprint for *Saturday Night Live.* The writers on the show also appeared in the sketches and the very competitive staff included such

comedy greats as Carl Reiner, Mel Brooks, Neil Simon, and Larry Gelbart. Competition around the writer's table was fierce. After the Caesar show, Allen became a stand-up comedian, working in night clubs, coffeehouses, and on the college circuit as well as television.

In 1965 Allen wrote and appeared in his first film, *What's New Pussycat?* The following year he directed his first film, a cheapie project in which he took a Japanese action film and dubbed it with comedy dialog in English. The title was *What's Up, Tiger Lily?* His real debut as a writer, actor, and director was in *Bananas* (1971), the story of a feckless Manhattanite who gets involved in a Latin American revolution. Allen's next project was the risky, *Everything You Always Wanted to Know About Sex, But Were Afraid to Ask* (1972). Based on a nonfiction sex manual, the film contains seven segments including one hilarious sketch in which Allen, costumed as a sperm, reenacts what happens to a sperm during ejaculation. *Sleeper* (1973) is the story of a health food store owner who is frozen and brought back to life far into the future. It is an excellent premise for Allen's commentary on modern love and sex. Allen's costar in the film is Diane Keaton one year before appearing in *The Godfather*. His next film was *Love and Death* (1975). The film is set in Tsarist Russia. Allen and Keaton play two distantly related cousins (so distant, Allen is romantically attracted to her) involved in a plot to assassinate Napoleon. The comedy derives from their bungling and Allen's always-clever dialog.

Annie Hall is a much more autobiographical film. Allen plays a comedian who is struggling with his career and his love life. He falls in love with Annie Hall, a quirky but entertaining companion. They break up and a middle passage in the film has Allen examining every moment of their life together, looking for clues as to what went wrong. Allen uses Manhattan as a character in the film, locating scenes in the city's many beautiful settings. The whole effect is sweet and funny. The film won Oscars for Best Actress (Keaton), Best Director (Allen), Best Picture, and Best Screenplay (Allen).

Close Encounters of the Third Kind is the project Steven Spielberg put aside to make *Jaws*. It is a science fiction film about man's first meaningful encounter with extraterrestrial life. Richard Dreyfuss stars as Roy Neary, an ordinary telephone lineman who has a meeting with the creatures and begins to obsess about how to meet them again. François Truffaut plays Claude Lacombe, a scientist leading a team of researchers who are trying to organize the encounter. Neary and others like him are led to a place in the mountains of New Mexico where the alien ship plans to land. Lacombe's team prepares the meeting site and develops a rudimentary system for communicating with the visitors. Spielberg pulls off the adventure with great flare. The final scenes are highly dramatic and worth the wait.

Eraserhead is David Lynch' first feature film after several years experimenting with short films and animation. Lynch was born in Missoula, Montana in 1946. His father was a forest ranger, so Lynch spent his childhood living in very small towns in the middle of nowhere. After high school, Lynch attended a number of art schools including one in a Philadelphia slum that served as the inspiration for *Eraserhead*. The

film is set in a post-apocalyptic world where noisy disgusting machines make it impossible to even think. Henry Spencer, the protagonist, leads a bizarre life. When his girlfriend gives birth to a mutant creature, things begin to get really crazy. After this film, Lynch would proceed to make a number of challenging and interesting films that are much favored by art house audiences.

Saturday Night Fever began as an attempt to cash in on the disco dancing craze of the late seventies. Veteran TV director John Badham was assigned this for his first feature. It was so successful, he rarely worked in television again. John Travolta, who had a very short acting resume at the time, stars as Tony Manero, a high school drop out from New Jersey who works in a dead end job in a paint store. The only thing he has to look forward to in life is Saturday nights and the disco where he is the king of the dance floor. He meets a girl who is his dancing equal and the team they form is greater than the sum of the parts. The soundtrack by the Bee Gees features several number one songs and can be given the blame or credit for the disco boom. Working class audiences saw themselves in these characters, making the film an unmitigated success.

TEN GREAT FILMS: 1978—*THE DEER HUNTER* BY MICHAEL CIMINO

By the late seventies it was finally time to take stock of the Viet Nam War. Having lasted a decade, it tore families, individual lives, and the nation apart. Now it was time to look back and incorporate the experience into the American mythos through film. Coppola was famously still working on his war film in 1978 when a relative unknown, Michael Cimino, delivered *The Deer Hunter*. Set in a small steel mill town in the western Pennsylvania hills, the film follows three young men as they go off to war.

The first section of the film's three segments introduces Michael (Robert De Niro), Nick (Christopher Walken), and Steven (John Savage) on their last day as civilians. The film begins with the three men and their friend, Stanley (John Cazale), leaving the mill to have a few drinks at John Welch's (George Dzunda) bar, their regular hangout. Later in the evening everyone attends a big Russian Orthodox wedding where they party deep into the night. The next morning they are up at dawn for their last deer hunt.

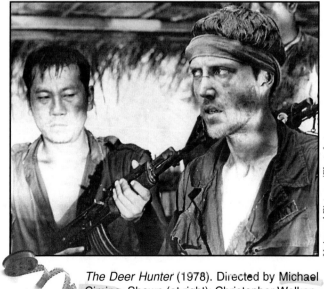

The Deer Hunter (1978). Directed by Michael Cimino. Shown (at right): Christopher Walken.

Universal Pictures/Photofest

The second section takes place in Viet Nam. Michael, Nick, and Steven have been captured by the Viet Cong who pen them up in rat-infested bamboo cages submerged in the river. One by one they are taken out and led to a room where the commander is conducting a game of Russian roulette with the prisoners. His men take bets and laugh and beat the participants until they agree to play. The winners are put back into their cages. It soon becomes clear that this "game" is making Steven break down completely and they are all doomed if they do not try something. In the ensuing escape Steven is shot and Nick gets separated from the others.

In the third segment Michael and Steven are back home. Steven has lost both his legs. Michael has always been a stoic but now his girlfriend, Linda (Meryl Streep) notices a darker side to his personality. He can only recover his emotional stability by going back to Saigon to find Nick. When Michael gets there he discovers that Nick is working at a gambling establishment where he has become a famous and rich professional Russian roulette player. Michael is powerless to save him and returns home with his body. After the funeral the gang gathers at Welch's and, after a particularly uncomfortable silence, they begin to sing "God Bless America."

Of all the films about Viet Nam, Cimino's is the least political and the least polemic. He artfully shows why working class young men would want to leave home and go off to war. Just as artfully he shows the power of war to crush the human body and spirit. The veterans in Cimino's picture are all ghostlike. They have seen, experienced, and done things that they will never be able to get out of their minds. These men turn out to be the invisible casualties of war. The film won five Oscars including Best Supporting Actor for Walken, Best Director, and Best Picture.

Coming Home is a Viet Nam movie from the viewpoint of director Hal Ashby. It stars Jane Fonda as Sally Hyde, Bruce Dern as Captain Bob Hyde, and Jon Voight as Luke Martin. Sally is married to the very gung ho Bob. He is all military and totally in favor of the war. She is a typical military wife who wants to be supportive of her husband and wants him to come back safely. Haskell Wexler was cinematographer.

While Bob is away at war, Sally begins to question the whole thing, including her role as a military wife. She decides to volunteer at the local veteran's hospital where she meets Luke who has been wounded in the war and is a paraplegic. The two begin to fall in love and Sally discovers that Luke can fulfill her sexually, whereas Bob could not. Sally begins to change her life and the way she looks. She buys a sports car and moves to a house at the beach. When Bob returns, Sally tries to put back together the pieces of their marriage but it does not work. Ashby brilliantly infuses the film with contemporary music including Simon and Garfunkel, Bob Dylan, Jimi Hendrix, and The Rolling Stones. Also Ashby's editing is superb in contrasting the three characters and how the war has changed them. The film has been favorably compared to the classic, *The Best Years of Our Lives* (1946).

The Last Waltz is the film that almost killed Martin Scorsese. The Band is the name of a band that had backed up Bob Dylan when he decided to forego the folk

tradition in favor of rock. The members of The Band had never gotten along very well and two of them, Robbie Robertson and Levon Helm, were enjoying successful solo careers that they wanted to pursue. Finally the group made the inevitable decision to break up but, before they did, they would do one last concert at the Winterland in San Francisco and invite all their musical friends to participate. Scorsese agreed to direct the film. He captures the event beautifully, mixing footage of the great performances (by The Band, Eric Clapton, Neil Diamond, Bob Dylan, Joni Mitchell, and many others) with backstage interviews that show why everyone is going their separate ways.

Scorsese had used cocaine as part of his creative process since the days of *Box Car Bertha.* Here with the mixture of sex, drugs, and rock and roll, the white powder was everywhere. By the time he emerged from the editing room Scorsese had to go straight to the hospital.

National Lampoon's Animal House was cashing in on the huge success of *Saturday Night Live* (SNL) on television. The college spoof about a war between preppie and slob fraternity houses is directed by John Landis and written by Harold Ramis. Both men would figure prominently in other *Saturday Night Live* spin-offs. John Belushi is the connection between the film and the TV show in this case. SNL vets who went into film are too numerous to count but Bill Murray, Dan Akroyd, Eddie Murphy, Mike Meyers, Amy Poehler, and Tina Fey are just a few.

Superman: The Movie is an example of a new kind of corporate filmmaking that was, no doubt, stimulated by the success of *Star Wars.* Superman began as a comic book and then became a comic strip. The Fleisher brothers acquired the rights to animate Superman and it was also a long-running television series. One thing was certain about the movie: no one would need to be told who the Superman character was. It came completely pre-sold. The real challenge was to make a film that would not pale in comparison to *Star Wars* and the other sequels Lucas had on the drawing board.

Director Richard Donner does a credible job bringing the comic book to life. Marlon Brando plays the man of steel's father from Krypton, Christopher Reeve was excellent as the dual character, Clark Kent/Superman, as was Margot Kidder as Lois Lane. Gene Hackman ably plays the villain, Lex Luthor. The special effects are good enough to satisfy an audience that would soon become very sophisticated about such things.

TEN GREAT FILMS: 1979–*APOCALYPSE NOW* BY FRANCIS FORD COPPOLA

Francis Ford Coppola hatched the idea to make his Viet Nam War film around the time *The Godfather* was being released. At one point before *Star Wars,* Coppola had asked Lucas to direct it. However, it was still just in the idea stage. No script existed yet. Once Lucas started *Star Wars,* Coppola decided to make *Apocalypse Now* himself. He began by writing a script based on Joseph Conrad's novel, *Heart of*

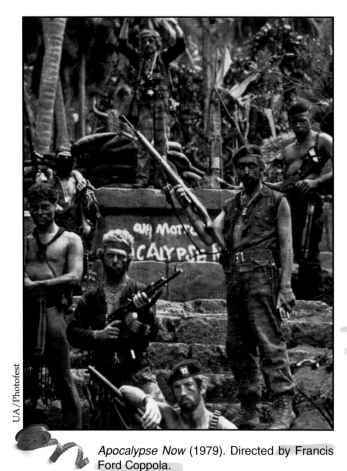

Apocalypse Now (1979). Directed by Francis Ford Coppola.

Darkness, the story of an explorer who travels to the upper reaches of the Niger River in search of a man who had disappeared into the desolated land years before. In Coppola's story an army assassin named Willard would be dispatched by the high command to travel up the Mei Cong River in search of the renegade Colonel Kurtz, to be played by Marlon Brando. Coppola planned to produce the film in the Philippines with his own money.

At the outset there were problems. Coppola had approached Steve McQueen, Al Pacino, Jack Nicholson, and Robert Redford to play the role of Willard. None were game for what was bound to be a long, uncomfortable, and challenging shoot. Eventually the director settled on Harvey Keitel as Willard, Robert Duvall as Kilgore, and he offered Brando a million per week and eleven percent of the gross, which was accepted. Coppola regular Fredrick Forrest was also signed, as well as Dennis Hopper.

The production moved to the Philippines in March 1976. Just before the company left Los Angeles, Coppola had fired Keitel and hired Martin Sheen for the Willard part. When they got there, it was monsoon season and it was raining constantly. The cast and crew went into a funk, blaming the director for everything that went wrong. Then Martin Sheen had a heart attack. That should have been the end of it. They could collect the insurance money and go home to the dry weather in Hollywood. Coppola would not have it. He was going to make his masterpiece and that was that. Sheen was smuggled back to Los Angeles to recuperate for six weeks while the production team tried in vain to work around him. Beset by innumerable problems, the production broke for Christmas in December.

Coppola returned to the Philippines at the end of January 1977 to attempt to finish his project. The entire set had become a drug den with the director smoking pot

constantly. All discipline had long since vanished. Photography finally wrapped in June. Coppola was in debt and needed money. The original budget of $13 million had ballooned up to $30 million with at least another $10 million needed to finish. Meanwhile the director's marriage was falling apart.

Apocalypse Now was edited and reedited over months. A new release date of April 1978 was set. United Artists (UA) had put up between $15 and $20 million of the production budget with Coppola on the hook for more than $10 million. UA was strapped for cash and almost out of business. Still the editing continued. Finally the director took a rendition of the film to the Cannes Festival where it won the top prize, the Palme d'Or. Thus reassured, Coppola was ready to release the film. It had cost $40 million and there was at least an additional hour or more of the movie that did not make it into the final cut. Once one of the most focused directors in Hollywood, Coppola had let his ego, lack of planning, and lack of a finished script almost destroy him. The whole enterprise was a shame.

Apocalypse eventually earned back the investment with $78 million in domestic rentals. At Oscar time it won only two awards, Best Cinematography for Vittorio Storaro, and Best Sound.

All That Jazz is an autobiographical musical written and directed by Bob Fosse. It tells his life story from three points of view: his wife's, his daughter's and his. It is an unvarnished look at a high energy choreographer-director who cannot say no to the women in his life or to the amphetamines and cigarettes that get him through the day. It all catches up with him on a wonderful production number, "Bye Bye Life."

Being There is a collaboration between Hal Ashby, Peter Sellers, and Shirley MacLaine. Based on a book by Jerzy Kosinski, it is the story of a man, Chance Gardner, who has lived a cloistered life until his caretaker dies. He has no knowledge of the outside world which draws the curiosity of the media who elevate him to celebrity status. His simple, uninformed responses to important people's questions are taken as gold plated wisdom. The film was Seller's last successful role.

Kramer vs. Kramer, written and directed by Robert Benton, is the story of a recently divorced man, Dustin Hoffman, who is left to take care of his son and must learn to be responsible instead of being completely self-involved. He becomes a really good, loving father in the process. Finally his wife Joanna, played by Meryl Streep, reappears, wanting to get her son back. A heartbreaking court battle ensues. The film won a Best Actor Oscar for Hoffman, Best Supporting Actress for Streep, Best Director, and Best Picture.

Star Trek was the next event in the brave new world of corporate Hollywood's attempt to create "movie franchises." Gene Roddenberry's brilliant television series from 1966 had never vanished from public consciousness. Paramount reunited the original television cast and hired veteran director Robert Wise (*The Day the Earth Stood Still*—1951, *West Side Story*—1961) to helm the feature. The project was a success from Paramount's point of view. To date nine motion pictures have been spawned by the scrappy little TV series.

The seventies had begun as an extension of those last, super creative years of the sixties. A new generation of star directors and actors were revolutionizing the American motion picture industry by making audacious films of such complete originality as to eclipse foreign competition. But success bred excess. All the money that was showered on the new film school generation changed things. Coppola and Lucas, who had once been so close, drifted apart after *Star Wars* made Lucas the richest director in town. The competition among directors to top each other and themselves became a joke. *The Last Movie, Heaven's Gate* (1980), and *Apocalypse Now* are all examples of undisciplined movie making. Films like these ruined opportunities for other new film talent and drove the industry into the hands of the corporations with their MBAs, spreadsheets, and movies by committee. So much risk taking had turned the industry risk averse. And the personal self indulgence was equally sloppy. Great talents wasted themselves on drugs and every other kind of overindulgence imaginable. What began with such hope and promise, ended like a bad dream with the establishment back in control because the kids just could not handle their freedom after all.

Ch. 6

1. Blade Runner was based on Philip K. Dick story. Do Androids Dream of Electric Sheep.

2. Errol Morris directed The Thin Blue Line

3. Platoon is example of film that contradict Reaganism

4. John Water & John Cassavete are regarded as pioneers of modern American independent cinema.

5. Bruce Willis was star of Die hard series of film.

6. David Lynch directed Blue Velvet.

7. Martin Scorsese direct The Last Temptation of Christ.

8. 1982 was Rocky III release.

9. Woody Allen play character, Sandy Bates in Stardust Memories.

10. Michael Moore began as Editor of Mother Jones magazine.

American Cinema in the Eighties

6

At the end of the 1970s, the motion picture industry had pretty much ended its love affair with young genius auteur directors. The big names all remained at the top of the film world. Coppola, Scorsese, De Palma, and Altman were working as much as they ever had but with varying degrees of success. Lucas and Spielberg were quickly becoming the most bankable and in-demand directors in the business. *Jaws* and *Star Wars* had been such huge successes that the two directors could do virtually anything they wanted. In fact, Lucas had driven the ultimate hard bargain for his sequel to *Star Wars*, *The Empire Strikes Back* (1980), that put him in position to make much more money from the film than the studio would. Spielberg was busy at work on a new concept that was sure to have sequel potential. In the executive suites, films like these were now being referred to as "franchises," movie concepts that could be replicated like hamburgers at McDonald's.

The blockbuster results that *Jaws* and *Star Wars* achieved served to whet the appetite of the new breed of studio executives who were more business people than movie makers. As films were becoming just one of the enterprises large media conglomerates engaged in, the emphasis shifted from making good movies to making movies that made money. The pride studios once took in making prestigious films was replaced by an emphasis on the bottom line during the eighties, except at Oscar time. American culture was shifting during the Reagan years. As Oliver Stone's character, Gordon Gekko, would famously declare in 1987, "Greed is good!" Increasingly, filmmakers interested in art retreated from the big-budget, corporate, film-by-committee world into the low-budget world of independent cinema.

1980: THE LAST YEAR OF THE SEVENTIES

Production schedules being what they are, most of the films that were released in 1980 were the product of attitudes and concepts that were hatched during the previous decade. To some extent, 1980 is the last great year of the seventies. Films like *Raging Bull*, *Stardust Memories*, and *Stunt Man* could easily have been made in the previous decade. Others like *The Empire Strikes Back* and *The Blues Brothers* are definitely products of the new decade.

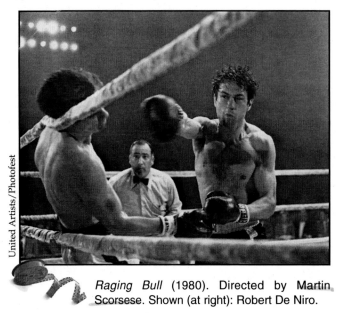

United Artists/Photofest

Raging Bull (1980). Directed by Martin Scorsese. Shown (at right): Robert De Niro.

Raging Bull is as much Robert De Niro's doing as it is Martin Scorsese's. In the mid-seventies the actor had come across the ghostwritten autobiography of one-time middle weight champion boxer Jake La Motta. By his own account, the boxer was a conflicted and violent man. In him, De Niro saw an opportunity to play a role that would finally allow him to show the full range of his acting ability. At first the director was reluctant. Physically, Scorsese was very slight and he had been sickly and asthmatic as a boy. The rough and tumble of the fight ring made no sense to him whatsoever. The director just did not believe he was cut out for such a film but the actor was persistent. He saw the character as a canvas on which to paint intense emotions. He convinced Scorsese that a boxing match can be a thing of awful beauty, two men in the middle of the ring with nothing but their wits and fists with which to dominate each other. It is a test of courage, and for La Motta, it was a way to prove how much punishment he could take. The director became convinced to do the movie.

Cinematographer Michael Chapman had worked with Scorsese twice previously on *Taxi Driver* and *The Last Waltz*. This would be the perfect project for the way they worked together. One early decision they made was to shoot in black and white. There were two reasons for this. Aesthetically, they wanted the film to look like the great fight photographs in *Life* and *Look* magazines in the forties and fifties. The other reason was more practical. In the seventies the film *The Exorcist* had made film goers physically ill. Scorsese knew that he was about to make one of the most violent films in history. He did not want theater owners to reject his film for fear it might be another *Exorcist*.

Casting was another challenge. La Motta had a brother, Joey, who trained and managed him. Joey was significantly smaller physically. Since De Niro is also small in stature, whoever was to play Joey needed to be quite small and to look convincingly enough like De Niro. Casting director Cis Corman scoured New York City for the right actor but did not find an acceptable Joey until she was reminded of a young man who had been a child actor in the city but had not been able to make the transition to adult roles. Joe Pesci was tending bar in Brooklyn when Corman approached him for the role. With Joey cast, the last remaining challenge was finding an actress who could play La Motta's wife, Vicky, who is fifteen at the beginning of

the film and in her thirties at the end. Pesci suggested a girl from his acting class. Cathy Moriarty was nineteen when she signed on. Scorsese planned to do a lot of improvisation in the film. Could such a young actress match the intensity that De Niro would bring to the role? Once rehearsals began, all doubts about Moriarty's abilities faded away.

Scorsese and Chapman made several artistic decisions as they prepared to commence production. One was to shoot every fight scene in a different style. Some were shot with the Stedicam; some used cranes. They used low and high angles. They shot with the movement on a horizontal plane and on a diagonal plane. The result is a compendium of visual composition. Another decision was to use the technique of over-cranking (running the film through the camera at speeds in excess of the normal 24 frames per second to create different degrees of slow motion) to give a subjective quality to scenes in which Scorsese wanted the audience to experience events from La Motta's point of view. The soundtrack also contributed to this effect with low-frequency rumble and animal sounds added to give the feeling of being inside the boxer's enraged state of mind. Another unusual sound effect was the use of breaking panes of glass to simulate the sound of the news cameras' flash bulbs. *Raging Bull* also contains another Scorsese trade mark: a long tracking shot. The night La Motta first fights for the championship, the camera follows him from his dressing room, through the halls of the stadium, onto the stairs of the arena, down to the ring. Just as the boxer goes to his corner to enter the ring, the camera operator steps onto a crane platform and is lifted 20 feet above the ring. All of this was accomplished in one continuous shot without editing. The effect is operatic.

De Niro plays La Motta from his twenties into his forties. After the boxer left the ring, he gained a great deal of weight. Dei Niro was determined not to use a fat suit for this part of the film. Instead, he got into the best shape of his life training for the boxing sequences. They were all shot first. The production took a small hiatus while the actor gained 65 pounds. On his small frame, the transformation is dramatic. At the end of the picture De Niro's La Motta is dissipated and pathetic. The actor had painted one of the greatest character arcs in movie history. Deservedly he won the Oscar for Best Actor. Thelma Schoonmaker also won for editing.

Stardust Memories is the third film in Woody Allen's self-referential trilogy. *Annie Hall* was the first and *Manhattan* (1979) was the second. Between the two, he made the devastatingly serious film, *Interiors* (1978). In *Stardust Memories* Allen plays Sandy Bates, a middle aged director, who is attending an out-of-town retrospective of his work. In an obvious reference to *Interiors*, people keep asking him when he is going to return to making funny movies. This depresses Bates who falls into an anxious self examination of his past and his body of work. Finally, he meets a beautiful woman who distracts him long enough to fall in love with her. If Allen was working out his own psychology in the film, (and there is much evidence he was) it worked. Freed of the need to explain and explore his own persona in his films, Allen made ten more features during the eighties en route to becoming one of the most prolific directors of his generation.

The Stunt Man is the kind of film that never would have been made later in the eighties. It defies categorization, being a combination of romance, comedy, and thriller. Steve Railsback plays a Viet Nam vet on the run from the police. During his escape, he stumbles upon a movie production. The crazy and malevolent director, played by Peter O'Toole, needs a new stunt man. Because of the director's negligence, the former stunt man is dead. Railsback takes the job, both to hide out and to pursue the beautiful leading lady, played by Barbara Hershey. The film moves back and forth from the reality of the story being told in the film in production to the real behind-the-scenes reality of producing the film, often without the audience or the stunt man knowing which is which. Is the director actually trying to kill his stunt man or is he just trying to capture a really vivid performance? The screenplay is completely original. It received both an Oscar nomination and a Writers Guild of America nomination. It is hard to imagine a bottom line-oriented executive giving a green light to a script like this. Both the director, Richard Rush, and O'Toole also received Oscar nominations.

The Empire Strikes Back is the first of two *Star Wars* sequels made in the eighties. The blockbuster nature of the film with its dazzling special effects and the relative simplicity of the story and characters give it a mass and global appeal that is representative of big-scale corporate filmmaking in the eighties. In the history of movie sequels, it is one of the best. George Lucas declined to direct it, giving that assignment to Irvin Kershner, a television veteran somewhat older than Lucas, who decided to focus his energies on producing the film. The original cast returned with the addition of Billy Dee Williams (as an old friend of Han Solo) and a new character, Yoda. He is a Jedi knight sent to educate Luke Skywalker about the use of "The Force." Yoda is a small animated puppet creature, who speaks in riddles and was voiced by Frank Oz. Lucas successfully managed to eliminate the usual executive interference that comes with studio financing. As a result, he was able to make the film he wanted to make without any compromises. *Empire* fell short of *Star Wars'* box office performance but not disappointingly so. It made $290 million domestically and another $247 million overseas, compared to the first film's three-quarters of a billion dollars. The film swept the Oscars' technical awards and composer John Williams won for his score.

The Blues Brothers is a prototypical eighties film. Based on two characters created by Dan Aykroyd and John Belushi for the NBC television show, *Saturday Night Live* (SNL) the film is a musical comedy romp. At the helm is John Landis, who had previously directed Belushi in *Animal House*, and who would go on to direct several films featuring SNL performers. The film is the story of Jake and Elwood Blues, two Chicago bluesmen recently paroled from prison, who are trying to get their band back together to raise money for the Catholic orphanage where they were raised. The plot basically serves as an excuse to put Aykroyd and Belushi on screen with great musicians including Cab Calloway, James Brown, Ray Charles, and Aretha Franklin. *The Blues Brothers* also features two amazing car chases and as much chaotic comedy as could be squeezed in. For a comedy, the film was a huge

financial success, doing $57 million domestically and $58 million overseas. The film is an example of the eighties staple, the concept movie. Rather than being based on a great story or a great character, concept (or high-concept) movies are based on an idea or on a pairing up of especially popular movie stars. *The Blues Brothers* is not the kind of film that would be expected to show up at Oscar time. It is intended as pure entertainment.

MTV AND THE MOVIES

The cable television industry as we know it today was born during the late seventies and early eighties. Two things happened in the seventies that led to the new media and entertainment phenomenon. First the Federal Communications Commission lifted its ban on cable television operators creating their own programming in 1972. Prior to this, cable television had been a "common carrier" business importing distant television broadcast signals into communities that lacked TV service. The second occurrence was a change in the method of financing the construction of cable systems. Previously, banks would not make large loans for cable system construction because it was difficult to place a value on a system once it was built. After the ban on programming was lifted, investment banks began to value systems based on the number of subscribers on a per customer basis. This greatly increased the amount of money available for cable construction. Once a significant number of desirable new cable channels came into being, there was a demand to build cable systems in cities with existing broadcast television service. Premium cable television networks like Home Box Office had been around since the early seventies, but MTV put cable over the top in terms of demand.

MTV made its cable debut on August 1, 1981 with a music video by The Buggles, "Video Killed the Radio Star." VeeJays hosted the network as if it were radio with pictures introducing the music videos. By the end of the year, the network had 2.1 million subscribers. An advertising campaign featuring rock stars like Pete Townshend of The Who, Mick Jagger of the Rolling Stones, and David Bowie made a big splash, driving demand for the channel. In March 1982, Michael Jackson became the first African American artist to appear on the channel with his video for the song, "Beat It." In December the 14-minute "Thriller" film, directed by John Landis, made its debut. Prior to "Thriller" most music videos were the same, featuring the artists lip synching to their recordings. But this video was original and exciting and showcased Jackson's talents as a performer. "Thriller" inspired a new generation of young directors to see the possibilities in the new genre.

MTV developed its own style. Rhythmic editing, extreme camera angles, fast action, and splashy color became the hallmarks of music videos. It was inevitable that Hollywood would adopt a style that was so successful in luring young people to their television sets. In 1983 two cheeky young producers, Don Simpson (who had been a failed executive at the studio before becoming a producer) and Jerry Bruckheimer, were given a deal to come to Paramount. They had developed a

reputation for making concept films and for refusing to defer to directors and actors. On a Simpson-Bruckheimer movie, you knew who was in charge, the producers. Their first project for the studio was *Flashdance*, a very simple story about a girl who works as a welder but dreams of becoming a ballet dancer. Jennifer Beals plays the girl who practices her art as an erotic dancer in a working class saloon. The script was completely rewritten for the producers by another rising star, Joe Eszterhas, who had no pretense of creating art or even of creating great stories. He was a concept man, just what the producers wanted and needed. Every time the story slows down a music and dance number is inserted. The critics described the film as a 96-minute music video. Two songs from the movie, "What a Feeling" and "She's a Maniac" became MTV hits and were played incessantly. In effect, this served as the ad campaign for the film. Initially it opened weakly except for Los Angeles and New York City, but with all of the cable exposure, it became a hit, earning over $92 million. Simpson and Bruckheimer were set with the studio. There would be no further questioning of their movie judgment for the time being. Paramount was so thrilled that it acquired a two-thirds stake in the MTV network two years later.

MOVIE FRANCHISES

At the end of the seventies, three movie franchises of varying quality were established: Sylvester Stallone's *Rocky* series, George Lucas' *Star Wars* films, and the *Star Trek* franchise. During the eighties other film franchises would emerge in the major studios' quest to develop movie properties that would be predictably profitable, easy to promote, and endlessly reproducible. This was not a new phenomenon by any means. In the thirties several successful franchises had been developed including *The Thin Man, Charlie Chan*, and *Andy Hardy*. However, these early series films were generally seen by the studios as B picture programs. In the eighties, franchises would become very important to the big motion picture companies that spent lavishly on them in hopes of replicating the success of *Star Wars*.

Rocky was originally released in 1976. *Rocky II* was released in 1979. It was a re-hash of the first film with all of the original characters returning. The first half of the film finds Rocky Balboa fighting to keep his marriage together while the Champion, Apollo Creed, taunts him for a rematch. The inevitable rematch resolves everything. *Rocky III* was released in 1982. This time a television character, Mr. T, is Rocky's brutal opponent and Apollo Creed joins team Rocky as his trainer. *Rocky IV* arrived in 1985. The film is pure cold war. Apollo Creed is killed in the ring by a Soviet superman, Captain Ivan Drago. Rocky must go to Russia to avenge Creed's murder and American pride. In 1990 the Rocky series supposedly came to an end with *Rocky V*. This time Stallone cast his son as Rocky's heir apparent. In the film Rocky Sr. is forced into retirement as a result of brain damage suffered in Russia. He has also lost his fortune in the stock market. Rocky really needs a miracle. A, hopefully, final Rocky film was made in 2006, *Rocky Balboa*. The 60-year-old champ comes out of retirement to engage in a cyber fight. The film is more of a game promotion than anything else.

Star Wars was followed up with *The Empire Strikes Back*. The third film in the series, *Return of the Jedi* (1983), was produced by George Lucas with Richard Marquand directing and Lawrence Kasdan sharing screenwriting credits with Lucas. The film features a new death star and new villain, Jabba the Hutt. The plot is designed to bring an end to the franchise. Luke does battle with his father, Darth Vader (aka Anakin Skywalker). The new death star is destroyed and everyone is united for a happy ending. However, as the decade of the nineties was nearing its end, Lucas dreamed up three new prequels to the series.

Star Trek: The Motion Picture had been a great success for Paramount. It made $82 million on a $35 million production budget. With sets built and effects, make-up, and costumes designed, sequels could be produced with much smaller budgets. The original cast of the television series was game to continue with the films. *Star Trek* had become a social phenomenon with conventions drawing thousands of fans dressed up as their favorite characters. *Star Trek: The Wrath of Khan* was released in 1982. It made $78 million on an $11 million production budget. Two years later came *Star Trek: The Search for Spock.* In 1986 *Star Trek: The Long Voyage Home* was released, followed by *Star Trek: The Final Frontier* (1989), and *Star Trek: The Undiscovered Country* (1991), the last of the series to feature the original cast. Paramount also spun off a number of television series from the franchise beginning with *Star Trek: The Next Generation* in 1987 and *Star Trek: Deep Space Nine* in 1993.

Raiders of the Lost Ark (1981) was the first film in the *Indiana Jones* series. The film represents the dream team approach to movie making. Steven Spielberg directed while George Lucas produced and co-wrote with Lawrence Kasdan. Harrison Ford reprises a Han Solo-like character, playing Indiana Jones for laughs, as well as a reluctant action hero. Stylistically, the film is a mash-up of thirties-style action serials with state-of-the-art special effects and stunt work. The first film has world-famous archeologist Indy trying to beat the Nazis in recovering the sacred and all-powerful Ark of the Covenant. Excellent villains and great sets make the film an entertainment treat. On a production budget of $18 million the film grossed over $242 million domestically and $141 million overseas. With results like these, obviously Paramount was going to make sequels.

Indiana Jones and the Temple of Doom was released at the end of May 1984 as an intended summer blockbuster. It did not disappoint. On a relatively modest

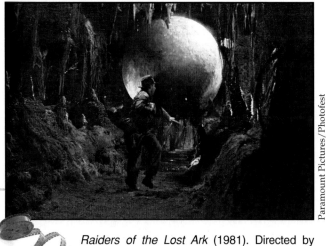

Raiders of the Lost Ark (1981). Directed by Steven Spielberg. Shown: Harrison Ford.

Paramount Pictures/Photofest

production budget of $28 million, it made $333 million worldwide. Spielberg returned to direct and Ford continued to star in the series. The big change was in the writing. Without Lucas' involvement in the story, the screenplay is a little off track. Its negative representation of Asian people is particularly off-putting. That mistake would not be repeated with the third film in the series.

Like its predecessors, *Indiana Jones and the Last Crusade* (1989) was made for summer release. This time, Lucas developed the story for what appeared to be an attempt at lengthening the franchise. The film features three generations of Joneses with Sean Connery playing Indy's father and River Phoenix playing Indy as a boy. Phoenix could have easily replaced Ford in subsequent films were it not for the fact that he died of a heroin overdose outside the notorious Viper Room in Hollywood in 1993. Nonetheless, *Last Crusade* was the most successful of the trilogy. On a substantial budget of $48 million, it grossed $197 million domestically and $277 million overseas. The fact that the film made considerably more money overseas than at home points to the future trend of global marketing for franchise movies.

OTHER FRANCHISES

Terminator *The Terminator* (1984), *Terminator 2: Judgment Day* (1991), and *Terminator 3: Rise of the Machines* (2003). Director James Cameron was fresh off his first feature film, *Piranha Part Two: The Spawning* (1981) when he co-wrote the script, produced, and directed the first *Terminator* movie. Arnold Schwarzenegger plays a cyborg from the future attempting to kill Sarah Connor (Linda Hamilton) to prevent her from giving birth to a son that led humans to ultimate victory over the cyborgs. Cameron also directed the second film in which the cyborg is again sent back from the future, this time to protect Sarah Connors' now-teenaged son. The first film made $78 million on a $6 million budget. The second made half a billion on a $100 million dollar budget and the third (which was not directed by Cameron) made $433 million on a whopping $200 million dollar budget.

Back to the Future *Back to the Future* (1985), *Back to the Future Part II* (1989), and *Back to the Future Part III* (1990). With the *Back to the Future* series, writer-director Robert Zemeckis was following up his biggest commercial hit, the love story-adventure, *Romancing the Stone* (1984). The film stars TV veterans Michael J. Fox (*Family Ties*) as Marty McFly and Christopher Lloyd (*Taxi*) as Dr. Emmett Brown, who has unlocked the secrets of time travel. Marty travels back to 1955 and accidentally stops his parents from meeting. He manages to find a younger version of the professor to help undo the mess. The second film, also written and directed by Zemeckis, has Marty needing to go back to 1955 again to undo something from his first trip without encountering himself. Everyone also returned for the third film in which Marty must go into the past to save Dr. Brown. The first film made $381 million on a $19 million budget. The second made $331 million on a $40 million budget and the third did $244 million against $40 million.

Lethal Weapon *Lethal Weapon* (1987), *Lethal Weapon 2* (1989), *Lethal Weapon 3* (1992), and *Lethal Weapon 4* (1998). The first script Shane Black ever sold was for the first *Lethal Weapon* film. He would proceed to write the other three as well. Richard Donner had great success with the first two *Superman* movies and directed all four installments of this franchise. Mel Gibson and Danny Glover star in the bi-racial buddy-cop picture series that is known for its intense action scenes. Gibson's character is an unhinged and suicidal danger seeker following the murder of his wife. Glover's character is a family man who is near retirement and wants nothing to do with excitement or action. In the first film they do battle with a violent drug gang. In the second they chase South African gangsters hiding out as members of the diplomatic delegation. In the third film Gibson and Glover are joined by a beautiful policewoman played by Rene Russo. In the last film, comedian Chris Rock joins the team as they track down a Chinese crime boss. Together, the four films took in almost a billion dollars at the box office.

Die Hard *Die Hard* (1988), *Die Hard 2* (1990), *Die Hard: With a Vengeance* (1995) and *Live Free or Die Hard* (2007). The first and third films team action director John McTiernan with Bruce Willis who plays a tough, indestructible New York City cop who is in Los Angeles to reconcile with his wife. He gets caught up in a terrorist plot when his wife's office party is taken hostage. In the second film Willis is fighting yet another terrorist group, this time at an airport. The third film has Willis doing battle with a mad bomber on the streets of New York. The four films grossed over $1.1 billion.

SNL FRANCHISES

The television show *Saturday Night Live* has produced many of the most successful movie comedians in the last 30 years including the following:

Dan Aykroyd	Jim Belushi	John Belushi
Dana Carvey	Chevy Chase	Billy Crystal
Jane Curtin	Joan Cusack	Chris Elliot
Jimmy Fallon	Chris Farley	Will Ferrell
Tina Fey	Al Franken	Anthony Michael Hall
Julia Louis-Dreyfus	John Lovitz	Norm Macdonald
Dennis Miller	Eddie Murphy	Bill Murray
Mike Meyers	Chris Rock	Adam Sandler
Martin Short	David Spade	

Hollywood never wasted time in finding movie vehicles for such talented people. Many had successful franchises built around them. They include the following examples that began in the eighties.

48 Hours (1982) and *Another 48 Hours* (1990) feature Nick Nolte as a tough guy cop and Eddie Murphy as a convict who can help solve a crime. The only catch is that Nolte will have to get Murphy a 48-hour parole to get his cooperation. It is a buddy picture with a twist. The two end up making a good team, especially when the trail leads the two into a redneck bar. Five years later the two team up again to track down the mysterious "Ice Man," a criminal mastermind. The two films grossed a combined $231 million.

Beverly Hills Cop (1984), *Beverly Hills Cop II* (1987), and *Beverly Hills Cop III* (1994) star Murphy playing a tough Detroit detective, Axel Foley. In the first movie, Foley is after the killer of his best friend. The trail leads to Beverly Hills where cop culture is much more sedate than back home. Judge Reinhold plays Detective Billy Rosewood who is assigned to keep Foley in line. The film is a combination "fish out of water" and buddy picture. Reinhold returned for the second film but not the third. Martin Brest directed the first, Tony Scott the second, and John Landis the third. Together the three films grossed $734 million.

National Lampoon's Vacation (1983), *National Lampoon's European Vacation* (1985), and *National Lampoon's Christmas Vacation* (1989) feature Chevy Chase as Clark Griswold, a middle class everyman on the annual family vacation. Everything goes wrong and ends up all right. John Hughes wrote all three films. Harold Ramis directed the first and Amy Heckerling (*Fast Times at Ridgemont High*) directed the second. Beverly D'Angelo plays Mrs. Griswold in all three films. The vacation series films were made inexpensively and managed to gross $181 million together.

Ghost Busters (1984) and *Ghost Busters II* (1989) both star Bill Murray, Dan Aykroyd, and Harold Ramis as paranormal scientists who go into the business of ridding peoples houses of ghosts, goblins, and other creatures that haunt. Sigourney Weaver plays the damsel in distress in the two films. Likewise, both are written by Aykroyd and Ramis and directed by Ivan Reitman. The films were sure audience pleasers with the first grossing $291 million and the second topping out at $215 million.

HORROR FRANCHISES

This type of franchise dates back to the thirties with films like *Frankenstein, The Mummy, Dracula,* and *The Wolfman,* with characters and storylines that were repeated in many sequels. Some sequels were even done as comedies. In the seventies fewer restrictions on depictions of violence led to the birth of the slasher-horror genre. Generally these were very low-budget films intended for teen audiences. Most of these films did modestly at the box office. Occasionally one would break through, especially the most recent remakes, but all of these series made impressive money when taken as a whole.

The Texas Chainsaw Massacre (1974) $30 million, *The Texas Chainsaw Massacre 2* (1986) $8 million against a $4.7 million budget, *Leatherface: The Texas Chainsaw Massacre III* (1990) $6 million, *The Texas Chainsaw Massacre* (2003) $107 million against

a $9.5 million budget, and *The Texas Chainsaw Massacre: The Beginning* (2006) $51 million against $15 million. Series total: $202 million.

Halloween (1978) $47 million, *Halloween II* (1981) $25 million, *Halloween III: Season of the Witch* (1982) $14 million, *Halloween 4: The Return of Michael Myers* (1988) $17 Million, *Halloween 5* (1989) $11 million against $5 million, *Halloween: The Cures of Michael Myers* (1995) $15 million, *Halloween: H20* (1998) $55 million against $17 million, *Halloween: Resurrection* (2002) $37 million against $13 million, and *Halloween* (2007) $79 million. Series total: $300 million.

Friday the 13th (1980) $39 million, *Friday the 13th Part 2* (1981) $21 million, *Friday the 13th Part III* (1982) $36 Million, *Friday the 13th: Final Chapter* (1984) $33 million, *Friday the 13th Part V* (1985) $22 million, *Friday the 13th Part VI* (1986) $19 million, *Friday the 13th Part VII* (1988) $19 million, *Friday the 13th Part VIII* (1989) $14 million, and *Friday the 13th* (2009) $90 million against $9 million. Series total: $293 million.

Nightmare on Elm Street (1984) $25 million, *Nightmare on Elm Street 2: Freddy's Revenge* (1985) $30 million, *Nightmare on Elm Street 3: Dream Warriors* (1987) $44 million, *Nightmare on Elm Street 4: The Dream Master* (1988) $49 million, and *Nightmare on Elm Street 5: The Dream Child* (1989) $22 million. Series total: $170 million.

THE REBIRTH OF INDEPENDENT FILM

As the big motion picture corporations began to increasingly define movies as "product" during the eighties, a vacuum was created for films that did not adhere to Hollywood formulas. There had always been a stratum of the movie business that was occupied by filmmakers who chose to avoid the studio system as much as possible. During the fifties people like Ed Wood and Roger Corman exemplified low-budget independent movies. In the sixties and seventies, companies like United Artists and BBS productions provided a safe haven for young talent attempting to create the new American cinema. But BBS ran out of steam and the Transamerica insurance company's acquisition of United Artists finally took its inevitable toll on creativity.

PIONEERS OF INDEPENDENT CINEMA

JOHN CASSAVETES

Cassavetes was the son of Greek immigrants. He was born in 1929 in New York City. He studied English at Colgate University before enrolling at the New York Academy of Dramatic Arts from which he graduated in 1950. He became a member of a repertory theater group in Rhode Island until landing his first movie role in 1953. This led to steady work in live television drama, usually playing a troubled young man. His career as a filmmaker began with an offhanded remark on a radio show. Commenting on how disappointed he was with a film he had recently appeared in, Cassavetes claimed that he could make better films than Hollywood if the

audience would send him a dollar or two. Within a few days the radio station had collected over two thousand dollars. He launched into production with a 16mm camera and the students from his acting workshop. The resulting film, *Shadows*, was a completely improvised story about a family of African American jazz musicians living in Greenwich Village. Because he knew nothing about movie technology, the soundtrack was a total mess. It took three years to fix it so it was good enough to release the film 1960.

The international film community fell in love with *Shadows*. It won the Critics' Award at the Venice Film Festival. This led to Cassavetes being hired to direct a Hollywood film, *Too Late Blues* (1962), starring pop-singer Bobby Darin. The result was terrible, both financially and artistically. However, Stanley Kramer still believed in the young director and hired him to helm *A Child Is Waiting* (1963) for United Artists. Before the film was finished, the two men were not speaking and it was clear that, for now, Cassavetes' directing career in Hollywood was over. He returned to New York embittered by the whole experience and resumed his acting career.

In 1968 Cassavetes returned to his cinema verité style filmmaking with *Faces*. The film stars his wife, Gena Rowlands. John Marley plays Richard and Lynn Carlin plays his wife, Maria. The couple has been married for 14 years and the relationship has fallen apart. She has a one night stand with a hippie (Seymour Cassel) and he hires a prostitute (Rowlands). No one is satisfied. The original version of the film was six hours long. Eventually it was cut to 130 minutes which is still long enough to exhaust the audience with its intensity of emotions and persistent close-up photography. Cassavetes received an Oscar nomination for the screenplay and Cassel and Carlin received nominations for Best Supporting Actor and Actress.

In 1970 Cassavetes made *Husbands*, starring himself and his close friends, Peter Falk and Ben Gazzara. After the death of a mutual friend, the three men decide to spend a weekend in London to cleanse their souls. They gamble, party, pick up girls, and generally try to recapture their lost youth, and as they do so, they expose raw emotions and the deep sadness of their lives. Consistent with Cassavetes' style, the film is mostly improvised by three actors who completely trust each other and their director. The result is a film that contains no tricks and is pure cinema verité. The director continued to work in this style in *A Woman Under the Influence* (1974) with Peter Falk as a blue collar type struggling to come to terms with his wife's (Gena Rowlands) mental illness. Other more conventional films followed including *Gloria* (1980) in which Rowlands plays a woman doing battle with the mob. Cassavetes died of cirrhosis of the liver in Los Angeles in 1989.

JOHN WATERS

He was born in Baltimore in 1946. As a child Waters was very odd, obsessed with violence and gore. He fell in with a similarly obsessed group of friends with whom he began making super 8mm and 16mm movies in the sixties. As his movie

making skills began to grow, his films became more polished and much more shocking. In the early seventies, Waters' films were being shown at special midnight screenings at art houses around the city. Occasionally, police confiscated the film prints for indecency.

Waters made his breakthrough with *Pink Flamingos* (1972), a film that stars drag queen Divine as the leader of an eccentric clan including her hippie son, Crackers, and her 250-pound mother. They believe themselves to be "the filthiest people alive," until they meet up with Connie and Raymond Marble who sell heroin to children and impregnate hitchhikers so they can steal their babies and sell them to gay and lesbian couples. The competition is on with both teams doing disgusting things to the other while the tabloid press reports it all.

After *Pink Flamingos*, Waters began to enjoy a cult following of surprising proportions as did his star, Divine. His next film, *Female Trouble* (1974) continues the trashy plots full of trashy characters, in which many of the women are played by transvestites. Divine and another Waters regular, Mink Stole, play their parts with customary flair and energy. The films are not for everybody, but they do work as campy satire. After *Desperate Living* (1977) Waters made one of his most commercially successful films, *Polyester* (1981). Divine stars as Francine Fishpaw, an upper class suburban housewife from Baltimore, whose husband supports the family with his porno theater business. Unfortunately, this results in their house being constantly picketed, and Francine's world is falling apart. Her daughter is a tramp, her son is a pervert, and her husband is having an affair with his secretary. She turns to drink for comfort until she meets a handsome stranger, played by fifties heartthrob Tabb Hunter.

Waters biggest success came with *Hairspray* (1988) which would also be Divine's last film appearance. He died of sleep apnea just after the film was released. The film is the story of an overweight young girl who wants to win the local dance contest. Waters' films were becoming acceptable enough that he was able to supplement his usual cast of actors with performers like Sonny Bono, Ruth Brown, Debbie Harry, and Jerry Stiller. In 2002 *Hairspray* was adapted as a Broadway musical which was, in turn, adapted for motion pictures (Hairspray—2007).

THE NEW INDEPENDENTS

In the mid eighties a new group of filmmakers began to emerge. Often they used grant money to finance their projects. Some would merge their resources to create a bare bones budget. Others would max out their parents' and their own credit cards in the hope of making their investment back. The lucky ones were supported by a number of small distribution companies that were getting into business as much to assist promising new talent as to make money. The American film festival movement was born around this time, which provided a forum for movies made outside the system. As the festivals grew, they became marketplaces where money could be raised to finish and distribute independent cinema.

DAVID LYNCH

He broke into the movie business with his 1977 film *Eraserhead*. Lynch's next film, *The Elephant Man* (1980), was almost conventional by comparison. Comedy giant Mel Brooks was a big fan of *Eraserhead* and sought out Lynch, whom he refers to as Jimmy Stewart from Mars. Brooks' company, Brooksfilms, financed the director's next project. The film is the real-life story of Joseph Merrick (called John Merrick in the film), a man born in Victorian England with a horrible disfiguring disease that left his body twisted and misshapen and his face a monstrosity. But beneath the surface, Merrick is a sweet and civilized man who wants nothing more than to live a normal life. He is deprived of it by a man called Bytes who uses Merrick as a freak show attraction and beats him savagely when he resists. John Hurt plays Merrick and Anthony Hopkins plays Dr. Frederick Treves who manages to get Merrick away from Bytes so that he can live comfortably among nice people who treat him respectfully with dignity. Lynch uses his genius to show the beauty trapped inside Merrick's body. The film received eight Oscar nominations including Best Actor for Hurt and Best Director for Lynch.

The eccentric Italian film producer, Dino De Laurentiis, was the next person to play a role in the financing of Lynch's work. He had acquired the movie rights to the sprawling science fiction classic, *Dune*, and was convinced that Lynch was the perfect director to bring it to the screen. Lynch accepted the project with the provision that De Laurentiis would also finance his next project which was going to be a relatively low-budget film noir. The producer agreed. *Dune* (1984) was not a successful film. The story in the book is much too long and complicated to be adapted for the screen. Lynch's visual imagination is evident throughout the film that has its moments, but when the production company decided to re-edit the film, any chance of salvaging a decent movie was gone. Fans of the book were disappointed and as a stand-alone film, it is incomprehensible.

Two good things did come out of *Dune*: Lynch's next film, *Blue Velvet* (1986), and its star, Kyle MacLachlan. Set in the small rural town of Lumberton, the film is a Hitchcockian mystery that also deals with some of the darker aspects of human sexuality. Jeffrey Beaumont (MacLachlan) has come home from college to help at the family hardware store after his father's stroke. He discovers a severed ear in a vacant lot on the way to the hospital and takes it to Detective Williams at the police

De Laurentiis Ent. Gr./Photofest

Blue Velvet (1986). Directed by David Lynch. Shown (from left): Dennis Hopper, Isabella Rossellini.

department. Later he meets a nice girl, Sandy (Laura Dern), who also happens to be Detective William's daughter. The two begin to investigate the ear in the spirit of the Hardy Boys and Nancy Drew. The trail leads to the apartment of a local nightclub singer, Dorothy Vallens (Isabella Rossellini—daughter of Ingrid Bergman and Roberto Rossellini). When Jeffrey tries to investigate Vallens' apartment he almost gets caught and hides in the closet from which vantage-point he witnesses a violent ritualized rape of Dorothy by the demented Frank Booth (Dennis Hopper). The trail leads into darker, more violent places and Jeffrey becomes involved in matters that are way over his head. *Blue Velvet* is both stylistically and thematically bold and original. The film is like no other film made before it and few made since. It could have never been made inside a conventional studio environment but it may very well be the greatest motion picture of the eighties.

SPIKE LEE

Nee Shelton Jackson, Lee was born in Atlanta, Georgia in 1957. His mother was a school teacher and was dedicated to teaching her children about their African American heritage and introducing them to museums, plays, and other things cultural. His father, Bill, was a successful jazz musician. When he was young the family, consisting of Spike, two younger brothers, and a younger sister, moved to New York City. When time for college arrived, Lee chose to attend the all-black Morehouse College in Atlanta where his father and grandfather had attended. His major was mass communications. After Morehouse, he enrolled in the Tisch School of Arts graduate program in film at New York University (NYU). His thesis film, *Joe's Bed-Stuy Barbershop: We Cut Heads* (1983), won the Academy Award for Best Student Film. His father added a beautifully written jazz score to the film.

His next project was to be his first feature film. Armed with an $18,000 grant from The New York State Council on the Arts, he rounded up the group that had worked on *Joe's Bed-Stuy* and started production on *She's Gotta Have It* (1986). The film is the story of a girl who has three lovers who are very different from one another. One is overbearing and chauvinistic; another is a rich, vain male model; and the third, Mars Blackman, played by Spike Lee, is funny and immature. The three constantly lobby her to make a choice, but when she does, it does not seem right. Jones' friend from NYU, Ernest Dickerson, was cinematographer and his father wrote the music. On October 30, 1985 Lee screened his work-in-progress on 16mm film with the sound on a separate sprocketed magnetic tape soundtrack. In attendance at the showing were potential investors, friends, cast members, and a few critics. Even though the soundtrack was unfinished, the film was complete enough to make the audience laugh and have a good time of it in spite of technical problems. Several investors put up money to keep the project going. A few days later Island Films (a division of the very successful Island Records Company) president Chris Blackwell arranged for a morning screening on his way to Los Angeles from London. Island passed at first, but Lee was undaunted and took the film to the San

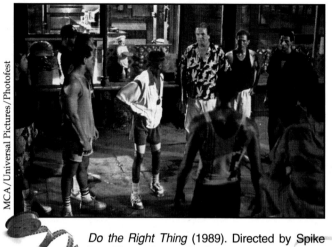

Do the Right Thing (1989). Directed by Spike Lee. Shown (from left): Spike Lee, Danny Aiello, Richard Edson, John Turturro.

Francisco Film Festival and on to Los Angeles. He was determined to take it to Cannes. Finally Island Films committed to a deal to distribute the film, including paying for any finishing costs, the cost of prints, and the deferrals that had been promised to the actors. *She's Gotta Have* was finally a bona fide feature film.

Lee's next film was a comedy, *School Daze* (1988), about a student at a black college trying to get into the most popular fraternity on campus. The cast includes newcomers such as Laurence Fishburne and Giancarlo Esposito. Lee uses the storyline to comment on issues such as colorism among African Americans and other common forms of snobbishness. It was controversial which helped sharpen Lee's image as a new and confrontational filmmaker. His next film, *Do the Right Thing* (1989), would solidify Lee's reputation as a filmmaker and as one who could deal with difficult subjects in a straightforward manner. By this point in his career, the director's own company, Forty Acres and a Mule Productions, was well enough established to attract its own financing, the mark of true independence. *Do The Right Thing* takes place on the hottest day of the summer in a one block in the Bedford-Stuyvesant neighborhood of Brooklyn. Lee plays Mookie who does deliveries for Sal's Pizzeria. Sal, played by Danny Aiello, and his two sons, Pino (John Turturro) and Vito, arrive in the morning from their suburban home and open for business. Cinematographer Ernest Dickerson beautifully captures the shimmering look of a hot day. Veteran actors Ruby Dee and Ossie Davis play the elders on the block and Bill Nunn is Radio Raheem, the young man who starts people's temperatures rising. The film ends in an explosion of violence as the people in the neighborhood lay waste to Sal's Pizzeria. Lee shows every step along the way from the peaceful morning to a riot and it is all understandable. In its time *Do The Right Thing* was the best film ever about racism. Aiello was nominated for a Best Supporting Oscar and Lee was nominated for Best Screenplay.

JIM JARMUSCH

Jarmusch was born near Akron Ohio in 1953. His father was a manager at the B.F. Goodrich tire company and his mother wrote about film and theater for the Akron

newspaper. In 1972 Jarmusch enrolled in the Journalism School at Northwestern University in Chicago. He decided against journalism and transferred to Columbia University in New York to become a poet. During his senior year Jarmusch studied abroad in Paris where he discovered cinema by reading in the archives of the Cinémathèque Française. He was inspired to apply for graduate studies at NYU and was accepted. He spent four years at the school, during which time he joined a band called the Del-Byzanteens. Meanwhile he worked on his thesis film, *Permanent Vacation,* the story of a young man who completely lacks ambition and spends his time wandering the streets of New York where he meets a collection of eccentric characters. As student films go, it is not bad. But Jarmusch needed to tackle something more challenging. In 1981 he began writing a script for a short film he called *Stranger Than Paradise*. With 40 minutes of film stock donated to him by Wim Wenders' company, Jarmusch shot his film over a single weekend. As he set about editing the short film, he realized that it could be the first act for a feature length movie. When the short was finished he entered it in the 1983 Rotterdam Film Festival where it won the critics' prize. With these credentials the young director traveled around Europe seeking financial backing for the feature version of the film. An aspiring German producer, Otto Grokenberger, was able to put together $120,000 with which Jarmusch was able to fashion a 90-minute film. He submitted it to the 1984 Cannes Film Festival where it won the Caméra d'Or award for best first feature film. The film deals with another slacker character, his Hungarian cousin, and a girl they hang out with. The first act is set in New York City. In the second act the two cousins go to Cleveland to visit the girl. In the third act they go to Florida for some fun, which they do not have. Nothing much happens in the film but the film's attitude and the characters' realism make the whole thing work.

Jarmusch's next film was *Down by Law* (1986). It stars singer-songwriter Tom Waits, Jarmusch regular John Lurie, Roberto Benigni and Ellen Barkin. It is the story of three men sharing a cell in a Louisiana prison. Benigni's character is the source of comedy with his broken English. He also just happens to know of an escape route. As they begin their journey away from prison the three men begin to develop similar personality traits and form a deep friendship as they do. Again, not a lot happens in the film but Jarmusch is so good at showing the audience small things about his characters that his films cease to feel slow and begin to feel rich and deep instead. With *Mystery Train* (1989) the director returns to the idea of structuring his film around three intertwined stories. One involves a Japanese Elvis fan who has brought his girlfriend to Memphis to see where it all began for his hero. The seedy hotel they stay in provides the connective tissue for the film. Another story involves two women forced by circumstances to share a room. As it proceeds it becomes a ghost story. The third chapter involves Joe Strummer of Clash fame and Steve Buscemi who play two of three guys who are so drunk, the only thing they can do is get a room. Once inside it all goes very wrong. The three stories of the film are individually excellent and the whole work has a beautiful moodiness to it.

ERROL MORRIS

Born in Hewlett, New York in 1948, he was two when his father died of a heart attack, forcing his mother to support her family as a music teacher. At age ten Morris was sent to a boarding school in Vermont where he studied music intensively. He received his bachelor's degree in history from the University of Wisconsin in 1969 and drifted through graduate studies at Princeton and Berkeley before returning to Wisconsin. In 1975 he conducted an extensive series of interviews with serial killer Ed Gein at the Mendota State Hospital in Madison, Wisconsin. During this time he was collaborating with the German filmmaker Werner Herzog. Nothing came of their project but Herzog gave Morris enough cash to start another project.

Morris decided to visit Vernon, Florida, a city famous for a particularly gruesome form of insurance fraud in which people would willingly amputate a limb to collect the insurance money. Vernon was also known as "nub city." After completing his research he returned to Berkeley to write about it. While there, he read a story in the newspaper about a pet cemetery in Napa. He went to investigate and the result was his first documentary, *Gates of Heaven* (1978). The documentary is the story of two different pet cemeteries. One is a very reputable family business in which the sons struggle with the issue of following in their father's footsteps. The other involves a man who built a cemetery on land he did not own which led to all of the pets in his cemetery being disinterred and buried elsewhere. When the film had its premiere, Werner Herzog very publicly cooked and ate his shoe making good on a bet he had made before Morris began his film. The event became a documentary film by Les Blank.

Morris' next film was *Vernon, Florida* (1981) which deals more with the odd people he met while doing his research years earlier rather than the insurance scam. The film is a celebration of human oddness and stands up as one of his best works. Morris' next project is his most celebrated. *The Thin Blue Line* (1988) was made with money from a grant from PBS to make a different film. In the years before he made *The Thin Blue Line*, Morris had supported himself as a private detective investigating Wall Street fraud. When he discovered the story of Randall Adams, a Texas man who might have been wrongfully accused of murdering a police officer, he decided to turn his investigative skills on the matter. As he dug in, Morris

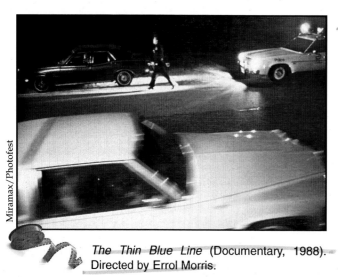

Miramax/Photofest

The Thin Blue Line (Documentary, 1988). Directed by Errol Morris.

discovered that, in all likelihood, the murder was committed by a hitchhiker Adams had picked up the night of the murder. Very methodically he began to interview all of the police and lawyers and convicts that had been involved in the incident. With the use of beautifully designed reenactments and extremely well-edited interviews, the film tells the story of how Adams was railroaded to death row. Adams won a retrial as a result of Morris' film. Spike Lee was once asked if films like his changed history. He responded "I know one film that changed a man's history. *The Thin Blue Line.*"

Michael Moore

Moore was born in Flint, Michigan in 1954. He was sent to Catholic schools including a year in the seminary. He was an Eagle Scout and at age eighteen, he was elected to the Flint school board. He attended the University of Michigan where he studied journalism but dropped out to start up the alternative newspaper, *The Flint Voice*, and became an occasional commentator on National Public Radio. In 1986 he was hired as editor in chief of the liberal *Mother Jones* magazine. It was a bad fit and he was fired after a few months. He won a $58,000 settlement for wrongful termination and used the money to make his first film, *Roger and Me* (1989). The film is more of a polemic than an investigation. In it Moore makes the argument that General Motors' decision to close its auto assembly plant in Flint effectively killed the town when 30,000 jobs were lost. In the film he tries to get a meeting with Roger Smith, the CEO of General Motors, to ask why the plant was closed. Along the way Moore interviews several of Flint's more colorful characters. Moore's sense of humor combined with his sharp attacks on GM make the film entertaining and a little educational.

John Sayles

Born in Schenectady, New York in 1950, Sayles was a bright child and began to read adult fiction by the age of nine. He graduated from Williams College in 1972 and spent a few years knocking around from one blue collar job to the next. During this time he constantly wrote short stories and submitted them to magazines for publication. His first novel, *Pride of the Bimbos*, was published in 1975. His second, *Union Dues*, arrived in 1977, and an anthology of his short stories was published in 1979. Unfortunately his literary output was not making him enough money to survive. During this time Sayles had taken a job writing for Roger Corman, a pursuit that paid much better than publishing. With the knowledge he gained working with Corman and $40,000 he had saved, Sayles made his first feature, *The Return of the Secaucus 7* (1980). It is the story of seven college friends who have a reunion in a New Hampshire summer house. The title comes from the fact that they had all been arrested at a demonstration in Washington DC. Although it is ten years since they have seen each other, people's problems have not changed much. What is different is that they are all on the cusp of becoming their adult selves and one can see how they will probably

end up. Cinematically the film is just okay. But it is obvious that Sayles has what it takes to become an excellent storyteller.

In 1983 Sayles released two films, *Lianna*, the story of a happily married woman who discovers that she is a lesbian after having an affair with a college professor. She has to make some adjustments in her life afterward. *Baby It's You* stars Rosanna Arquette and Vincent Spano. Set in New Jersey in 1966, she is a bored high school girl who becomes attracted to a new student who is known as "The Sheik." She goes off to college and he goes to Florida to work as a Sinatra impersonator. The class differences between the two prove to be insurmountable. That year Sayles was awarded a MacArthur Foundation "genius grant" which provided $32,000 tax free for five years, leading to his next film, *The Brother From Another Planet* (1984), the story of a mute African American man from outer space who wanders the streets of Harlem experiencing the human condition, particularly in the black community. Sayles followed this with *Matewan* (1987) the story of coal miners struggling to start a union in the 1920s. They are met with every kind of thug and dirty trick from the mining company that wants to keep them down. Chris Cooper, James Earl Jones, Mary McDonnell, and David Strathairn star. Sayles' last film of the eighties is his best, *Eight Men Out* (1989), the true story of how the Chicago White Sox threw the 1919 baseball World Series. The amazing cast includes John Cusack, Christopher Lloyd, John Mahoney, Charlie Sheen, and David Strathairn. The film is a true account of the events that led to the darkest hour in baseball history as well as a beautifully acted ensemble piece.

MOVIES AND THE REAGAN ERA

No one expected to ever again see or hear much of Ronald Reagan after he betrayed so many of his fellow Screen Actors Guild members before the House Un-American Activities Committee by branding them communists. When he traded his acting career for a job as corporate spokesperson for the General Electric Company, it appeared that he had dropped out of the public spotlight forever. But GE had other plans for him. Soon he was hosting the *General Electric Theater* on television and playing the heroic westerner in occasional episodes. He was making public appearances to speak out on political issues with a muscular pro-capitalist conservatism. He was the perfect company man, the antithesis of the long-haired anarchists who were disrupting American society. When he ran for governor of California in 1966, many experts dismissed him, but his script was a pitch-perfect demand that America return to its old virtues of patriotism and family. By the time he became president in 1981, he had successfully convinced the country that the America that had lost the Viet Nam war was in the past. His new America was the world's last great hope, bristling with a mighty arsenal, ready to take down the godless communists and restore order in the world. It was "morning in America," a message people wanted to believe, and Hollywood did not waste any time repeating it.

President Reagan loved to use the language of movies to make his point. When he described the Soviet Union as "an evil empire," he was borrowing language right out of the *Star Wars* trilogy. In fact, when the pentagon began to make plans for an anti-missile defense system, the name Star Wars just sort of attached itself to the program. *The Right Stuff* (1983) was the perfect Reagan-era movie. It tells the story of the first astronauts. They were the best, the brightest, and the bravest the American military had to offer. Every mission entailed squeezing into a capsule attached to the top of a huge bomb and waiting for the bomb to ignite. These men became national heroes and were symbolic of the belief that America had the "right stuff." The film's other storyline deals with test pilot Chuck Yeager, who was flying airplanes to the edge of space and back to the sagebrush of the Mojave Desert. The astronauts drove fast cars. Yeager rode a horse. They all had one thing in common; they were all brave beyond sensibility. By contrast, *The Big Chill* (1983) shows what became of those anti-war hippie protesters. They became yuppies, suburban professionals in pursuit of material happiness. They were nostalgic for their time in the protest movement but they did not seem affected by it. In fact, they appear to be more moved by the music of their youth than by the events. If *The Right Stuff* is a confirmation of American core values, *The Big Chill* is a repudiation of the sixties.

MOVIES THAT REFLECT REAGANISM

Hollywood was almost schizophrenic during the eighties. There was a constant stream of films that supported the idea of a militaristic America, ready to save the world. There were just as many films that outwardly criticize that bellicose ideology and others that satirize it.

Rambo is an example of both ideologies. Sylvester Stallone did not rest on his laurels from the *Rocky* films in the eighties. He created the ultimate anti-war war monger character in John Rambo. *First Blood* (1982) introduces Viet Nam war veteran John Rambo as a man who is clearly struggling with post-traumatic stress disorder. When he shows up in a small town in the Pacific Northwest, the local sheriff senses that he is a dangerous character and throws him in jail where the deputies torment him. Rambo has flashbacks to his time as a prisoner of war and breaks out of jail leaving a trail of destruction behind as he disappears into the forest where his Green Beret survival skills make him dangerous prey. Eventually the military learns what has happened and Rambo's former commander is sent to get him. The film ends with Rambo unloading his emotions about the war as he is taken to prison.

The first *Rambo* is a pretty clear cut anti-war film. But over the years, the warrior side of his personality becomes dominant. In *Rambo: First Blood Part II* (1985) Rambo is let out of prison by his commander, Colonel Trautman, to help rescue American soldiers who are stranded in Viet Nam as prisoners of war and missing in action. Rambo finds what he is looking for but it is a double cross and the Americans leave him in the jungle. Rambo decides to take it out on the Vietnamese and Russians before settling into life in Viet Nam. In *Rambo III* (1988) Colonel Trautman convinces Rambo to

join him on a mission to Afghanistan where American troops are under assault by Russian forces. Rambo manages to defeat the entire Russian Army, thereby completing his transformation from anti-war hippie to full-blooded American hero. Stallone has made two other sequels to the *Rambo* series.

Top Gun (1986) is the perfect Reagan-era film. It is a mash-up of *Flash Dance* and *The Right Stuff*. Tom Cruise stars as Maverick, a hot shot Navy pilot, in this Simpson-Bruckheimer production. He is attending the Top Gun Naval Flying School in San Diego. We learn that his father had been killed in fighter combat and that others died because of his mistake. Val Kilmer plays Ice Man, Maverick's main competition at the school. The film contains lots of exciting aerial action edited to the tune of a pounding rock score that includes the hit song, "Danger Zone." In the third act Maverick and Ice Man team up to do battle with Russian MIGs.

Red Dawn (1984) is a John Milius production about the day the Russians and Cubans invaded America. Set in a small town in the Rocky Mountains, the action begins when a group of high school students witness a mass landing of paratroopers outside their classroom window. Patrick Swayze is Jed, a natural leader and football star. He leads the other kids, including Robert (C. Thomas Howell), Erica (Leah Thompson) and Matt (Charlie Sheen), into the mountains where they fight an insurgency. They have to grow up fast as they attempt to get to an American "Safe Zone." This film very successfully paints the cold war as a hot one, supporting Reagan's notion of the "evil empire."

MOVIES THAT CONTRADICT REAGANISM

Hollywood in the post Viet Nam era was much more politically liberal than the rest of the country. There was no shortage of filmmaking that criticized the values of Reaganism. Anti-military films, anti-capitalist films, and pro-feminist films all defied the values of a strong military, unbridled corporatism, and family values that hold that "a woman's place is in the home." Oliver Stone during this period became a one man anti-Reagan campaign.

Salvador and *Platoon* are two movies made in 1986 by Stone that belied Reaganism. *Salvador* stars James Woods as the real-life Richard Boyle, an unconventional freelance journalist in need of a good story. He enlists the help of his sidekick, Doctor Rock (James Belushi) to go to El Salvador to investigate the U.S.-backed right wing dictatorship that has just assassinated religious leader Archbishop Oscar Romero. When they arrive in-country they meet a crazy photojournalist, John Cassady (John Savage). The story they find is more than they bargained for. Death squads, backed by the Reagan-supported military regime, wipe out anyone who dares to speak out, including American members of the press. Along the way Boyle falls in love with the beautiful Maria (Elpidia Carrillo). Woods was nominated for a Best Actor Oscar and Stone and Boyle were nominated for Best Screenplay.

Platoon begins with an amazing cast, including Charlie Sheen as Chris, Willem Dafoe as Sgt. Elias, Tom Berenger as Sgt. Barnes, Johnny Depp as Lerner, Kevin Dillon as Bunny, and Forest Whitaker as Big Harold. Chris is a young patriot who quits college and enlists for Viet Nam. When he arrives at the front, he learns that the combat veterans do not even attempt to learn the new guys' names because they will soon be dead. The two sergeants who lead the platoon are at war with each other. Barnes is amoral. He does not object to the senseless killing of non-combatants because they might really be the enemy or help the enemy. Elias believes in the rules of war and fights to hold on to his morality. The men in the platoon are divided between their two leaders but Chris refuses to choose which makes him suspect to everyone. Stone was a Viet Nam veteran himself. He portrays war as a waste of humanity, not as a noble mission. Stone won the Oscar for Best Director; the film won Best Picture and two other Oscars. It was nominated for four others.

Wall Street (1987) is Stone's critique of capitalism. Charlie Sheen stars as Bud Fox, a young stockbroker trying to make it in an ultra-competitive world. Martin Sheen is Carl Fox, Bud's father, who is a union officer working for the Bluestar Airline Company. Michael Douglas is Gordon Gekko, a bloodthirsty stock trader who feeds off the remains of the companies he destroys. Bud visits Gekko's office every day trying to get a minute of face time with the best in the business. He finally succeeds and gives Gekko a stock tip that makes a lot of money. Bud is rewarded with a million dollar account to trade for his new customer and mentor. Gekko teaches Bud how to dress, drink, and think. "Greed is good" is one of his core beliefs. Eventually Bud learns some inside information about Bluestar Airlines that he passes to Gekko, which is against the law. Bud gets caught but manages to stop Gekko from destroying Bluestar. At a time when the Reagan Administration was deregulating corporations at a furious pace, *Wall Street* provides an unflattering view of the men who occupy the penthouse office suites. Michael Douglas won the Oscar for Best Actor.

Born on the Fourth of July (1989) is Stone's critique of how America treated its Viet Nam veterans. Tom Cruise plays the real-life Ron Kovic, a veteran whose wounds have left him a paraplegic. The military hospital where he is sent to recover is totally inadequate. When he returns home, people shy away from him. His girlfriend has not waited for him and, if she had, he is incapable of having children. He spends his time drinking and feeling sorry for himself. He decides to turn his life around and attends the 1972 Republican Presidential Convention to remind people about the true cost of war. This leads to his new life as a veterans' rights activist. Tom Cruise's truly moving performance is one of the best of his career. Stone won the Oscar for Best Director.

Nine to Five (1980) and *Working Girl* (1988) are examples of movies that argue on behalf of women's rights in the workplace. *Nine to Five* is a comedy with a message. It stars Jane Fonda as Judy, Lily Tomlin as Violet, and Dolly Parton as Doralee. Dabney Coleman plays their abusive boss, Franklin Hart. The three women work in

the executive offices of the Consolidated Corporation. Violet is the office manager, Judy is just going back to work after her husband has left her for his secretary, and Doralee is Hart's private secretary. His egotism, lying, thoughtlessness, and male chauvinism drives the three women to the breaking point. They kidnap Hart and imprison him in his home. They do his job as a cover-up. Eventually the president of the company discovers what is going on. He is not exactly mad, because the three women have made some very productive changes in the business. Hart is sent to Brazil on special assignment and Violet gets his job. Judy marries the Xerox repairman and Doralee becomes a country western singer.

Working Girl was directed by Mike Nichols. Melanie Griffith plays Tess, a hard working secretary who reports to Katharine, played by Sigourney Weaver. Harrison Ford plays Jack Trainer, an investment broker. Katharine has a nasty habit of taking Tess' good ideas and passing them off as her own. When Katharine breaks her leg in a skiing accident, Tess takes the opportunity to team up with Jack and work on one of her ideas. She proves she has what it takes to get ahead in business without having a fancy MBA and gets her man in the bargain. The film received six Oscar nominations.

HIGH SCHOOL MOVIES

High school movies had become a popular new genre since the fifties. The eighties were an especially good decade for them. The high school movie has historically given large casts of talented young actors an opportunity to be showcased. A lot of careers began in the genre. They are inexpensive to produce because a rented high school provides most of the needed locations and young actors work cheaply. Music is another important element of the high school movie which creates an opportunity to include a band in the picture.

Fast Times at Ridgemont High (1982). Directed by Amy Heckerling. Shown: Sean Penn, Ray Walston.

Fast Times at Ridgemont High (1982) is a truly seminal film in that many of the cast members went on to have significant careers. Sean Penn, Jennifer Jason Lee, Judge Reinhold, Phoebe Cates, Forest Whitaker, Eric Stoltz, Nicolas Cage, and Anthony Edwards all count the film as a starting point. *Fast Times* was directed by Amy Heckerling, one of the few women directors at the time. The film perfectly captures the intersection of mall

culture, the high school experience, and stoner culture. The soundtrack features music by The Go-Gos, Jackson Browne, Oingo Boingo, Jimmy Buffett, and Sammy Hagar among others.

Risky Business (1983) stars Tom Cruise as Joel, a typical teenager until his parents leave for a week's vacation. He promises to be good, but before his parents have reached their hotel, he and his friends are planning a party. One of the attractions is Lana, a beautiful prostitute played by Rebecca De Mornay. When dad's Porsche ends up at the bottom of Lake Michigan, Joel needs money fast. He makes a deal with Lana to turn the house into a party house where her friends can do business while he gets a share of the proceeds. It is a race to put everything back together before his parents return. The soundtrack includes music by The Police, Bob Seger, Bruce Springsteen, Talking Heads, and Prince.

Sixteen Candles (1984) was written and directed by John Hughes. It stars Molly Ringwald as a girl whose 16th birthday goes all wrong. The boy she likes does not notice her. Her grandparents are a big embarrassment. Her sister is getting married and the family has forgotten it is her birthday. The cast includes Anthony Michael Hall and Joan Cusack and her brother John. The soundtrack includes AC/DC, Spandau Ballet, Oingo Boingo, Billy Idol, and Patti Smith.

The Breakfast Club (1985) is another film written and directed by John Hughes and starring Molly Ringwald. The story takes place on a Saturday during detention in the high school library. The detainees include Emilio Estevez, Anthony Michael Hall, Judd Nelson, and Ally Sheedy. The crew contains all of the high school archetypes such as the jock, the nerd, the gangster, the goth and the soch. As the day drags on, they discover that they all have more in common than they thought as new friendships are born. The soundtrack includes music by Simple Minds, Elizabeth Daily, and Wang Chung.

Ferris Bueller's Day Off (1986) is yet another John Hughes movie. This time Matthew Broderick stars as the title character. Ferris decides to take a day off from school. It is his senior year and he needs a little break. He talks his girlfriend, Sloane, and his buddy, Cameron, into joining him on a trip to see the sights of Chicago. The principal, Mr. Rooney, is convinced that the three are up to something and decides to catch them. They see such sights as Wrigley Field, the Sears Tower, and the Art Institute of Chicago and participate in the Von Steuben Day Parade. The cast includes Mia Sara as Sloane, Alan Ruck as Cameron, Jeffrey Jones as the principal, and Jennifer Grey as Bueller's sister. The soundtrack has almost no memorable music except the song "Bad" performed by Big Audio Dynamite.

OTHER IMPORTANT FILMS OF THE EIGHTIES

Reds (1981) was written and directed by Warren Beatty. It chronicles the life of the American journalist and founder of the American Communist Party, John Reed, played by Beatty. He went to Russia to report on the Russian Revolution in 1919 and became part of it instead. Diane Keaton is Reed's lover Louise Bryant, and Jack

Nicholson is Reed's close friend, Eugene O'Neill. The movie begins in 1915 with Reed organizing his group of radicals while Bryant returns to America. The only American buried in the Kremlin, Reed became increasingly disillusioned by the violence of the revolution but believed in it as a cause throughout his life. Beatty won the Best Director Oscar and Maureen Stapleton won Best Supporting Actress playing Emma Goldman.

Blade Runner (1982) is based on a story by Philip K. Dick, "Do Androids Dream of Electric Sheep?" Ridley Scott directed this great science fiction Film Noir. Harrison Ford plays Deckard, a Blade Runner, which is a member of the police force that specializes in eliminating escaped replicants. Replicants are organic humanoids who have been designed to withstand the rigors of working in outer space mining colonies. Four of them have escaped and returned to Earth to find their creator, Tyrell, in the hopes that he can reverse their built-in life span of four years. Tyrell has a beautiful replicant, Rachel, living with him. As Deckard tracks down the escapees, he begins to fall for Rachel. This stirs his own doubts about being a replicant himself. Scott originally wanted to leave the question of Deckard's humanity ambiguous, but Warner Brothers executives objected and put a happy ending on the film. It has been returned to the director's vision in DVD releases.

Diner (1982) is a seminal buddy picture. Its cast includes an incredible grouping of new talent, including Steve Guttenberg as Eddie, Daniel Stern as Schrevie, Mickey Rourke as Boogie, Kevin Bacon as Timothy Fenwick, Paul Reiser as Modell, and Ellen Barkin as Beth. The film is set in 1959 in Baltimore. A group of twenty-something boys hang out at a local diner where they act as sort of a support group to help each other avoid growing up. One by one they decide to come of age and shoulder the responsibilities of adulthood.

Amadeus (1984) is director Milos Forman's adaptation of Peter Schaffer's very successful play. Tom Hulce stars as the musical genius, Wolfgang Amadeus Mozart. F. Murray Abraham plays Antonio Salieri, who was also a composer. Salieri is haunted by envy. Mozart is a drunkard who likes to spend his days playing pool. Occasionally he dashes off a brilliant opera or concerto when he needs the money. Otherwise Mozart seems to have no respect for his own talent. Salieri, on the other hand, struggles to create music that pales in comparison to Mozart's. He blames God for the cruel joke and it drives him crazy. The film swept the Oscars including Best Actor for Abraham, Best Director for Forman, Best Picture for Producer Saul Zaentz, and Best Screenplay for Shaffer.

The Last Temptation of Christ (1988) is based on a book of the same name by Nikos Kazantzakis. Willem Dafoe plays Christ. The story of the carpenter from Nazareth begins in its usual fashion until it reaches the crucifixion at which point an angel stops Jesus' death and nurses him back to health. He enjoys life well into old age when he is confronted by Judas who tells Jesus that the angel was, in fact, a manifestation of Satan, and he has been duped. Jesus prays for the crucifixion to continue to death. Director Martin Scorsese embraces this opportunity to infuse this alternative passion play with his visual mastery. The style is breathtaking with

an amazing color palate, long tracking shots, surprising points of view, and great editing. It is as good as the director's best work. Unfortunately, fundamentalist church groups attempted to have the film censored and generally made it difficult for theaters to book it. Harvey Keitel is brilliant as Judas as is Barbara Hershey as Mary Magdalene.

Rain Man (1988) Barry Levinson directs Tom Cruise and Dustin Hoffman in film history's most improbable buddy picture. Cruise is Charlie Babbitt, a self-centered car dealer and hustler living in Los Angeles who gets word his father has died. At the reading of the will, Charlie learns that all his father left him was his vintage 1948 Buick convertible. He also learns he has a brother, Raymond (Dustin Hoffman) who is autistic and has been institutionalized his whole life. Charlie decides to kidnap Raymond in hope of getting a ransom. Charlie, his girlfriend Susanna, and Raymond head back to California in the car. At first Charlie is exasperated by his brother's odd behavior. But a bond begins to grow between them and Charlie starts to become a human being. Raymond is a savant and when Charlie discovers his gift for numbers, Las Vegas becomes an inevitability. The movie won four Oscars including Best Actor for Hoffman, Best Director for Levinson, Best Picture, and Best Screenplay. Cruise's performance is also deserving of an award.

1. <u>Luc Besson</u> make La Femme Nikita.

2. <u>Costa Garvas</u> known for make political thriller such as Z and State of Srege.

3. <u>Neil Jordan</u> directed the Crying Game.

4. <u>Stephen Frears</u> made the film High Fidelity.

5. <u>Werner Herzog</u> direct Aguirre, the Wrath of God

6. <u>Raise the Red Lantern</u> example of 5th generation Chinese film

7. Bollywood - nickname given to Indian filmmaking capital Mumbai

8. Stephen Frears worked for Karel Reisz (British filmmaker) at beginning of his career.

9. Lina Wertmuller is most associated with post. Fellini in Italian Cinema.

Contemporary World Cinema

7

DAS NEUE KINO (THE NEW FILM)

Following World War II, the German motion picture industry was moribund. A great deal of the production infrastructure had been almost completely destroyed in the last year of the war. Major cities like Berlin and Dresden ceased to exist after months of constant aerial bombardment. The country had been partitioned with the Soviets in control of the eastern half and the Americans in control of the west. The few films that were made were irrelevant. The country was necessarily focused on rebuilding and establishing a functioning economy. Partially the result of the Americanization of West Germany, the television industry was establishedbefore the movie industry was rebuilt. There was also a generational issue. Like every other country involved in the war, Germany experienced a baby boom in the post-war years. This new generation was at odds with its parents, both culturally and politically. The holocaust was a central issue in the generational split. The youth resented carrying the guilt for its horrors and the older generation wanted to atone by proving to the world how quickly the country could recover. Meanwhile, the movies that played in West German theaters tended to be American while German culture was primarily expressed through television.

The Oberhausen Film Festival of 1962 is the point of origin for the new German cinema. The gathering was dominated by young filmmakers and film goers who were completely dissatisfied with the status quo of German cinema. A manifesto was developed at the festival to express the need for a new cinema.

> *"The collapse of conventional German film finally removes the economic basis for a mode of filmmaking whose attitude and practice we reject. With it the new film has a chance to come to life.*
>
> *German short films by young authors, directors and producers have in recent years received a large number of prizes at international festivals and gained the recognition of international critics. These works and these successes show that the future of German film lies in the hands of those who have proven they speak a new film language.*

Just as in other countries, the short film has become in Germany a school and experimental basis for the feature film.

We declare our intention to create the new German feature film.

This new film needs new freedoms. Freedom from the conventions of the established industry. Freedom from the outside influence of commercial partners. Freedom from the control of special interest groups.

We have concrete intellectual, formal and economic conceptions about the production of the new German film. We are as a collective prepared to take economic risks.

The old film is dead. We believe in the new one."

Oberhausen, February 28, 1962

Armed with the manifesto, young filmmakers lobbied the German parliament for financial support. Their efforts were successful and the Young German Film Board was established. The government also agreed to establish two film schools: one in Berlin and one in Munich, as well as an archive in Berlin. Between 1965 and 1968, the Film Board supported the work of dozens of new filmmakers but the financing was an insufficient foundation upon which to build a new film industry. A private company emerged to address the problem of consistent financing. Author's Film-Publishing Group was financed with television subsidies and taxes and took on the role of financing and distributing new German films. At this point the three filmmakers who exemplify Das Neue Kino emerged: Werner Herzog, Rainer Werner Fassbinder, and Wim Wenders.

WERNER HERZOG

Herzog was born in Munich in 1942. Because it was wartime, the family sent him to live in Sachrang, a remote mountain village in Bavaria. The place was so rural that Herzog was 11 when he saw his first film. He began to travel the countryside on foot at age 14 and around that time he decided to become a filmmaker and began writing screenplays. When there were no takers for his scripts, Herzog decided to produce his own films. He was 19 when he directed his first short, *Herakles* (1962) which consisted of editing together footage of body builders with footage of a notorious accident at the Le Mans road race. He described the film as an exploration of the character of a "strong man." His next short was *Game in the Sand* (1964) which was never shown. At this point Herzog left Germany and traveled through Europe and North America for several years, returning to Munich in 1968.

In Munich, Herzog met Fassbinder and other aspiring filmmakers who inspired him to make his first feature film, *Signs of Life* (1968), the story of a young German soldier who is part of the German occupation of Greece. He is assigned to guard an ammunition dump where he goes insane defending against a non-existent enemy. The film was shown at the 1968 Oberhausen Film Festival and resulted in Herzog becoming known in the German film community. The following year he traveled to Africa to make a documentary about European doctors who treat eye disease

among the poor, *The Flying Doctors of East Africa* (1969). On the same trip he made *Fata Morgana*, a surreal documentary that attempts to document the "embarrassed landscapes of our world." His third African film, *Even Dwarfs Started Small* (1970) is a dark comedy about inmates who take over an insane asylum.

In 1972 Herzog united with the eccentric German actor, Klaus Kinski, to make *Aguirre, the Wrath of God*. Kinski plays a Spanish conquistador in the Amazon River valley. Aguirre hates his Spanish masters for what he is forced to do and he

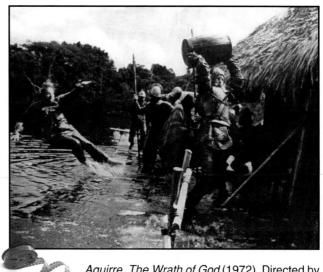

Aguirre, The Wrath of God (1972). Directed by Werner Herzog. Shown: Klaus Kinski.

despises nature for the trials it presents to him. Slowly he descends into madness. The film is considered Herzog's first allegory about Nazism and the holocaust. After *Aguirre*, Herzog began to feel uncomfortable about the poor distribution his films were receiving. He made a deal with Twentieth Century Fox to distribute his films in America and elsewhere outside of Germany, thus becoming an internationally known and respected filmmaker. His next film was a documentary, *The Great Ecstasy of the Woodcarver Steiner* (1973), showing the great ski-jumper's great flights and crashes. This was followed by his most critically successful film to date, *The Enigma of Kaspar Hauser* (1974). It is the story of a young man who is imprisoned for the first 16 years of his life. He has no language and must learn to navigate society upon his release but he sees the world through a fresh pair of eyes.

In 1979 Herzog took on the most daunting task of his career, a remake of the great F. W. Murnau's vampire classic, *Nosferatu* (1922). Based on Bram Stoker's 1877 book, *Dracula*, it is the story an undead humanoid that lives off the blood of others. Klaus Kinski plays the vampire as an existential hero. He is the eternal outsider, a symbol of the terrors of nature. 1982 is generally considered the year that Das Neue Kino died when Fassbinder, himself, died of a drug overdose. Herzog's last new cinema film, *Fitzcarraldo*, was made that year. Kinski stars as the title character who is a nineteenth century European who decides to bring culture to the indigenous people of the Amazon Forest in the form of a showboat in which he will stage operas. In order to get the boat to its destination, he must enslave the very people he is trying to help so that the boat can literally be carried up a mountainside. Again the film serves as an allegory for the holocaust in that the hero is doing a really bad thing for what he thinks is a good reason.

RAINER WERNER FASSBINDER

Born in 1945 in Bad Wörishofen, Bavaria, his father was a doctor and his mother was a translator so the family was financially comfortable. When his mother was busy with her work, she would send him to the movies which became a lifelong obsession. Fassbinder came out as a gay man at age 15, a very brave act in Germany where homosexuals had been sent to the gas chambers along with the Jews and Gypsies. At this time he quit school, got a job, and studied theater at the Anti-Theater in Munich. During his theater period, Fassbinder learned all phases of stage craft including art direction, theater management, and directing actors. In his film career he would often perform the functions of the art director, composer, producer, and director, as well as acting.

Fassbinder's first films were an extension of his theater work. *Love is Colder Than Death* (1969) is his first feature. It shows the strong influence of Godard on his work. This was followed by a few more movies that could have been filmed stage plays. In 1970 he began to break out of the stage paradigm with *Beware of a Holy Whore* and *The American Soldier*. Fassbinder's work became much more cinematic when he organized a retrospective of the work of Douglas Sirk, a German-American director who made popular melodramas in Hollywood in the fifties. What influenced Fassbinder was Sirk's use of Hollywood style to make films that were subtle critiques of American society and values. *The Bitter Tears of Petra Von Kant* (1974) is a good example of the director's exploration of the melodrama. It is the story of woman who wallows in her grief after she is rejected by a young married woman she fell in love with while mistreating her own lover.

The third phase of Fassbinder's career began in 1976 with *Satan's Brew* and *Chinese Roulette,* films that explore the cruelty of group behavior and the emptiness of marriage. In spite of the fact he was openly gay, Fassbinder married twice, which might have contributed to his dismal view of matrimony. In 1978 he began work on his trilogy dealing with the history of the German Republic. The work consists of *The Marriage of Maria Braun* (1978), *Lola* (1981), and *Veronika Voss* (1982). The three films deal with women in the aftermath of World War II. The first is about a wife looking for her missing husband. The second is a study of a cabaret performer caught between two powerful men, and the third deals with a Nazi film star whose career has ended. Fassbinder's greatest work was a 15-episode television series titled *Berlin Alexanderplatz* (1980). The work is based on a novel by Alfred Döblin and is set in the red light district of Berlin before the Nazis. It follows the lead character, Franz Biberkopf, as he navigates the despair of the time and place. In the late seventies Fassbinder began to drink and consume cocaine in dangerous proportions until his death in 1982.

WIM WENDERS

Wenders was born in Düsseldorf, Germany in 1945. He is considered the most American of the Neue Kino directors. As a teenager he was obsessed with American

pop culture, British rock, and pinball machines. His father was a doctor who encouraged his son to study medicine. Wenders did for a couple of semesters but dropped out and spent a few years at different colleges before deciding he wanted to be a painter. He spent a year in Paris attempting to get into an art and film school with no success except for the time he spent watching movies at the Henri Langlois Cinémathèque where he saw over a thousand films. Wenders returned to Düsseldorf where he did an internship with United Artists while waiting for his acceptance to film school. Finally, he enrolled at the new Hochschule für Film und Fernsehen in Munich. Two of his early short films, *Locations* and *Silver City*, were extensions of his painting. They are static, almost still life studies of Munich. Wenders graduated in 1970 with the completion of his thesis film and first feature, *Summer in the City*, the story of a man dealing with life on the outside after his release from prison.

In 1972 the WDR Company offered Wenders the opportunity to film Peter Handke's screenplay, *The Goalkeeper's Fear of the Penalty*, the story of a goal keeper who has been ejected from a game and begins to wander through Vienna where he meets a woman and strangles her. He continues drifting until he reaches a village on the Yugoslavian border and gets in more trouble. WDR was pleased with the director's work and signed him to an adaptation of Hawthorne's *The Scarlet Letter* (1972). Following that production, Wenders moved to New York City and began working on the story for his next film, *Alice in the Cities* (1974). Inspired by a Chuck Berry song, the film is the story of a journalist who has an existential crisis while traveling through America by car. Wenders returned to American themes with *The American Friend* (1977), a film that stars Dennis Hopper as an American gangster dressed as a cowboy in Hamburg. He tricks a picture framer (Bruno Ganz) into committing murders for the mob. The look of the film is based on the work of the American painter, Edward Hopper.

In 1980 Wenders made *Lightning Over Water* with Nicholas Ray. It is a documentary of Ray's last weeks of life. As he is dying of cancer, Ray reflects on his life and career in the movies. In 1984 Wenders completed work on *Paris, Texas*, a collaboration with the American playwright, Sam Shepard. The film is the story of a man, played by Harry Dean Stanton, who collapses outside a small town in Texas. He cannot speak and has no memory, but a doctor finds a card in his wallet with the telephone number of his brother on it. The brother takes him home to Los Angeles to recuperate and regain his memory. Once his memory returns, the family goes to Texas to find the man's lost wife. One of Wenders' best post-Neue Kino films, *Wings of Desire* (1987), stars Bruno Ganz. He plays an angel who watches over Berlin with his fellow angels. Ganz becomes interested in a mortal and begins to long for life, knowing that with it comes pain and mortality.

BRITISH FILM AFTER THE SIXTIES

Some of the most important films to come out of the United Kingdom after the sixties are covered in the next chapter which discusses the James Bond series and the Harry Potter series. The trend in the contemporary period is for British films to be

either co-productions with the British Broadcasting Company, films that have some American financing or international financing, or very independent films made on small budgets. No matter which was the case, most films made in the United Kingdom post-sixties had significant American distribution.

NICOLAS ROEG

Roeg was born in London in 1928. He spent the first 23 years of his movie career as a film editor and cinematographer. In 1970 Roeg broke onto the scene as a director with *Performance*, the story of Chas (James Fox) a violent psychopath at large in London. The first 20 minutes of the film are non-stop violence until Chas lands at the house of Turner, played by rock star Mick Jagger, who conducts rituals with magic mushrooms. Over time Chas becomes Turner and Turner morphs into Chas. Roeg's second film was set in Australia. *Walkabout* (1971) is the story of two European children stranded in the outback, forced to fend for themselves. They encounter a young aboriginal boy on walkabout (the ritual separation from his tribe that leads to manhood). With the aboriginal boy's knowledge of nature, the children survive both the environment and the girl's dawning sexuality. *The Man Who Fell to Earth* (1976) is one of Roeg's most successful films. David Bowie stars as Thomas Jerome Newton, a human-like alien who comes to earth to get water for his dying planet. He starts a technology company to get the money to build a spaceship to take him home. He makes billions of dollars and forms a relationship with an earth woman played by Candy Clark. In one amazing scene, Newton decides to reveal his alien nature to his girlfriend who gets completely freaked out by the experience.

KEN RUSSELL

Born in Southampton, Hampshire in the United Kingdom in 1927, Russell worked at several occupations before becoming a director, including photographer, dancer, and soldier. In 1956 he began to teach himself to direct by making small films. Three years later the BBC hired him to direct television shows. He continued to work in television for the next 10 years until he made *Women in Love* (1969). Known for his intense, almost over the top style, Russell is particularly interested in the lives of artists. *The Music Lovers* (1970) is the story of Tchaikovsky's life and music. Nineteenth century Russia is the setting and the American television actor, Richard Chamberlain, plays the tortured composer who hides his homosexuality when he marries the nymphomaniac, Nina (Glenda Jackson). The film's wild climax is set to the music of the composer's 1812 Overture. Russell's next film was no less energetic. *Devils* (1971) is based on Aldous Huxley's novel about Cardinal Richelieu's destruction of the priest, Father Grandier (Oliver Reed), who governs a fortified town that the Cardinal must capture to control France. He is set up as the person in charge of a nunnery full of satanic nuns, led by Sister Jeanne (Vanessa Redgrave). An investigator is sent to gather information against the priest. The film is full of torture, sex, and possession, the perfect subject matter for the director's fertile imagination.

Russell followed *Devils* with four films about art and artists: *Savage Messiah* (1972); *Mahler* (1974); *Tommy* (1975), the rock opera by The Who; and *Lisztomania* (1975). In 1980, the director collaborated with Paddy Chayefsky on a wild science-fiction druggie film, *Altered States*. William Hurt stars as a Harvard professor who has discovered a strain of new hallucinogenic drugs in the jungles of South America. Back home he begins to take the drugs in a sense isolation chamber and his body begins to become Neanderthal in appearance and strength. Russell's direction manages to make the film completely believable and completely scary. Many think it is his best film. Following *Altered States*, Russell returned to the relative freedom of television with only an occasional foray into motion pictures.

Monty Python

Monty Python's Flying Circus was a seminal BBC television series that debuted in 1969. The cast members, Graham Chapman, Eric Idle, Terry Jones, Michael Palin, Terry Gilliam, and John Cleese, wrote, performed, and filmed a surreal and madcap style of comedy. The show lasted four seasons and consisted of forty-six episodes. It became a hit show in America on PBS in 1971. After the series went off the air, the group made three feature films. The first was *Monty Python and the Holy Grail* (1975) the story of King Arthur and his knights in search of the Golden Chalice. Next was *The Life of Brian* (1979), the story of a young man who is constantly mistaken for Jesus. The third, and last film, is *The Meaning of Life* (1983). This film is a musical comedy about the different stages of life. The film contains the grossest depiction of gluttony in movie history. Monty Python is not everyone's taste, but the group's fans form one of the biggest movie cults in the contemporary era.

Neil Jordan

Born in Sligo, Ireland in 1950, his father was a university professor. Jordan received his degree in Irish history and English at University College in Dublin. After graduation he became a writer and founded the Irish Writers Cooperative. His volume of short stories, *Night in Tunisia*, was published in 1976. He also wrote three novels, *The Past* (1979), *The Dream of a Beast* (1983), and *Sunrise With Sea Monster* (1993). After working for John Boorman on *Excaliber* (1981) Jordan decided to make his own films. After a few early efforts he came to prominence with the Film Noir, *Mona Lisa* (1986), starring Bob Hoskins, Cathy Tyson, and Michael Caine. Hoskins plays an ex con who can find work only as a driver for a high-priced call girl. The girl entices Hoskins to get involved in other crimes; he then becomes hunted by the local crime boss (Caine).

In 1992 Jordan created a sensation with *The Crying Game*. Steven Rea plays an IRA soldier who has accidentally caused the death of a British soldier. He seeks out the soldier's girlfriend with whom he becomes romantically involved. When he discovers she is a transvestite, it complicates their relationship but does not end it. This was followed by *Michael Collins* (1996) in which Liam Neeson plays the title role in

a historical drama about the Easter Rising of 1916, a pivotal event in the Irish independence movement. Alan Rickman plays Collins' political adversary and Julia Roberts plays his lover.

In a body of work that contains challenging and disturbing films, *Butcher Boy* (1997) may be Jordan's most challenging. The film begins as a comedy. Francie, the butcher boy, is played by Eamonn Owens. He lives with his suicidal mother and alcoholic father in post-war Ireland. He escapes the dreadfulness of home through inventive playtime with his pal, Joe. Eventually his mother succeeds in killing herself. Joe is sent to boarding school and Francie becomes paranoid about his gossipy neighbor, Mrs. Nugent. He begins to have visions of the Virgin Mary, played by Sinead O'Connor. When his father dies, Francie flips out and goes on a murderous rampage.

STEPHEN FREARS

Frears was born in Leicester, England in 1941. He studied law at Cambridge University before changing his interest to the theater. He worked at the Royal Court Theater in London where he was an assistant to Lindsay Anderson. From there he went to work for filmmaker Karel Reisz, from 1966 to 1972. He began directing television programs in 1969 and continued in the TV business until 1984. His first important feature film was *My Beautiful Launderette* (1985). Written by Hanif Kureishi, the film is about Nasser, a Pakistani man striving to become middle class in Margaret Thatcher's London. He is married to a white woman and owns several small businesses including a gleaming new launderette. Nasser's brother has a son, Omar, who needs work and is given the responsibility of managing the launderette. The problem is that Omar's best friend is an unstable punk, played by Daniel Day Lewis, who is only too happy to help Omar run the business into the ground.

In 1987 Frears directed Gary Oldman in the biography of playwright Joe Orton, *Prick Up Your Ears*. Alfred Molina plays Orton's older lover and caretaker, Kenneth Halliwell. Orton is self destructive, drawn to the danger of public restrooms and bath houses where he seems as interested in violence as sex. Oldman is excellent and funny in an extremely challenging role. In 1988 the director made *Dangerous Liaisons*, a film set in France in the mid-1700s. Glenn Close, John Malkovich, and Michelle Pfeiffer play bored aristocrats who play risky sex games to relieve the boredom. Inevitably jealousy complicates the fun. Julia Roberts is the title character in *Mary Reilly* (1996). She is the maid in the house of the infamous Dr. Jekyll and his alter ego, Mr. Hyde. She finds herself attracted to Hyde which complicates matters to no end. Frears' most entertaining film is the American production of Nick Hornby's novel, *High Fidelity* (2000). John Cusack stars as Rob Gordon, a compulsive record collector and record store owner with commitment issues when it comes to relationships. Jack Black and Todd Louiso play Barry and Dick, Gordon's staff at the record store. Gordon is also a compulsive list maker who becomes obsessed when he compiles a list of his five greatest romantic break-ups. When he decides to revisit his old relationships, things get funny and complicated.

JIM SHERIDAN

Born in Dublin, Ireland in 1949, Sheridan's father was a stage director and he followed suit, working on Dublin children's theater projects and founding the Project Art Center. In 1982 he moved to New York City and enrolled at NYU for a short time until the money ran out. He lived in the Irish "Hell's Kitchen" neighborhood of the city and worked at odd jobs while writing his first film, *My Left Foot: The Story of Christie Brown* (1989). Daniel Day-Lewis stars as the title character whose cerebral palsy has rendered him a quadriplegic except for his left foot. Through determination and sheer will, he becomes a great painter, poet, and author. Day-Lewis' performance is brilliant and won him a Best Actor Oscar. Sheridan and Day-Lewis worked together again on the film *In The Name of the Father* (1994) in which the actor plays a man who is wrongfully accused and imprisoned as an IRA bomber. He spends 15 years in jail while his family works for his freedom. The film was nominated for seven Oscars including Day-Lewis' performance and Sheridan's direction.

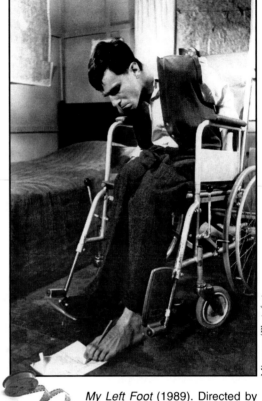

My Left Foot (1989). Directed by Jim Sheridan. Shown: Daniel Day-Lewis.

Miramax/Photofest

The director's next film was also with Day-Lewis playing Danny Flynn in *The Boxer* (1997). Flynn is a 19-year-old Belfast boy sent to prison for his IRA activities. When he is released he goes back to his old neighborhood and starts a career as a boxer. He starts a gym to help young Irish boys stay out of trouble by spending their time in the boxing ring. Sheridan's next film, *In America* (2003), is the story of an Irish couple having a difficult time adapting to life in New York City. The film received three Oscar nominations. His most recent film is the excellent Terence Howard rap movie, *Get Rich or Die Tryin'* (2005).

DANNY BOYLE

Boyle was born in Radcliff, Lancashire, England in 1956. As a boy he attended a Catholic seminary until a priest warned him against the priesthood. He completed his college education at Thornliegh Salesian College in Bolton after which he attended Bangor University in Wales. He began working in the theater and eventually became the artistic director at the Royal Court Theater from 1982 to 1985. He also

Slumdog Millionaire (2008). Directed by Danny Boyle.

directed for the Royal Shakespeare Company. He started working in television in 1980 and directed made-for-television movies. In 1996 he directed the film *Trainspotting*, which was based on the popular novel by Irvine Welsh. The film is set in Edinburgh among the young heroin addicts of the city. Ewan McGregor stars. Boyle's style in the film is very fast paced and madcap. He has a real talent for blending scenes of violence and horror with scenes of intense comedy. His next important film was *28 Days Later* (2002), an apocalyptic story of escaped laboratory viruses that cause rage in humans. Cillian Murphy plays Jim, a young man who was in a coma at the time the virus struck London. When he wakes up, the city is deserted and he goes off in search of anyone else who has escaped the virus. It is an excellent horror film.

In 2008 Boyle made *Slumdog Millionaire*, the story of a poor tea boy from the Mumbai slums who is a contestant on the Indian version of *Who Wants to Be a Millionaire*. The police suspect he is cheating every time he gets the right answer and try to torture the truth out of him. Instead, a flashback scene shows each time how he has come by the right answer honestly. When he wins the top prize he is able to rescue the love of his life from a career in prostitution. Boyle captures the city in beautiful colors despite the horrific conditions of slum life. The fast-paced editing and action make the two-hour film go by in the blink of an eye. *Slumdog* won eight Oscars including Best Cinematography, Best Editing, Best Director for Boyle, and Best Picture.

ITALIAN FILMMAKING AFTER FELLINI

Italian Cinema after Fellini and Sergio Leone ceased to have a presence in the realm of international film. Very few Italian movies were distributed in America and the number of theatrical feature films produced each year in Italy had fallen below fifty. Italian television is dominated by the Prime Minister, Silvio Berlusconi, who owns three national television networks which represent half the national TV assets in Italy. As a result, television is not a good training ground for independent-minded young Italian filmmakers. One director stands out in the post-Fellini era, Lina Wertmüller.

LINA WERTMÜLLER

Wertmüller was born in Rome in 1928. She studied stage directing at the Accademia d'Arte Drammatica Pietro Sharoff in 1951. After graduation she worked as an assistant for Giorgio De Lullo and assisted Fellini on *8 1/2* (1963). In 1965 she directed her first feature film, *The Basilisks*. In the early seventies the Italian Communist Party was gaining power in parliament with its women's liberation platform. The status of women in Italy was far behind the rest of the western world at the time. Divorce laws favored men and there were no protections for women in the workplace. Wertmuller's films in the mid-seventies addressed the issues of sexual politics and women's power.

Swept Away (1974) is a comedy adventure with a point. A spoiled rich woman and some friends charter a yacht. She becomes shipwrecked with one of the poor deck-hands who is a communist. He has survival skills that she must rely on but she has the power of sex over him. At first they engage in a battle of wills but eventually romance wins out. Wertmüller's favorite actor, Giancarlo Giannini, plays the deck hand who must overcome the lady's class prejudices while recognizing her humanity. *Seven Beauties* (1975) also stars Giannini as a soldier who deserts the Italian army during World War II. He is captured by the Germans and sent to a prison where he has to be resourceful to survive. While in prison he recounts the terrible things he has done to his seven sisters and the other women in his life, now that he is deprived from the company of women. *A Night Full of Rain* (1978) stars Giannini and the American actress, Candice Bergen. She plays a liberated American photographer living in Rome. The two meet, fall in love, and marry. He is an old world Italian man who has difficulty adjusting to his wife's attitudes about the role of women in marriage and society.

FRENCH CINEMA IN THE SEVENTIES AND BEYOND

Continuing the legacy of the seventies, French cinema was still, if not dominated by the directors of the new wave, slow to adopt new filmmakers and film style. Some directors, like Costa Gavras and Polanski, simply adopted France as their cinematic homeland. Other native directors slowly emerged to change the face of French film. Today, in spite of the fact that the French have limited the amount of American films allowed to be shown in French theaters to one-third, Hollywood product accounts for two-thirds of all French box office. This means that young directors must be resourceful in getting financing for their work. French television, like other European countries, subsidizes much of current production.

COSTA GAVRAS

With his audacious political thriller, *Z*, Gavras burst onto the international film scene in 1969. He was born in Athens, Greece in 1933. His father was a government official who had been outspoken against the Nazi occupation of Greece during World War II.

After the war he was branded a communist for his political views which prevented his son from being granted a visa to come to America to study film. Instead Costa Gavras moved to Paris and enrolled in the Sorbonne to study literature. He became a French citizen in 1956. Eventually he got work as an assistant director and made his first feature, *The Sleeping Car Murders* (1966).

With the release *Z*, Costa Gavras became an international star. The film tells the fictionalized story of a political assassination and coup in Greece in the sixties. Yves Montand plays the deputy, a Kennedy-like liberal politician who is campaigning to become the head of state. While attending a peace demonstration he is murdered. The magistrate attempts to identify the murders before the plot is covered up. The film very intentionally plays off the political assassinations in America in the sixties. Gavras gives the film an intensity and urgency that feels like a documentary. *Z* received nine Oscar nominations and won for Best Foreign Film.

Costa Gavras' next several films were political dramas. Yves Montand starred in two more films, *The Confession* (1970), based on a true incident in Czechoslovakia, and *State of Siege* (1972). In the later film, Montand plays an American official who is attempting to initiate a counterinsurgency in Uruguay. He is captured by the guerillas and his capture exposes the meddling of American agents in Latin American politics. In 1982 Costa Gavras made an American political thriller, *Missing*, starring Sissy Spacek and Jack Lemmon as the wife and father of a journalist kidnapped in South America. Spacek is a liberal and Lemmon is a conservative. Over time, he comes to realize that he has been betrayed by the government that he believed in so much.

LOUIS MALLE

Malle was born in Thumeries, France in 1932 to a very rich aristocratic family. His family tried to discourage his interest in filmmaking, but when they could not, he was allowed to enroll in the Institute of Advanced Cinematographic Studies in Paris. He worked as an assistant to Robert Bresson before being hired by underwater explorer Jacques Cousteau as his camera operator. He was soon promoted to co-director on *The Silence* (1956). Malle's first feature on his own was *The Lovers* (1958).

Malle became well known with his 1971 film, *Murmur of the Heart*. It is the story of a 15-year-old boy coming of age. The film is a romp with the boy seeking every possible kind of trouble and pleasure. The film received one Oscar nomination. In 1978 Malle came to America to make *Pretty Baby* (1978) starring a young Brooke Shields as a girl growing up in a house of prostitution in New Orleans in 1917. Susan Sarandon plays the madam who is also the girl's mother. Shield's performance is amazing for such a young actress. The director's next film, *Atlantic City* (1980), also starred Sarandon with Burt Lancaster. He is an aging hood and she is studying to work in an Atlantic City casino. When her husband turns up with a bunch of stolen drugs, she gets Lancaster to sell them for her. In 1980 Malle married Candice Bergen and settled down to life as a Hollywood director. He died in 1995.

KRZYSZTOF KIESLOWSKI

Born in Warsaw, Poland in 1941, he graduated from the Lodz Film Academy in 1969. Kieslowski made short documentaries, was a screenwriter, and did television work until making his first feature, *The Scar* (1976). He returned to making short films until he tackled the very challenging TV project of making ten short films based on the Ten Commandments, *Dekalog* (1989). Following that, Kieslowski made a French-financed feature, *The Double Life of Veronique* (1991). The film is about two women. One lives in Paris, the other in Poland. Somehow they seem to be psychically connected.

In 1993 Kieslowski moved to Paris to begin work on his magnum opus, the *Three Colors Trilogy*. The work is based on the colors in the French flag, blue, white, and red which stand for liberty, equality, and fraternity. The first film, *Three Colors: Blue* (1993) stars Juliette Binoche as the wife of a famous composer. Her husband and daughter are killed in a car crash which she survives. She tries to obliterate every reminder of her old life and starts anew only to discover that she must accept her artistic talent to really be free.

Three Colors: White (1994) is about a Polish man who marries a French woman, Julie Delpy. She divorces him because he cannot consummate the marriage. He explains to the judge at the trial that he had no trouble in that department until the couple married. He just needs more time but she will not wait. He is afraid he will not get a fair chance in court. After the divorce he loses all his possessions and is literally driven out of France by his ex-wife.

Three Colors: Red (1994) is about Valentine, a young model and student who is in love with a cold and distant man who tries to control her. She befriends an elderly judge through one of the many chance encounters contained in the film. She learns that the judge likes to listen in on other people's telephone conversations (the film also contains many of these). Auguste, the young law student who lives next to Valentine, is obsessed with a woman whom he only knows from the telephone. By the end of the film, everyone has met and all the loose ends are finally connected. Kieslowski, always a workaholic, died of a heart attack in 1996 at age 55. His trilogy is one of the great works of French cinema.

LUC BESSON

Primarily known as a writer, but directed two very stylish movies, *La Femme Nikita* (1990) and *The Fifth Element* (1997). *Nikita* is the story of a woman who is convicted of a crime but instead of being sent to prison, she is sent to a school for secret agents. She redeems herself by becoming the best possible agent. *The Fifth Element* is a colorful science fiction film. Bruce Willis plays a cab driver in the future and Gary Oldman plays the evil Mr. Zorg. Zorg is attempting to capture five powerful stones that will give him the ultimate power. Willis has to save the world. Besson's imagined future is really the attraction here. The story is fun but the art direction and the great action are what make the movie worth seeing.

FRANÇOIS OZON

Ozon was born in Paris in 1969. He represents both the gay and the youth movements in current French cinema. He received his master's degree in cinema from Université de Paris and was mentored by Eric Rohmer. In the nineties Ozon made 14 shorts and one 52-minute film in preparation for his career as a feature director. His first feature film was *Sitcom* (1998). The title not only refers to the American television genre but to French bourgeois comedies as well. The film contains every kind of sexual practice and perversion possible. Its in-your-face quality was rejected by the French critics but the visual style in unmistakably interesting. Ozon's third feature, *Water Drops on Burning Rocks* (2000), is an adaptation of an obscure Rainer Werner Fassbinder play about a romance between a fifty something salesman and a young student. *8 Women* (2002) is an homage to George Cukor's *The Women* (1939). *Swimming Pool* (2003) is considered Ozon's best work to date. It is the story of a woman who refuses to deal with her husband's death and acts as if he were still alive.

THREE GREAT MEXICAN DIRECTORS

ALEJANDRO GONZÁLEZ IÑÁRRITU

Iñárritu was born in Mexico City in 1963. He began his career as a radio disc jockey in 1984 on one of the top-rated stations in the country. From 1988 to 1990 he composed music for six Mexican feature films. In the nineties he worked for the Televisa network as a producer. He left to start his own television commercial production company, where he taught himself to direct. In the late nineties he was introduced to the writer, Guillermo Arriaga. The two began planning a series of short films about the contradictions of life in Mexico City. Eventually they pared the project down to three interwoven stories and a feature film script.

Amores Perros (2000) was Iñárritu's feature debut. The film follows three characters whose lives intersect in a traffic accident. The first story features Gael García Bernal as Octavio, a young man who is trying to save money so he can run away with his sister-in-law. He turns to dog fighting for the money. His dog is badly hurt in the fight and, on the way to the veterinarian, there is a car crash. Goya Toledo is Valeria, the woman in the other car who loses her leg and, consequently, her lover in the accident. El Chivo is a vagrant who takes care of stray dogs and is the only witness to the accident.

After producing and directing a segment of *11*09*01—September 11* (2002) a project about the terrorist attacks, Iñárritu made *21 Grams* (2003). The film stars Sean Penn as Paul and Naomi Watts as Cristina. He is a critically ill mathematician and she is a mother grieving for her husband and two daughters who were killed when they were run over by Jack Jordan (Benicio Del Toro). The husband's heart is donated to Paul and saves his life. Once again Iñárritu and Arriaga have created a story with intersecting plots. *Babel* (2006) has the same type of structure as the earlier films with four interlocking stories about the impossibility of communication.

GUILLERMO DEL TORO

Born in Guadalajara, Mexico, he was raised by his grandmother and developed an interest in film-making in his teens. Del Toro was taught make-up and special effects by Dick Smith whose best work was *The Exorcist* (1973). He was twenty-one when he produced his first feature in Mexico after which he spent ten years as a make-up supervisor. His 1993 film, *Cronos*, brought him to the attention of the film world. The film is the story of a mechanized beetle that was constructed by an alchemist in the 1500s. It opens up and stings the holder who is then overcome with youth and vigor and a need to feast on human blood. A dying millionaire is pursuing the device that is in the hands of an antique dealer.

21 Grams (2003). Directed by Alejandro González Iñárritu. Shown: Sean Penn, Naomi Watts.

Photofest

In 2002 del Toro directed the second installment of the Wesley Snipes superhero movie, *Blade II*. This led to his successful adaptation of the comic book character, *Hellboy* (2004). Following that he made the masterpiece, *Pan's Labyrinth* (2006). Set in Fascist Spain during World War II, the film is the story of a young girl and her mother who has remarried. Her new husband is a Spanish Army captain who is fighting revolutionaries in the countryside. Their new home is a lonesome place for the girl especially when her mother gets pregnant and must stay in bed. The girl is led to a magical labyrinth by a fairy. It is inhabited by an old, fawnlike creature who leads the girl through challenges to become a princess in the magical kingdom. The film is beautiful and frightening thanks to del Toro's magic with make-up and effects. He followed *Pan's Labyrinth* with the very successful, *Hellboy II: The Golden Army* (2008).

ALFONSO CUARÓN

Cuarón was born in Mexico City in 1961. He studied filmmaking at the National Autonomous University of Mexico. He worked in television after graduation and as an assistant director for several Latin American directors. In 1991 he was hired to direct his first feature, *Sólo Con Tu Pareja*, a dark comedy about a womanizing businessman who learns he has contacted AIDS. The film was a big hit in Mexico and brought the young director to the attention of Sidney Pollack who hired him to direct an episode of his *Fallen Angels* cable TV project in 1993. After that he was hired by Warner Brothers Family Entertainment to direct *The Little Princess* (1995). In 1998, Cuarón directed the Dickens' novel, *Great Expectations*.

Cuarón both wrote and directed his first film as an auteur, *Y Tu Mamá También*, in 2001. The film stars Gael García Bernal and Diego Luna as two young men on a road trip to a spectacular secret beach, Boca del Cielo. An older woman, Luisa, asks to come along, thereby forming a classic love triangle. The film was popular with critics and audiences alike and led to Cuarón being hired to direct *Harry Potter and the Prisoner of Azkaban* (2004). His next feature was *Children of Men*, an apocalyptic film set in the future where people have lost the ability to reproduce and the human race is dying out. A young woman gets pregnant and it becomes dangerous to stay in London. She goes on the run to safety among a colony of friendly people in the countryside. Clive Owen plays the man who gets her to safety.

CONTEMPORARY DANISH FILMMAKING

DOGME

A film movement founded by Lars von Trier and other Danish filmmakers in 1995. Lars von Trier was born in Copenhagen, Denmark in 1956. His family was strict and he claims that he was permitted everything except "feelings, religion and enjoyment." He began to make super 8mm films when he was eleven and created the television series *Clandestine Summer* (1968) when he was twelve. He dropped out of school, partied and drank too much as he devoured movies for a period of time until enrolling in the Copenhagen film school in the early eighties. After his time in school, von Trier made a variety of films for several years including films for television and for theatrical release. His best known work from his pre-Dogme period is *Zentropa* (1991), the story of an American pacifist working on a German passenger train in the post war years. He claims he doesn't want to be involved with the other workers, but his pacifism ends up helping further every evil plan that is hatched around him.

In the spring, 1995 von Trier and other young filmmakers formed a collective they called Dogme 95. Von Trier and his collaborator, Thomas Vinterberg issued a manifesto that was influenced by the work of Godard, Cassavettes, and the Oberhausen manifesto. They named their statement the "Ten Vows of Chastity." It was released at a press conference in Copenhagen in March, 1995. The document was a set of rules for making movies that were intended to remove artificiality from the process and to adhere film makers to a strict discipline.

The first vow established the rule that all Dogme films would be shot on location and that the location would have to be authentic. The only furnishings or props used in the film would be those that were present at the location when it was found. This necessarily placed a lot of emphasis on finding the perfect location.

The second rule was that all sound has to be natural. Dialog must be captured during the filming of a scene. Any music must be diagetic; it must be performed and recorded for the camera and act as part of the narrative.

The third rule requires the camera to be hand held. The only allowable camera movement is that which can be accomplished by hand held operation.

The fourth rule dictates that the film must be shot in color. No extra lights may be used to attain a proper exposure. If there is not enough light to shoot a scene, the director must redesign the scene so that it can be shot where the existing light is adequate for exposure. Where necessary a single light source can be attached to the camera.

The fifth rule prohibits the use of lens filters and lab work such as the use of an optical printer.

The sixth rule pertains to the narrative structure of the film. It prohibits plot devices such as murders and fight scenes that employ weapons such as guns and knives.

The seventh rule also refers to narrative structure. It demands that the film shall not use time shifting devices such as flashbacks and flash forwards. Neither can there be a sudden change of location. Everything must take place within the film's time frame.

The eighth rule is a prohibition against genre movies such as westerns, musicals and detective movies. There can be no reliance on the conventions of established movie genres.

The ninth rule requires the use of standard 35mm film and a four by three aspect ration for work prints and release prints alike. As digital formats became more prevalent in the ensuing years, the Dogme movement changed this rule to allow for the straightforward use of digital cameras.

The final rule forbids the director from being credited on the film. Since one of the main ideas of Dogme is to remove the director's vanity from the filmmaking process, the director should not be given the status of creator.

A post script to the rules defines the director's attitude toward the film. He or she is not to use the film as a personal expression. The characters are supreme and only they should dictate the story and the way it is told.

Five Danish directors took the vow. They agreed that they would each make a film under the rules when the financing became available. They agreed that the total budget for the five films would be 20 million kroner ($533,000 per film). They also agreed to wait until 1997 so that they could finish the projects they were currently making and ensure the availability of financing. The money did not materialize at first, and after a controversy involving the minister of culture, the head of the Danish Broadcasting, Björn Erichsen, was able to get television stations to do the financing.

Thomas Vinterberg was the first to make his Dogme film; *The Celebration* (1998) concerns a family gathering in an old hotel to celebrate the patriarch's 60th birthday. Things go wrong when one of the sons makes a toast congratulating the father for his sexual abuse of their sister who had just committed suicide.

Lars von Trier was the second Dane to make a Dogme film, *The Idiots* (1998). The film is about a group of twenty-somethings who have formed a commune. They rent an old villa outside Copenhagen where they spend their time trying to freak out the local citizens by pretending that they are mentally retarded. Eventually the group begins to squabble and falls apart.

The third of the Danish Dogme films was made by Søren Kragh-Jacobsen, *Mifune* (1998). A young professional man from Copenhagen must return to the rundown family farm to settle matters when his father dies. He has a mentally retarded brother living in

the home and he hires a housekeeper to clean up while he tries to find a home for the brother. The housekeeper turns out to be a call girl who is on the run from a stalker. Later her juvenile delinquent brother shows and the four form a family unit.

The fourth film in the series is *The King Is Alive* (1999) by Kristian Levring. The film tells the story of a group of tourists whose bus breaks down in the Namibian desert. They are near a deserted mining town which they occupy while they wait for help. Boredom becomes their enemy and they decide to put on a production of Shakespeare's *King Lear* to pass the time. By the time they are rescued, the group has experienced a spiritual awakening.

Before the fifth Danish Dogme film was made, foreigners had joined the movement. A French director, Jean-Marc Barr, made *Lovers* (1999). The American director Harmony Korine made *Julien Donkey-Boy* (1999) and the South Korean filmmaker, Daniel H. Byun, made *Interview* (2000). Other filmmakers from other countries joined in as well. The final of the first five Danish Dogme films was *Italian for Beginners* (2000) by Lone Scherfig. By 2003 35 Dogme films had been produced around the world. For the originators, the movement has run its course and Dogme is over for them as they have returned to conventional filmmaking. Yet, the challenge of making films with these restrictions continues to interest young directors.

ASIAN CINEMA

South Korea, China, Japan, Hong Kong, Taiwan, and India have become important centers for world cinema over the last three decades.

MODERN CHINESE CINEMA

Modern Chinese cinema begins with the "fifth generation"—in 1982 the first filmmakers began to graduate from the Beijing film school after the Cultural Revolution. The directors that make up this generation are quite diverse in their film styles but can be divided into two broad groupings. The new wave directors wrote manifestos and generally tried to break with tradition. The other group was Taoist-influenced and interested in realizing some kind of formalism. One thing that united the fifth generation was their desire to make films that reflected their experiences during the Cultural Revolution. Tian Zhuangzhuang and Li Shouhong had left school to join the army. Kan Caige and Zhang Yimou worked among the peasants. Either way, they had become critical of the regime.

Examples of films by fifth generation directors include the following. *Raise the Red Lantern* (1991) by Zhang Yimou, stars Gong Li as a headstrong girl who is sent to become one of the wives in the house of a wealthy man. She is at odds with her circumstances especially in her relationships with the other wives. Her inability to come to terms with her situation leads to tragedy for one of the other wives.

Farewell My Concubine (1993), by Ken Caige, is the story of a romantic triangle set against the backdrop of a half century of Chinese history. Two boyhood friends endure the grueling training for the Beijing Opera. They become stars, one playing the male leads and the other the female. When one of men announces his intention

to marry a prostitute (Gong Li), the other finds solace in opium and in a romance with an opera patron. They grow apart over the years until they renounce each other during the Cultural Revolution.

The Blue Kite (1993) was directed by Tian Zhuangzhuang. It tells the story of a young couple who marry during the Cultural Revolution. Evidence of the regime is everywhere with posters of Mao, loudspeakers blaring announcements, and visits by the local committee to be sure everyone is conforming.

Raise the Red Lantern (1991, China). Directed by Yimou Zhang.

The couple have a baby and seem to have achieved some happiness until a neighbor tells a lie about the husband who is then sent to a reform camp where he dies.

There is a healthy debate taking place within the Chinese film community about the existence of a sixth generation of filmmakers. Those who do not believe there is see themselves as a continuation of the fifth generation. Those who believe in the sixth generation point to changes in Chinese society that have affected filmmaking since the early eighties and nineties. First, the government has changed its economic policies to create a young, educated, urbanized generation of citizens. Second, attitudes about materialism have evolved to the point that socialism is often hidden in the background. Third, the liberalization of censorship rules has continued to evolve; no doubt prompted by the influence of the internet. Fourth, Chinese filmmakers are increasingly being educated outside China and have gained both an international perspective and following. The sixth generation filmmakers are also called the urban generation, interested in making films about the way people live now and exploring once-forbidden themes such as homosexuality. The following are examples of the sixth generation.

Perpetual Motion (2005), by Ning Ying, is the story of twenty-four hours in the lives of four women spending the lunar New Year together. Unbeknownst to the other three, the hostess has planned the party to investigate which of the women are having an affair with her husband. They engage in ordinary activities like mah-jongg, eating, conversation, and television. The real action of the film is in the women's moods. The only professional actress of the four is Li Qin qin. The others include a magazine publisher, a radio personality, and a musician/writer.

Jia Zhang-ke's film *Still Life* (2006) is the story of the Three Gorges Dam and the lives that were disrupted by its construction. Two people arrive in their devastated town to find what they can salvage. One is a nurse who has not seen her husband who has not been home in two years. The other is a coal miner whose wife has left him taking their

Orion Classics/Photofest

daughter with her. The woman is reunited with her husband but there is nothing left of the relationship. They decide to end their marriage just like the dam has ended their village and a new one has been built to replace it.

SOUTH KOREAN CINEMA

Brought on by the extreme censorship of the Park Chung-hee military regime, South Korean cinema went into a tailspin in the seventies. After Park's assassination, the country fell into a period of turmoil. In 1988 the country adopted a new constitution that significantly relaxed the country's strict censorship laws and opened the door for a new generation of filmmakers. Unfortunately, the new constitution also lifted the restrictions on imported films, which stunted the growth of the film industry, and it would take until the nineties for the Korean new wave to begin. Three films represent the coming of the new generation.

Shiri (1999) by Je-gyu Kang is in the tradition of the Hong Kong action film. It is the story of two secret agents whose mission is to track down a super-violent team of North Korean agents who have hijacked a shipment of a potent new explosive, CTX. Hee, a bloodthirsty female sniper, tries to keep the good guys from getting the explosives back.

Attack the Gas Station (1999) is a comedy by Sang-Jin Kim. A gang of four young outcasts robs a gas station and retreats to a noodle shop to enjoy the fruits of their crime. They decide to go back and take over the gas station and have some fun. They kidnap customers who complain; they force the manager to entertain them; and they arrange fights between local street gang members and the employees of the gas station. The actions of the gang are a reflection of their general dissatisfaction with Korean society.

Tell Me Something (1999) is a horror thriller by Yoon-Hyun Chang. Body parts of three corpses are found in garbage bags in different locations around Seoul. Detective Jo and his squad are handed the mission. Once the corpses are identified, the one thing they have in common is that they have all been lovers of a beautiful museum curator. Detective Jo spend most of his time trying to unlock the woman's troubled past in search of clues, meanwhile the killing continues. Soon the killer is stalking Jo.

BOLLYWOOD

The name given to Mumbai, the filmmaking capital of India. In the fifties and sixties, filmmakers Guru Dutt and Satyajit Ray ruled the Indian movie industry. Today many, if not most, of the films that are made in Bollywood are musicals. They are very colorful, tend to be about three hours long, and contain comedy scenes, stunt scenes and, of course, singing and dancing. The plots often include character stereotypes such as the prostitute with a heart of gold, corrupt politicians, and kidnappers. Familiar storylines are preferred such as lovers whose parents do not approve, love triangles, and family ties. In 2002 over 1,000 films were produced in India compared to a little over 700 in America. However, total revenue for Bollywood was $1.3 billion versus $51 billion for American movies. Bollywood films have exerted their influence on international cinema, including filmmakers such as Baz Lhurmann and Danny Boyle.

American Cinema in the Nineties and Beyond

8

New technologies and corporate mergers and acquisitions beginning in the 1990s have had a profound effect on the motion picture industry. Today, the question, "what is a film?" is as valid as it was in 1902 when the pioneers were trying to figure out what to do with their moving picture cameras. They had to deal with issues of how to make money from a film, where to show a film, would films be a passing fad or should investments be made in long term infrastructure. All of these questions and more are in play in the motion picture's millennial era. During the nineties entertainment corporations made enormous investments on single-film projects and spent even more money on potential movie franchises. One of the results of these mega-projects was that almost all of the filmmaking capacity and capital of the entertainment companies' film divisions became devoted to just a few projects. This created a need for smaller, more agile production companies that could make and acquire smaller, more intimate films. Independent filmmakers also benefited from the business climate created by the behemoths.

THE CHANGING BUSINESS LANDSCAPE

In 1990 the Japanese equipment manufacturer, Matsushita, acquired MCA/ Universal for $6.1 billion. The idea was that all of the players in the entertainment segment of the economy needed to get bigger and diversify in order to take advantage of the many new media platforms that existed or were on the horizon. Different companies were taking different approaches to the issue but all agreed it was "grow or die." During the eighties and nineties the Reagan, Bush, and Clinton Administrations almost completely deregulated the communications industries which facilitated the growth of the mega-media conglomerates. In 1993 the Federal Communications Commission (FCC) reversed the fin-syn rules that had prohibited television networks from having a financial interest in their programming after it aired on the network. Since the syndication business was often more profitable than the broadcasting business, it became incumbent on the networks to merge with television and motion picture production companies. After the Disney-ABC

merger, CEO Michael Eisner became so frustrated that ABC's executives in New York City were not buying from Disney that he moved the network headquarters to the Disney lot in Burbank, California.

UNIVERSAL STUDIOS

In 1996 the Canadian beverage maker, Seagram Inc., led by Edgar Bronfman Jr., purchased Universal from Matsushita. Bronfman acquired Polygram Records form Philips Inc. and merged it with MCA Records to create the largest record company in the world. In 2000, Vivendi Universal Entertainment was formed from the merger of the French media group with French television corporation Canal+ and the Seagram Company, which caused the Bronfman family to lose control of Universal. In 1986 the General Electric Company acquired Radio Corporation of America, parent company of NBC Television. In 2004 General Electric bought Vivendi's Universal Studios and Theme Parks to create the new NBC Universal Company.

SONY

Sony got into the entertainment business in 1968 when it formed a joint venture with CBS's Columbia Records label. In the years that followed, Sony became a world leader in the manufacture of high quality audio and television equipment. The marriage of a content maker and a delivery system maker made sense and it worked. Other subsequent new technologies included the home videocassette recorder in 1975 which changed the way the world watched old movies. In 1988 Sony acquired complete ownership of the record venture with CBS. And the following year it purchased Columbia TriStar Pictures. In 1990 Sony announced the development of a high definition television system that was capable of duplicating the theater experience in the home. In 1995 Sony was one of the leaders in establishing technical standards for the DVD. In 2004 Sony took over management of the Bertelsmann Music Group, forming Sony BMG music. That same year it acquired the former MGM studio facility for $5 billion.

TIME WARNER

Time Warner grew out of a merger between equals. The Kinney National Company acquired Warner Brothers-Seven Arts in 1970 and named the new company Warner Communications. The magazine publishing giant, Time Inc., acquired Home Box Office in 1972. In 1978 Warner acquired the cable television company, American Television & Communications. In 1987 Warner bought Chappell Music to create the second-largest music publishing company in the world, Warner Chappell Music. In 1989 Time Warner was formed when the two companies merged. In 1996 Congress

passed a revised telecommunications act that made possible the acquisition of Turner Broadcasting which owned Castle Rock Entertainment and New Line Cinema Corporation, as well as CNN and the Atlanta Braves baseball franchise. In 2000 America On Line (AOL) announced it was merging with Time Warner. AOL President, Steve Case, became the president of the new company, declaring that the marriage of one of the world's largest content providers with one of the world's largest internet service providers would be the perfect model for the future. The total value of the combined companies was $183 billion, but before the ink was dry on the merger, the value of stock in the new company began to drop precipitously. In 2003 Case resigned as president and was replaced by Richard Parsons, who immediately began cost cutting measures, such as selling off the record unit, to prop up the value of the stock shares.

DISNEY

Disney had always been one of the smaller motion picture companies because its animated entertainment took so long to go from the idea stage to the screen. However, over the years, Disney had diversified through its theme park and Imagineering divisions. In 1984 Michael Eisner (who had previously been at Paramount and at the ABC Television network) became the chief executive officer of Walt Disney Productions. That same year ABC acquired the ESPN cable sports network. In 1986 the Capital Cities Communication Company acquired ABC. In 1991 Disney made a deal with Pixar (a computer animation company that specialized in making commercials) to develop and make three feature length computer animated films. In 1993 Disney acquired Miramax Films, a small company that specialized in buying independent films at film festivals and distributing them. In 1995 Disney paid $19 billion for Capital Cities/ABC including ESPN. In 2005 Pixar announced plans to withdraw from its arrangement with Disney. Eisner was forced to resign and Robert Iger (former Capital Cities/ABC CEO) was appointed CEO of Disney. In 2006 Disney acquired Pixar.

PARAMOUNT-VIACOM

In 1970 CBS was forced to divest its syndicated programming division by the Federal Communications Commission. The new company was called Viacom. In 1986 William S. Paley was replaced as CEO of CBS Entertainment by Laurence Tisch. In 1987 the National Amusements Company (a New England movie theater company owned by Sumner Redstone) acquired Viacom. In 1989 Gulf+Western, owner of Paramount, changed its name to Paramount Communications. In 1994 Viacom bought Paramount Communications for $10 billion. The same year Viacom acquired Blockbuster Video stores for $8.4 billion. In 1995 CBS was sold to the Westinghouse Corporation for $5.4 billion. In 1996 Redstone became the CEO of Viacom and Westinghouse/CBS

bought Infinity Radio and Outdoor Advertising for $4.7 billion. In September the FCC gave permission for Viacom and CBS to merge.

NEWSCORP-FOX

In 1980 Rupert Murdoch, an Australian newspaper magnate, formed News Corporation. In 1983 Murdoch created Sky satellite television to serve Europe. In 1985 Murdoch became an American citizen which cleared the way for him to own American broadcast stations. As a result, he bought seven television stations from Metro Media and purchased TCH Holdings, owner of Twentieth Century Fox Film. In 1986 the Fox Broadcasting Company was established. In 1990 Sky merged with British Satellite Broadcasting to create BSkyB. In 2003 News Corporation purchased DirectTV, the largest American satellite broadcaster.

MEGA-FILMS

The movie franchise trend intensified in the nineties and beyond. Time Warner is by far the leader in this type of production because of its ownership of several of the underlying characters and literary works that movies and franchises are based on, including Superman, Batman, the Tolkien books, and Harry Potter. Disney, Paramount, Sony, and Fox all have their successful franchises as well. The following is a timeline of mega-films from the corporate era of U.S. filmmaking and the dollars involved.

STAR WARS (FOX) TOTAL GROSS: $2.621 BILLION

Title	Budget	Domestic Gross	Overseas Gross	Total Gross
The Phantom Menace (1999)	$115 million	$431 million	$493 million	$924 million
Attack of the Clones (2002)	$115 million	$310 million	$338 million	$649 million
Revenge of the Sith (2005)	$113 million	$380 million	$468 million	$848 million

BATMAN (TIME WARNER) TOTAL GROSS: $2.65 BILLION

Title	Budget	Domestic Gross	Overseas Gross	Total Gross
Batman (1989)	$35 million	$251 million	$160 million	$411 million
Batman Returns (1992)	$80 million	$162 million	$103 million	$266 million
Batman Forever (1995)	$100 million	$184 million	$152 million	$336 million
Batman and Robin (1997)	$125 million	$107 million	$130 million	$238 million
Batman Begins (2005)	$150 million	$205 million	$167 million	$372 million
The Dark Knight (2008)	$185 million	$533 million	$468 million	$1 billion

LORD OF THE RINGS (TIME WARNER) TOTAL GROSS: $2.289 BILLION

Title	Budget	Domestic Gross	Overseas Gross	Total Gross
The Fellowship of the Ring (2001)	$93 million	$314 million	$555 million	$870 million
The Two Towers (2002)	$94 million	$341 million	$583 million	$925 million
The Return of the King (03)	$94 million	$377 million	$742 million	$1.1 billion

HARRY POTTER (TIME WARNER) TOTAL GROSS: $5.253 BILLION

Title	Budget	Domestic Gross	Overseas Gross	Total Gross
The Sorcerer's Stone (2001)	$125 million	$317 million	$657 million	$974 million
The Chamber of Secrets (2002)	$100 million	$261 million	$616 million	$878 million
The Prisoner of Azkaban (2004)	$130 million	$249 million	$546 million	$795 million
The Goblet of Fire (2005)	$150 million	$290 million	$605 million	$895 million
The Order of the Phoenix (2007)	$150 million	$292 million	$646 million	$938 million
The Half Blood Prince (2009)	$250 million	$260 million	$493 million	$753 million

SPIDER-MAN (SONY) TOTAL GROSS: $2.494 BILLION

Title	Budget	Domestic Gross	Overseas Gross	Total Gross
Spider-Man (2002)	$139 million	$403 million	$418 million	$821 million
Spider-Man 2 (2004)	$200 million	$373 million	$410 million	$783 million
Spider-Man 3 (2007)	$258 million	$336 million	$554 million	$890 million

PIRATES OF THE CARIBBEAN (DISNEY) TOTAL GROSS: $2.774 BILLION

Title	Budget	Domestic Gross	Overseas Gross	Total Gross
The Curse of the Black Pearl (2003)	$140 million	$305 million	$348 million	$654 million
Dead Man's Chest (2006)	$225 million	$423 million	$642 million	$1.06 billion
At World's End (2007)	$300 million	$309 million	$651 million	$960 million

Clearly media companies made huge investments on these film projects and reaped even greater rewards. Several factors contributed to the success of film franchises. In the case of Batman and Spider-Man, the comic book characters the films were based on had a built-in fan base. The same is true with the Lord of the Rings and Harry Potter films. Best-selling books will bring audiences to the theater on the opening weekend. However, if the films are not well executed, word of mouth will keep audiences away in subsequent weeks. All of these films represent the state of the art in special effects production. They are excellently photographed and the art direction is superb. In other words, they are well made and they have high entertainment value.

OTHER MEGA-FILMS

Not all of the mega-films of the nineties and beyond are listed above and there are many that deserve mention.

JURASSIC PARK (1993)

The first installment of this series was a collaboration between Steven Spielberg and writer Michael Crichton, the creator of such diverse projects as *The Andromeda Strain* (1971), *Westworld* (1973), *Coma* (1978), and the television series *ER* (1994–2009). Crichton had written a novel about a scientist who is able to isolate dinosaur DNA and uses it to clone real-life dinosaurs in the laboratory. He decides to turn his menagerie of prehistoric creatures into a theme park attraction. Spielberg was intrigued with the idea of bringing the story to life. The live elements for the film were shot on the island of Kauai along the breathtaking Napoli Coast. The computer-generated and puppet elements were created at Universal and at the Stan Winston Studio. The film stars Sam Neill, Laura Dern, Jeff Goldblum, and Sir Richard Attenborough. John Williams wrote the music. The film won three technical Oscars and grossed $914 million on a $63 million budget. Two sequels were made, *The Lost World: Jurassic Park* (1997), directed by Spielberg, and *Jurassic Park III* (2001), directed by Joe Johnson. The total series has grossed $1.9 billion

JAMES BOND

Bond movies date back to 1962 with Sean Connery as *Dr. No.* In the nineties, Ian Fleming's indestructible character and the series were brought back into production with Pierce Brosnan in the Bond role. The original series creator, Albert Broccoli, consulted with his daughter, Barbara, producing the James Bond character restored to his original luster. The first of the films was *GoldenEye* (1995), followed by *Tomorrow Never Dies* (1997), *The World is Not Enough* (1999), and *Die Another Day* (2006). In 2006 Brosnan was replaced by a far more rugged Daniel Craig, and the action sequences were greatly amplified in *Casino Royale* (2006) and the twenty-second-installment of the series, *Quantum of Solace* (2008).

MISSION IMPOSSIBLE

Originally a great television series from the sixties, *Mission Impossible* starred Peter Graves, Barbara Bain, and Martin Landau. It was owned and produced by Desilu Productions, the company owned by Desi Arnaz and Lucille Ball. In 1996 Paramount acquired the rights and hired veteran action director Brian De Palma (*Scarface*, *The Untouchables*) to supervise. Tom Cruise was cast in the lead role, with Jean Reno, a highly re-

The Matrix (1999). Directed by Andy Wachowski and Larry Wachowski.

Warner Bros./Photofest

spected French action actor, as a member of the team. In the film Cruise's character must lead his team to uncover a spy within the agency. The stunts and the action sequences are spectacular. Two other sequels were made including *Mission Impossible II* (2000) and *Mission Impossible III* (2006).

THE MATRIX (1999)

The Matrix was the creation of brothers Andy and Larry Wachowski who both wrote and directed the project. Keanu Reeves, Laurence Fishburn, and Carrie-Anne Moss star as free people in a future world where everyone lives plugged into the matrix and experiences life as virtual reality when, in fact, they are housed and nourished like so many bees in a hive. Obviously someone has created and controls the matrix. It is the task of this small band of free people to find out who they are and destroy them. The film contains an Asian-influenced type of stop action martial arts fighting that is very exciting. The film was released on the last day of March, to avoid being in theaters at the same time as Lucas' *Phantom Menace*. The early opening strategy for what was clearly intended to be a summer movie worked, and the Wachowskis single handedly lengthened the summer blockbuster season. Two sequels followed, *The Matrix Reloaded* (2003—summer) and *The Matrix Revolutions* (2003—fall).

MEN IN BLACK (1997)

A charming science fiction buddy picture. Steven Spielberg was the executive producer and Barry Sonnenfeld, who made the Addams Family films, directed. The premise of the film is that the United States operates a secret service tasked with the job of controlling all of the space aliens that make the Earth their residence and to rid the planet of aliens that do not follow the rules. In addition to featuring excellently rendered space creatures, the film contains a very funny patter between the two

agents, Kay (Tommy Lee Jones) and Officer James Darrell Edwards III (Will Smith). The title denotes that, like the real Secret Service, the agents wear black suits and ties and white shirts. The sequel, *Men in Black II*, was released in 2002.

INDEPENDENCE DAY (1996)

Independence Day was a summer blockbuster, obviously timed for release on the Fourth of July weekend. It features a huge all-star cast led by Will Smith, Bill Pullman, Jeff Goldblum, and Mary McDonnell. In the story, astronomers discover a large spacecraft headed straight for Earth that is timed to arrive on July 2. The next day it destroys New York City, Washington DC, and Los Angeles. Survivors form a caravan to go to Area 51 in Nevada, where they plan to make their stand against the space invaders. The film is a commercial mixture of science fiction and patriotic war movie. On a relatively modest budget of $75 million, it grossed $817 million worldwide.

JASON BOURNE

Jason Bourne is a character created by the great spy novel writer, Robert Ludlum. The first of three films featuring the character was *The Bourne Identity* (2002). Matt Damon stars as Jason Bourne who is pulled from the ocean by a group of fishermen. He is wounded and does not remember his past. After he regains his health, he goes in search of his identity. Along the way he discovers that he has secret agent skills and that people still want him dead. German actress Franka Potente is the girl who helps him, and Chris Cooper is the American agent who was Bourne's handler. The film is fast moving and exciting with great stunt work. Two sequels have been made, *The Bourne Supremacy* (2004) and *The Bourne Ultimatum* (2007).

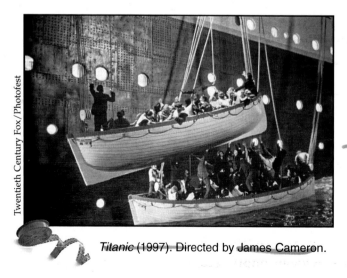

Twentieth Century Fox/Photofest

Titanic (1997). Directed by James Cameron.

TITANIC (1997)

The biggest grossing film in movie history. Writer, director, and producer, James Cameron spent more money than had ever been spent on making a movie up to this time. The published budget is $200 million but some reports claim that Cameron's post-production company just quit sending bills at some point, knowing it would just get the studio upset. The project began at Twentieth Century Fox which built a waterfront studio in Rosarito Beach, Baja California

(Mexico) to accommodate the huge ship's model that was to be used in the production. Somewhere along the line, Fox executives began to get squeamish about the cost of the film and convinced Paramount to partner, thereby lessening Fox' exposure to risk and halving the studio's share of the profits. A young Leonardo DiCaprio and Kate Winslet star as two lovers from different worlds. He is from the lower decks of steerage and she is in first class. They are united by the great ship's disastrous fate. Billy Zane plays Winslet's fiancé and the villain. The first half of the film is all romance and was very appealing to female audiences. The ship hits the iceberg at the film's halfway point, and it becomes a pure action movie which added appeal for male audiences. The stunts and effects are marvelous. Ingeniously, Cameron's effects crew was able to build only half of a ship model and flip it digitally to create the whole ship. The film won ten Oscars including Best Director, Best Picture, and a number of technical Oscars as well. It grossed $600 million domestically and $1.242 billion overseas for a total of $1.842 billion. One particularly interesting result of the grosses was that two-thirds of the take came from overseas, which at the time, set the standard for success in the overseas environment.

THE RESURGENCE OF INDEPENDENT FILMMAKING

MIRIMAX

The Miramax Company was founded by brothers Harvey and Bob Weinstein when they acquired the Century Theater in downtown Buffalo, New York as a venue for their concert promotion business. Since the theater was dark most of the time, they started screening independent and foreign film between concerts. They moved their company to New York City in 1979 and named it after their parents, Miriam and Max. At first the company specialized in acquiring the rights to foreign films and distributing them to American art house theaters. Soon they were competing with companies like Cinecom, Island, and Vestron for the rights to American independent films. Sometimes this required helping a young filmmaker finish a project or just survive financially until the film could be sold. Over time the Weinstein brothers were developing an interest in producing films from their inception, rather than trying to help fix them up for market.

By the late eighties, Miramax was developing lasting relationships with filmmakers like Errol Morris and Lizzie Borden. In 1989 they connected with their first big hit, *Sex, Lies and Videotape*, the first feature film by a promising young director, Steven Soderbergh. The film was made for $1.2 million on a budget that was raised by selling off the domestic videocassette rights to RCA/Columbia and the foreign videocassette rights to Virgin. Soderbergh took his film to the Sundance Film Festival where it became the sensation of that year's festival. Miramax outbid the competition by a considerable margin. Harvey Weinstein insisted that they would take the film to Cannes to get the European imprimatur of class and hipness. The

young director was skeptical and insecure until his film won the Palme d'Or grand prize. Back in America, Miramax prepared for the movie's release by putting up another $2.6 million in prints and advertising and making sure it got booked into the suburban multiplexes. The results were smashing. The film grossed $24.7 million domestically and another $30 million overseas. Both Soderbergh and Miramax were on their way to becoming important players in the movie business.

In the early nineties Miramax continued to score. In 1990 they acquired Stephen Frears' *The Grifters*, starring Angelica Huston and John Cusack as a mother and son team of con artists. Their most successful film of 1991 was *Truth or Dare*, the backstage documentary of Madonna's concert tour. In 1992 they helped young Quentin Tarantino get his film, *Reservoir Dogs*, made as well as John Sayles' *Passion Fish* and Tim Robbins' *Bob Roberts*. That same year the Weinsteins made a deal with Paramount to distribute their films. In 1993 Disney came calling. The studio desperately needed a source of low-budget, high-quality films to feed its distribution operation. The company culture had always been so careful with the Disney brand and image that the world of independents was foreign. Miramax presented the solution. Disney purchased the company for $80 million and installed Harvey and Bob Weinstein as the co-heads with a $100 million budget and a mandate to buy and/or make ten films per year. For the brothers it was a dream come true. They were now a studio and could bankroll productions.

In 1994 Miramax scored again with Tarantino's *Pulp Fiction* and Kevin Smith's *Clerks*. *Pulp Fiction* was a daring film with its circular plot, ultra-violence, and witty, chatty dialog; it was like no movie ever made. With the Weinsteins' genius for marketing, the film grossed $108 million domestically and $106 million overseas. *Clerks* was considerably more modest. Made on a budget of $27,000, it grossed $3.1 million. Most importantly the film established the relationship between Miramax and the very talented Smith who would become not only one of the company's best directors, but would produce, script doctor, and bring other filmmakers to the company as well. In 1995 the company produced two films by established masters, Robert Altman's *Prêt-à-Porter* and Woody Allen's *Mighty Aphrodite*. The following year Miramax owned the Oscars. Between *The English Patient* and *Sling Blade*, the company and its people took home ten Academy Awards including Best Actor, Best Supporting Actress, Best Director, and Best Picture. The domination was so complete that the other studios cried foul. It was unfair to have so much creative talent bankrolled by Disney.

In 1997 Miramax produced one of its best pictures, ever, *Good Will Hunting*. It was a film that almost did not get made. Two relative unknowns, Matt Damon and Ben Affleck, had sold their script for the film to Warner Brothers with themselves attached to star. The studio got cold feet about Damon and Affleck starring and tried to buy them out. They refused and the film was put into turnaround with a $6 million price to buy it and put it into production. Kevin Smith was aware of the situation and begged Harvey Weinstein to buy the film. Six million was a steep price but Weinstein liked the script and he trusted Smith's instincts. With Minnie

Driver as Will's girlfriend, Robin Williams as his therapist, and Casey Affleck as one of the gang, the film has an excellent cast. Gus Van Sant directed the film with great intimacy and sensitivity. Danny Elfman's score is some of the best movie music ever written. Robin Williams won a well-deserved Oscar for his Supporting Actor Role and Damon and Affleck won for their screenplay. The movie grossed $226 million worldwide.

In 1998 the company peaked. True to its indie roots, Miramax produced Penelope Spheeris' *Senseless*, the story of a young college student who volunteers for a corporate drug experiment that goes wrong. *Rounders* featured Matt Damon as a reformed gambler who has to go back to playing poker to save his friend (Ed Norton) from being killed by bookies. *Sliding Doors* and *Velvet Goldmine* were also excellent independent films. However, the film of the year was *Shakespeare in Love.* With an excellent script by Tom Stoppard and Marc Norman and an all-star cast including Dame Judi Dench as Queen Elizabeth I, Gwyneth Paltrow, Geoffrey Rush, and Tom Wilkinson, and Joseph Fiennes as the title character, the director, John Madden, created a masterpiece of romance. The film won seven Oscars including Best Actress for Paltrow, Best Supporting Actress for Dench, and Best Picture. Once again the other studios expressed their unhappiness with the Miramax touch. On a $25 million budget, *Shakespeare in Love* made $289 million worldwide.

In 1999 Miramax produced sixteen films, two of which were truly outstanding: *The Cider House Rules* and *The Talented Mr. Ripley*. *Cider House* was based on a John Irving novel and screenplay and was helmed by the Swedish director, Lasse Hallström. The film won Oscars for Michael Caine's colorful supporting actor performance and for Irving's writing. *Mr. Ripley* was another starring vehicle for Matt Damon. A chill gripped the relationship between the Weinsteins and Disney head Michael Eisner in 1999. Kevin Smith had made a religious satire titled *Dogma* that was a little sophomoric but was genuinely funny. Eisner was afraid that it would damage the Disney brand with Christian conservatives and Catholics so he refused to release it. The Weinsteins were forced to buy it back from the company and distribute it independently which caused the box office for the film to suffer. More damaging was the disrespect shown to Smith by the parent company. In 2004 there was an even more serious falling out between Miramax filmmakers and Disney. Michael Moore had

Shakespeare in Love (1998). Directed by John Madden. Shown: Gwyneth Paltrow, Joseph Fiennes.

Miramax/Photofest

made *Fahrenheit 9/11*, a documentary that was very critical of President Bush's handling of the attacks of September 11, 2001. There was much concern in the Disney executive suites about how the Bush Administration would react to the film, especially considering that the company operated several television stations under FCC waivers that could be easily revoked. Once again the decision was made to drop the film. The Weinsteins had to buy it back from Disney and distribute it independently. This time, however, the box office story was different. The film made $119 domestically and $103 million overseas and became the top-grossing documentary in movie history. The question that hung in the air after this event was, "Can Miramax maintain its independence under Disney management?" The answer was, "no." In September, 2005 the Weinsteins left Disney. The Miramax label stayed with the parent company and the brothers went back on their own but with their relationships with the independent film world intact.

PIXAR

The Pixar Company began business in 1979 when George Lucas recruited a group of computer animation specialists from the New York Institute of Technology to join the Lucasfilm Company in the San Francisco Bay area. Five years later John Lassiter, a promising young Disney animator, quit his job to join the computer animation revolution at Pixar. In 1986 Lucas spun off the Pixar unit which was purchased by Steve Jobs, cofounder of the Apple computer company. In May 1991 Pixar signed an agreement with Disney to develop three feature films. The terms of the agreement called for Disney to finance all production and distribution for an 85% share of the gross. The first film produced was *Toy Story* (1995) which grossed $361 million. Not only did the film have an excellent story, it had a look that was much more three-dimensional than cell animation had ever achieved. There was also an astonishing complexity of motion. The director, John Lassiter, had delivered an animation masterpiece. A week later Pixar announced an initial public offering of stock in the company that raised $140 million in cash, making Steve Jobs' 80% stake in the company worth $1.2 billion. The following year the Pixar/Disney deal was renegotiated with Pixar agreeing to produce five more films with a 50% share of the profits instead of the original 15%. Not only did *Toy Story* do great at the box office, but the merchandising of the toy characters in the film added to the success.

Over the next few years a string of hits followed. The John Lassiter-directed *A Bug's Life* (1998) made $363 million. For *Monsters Inc.* (2001) Lassiter changed roles to producer. The film made $525 million. With each new film Pixar's technology and artistry was getting better. *Finding Nemo* (2003) contained beautifully rendered seascapes wherein every plant, bubble, and fish is in a constant symphony of motion. The film made $846 million, eclipsing the record for an animated film of $783 million established by *The Lion King* (1994). It was becoming clear that computer animation had definitively replaced the cell method. The next film featured a family

of superheroes known as *The Incredibles* (2004) which topped out at $631 million. The last film under the deal, *Cars* (2006), was directed by Lassiter and made a relatively modest $461 million on a budget of $120 million; but, by any measurement, it was a big success.

Trouble began to appear on the horizon between Pixar and Disney dating back to 2004 when Steve Jobs and Michael Eisner began talks to renegotiate their deal. From Jobs' point of view, the only thing that Disney brought to the game anymore was distribution since Pixar was now totally capable of financing its own films. The customary fee for distribution is 15% not the 50% that Disney was receiving. Eisner countered that the Disney brand and its ability to push products based on film characters into the marketplace was unrivaled. The two men squabbled back and forth until negotiations broke down completely. Pressure began to mount on the Disney board of directors to do something and they did. Michael Eisner was removed and a more conciliatory Robert Eiger was installed as the new CEO. Talks resumed with Jobs and on January 24, 2006 Disney announced that it would buy Pixar for $7.4 billion in Disney stock, making Jobs the biggest shareholder in Disney. His initial $10 million dollar investment had grown to $8 billion.

There is a moral to the Pixar and Miramax stories and that is that there is an inevitable clash between corporate and creative cultures. In the early days of the movie business the money men pretty much stayed in New York City and let the creative people alone in Hollywood. Occasionally someone would be dispatched west to remind the creative types that they were in a business. Otherwise, it was hands off. In the modern era, the big corporations and their executives are under tremendous pressure from Wall Street to constantly improve on their last quarter's results. This kind of short-term, instant-results thinking is far removed from the kind of dreaming that makes for great films.

THE SUNDANCE INSTITUTE AND FILM FESTIVAL

In the mid-sixties Robert Redford, an avid skier, began to buy land in the Wasatch Mountains near the Park City, Utah ski resort. By 1968 he owned thousands of acres when he purchased the Timp Haven ski and recreation facility and renamed the whole property The Sundance Ranch, after the character that made him a star, The Sundance Kid from *Butch Cassidy and the Sundance Kid* (1969). In 1981 the actor invited a number of his friends from Hollywood to discuss the formation of an institute that would help young Native American, women, and minority filmmakers learn from industry insiders who would mentor production projects at the institute. In 1984 playwrights were also invited. Today programs include feature films, documentary films, film music, theater, and the annual festival.

The Sundance Film Festival was created by a merger with the Utah/U.S. Film Festival in 1985. In 1978 the Utah festival was established in Salt Lake City. In 1981 one of the festival board members, Sidney Pollack, convinced the organizers to move the festival to Park City in January to take advantage of the tourism. In 1985 the

Sundance Institute with its year-around staff offered to merge the festival into the Institute's programs and it was renamed the Sundance Film Festival. The stated purpose was to create the preeminent showcase for American independent cinema. In the nineties, foreign independent film submissions were also admitted to the festival. Over the last 20 years it has become the most important marketplace for exciting new films and filmmakers.

OTHER IMPORTANT NORTH AMERICAN FILM FESTIVALS

In America every year there are over 600 film festivals. Most are showcases where filmmakers can bring their projects to be seen by an audience. Some, like Sundance and those listed below, are also film marketplaces where the guests also represent film production and distribution companies in search of new films to buy or new filmmakers to do business with. Many of the showcase festivals are themed. Themes include short films, comedies, gay films, environmental films, documentary films, and films made by first-time filmmakers. With the coming of YouTube, a new model for showcasing films has emerged. Virtual film festivals will play an important role in the future.

THE SOUTH BY SOUTHWEST FILM FESTIVAL

In 1987 a group of artists from Austin, Texas formed the South by Southwest Company (SXSW) to stage a music and media festival and conference. It quickly became the premier roots music festival in the world. With the help of Austin resident and filmmaker, Richard Linklater, a film festival was added in 1994. The festival specializes in new directors.

THE NEW YORK FILM FESTIVAL

The New York Film Festival was founded in 1963 at the Lincoln Center, one of the city's most important cultural destinations. The festival is related to the Film Society of Lincoln Center which programs the Walter Reade Theater at the center throughout the year. The annual festival runs for two weeks and attracts over 200,000 participants. Both American independent and foreign films are invited to the festival which has sections for documentary and short films in addition to features.

THE TORONTO FILM FESTIVAL

This festival was founded in 1976 at the Windsor Arms Hotel in Toronto, Ontario. Originally it was a "festival of festivals" in that the organizers selected films that had won at other festivals. Today the Toronto festival screens between three and four hundred films. The focus is on Canadian film but many international filmmakers chose to debut their films at Toronto because of the friendly atmosphere and enthusiastic audiences. Audiences for the 10-day event often exceed 300,000.

FESTIVAL RECOGNITION

Several Sundance filmmakers and actors careers were jump started by recognition at the festival. The festival's first year, 1985, introduced the Coen Brothers with their stylish debut film, *Blood Simple*. The film also introduced actress Frances McDormand who eventually became Joel Coen's wife and collaborator. John Water's gender-bending film *Hairspray* appeared at the 1998 festival and proceeded to be adapted as a stage musical and a screen adaptation of the stage musical. The following year director Steven Soderbergh broke through with *Sex, Lies and Video Tape*, the success of which led to films as diverse as *Erin Brockovich, Traffic,* and *Oceans Eleven, Twelve* and *Thirteen*.

The Tao of Steve starring Donal Logue.

Sony Pictures Classics/Online USA/ Getty Images

In 1991 Richard Linklater added a new word to the language with *Slacker*. In 2000 Donal Logue gave the word a face and style with his star turn in *The Tao of Steve*, the story of a young slacker who has lots of potential and no ambition until he meets a girl at his tenth high school reunion. In the film Logue creates a new kind of leading man who is attractive as much for his intelligence and humor as for his unconventionally dumpy looks. Quentin Tarantino got his start at Sundance with the screening of his first project as director, *Reservoir Dogs*. Sundance has given rise to important cult films such Robert Rodroguez' *El Mariachi* (1993) and Kevin Smith's *Clerks* (1994). Darren Aronofski's *Pi* won in 1998 and led to highly respected films such as *Requiem for a Dream* (2000) and *The Wrestler* (2008). *Donie Darko*, the big cult hit from 2001 launched the careers of Jake and Maggie Gyllenhaal. *Napoleon Dynamite* was the surprise film of 2004 and both *Hustle and Flow* and *The Squid and the Whale* received a great deal of positive attention after their initial Sundance screenings.

No film epitomizes the Sundance ethos better than the *Blair Witch Project* (1999). It wasn't a Sundance winner but it became an all time winner in the box office category. The film was made by two Florida filmmakers, Daniel Myrick and Eduardo Sanchez on a reported budget of $60 thousand. They sold the distribution rights to Artisan Entertainment for approximately $1.5 million. The film became a horror sensation and by the end of the year had grossed $248 million worldwide, making it the most commercially successful Sundance film ever. Also in 1999 a little known German film, *Run, Lola, Run* caught the imagination of the audience. The star, Franka Potente proceeded to co-star with Matt Damon in the *Bourne Identity* (2002) and the director, Tom Tykwer went on to make the excellent action film, *The International* (2009). This year the surprise hit that emerged from Sundance was *Precious: Based on the Novel Push by*

Sapphire. It is the story of an overweight, illiterate girl from the projects who is abused by her father and her struggle to climb out of the hopelessness that surrounds her.

NEW FILMMAKERS OF THE NINETIES AND BEYOND

PAUL THOMAS ANDERSON

Anderson was born in Studio City, California in 1970. His father was a voice actor who had hosted a late-night horror movie show in Cleveland. Movies were always a part of Anderson's family life. In 1992 he enrolled at New York University but got his money back after two days and used it to make his first short film, *Cigarettes & Coffee*. Anderson spent the next few years as an assistant on commercials and music videos before getting funding from the Sundance Laboratory for his first feature film, *Hard Eight* (1996). Anderson's stylistic flourishes are evident from the beginning. He keeps the camera moving. He uses his color palette purposefully, and most importantly, he gets great performances out of ensemble casts of actors. *Hard Eight's* cast includes Anderson regulars Philip Seymour Hoffman, John C. Reilly, and Philip Baker Hall joined by Gwyneth Paltrow and Samuel L. Jackson. One of his early influences was Robert Altman, the master of directing ensemble casts.

Anderson's breakthrough came with *Boogie Nights* (1997) a film about life in the porn industry in the seventies. The huge cast is lead by Burt Reynolds who plays a director and the leader of something that functions like a family unit making skin flicks. Mark Wahlberg, Julianne Moore, William H. Macy, John C. Reilly, Philip Seymour Hoffman, Heather Graham, and Luis Guzmán are among the cast members. The film follows the ascent and decline of Dirk Diggler, a famously endowed porn star. The story, by Anderson, has a sprawling, almost epic quality with many different sub plots and chances for the actors to show their stuff. Reynolds and Moore were nominated for Best Supporting Actor Oscars as was Anderson's script. His next film, *Magnolia* (1999), was also set in the San Fernando Valley and involves many actors from his ensemble, including Moore, Macy, Reilly, Hall, Hoffman, and Guzmán. Written by Anderson, the story involves two interwoven stories about men who are on the verge of death and in need of mending relationships with their children. Tom Cruise plays a self-absorbed self-help guru. In one of the greatest scenes in his career, Cruise is interviewed by a writer who completely dismantles his personality during the course of their meeting.

Anderson directed a few episodes of *Saturday Night Live* before making *Punch-Drunk Love* (2002), a complete change of pace from his earlier work. The film is a romantic comedy starring Adam Sandler as Barry Egan, a henpecked man who has seven sisters. He owns a business that makes novelty toilet plungers and lives alone in a dingy apartment. One day he meets Lena Leonard (Emily Watson), a pretty single woman who finds him interesting. Egan is awkward and has difficulty hiding his anger issues from Lena who is perfectly understanding. Eventually love wins out.

In 2005 Anderson did something completely selfless. His hero, Robert Altman, was dying of cancer but wanted to make one last movie, *A Prairie Home Companion* (2006).

Altman could not be insured and the movie could not happen unless a competent director was willing to accompany him through the entire production process. Anderson volunteered for the job and the great master got to make one last movie, not the kind of Hollywood story that is often told. Anderson returned to movie making in 2007 with the epic *There Will Be Blood*. The film stars Daniel Day-Lewis as a California oil pioneer, Daniel Plainview. Lewis is spectacular as the driven, complex anti-hero who is constantly under attack from the big oil companies and an evangelical preacher, Eli Sunday (Paul Dano) whose family farm was bought by Plainview for pennies and became his big oil strike. Lewis won a Best Actor Oscar for his performance.

JANE CAMPION

Born in Wellington, New Zealand in 1954, Campion began her film career as a student at the Australian School of Film and Television. Her first student film, *An Exercise in Discipline—Peel* (1982) won the Palme d'Or for short films at the Cannes Film Festival. After making several more short films and a few television projects, Campion wrote and directed her first feature, *The Piano* (1993). Holly Hunter stars as Ada, a mute woman who is sent to marry a man in remote New Zealand in the 1850s. She arrives with a daughter and her most prized possession, her piano. Sam Neill plays the husband who has no interest in having the instrument in his household and leaves it stranded on the beach. Harvey Keitel plays George Baines, a European who has gone native and has his body tattooed and speaks the language of the local Maori tribe. Baines brings the piano to his hut in the woods where he trades intimacies with Ada for the right to play it. Hunter won the Best Actress Oscar for her performance and Anna Paquin, who played the daughter, won Best Supporting Actress. Campion won for her script.

In 1996 Campion made her second feature, an adaptation of Henry James' novel, *The Portrait of a Lady*. The film stars Nicole Kidman and John Malkovich. The director's next film, *Holy Smoke*, was a comedy featuring Kate Winslet and Harvey Keitel. She plays a young woman who comes under the spell of a holy man while traveling in India. Keitel is a deprogrammer sent to straighten out the young lady who is more than a match for his tricks. Campion's next film, *In the Cut* (2003), was a bizarre crime drama with Meg Ryan and Mark Ruffalo. Campion is one of the leading women directors in the motion picture business. Her films are uncompromising in telling stories from a woman's point of view.

THE COEN BROTHERS

Joel Coen is the older brother, born in 1954; Ethan was born in 1957. They were raised in a suburb of Minneapolis, Minnesota where they claim the cold winters led to watching movies all day. Joel graduated with a film degree from New York University and Ethan majored in philosophy at Princeton. Before teaming up, Joel worked as an assistant editor on a series of horror films and Ethan wrote for the television series, *Cagney & Lacey*. The brothers wrote the script for their first movie, *Blood Simple* (1984), then filmed a three-minute trailer that they used to raise the production budget of

$1.5 million. The film is a very dark story of murder and double crosses. In won the Grand Jury Prize at the Sundance Festival.

The brothers became well known after the 1987 release of their film, *Raising Arizona*. Nicolas Cage and Holly Hunter star as a couple with an infertility problem. They decide to solve it by kidnapping one of five quintuplets, reasoning that the baby's parents will still have plenty of kids. The quirky comedy was a financial success and opened the door for future financing for their independent productions. Looking at the brothers' career, they tend to gravitate toward making very serious and violent films or go in the opposite direction with comedies that feature unusual people and situations. Their next film, *Miller's Crossing* (1990), is an example of their violent and bloody style of filmmaking. It is a gangster drama set in the twenties.

In 1996 the Coens had their best critical and commercial success to date with *Fargo*. The film stars Frances McDormand (Joel's wife) as a very pregnant police detective in the frozen wasteland of a North Dakota winter. William H. Macy plays an auto dealer who hires a couple of thugs to kidnap his wife so he can use the ransom that her wealthy father will pay to finance a business scheme. Everything that could go wrong does. *The Big Lebowski* (1998) is a classic cult film. Jeff Bridges plays Jeffrey Lebowski, who is the ultimate slacker, living to bowl and drink white Russians. He keeps getting his identity mixed up with an older, wealthy, man with the same name whose wife has been kidnapped.

O Brother, Where Art Thou? (2000) stars George Clooney as one of a not-too-smart trio of criminals who escape a chain gang and encounter unusual characters along the way. The other gang members are Coen favorites, John Turturro and John Goodman. The story is based on Homer's Odyssey and has an excellent soundtrack by Ry Cooder. *No Country for Old Men* (2007) is an adaptation of Cormac McCarthy's very dark novel. It stars Tommy Lee Jones, Josh Brolin, and Javier Bardem as the coldest blooded killer in movie history. The film was a financial success for an independent production, grossing $162 worldwide. It was also the Coen's biggest critical success, winning them Oscars for Directing and Screenplay. Bardem won Best Supporting Actor and the film won Best Picture.

TIM BURTON

Burton was born in Burbank, California in 1958. He was interested in drawing as a child which led to his enrollment at the California Institute of the Arts where he studied animation. He was awarded a fellowship by Disney which has strong connections with the school. The fellowship led to a job at Disney working on *The Fox and the Hound* (1981). At the studio, Burton was allowed to work on his own projects which included *Vincent* (1982) a tribute to horror film actor Vincent Price, and *Frankenweenie* (1984), a live action film that was never released. Paul Rubens (Pee-Wee Herman) did see the film and asked Burton to direct his first feature, *Pee-Wee's Big Adventure* (1985) which led to Burton's first hit, *Beetlejuice* (1988).

In 1989 Warner Brothers hired Burton to direct *Batman* starring Michael Keaton who had also starred in *Beetlejuice*. Jack Nicholson, in one of his wildest roles, co-starred as the villain, The Joker. The huge financial success of the movie insured that Burton

would always be able to acquire financing for his projects. In 1990 the director made *Edward Scissorhands*, with Johnny Depp in the title role and Winona Ryder as his love interest. It is one of Burton's enduring cult films, telling the story of a gentle young man who has scissors for hands. After making *Batman Returns* in 1992, Burton reunited with Depp on *Ed Wood*, a loving tribute to the fifties king of schlock movies. Martin Landau plays the great horror actor, Bella Lugosi, at the end of his career and life. Ravaged by a heroin addiction, the old Lugosi is a god to Ed Wood who cannot get enough of his movie wisdom. Landau won a Best Supporting Actor Oscar for his performance in a film that is a valentine to every wannabe filmmaker who ever looked through a lens.

Mars Attacks (1996) is a wonderfully weird satire on fifties space invader movies. Jack Nicholson leads an all-star cast of Earthlings who are defenseless against the Martians. In 1999 Burton and Depp collaborated on *Sleepy Hollow*, an action-filled visualization of the headless horseman story. Depp is at his pale best as Ichabod Crane, the policeman who is sent to investigate the haunting of the hamlet, Sleepy Hollow. After the remake of *Planet of the Apes* (2001) and the fantasy fable, *Big Fish* (2003), Burton and Depp reprised Roald Dahl's dark comedy, *Charlie and the Chocolate Factory* (2005). The film adaptation of Stephen Sondheim's dark Broadway musical, *Sweeney Todd* (2007) was Burton and Depp's most recent collaboration in an artistic relationship that has come to define both men's body of work.

SPIKE JONZE AND CHARLIE KAUFMAN

These directors have collaborated on two of the strangest movies in recent history, *Being John Malkovich* (1999) and *Adaptation* (2002). Jonze, who was born in Rockville, Maryland in 1969, began his professional life as one of the founders of *Dirt* magazine. He began his movie career as a music video director for bands that include The Beastie Boys, R.E.M., Bjork, and Weezer. Writer Charlie Kaufman got his start writing *The Dana Carvey Show* in 1996. Propaganda Films, a company specializing in music videos, produced *Being John Malkovich* after the actor agreed to appear in the film bearing his name. The film stars John Cusack, Cameron Diaz, Catherine Keener and, of course, John Malkovich. Cusack is a puppeteer who is forced to find a day job, which he does at a very weird company. One day he finds a portal behind a filing cabinet. He goes through and ends up inside John Malkovich's mind. He remains there for 15 minutes until he is dumped through another portal onto the New Jersey shore. Jonze and the cast bring Kaufman's weird script to life with a drollery that is a joy.

The second film in the Kaufman-Jonze collaboration, *Adaptation*, is the most self-referential film in movie history. Kaufman and his imaginary brother are played by Nicolas Cage. Kaufman gets an assignment to adapt the real-life Susan Orleans' (played by Meryl Streep) book, *The Orchid Thief*, into a movie script. The thief in the book and the film is played by Chris Cooper. The story moves from fantasy to real time with such smoothness, it is impossible to know which is which after a while. Once again Jonze shows that he can film great acting performances because that is exactly what the three principals give.

ANG LEE

Lee was born in 1954 in Pingtung, Taiwan. After graduation from the National Taiwan College of Arts, Lee enrolled at the University of Illinois where he received a degree in theater direction. Next he enrolled in the master's program in film at New York University, where he met Spike Lee and served as assistant director on Spike Lee's first film. Ang Lee's first film was *Pushing Hands* (1992) a story about the conflict between younger and older generations in Chinese families. This was followed by Lee's first film to gain him notice, *The Wedding Banquet* (1993), the story of a young gay Chinese man who pretends to get married to appease his parents. His third film, *Eat, Drink, Man, Woman* (1994) is the story of a great Taiwanese chef and his three daughters. He has lost his sense of taste after the death of his wife, but continues to cook amazing meals for his unappreciative daughters. Cooking becomes his way of showing love. Warning! Never see this film on an empty stomach!

One of the most amazing qualities in Ang Lee's films is how deftly he can move between Asian subject matter and European and American films. He demonstrated this with his adaptation of Jane Austen's *Sense and Sensibility* (1995). The film stars Emma Thompson, Kate Winslet, Hugh Grant, and Tom Wilkinson in a story of inheritance and the unfairness of the British legal system toward women in the late eighteenth century. Lee's next film, *The Ice Storm* (1997), was even more surprising. It is a story about a group of middle aged suburban couples who experiment with wife swapping while their children's lives are spiraling out of control. The film, adapted by James Schamus (Lee's frequent collaborator), is completely American in the way it perfectly captures the decadence and smugness of suburban life.

Over the next few years Lee made a Civil War western, *Ride With the Devil* (1999), A great martial arts film, *Crouching Tiger, Hidden Dragon* (2000), and a comic book fantasy, *Hulk* (2003). On every occasion he showed his understanding of the material and his desire to make great movies. Lee's masterpiece came in 2005, *Brokeback Mountain*. Heath Ledger and Jake Gyllenhaal star as two men who want to live conventional lives but are powerless in their attraction for each other. Both actors were nominated for Oscars and Lee won Best Director.

Brokeback Mountain (2005). Directed by Ang Lee. Shown (from left): Heath Ledger, Jake Gyllenhaal.

Focus Features/Photofest

RICHARD LINKLATER

Inventor of the word slacker. Linklater was born in Houston, Texas in 1960. After dropping out of college he worked on oil rigs until landing in the Texas outpost of hipness, Austin. Once there, he started a film club and began work on his first project, *It's Impossible to Learn to Plow by Reading Books* (1988). The film was not seen by anyone outside his circle of friends. Linklater's next film, *Slacker* (1991), is a chatty film about a day in the life of a few eccentric Austin characters. His next film, *Dazed and Confused* (1993), is an excellent high school film set on the last day of school in 1976. It follows a group of incoming freshman boys and the older boys who torment them. Matthew McConaughey and Ben Affleck are just beginning their acting careers in the film and Renee Zellweger has an uncredited walk-on. The story perfectly captures the teen spirit of the time.

Linklater's next film was a complete change of pace from his earlier, jokey work. *Before Sunrise* (1995) stars Ethan Hawke and Julie Delpy as two people who meet on a train ride and have one romantic night in Vienna. His next film, *The Newton Boys* (1998) is about a family of bank robbers in the twenties. This was followed by *Waking Life* (2001) a rotoscoped animation about the meaning of dreams. In 2003 the filmmaker had his greatest commercial success with the very entertaining *The School of Rock*. This was followed by the sequel to *Before Sunrise, Before Sunset* (2004). Linklater continues to make films that show his independent spirit and his willingness to experiment.

QUENTIN TARANTINO

Tarantino was born in Knoxville, Tennessee in 1963. His family moved to the Los Angeles area where he grew up. Tarantino dropped out of high school at age 15 to study acting at the James Best Theater Company. When he was 22, he got the ultimate movie slacker job at the Manhattan Beach Video Archives. He and his future writing partner, Roger Avery, soaked up all of movie history in their time at the video store. They specialized in Kurosawa and Hong Kong action features. Avery had written a story, "The Open Road," which Tarantino adapted into a sprawling 400-page script that contained the story for *True Romance* (1993) and elements of three other films, *Reservoir Dogs* (1992), *Pulp Fiction* (1994), and *Natural Born Killers* (1994).

Reservoir Dogs was accepted for the 1992 Sundance festival. The movie had been financed by the Live Video Company on a cast contingency basis. Tarantino had to sign an actor of significant enough stature to help sell the project. Harvey Keitel served that function. The film was almost notorious by the close of the festival. It is the story of a bank robbery gone wrong. What made it interesting was the cool dialog and the shocking but not over-the-top violence. It was clearly the work of a new voice in the world of independent film.

After writing *Natural Born Killers* with Oliver Stone, Tarantino proceeded to make *Pulp Fiction*, his most original work to date. The film is a boldly circular narrative that tells several interwoven stories. One storyline involves two professional killers, Vincent Vega (John Travolta) and Jules Winnfield (Samuel L. Jackson). Another involves Vincent's

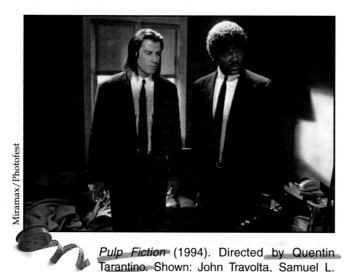

Miramax/Photofest

Pulp Fiction (1994). Directed by Quentin Tarantino. Shown: John Travolta, Samuel L. Jackson.

unfortunate night out with the boss' wife, Mia Wallace (Uma Thurman) and the third story involves a prize fighter, Butch Coolidge (Bruce Willis). Again Tarantino's witty and chatty dialog is half the fun, the other half coming from surprising and violent action. At the insistence of Harvey Weinstein the film was entered at the Cannes Festival where it won the Palme d'Or, making the brash young director an international celebrity. Tarantino and Avery won Oscars for best screenplay and the film grossed $214 million on an $8 million budget making it the most successful independent film in history. *Pulp Fiction* also helped revive the careers of Travolta and Willis and to promote the careers of Uma Thurman and Samuel L. Jackson.

Tarantino's next important film was *Jackie Brown* (1997), an homage to the Blaxploitation films of the seventies. It stars Pam Grier (Jackie Brown) as a flight attendant and Samuel L. Jackson (Ordell Robbie) as an arms dealer. Based on a novel by Elmore Leonard, the story involves arms smuggling and a big double cross. Robert De Niro is wonderful as an ex con and Bridget Fonda plays Ordell's annoying girlfriend. Next for Tarantino was *Kill Bill: Vol. 1* (2003) and *Kill Bill: Vol. 2* (2004) an extended meditation on violence and revenge starring Uma Thurman and David Carradine. *Grindhouse* (2007) was an audacious concept film made in collaboration with Robert Rodriguez. Tarantino's contribution is an excellent car chase movie, *Death Proof* and Rodriguez' companion piece, *Planet Terror*, are packaged with fake trailers to create a tacky and campy double feature program typical of the third run theaters (grind houses) of the seventies.

Tarantino's next film, *Inglourious Basterds* (2009) is an homage to World War II films. It stars Brad Pitt as Lt. Aldo Raine, a member of a group of Jewish-American soldiers sent behind enemy lines to terrorize and demoralize the Germans with their acts of atrocity. The director has described the film as his "spaghetti-western." Tarantino has remained affiliated with the Weinstein Company that has a production arrangement with Universal Studios. The importance of this arrangement is that he is able to make films without the meddling of financial backers and among people who share his passion for movies.

KEVIN SMITH

Smith is an actor, writer, director, and producer. As was discussed earlier, his contributions to other filmmakers' works are the unseen value that he brings to contemporary movie making. He was born in Red Bank, New Jersey in 1970. His first film, *Clerks* (1994),

was made in collaboration with his partner and co-producer, Scott Mosier, who also did the sound and helped edit. *Clerks* became an instant sensation in the independent film world because of the resourcefulness of the filmmakers and their ability to make the film on a $27,000 budget. The film was shot at the convenience store and video store where Smith worked during the daytime while he shot the film at night. It won the top prize at the Sundance Festival and received the Award of Youth at Cannes. Although its domestic gross was only $3 million, the film has sold ten times that in DVDs since its release.

Smith's next film was *Mallrats* (1995), another hanging out picture, but in a better location, the mall. Shannen Doherty, of *Beverly Hills 90210*, stars with Jason Lee and Ben Affleck. Smith interjects his love of comic books into the film and reprises Jay and Silent Bob from *Clerks*. His next movie, *Chasing Amy* (1997), is about two comic book artists played by Ben Affleck and Jason Lee. They have a great life until they meet a lesbian who proceeds to help them grow up in their attitudes about sex. *Dogma* (1999) has been previously discussed. Smith's career reached a low point when he directed Jennifer Lopez in *Jersey Girl* (2004). The independent world saw the film as a sell-out and the film critics were not pleased either. He redeemed himself with *Clerks II* (2006) which is a pleasing and truly funny sequel to his original film.

GUS VAN SANT

Born in Louisville, Kentucky in 1952, Van Sant's father was a salesman who worked his way up the corporate ladder by moving from job to job and city to city. Being moved so often as a kid, Van Sant withdrew into making super 8mm movies and painting. He attended the Rhode Island School of Design in 1970 and his classmates included David Byrne and the other members of Talking Heads. He came to Los Angeles in 1976 and got a job as a production assistant. His first film, *Mala Noche* (1985) was made for $25,000 that he had saved working at an advertising agency. The film, based on a novel by Walt Curtis, is the autobiographical story of a liquor store clerk on skid row who falls in love with an illegal Mexican boy. Van Sant captures the seamy side of street life excellently. *Drugstore Cowboy* (1989) stars Matt Dillon as the head of a de facto family of addicts that include his wife, Kelly Lynch, and another couple, James LeGros and Heather Graham. Together they travel the countryside robbing pharmacies. The poet, William S. Burroughs, has some wonderful scenes near the end of the film.

Other excellent films by Van Sant include *My Own Private Idaho* (1991), *Even Cowgirls Get the Blues* (1993), *To Die For* (1995), *Good Will Hunting* (1997), *Finding Forrester* (2000), and *Elephant* (2003) which won the Best Director and Palme d'Or awards at the Cannes Festival. In 2008 Van Sant directed *Milk*, starring Sean Penn as the ground breaking San Francisco gay activist, Harvey Milk. The film is an almost epic biography, following Milk from his days in New York to his Castro District photo store which became headquarters for his successful campaign to become the first gay city councilman in San Francisco history. Josh Brolin co-stars as Dan White, a former cop and fellow city councilman, who assassinates Milk and the mayor, George Moscone. Penn won a Best Actor Oscar for his excellent performance.

THE DVD AND THE MOVIE BUSINESS

In September 1996 the computer and electronic equipment industries announced adoption of technical specifications for a five-gigabyte digital storage medium that would be known as the DVD (digital video disc). In November that year the first DVD players and discs became available in Japan. The system was launched in America in March 1997 and the following year in Europe. The new system was capable of containing and playing back relatively high definition 16 by 9 television pictures and 5.1 surround sound. This opened the door to high quality home video systems using a movie format that had the convenience and storage size of the compact disc. By 2003 DVD sales and rentals surpassed the videocassette. By 2004 sales and rentals exceeded $21.2 billion. Unlike the videocassette, consumers showed a preference for owning DVDs over renting them. Sales accounted for $15.5 billion of the 2004 total income from DVDs. In 2006 the Sony-Phillips collaborative launched a high definition DVD technology called Blu-ray which was intended to serve both the gaming industry and the high definition home video industry.

The DVD had a profound effect on Hollywood. Just as the introduction of the compact disc created an opportunity for the music industry to repackage and resell the music in its libraries, the DVD opened up a new revenue stream for classic movies. It also profoundly changed the marketplace for new films. Prior to the DVD, movie producers wanted their films to remain in theaters as long as possible. Once they were played out in theaters, a pay-per-view cable television and home satellite window was opened for a few months before new films were released into home video rental stores. Today, DVDs are more profitable than movie tickets with the margin on a $25 disc being greater than $10 dollars per unit. A DVD that sells 5 million copies adds an additional $50 million in profits for the producer. Therefore, producers are in a hurry to get the DVD versions of their films to market while audiences can still recall the promotional campaign for the theatrical release of the film. This has led to some contentiousness between the theater business and the production business. Theaters do not want their ticket sales to be undercut by DVD sales.

The DVD has dramatically changed the rental business. The Netflix Company began renting DVDs by mail in 1997. Today the company boasts over 100,000 titles in its library of 55 million discs. It ships out over 1.9 million discs to its 10 million subscribers every business day. On April 2, 2009 Netflix shipped its 2 billionth disc. The company has also introduced an internet downloading service for watching movies instantly. Blockbuster, the industry leader in videocassette rentals, was forced to respond to Netflix. It launched a mail rental service in 2004.

GREAT FILMMAKERS IN THE NINETIES AND BEYOND

MARTIN SCORSESE

Scorsese continued to be one of the most prolific figures in the motion picture world in the nineties. He began the decade with one of his greatest films, *Goodfellas* (1990). Based on Nicholas Pileggi's biography of the real-life New Jersey gangster, Henry Hill, it is the

story of the rise and fall of a man who adored the mob life. Ray Liotta plays Hill, Robert De Niro plays the boss, Jimmy Conway and Joe Pesci play the out of control sidekicks. In 1995 Scorsese made a companion piece to *Goodfellas*, *Casino* with De Niro playing Ace Rothstein, an odds maker sent by the mob to run their Las Vegas casino. Joe Pesci is the killer who is sent to look after things and Sharon Stone plays the prostitute Ace falls in love with. Both films reflect the director's style with great use of color, fluid moving camera, long tracking shots, intense violence, and great performances.

Scorsese changed leading men in 2002 when he cast Leonardo DiCaprio as the lead in his long-awaited *Gangs of New York*. Set during the Civil War, the film is basically a revenge plot using the Irish street gangs that control the city as its background. Daniel Day-Lewis is superb as the bloodthirsty gang leader, Bill "the Butcher." *The Aviator* (2004) also stars DiCaprio, this time as a young Howard Hughes during his time in the movie business in the twenties and thirties. An expert on film history, Scorsese beautifully recreates that colorful period in Hollywood. In 2005 Scorsese completed a documentary on Bob Dylan that had been started by one of his mentors at NYU, D.A. Pennebaker. *No Direction Home: Bob Dylan* is a wonderful recollection of the great American poet's days as a Greenwich Village folksinger in the early sixties. In 2006 the great director finally won a long overdue Oscar for Best Director with his remake of a Hong Kong action film, *The Departed*. DiCaprio stars as Billy Costigan, a police officer who goes underground as a member of the Boston crime family led by Frank Costello (Jack Nicholson). Matt Damon co-stars as Colin, a boy from the neighborhood whom Costello has recruited to go underground as a member of the police force. Scorsese's editing partner since college, Thelma Schoonmaker, also got the Oscar for editing.

STEVEN SPEILBERG

He managed to maintain his movie empire during the nineties and still make the occasional great motion picture. In 1993 he not only made *Jurassic Park*, but he also made one of the best films ever made about the holocaust, *Schindler's List*. Liam Neeson stars as the real-life Oskar Schindler who convinces the Nazis to let him use Polish Jews from the notorious Auschwitz concentration camp to work in his factory. In so doing, Schindler managed to save over 1100 lives from the gas chambers. Ralph Fiennes is chilling as the sadistic camp commander. *Amistad* (1997) is Spielberg's film about the 1839 mutiny aboard a slave ship on its way to America. The film is riveting in its realistic depiction of the cruelty and sadism of the slave trade.

Like Scorsese, the Oscars always seemed to overlook Spielberg's work but in 1998 he finally received a Best Director statuette for *Saving Private Ryan*. Tom Hanks stars as Captain John H. Miller who is tasked with finding and saving Private James Francis Ryan whose other brothers have perished in the war. The policy of the military was not to allow all of a family's sons be killed if possible. Miller takes his mission seriously. The first 20 minutes of the film depict the D-day landing on Omaha Beach from a soldier's point of view. It is one of the most complicated and frightening scenes ever filmed.

ROBERT ALTMAN

Altman has been discussed previously in this chapter, but a couple of his later films deserve discussion here. In 1992 he made one of the most cynical and witty Hollywood satires in the long history of the genre. *The Player* is the story of Griffin Mill (Tim Robbins), a young movie producer with a shark's instincts. The film begins with a very sly long tracking shot through the studio offices as writers are pitching their stories to executives. When the aloof Mill arrives at work the next day he finds a threat letter from an anonymous writer in his mail. He has been mean to so many writers, that he has no idea who this one is. Coolly he tries to find discover his tormentor's identity and along the way Altman shows us every Hollywood type he has ever known. *Short Cuts* (1993) is a rambling ensemble film based on a collection of short stories, set in Los Angeles, by Raymond Carter. The cast includes Andie McDowell, Jack Lemmon, Julianne Moore, Mathew Modine, Robert Downey Jr., Anne Archer, Tim Robbins, Lily Tomlin, Tom Waits, Frances McDormand, Peter Gallagher, Lyle Lovett, and Alex Trebek. This list of actors is testament to the fact that everyone in Hollywood wanted to be in an Altman film. *Short Cuts* puts all of this talent to good use. In 1995, the director was told he needed a heart transplant. He was terrified that this would spell the end to his career. He kept the operation a secret for ten years and, during that time, he made eight more films including the very excellent period comedy/mystery, *Gosford Park* (2001).

DIGITAL FILM

In 1987 the Avid Company introduced the first non-linear digital editing platform. This revolutionized the post-production process in the movie industry. Before Avid, editors worked from work prints of pieces of film that were shot during production and with magnetic tape that contained dialog and other sound elements. The process of re-editing a scene was time consuming and frustrating. Editors had to depend on their ability to visualize what the finished product would look like. In non-linear systems, the bits of film and sound are all stored on massive computer hard drives. The program allows the editor to manipulate these elements without splicing and cutting and splicing again. The finished product is a precise edit decision list that is delivered to the laboratory where the negative is cut, the sound is added, and the finished film is printed.

 The use of digital editing opened the door to digital cameras. In 1990 the Sony Corporation launched the first professional-quality, 16 by 9, high definition camera. This product was intended for the television industry but it also drew the interest of cinematographers. By the end of the nineties both the Ariflex and Panavision motion picture camera companies introduced digital cameras. The advantages of digital cinematography are many. Film is expensive. Digital media are cheap. Film needs careful handling. Digital media are rugged. You do not know what you filmed until it gets back from the lab. Digital media can be played back instantly. The one big advantage film has over digital is the look. However, advances in digital cameras have all but eliminated image quality differences. For independent filmmakers digital has been a godsend by making production much more affordable and expanding the creative options. The Sundance

Festival began accepting digital media in the late nineties. Today digital has become the norm in the festival world. Recently the Red Digital Camera company introduced a new line of cameras that cinematographers seem to love. Some of the films shot with the camera include: *District 9* (2009), *Angels and Demons* (2009), and *Night at the Museum: Battle at the Smithsonian* (2009).

District 9 (2009). Directed by Neill Blomkamp. Shown: Scene.

Sony Pictures Entertainment/Photofest

In 1999 the first four American theaters to convert to digital projection began to demonstrate the new technology with Lucas Films' *Star Wars: Episode 1—The Phantom Menace.* Over the next few years the theater business began to embrace the technology. China adopted a digital projection standard in 2005 with plans for 40,000 digital screens by the end of 2009. In March 2009 AMC theaters announced a deal with Sony to equip all of its theaters with digital projectors. Regal Cinema has also announced plans to go all digital.

Early digital cinema projectors did not reproduce pictures that equaled film image quality, resulting in hesitance in the theater industry to adopt the technology. By 2005 the differences in image quality were all but obliterated. Digital cinema has many advantages over film. Film prints are expensive and after several screenings they become scratched and faded. Digital media reproduce the same image quality in every screening. There is no image degradation. Eventually movie companies will distribute films electronically through encrypted networks. This will greatly reduce the instances of film piracy that cost the industry between $8 and $12 billion each year.

Analyzing Film 9

THE MOVIE ENVIRONMENT

Where, how, and under what conditions an individual views film exerts a powerful influence on the subjective experience of film study. The most ideal setting for film viewing is in a theater with comfortable seats, good sight lines, and a great projection and sound system. Viewing as a member of an audience intensifies and amplifies the power of movies to affect us. Everyone has had the experience of watching a comedy film in a theater full of strangers. The jokes build, the laughter becomes contagious, and before long everyone is wiping their eyes with delight. Take the same film and watch it at home alone and one begins to question what was so funny about the movie after all? The answer is that the audience helped make it funny.

Film scholars talk about the willing suspension of disbelief when we watch movies. Intellectually, we know that a film is nothing more than a series of still pictures being projected fast enough to have the appearance of motion. But our acceptance of make believe does not stop there. When we watch a science fiction movie, we know that it is unlikely that earthlings have encountered space monsters, yet we let ourselves believe it for the moment anyway. The same can be said for any non-documentary film: westerns, war films, musicals, horror films, even dramas. All fiction cinema relies on us forgetting to be skeptics for a little while.

A few pointers might be helpful in preparing the home environment for the serious study of film. First, do not view on a computer screen. It is the smallest screen in the house. If there is a big screen and theater type sound system in the home, use it. The effect will be more dramatic and help achieve the feeling of getting inside a movie. The same is true for the sound system. Theater audio is purposely set at high volumes to command the viewer's attention and to overwhelm any distracting sounds in the room. Lighting is another issue. Dark theaters cause us to focus on the screen. Images take on greater depth and we tend to notice things in a dark or near-dark room that get lost in a brighter setting, particularly if there is any glare on the screen. Finally, the first time the film is viewed it should be experienced in its entirety without any breaks. This will allow the viewer to feel the emotion or excitement of the film better and have a more cinematic experience. Do not take notes the first time

through. Do not pause unless it is absolutely necessary. A break in movie continuity means a break in the spell the movie creates. In subsequent viewings when looking for specific examples and moments, by all means, stop and start.

ELEMENTS OF FILM WRITING: NARRATIVE AND STORY

THEME

The theme of a film is the central idea to which most of the parts are related. The actual theme is rarely stated outright. Instead, it is the idea which upon reflection seems to best explain the point of the film. When a filmmaker sets out to interpret a script into a finished movie, his or her understanding of the theme will often guide decisions about casting, art direction, cinematography, music, and the use of symbols. Fashioning these cinematic elements to support the theme as well as the story gives the finished product artistic unity and reinforces the audience's perception that the film is logical and complete. To identify the theme of a movie it is necessary to first view it and then ask the question, what was the point of the work?

Action films often focus mostly on the plot and the need to create excitement for the viewer. Sometimes it seems as if there is no point other than to entertain. However, even the shallowest films of this genre usually deal with issues such as good versus evil, man versus nature, or the quest for some noble goal. Other films focus on character and understanding lives that are either historically or intellectually interesting or both. Some films focus on mood and emotion, attempting to invoke some response from the audience. Still, other films focus on ideas with the aim of stimulating the viewer in thought or action.

Movie themes can be uplifting, complex, or mundane. Morality, the nobility of humanity, and the struggle for human dignity are common themes. Other films might explore social problems or the challenges of life's various stages of development. But even films that deal with supernatural serial killers and gross-out comedies also contain themes and unifying ideas. Make it a habit to take a moment every time you see a film to think about the theme no matter how lightweight the movie may seem. Before long you will develop the ability to spot the central idea easily.

NARRATIVE

The plot of a film and the story it tells are two related but different things. The story includes everything that happens whether it is implied or shown. The plot consists of the scenes that we are presented and the order and manner in which they are shown to us. Great writers and directors have the ability to use plot devices to surprise and to make the audience eager to experience what will be presented next.

There are many elements of a good film story. Whether it is fictional or a true story, it must contain an interesting balance of conflict, character, action, and behavior and all of this should be resolved in a manner that is either satisfying or meaningful to the audience.

A good story should be recognizable to the audience as containing some basic human truth about the way we see the world or the way we want the world to be. Even films based on toys like *Toy Story* or *Transformers* deal with the human nature of the toys; otherwise there would be no connection with the audience and no logic for the way the toys behave. Stories that are set in completely imaginary realms such as *Star Trek* and *Avatar* also contain elements that illuminate the human condition.

A good story has qualities that engage the audience and keep it interested such as suspense and action. Alfred Hitchcock was a master at creating movie suspense. One of his favorite suspense strategies was to give the audience information about the characters in the story that was withheld from the characters themselves. In *North by Northwest* the audience finds out what is happening to the protagonist, Roger Thornhill (Cary Grant), at the end of the first act. Thornhill does not find out what has been happening until the end of the second act (one half of the film later). Foreshadowing, giving the audience a hint of what is to come, is also a related suspense device. Another is surprise or shock when something horrible suddenly jumps onto the screen.

Action has been a staple of the film experience for generations. D.W. Griffith was fond of ending his films with dramatic chase scenes that involved the hero coming to the rescue of a doomed victim. Mack Sennett's Keystone comedies often played off Griffith's chase scenes with the emphasis on getting laughs rather than on creating tension. Modern action films often begin with a chase, a rescue, an escape, or a fight, leaving the audience with the expectation that they will end with an even more spectacular and defining action sequence. Even non-action films contain action, often in the form of emotions experienced by the characters.

A good story should be self-contained and simple enough to show the audience all the information it needs to follow within the ninety-minute to three-hour time constraints of most film stories. It should not be so loaded with unnecessary information that it sacrifices entertainment values. On the other hand, a good story should have enough conflict, complications, and set-backs of the characters that it does not become too predictable and lose the audience's interest. In the 1960's devotees of cinema verité like Jean-Luc Godard became very concerned with presenting the true human experience including feelings of boredom and dissatisfaction. Often there would be long passages where little happened. These scenes do mirror the way life really is experienced. In the sixties these passages were seen as bold and revolutionary examples of truthfulness. Today's audiences do not see these films in that context and usually experience them as slow and difficult.

A good story should deal with real human emotions without going too far, which risks turning drama into comedy. The big screen amplifies everything, especially dramatic scenes in which the characters are in states of high emotion. If the scene goes "over the top" the drama turns into something else. The film, *Tropic Thunder*, relies on this effect. Its characters are a group of self-indulgent, self-involved actors who are constantly over dramatizing their predicament to comedic effect. Good drama requires making emotional behaviors subtle and hidden. Often when they are revealed it comes as a surprise to both the audience and the character.

A good story should contain conflict. There should be a major obstacle for the protagonist to overcome. In *The Godfather* there are two central conflicts. The first is the battle for the Corleone family to survive. Who will succeed Don Vito? Once Michael becomes the likely heir the film shifts onto a loftier plane, portraying the battle between good and evil for Michael's mortal soul. Along the way the family does battle with the evil drug dealer, Sollazzo, and his body guard, Captain McClosky. Moe Green and Don Barzini must also be dealt with if the Corleone family is going to survive and make their move to Nevada. Each one of these conflicts leads to action and greater intensity as the movie progresses. Even comedy films deal with conflict and obstacles. In *The Hangover* (2009) the members of the groom's bridal party must first find the groom after a wild night of blackout drinking and then get him to the wedding. These prove to be daunting challenges indeed.

STORY AND PLOT STRUCTURE

Most literary stories and film plots are told and shown in a linear, chronological fashion. The classic structure for movie scripts is as follows:

Act One One quarter of the length of the finished film. It contains the exposition including the location, time frame (as shown through place, wardrobe, social conventions, etc.), and the introduction of the major characters and their basic character traits. The act usually ends with (but always contains) the event that sets the plot in motion. For instance, in *The Godfather* the first act begins with Carlo and Connie's wedding including all the members of the wedding party and Don Vito giving private audiences to his business associates because "no Godfather can refuse a request on the day of his daughter's wedding." The act proceeds to Hollywood where Woltz, the studio boss, experiences the meaning of "an offer he can't refuse." Then Sonny speaks out of turn in the meeting with Sollazzo, the drug dealer, thus leading to the major events of the story.

Act Two One half of the length of the finished film with a mini-act break in the middle. The protagonist deals with the challenges and conflicts that result from the initiating event in the first act. Initially his strategies do not work. Just before the mid-point in the act, he

The Godfather (1972) Directed by Francis Ford Coppola. Shown: Marlon Brando, director Francis Ford Coppola on set.

Paramount Pictures/Photofest

undergoes a change of strategy or a change of heart or both. The second half of the act shows the results of the protagonist's change and how it leads toward resolution.

Act Three Contains the climax to the rising action, the resolution and, if any, the denouement. During the second act, the action has been rising to a higher plateau then lowering, then rising to yet a higher plateau throughout. It reaches its crescendo in the third act. The climax should lead to the resolution of all conflicts and challenges. In *The Godfather* the baptism sequence inter-cut with the revenge killings of all the Corleone family adversaries reaches the highest peak of action in the entire film. One act of vengeance remains undone: dealing with brother-in-law Carlo for setting up the murder of Sonny. With that accomplished, all is resolved and the denouement commences with Connie confronting Michael about her husband's murder and Michael's shutting out of his wife, Kay. At the end, Michael has become the uncontested Godfather through his own baptism in blood and the complete estrangement of the women in his family from the business world of the Godfather.

Throughout movie history, storytellers have experimented with changing the basic rules of linear story construction. Griffith's 1916 film *Intolerance* is an early example of a film that connects different intersecting story threads. Orson Welles' masterpiece *Citizen Kane* begins at the end of the story with Kane's death and proceeds to tell the story from the beginning five times from five different points of view. Billy Wilder's *Sunset Boulevard.* (1950) begins with the narrator face down, dead in a swimming pool. He proceeds to tell the story of how he got there in flashback. Akira Kurosawa's classic *Rashômon* (1953) is another example of the same story being told from different points of view.

In the 1990's the post modern philosophy of deconstructionism began to take root in independent and mainstream filmmaking. Quentin Tarantino's *Pulp Fiction* (1994) is a good example of a film that begins in the middle of the story's timeline and ends at a point just before the beginning. Paul Thomas Anderson's *Magnolia* (1999) consists of several intersecting stories that share the commonality of occurring in one twenty-four hour period in the city of Los Angeles. David Lynch's 2001 film, *Mulholland Drive,* is a movie puzzle in which the first and second acts portray the protagonist's (Naomi Watts) Hollywood dream before landing in the uncomfortable reality of act three. Christopher Nolan's 2000 film, *Memento,* involves a protagonist with no short term memory attempting to solve his wife's murder using post-its and tattoos as reminders of what has been discovered along the way.

Mexican director Alejandro González Iñárritu and screenwriter turned director Paul Haggis have both specialized in making films with intersecting stories. González's 2000 breakthrough film, *Amores Perros,* intertwines three stories dealing with dog owners and their animals. His 2006 movie, *Babel,* is an international production that involves stories in which people have difficulty communicating. Paul Haggis' 2004 movie, *Crash,* interweaves stories that portray the problems that immigrant families face during a twenty-four period in Los Angeles.

CHARACTERIZATION

Characterization is a necessary element of a good story. Audiences are intrinsically interested in other people, whether it is from a voyeur's point of view studying the reactions of people under tremendous pressure as in much of Hitchcock's work, or simply a chance to spend a little time with interesting characters caught in an unusual situation as in the 2009 comedy hit, *Up In The Air*. We want to see characters change, learn, overcome adversity and achieve success or knowledge, or both. In action films the characters are not usually very deep because that would tend to draw our attention away from the excitement and it would make the film difficult for foreign audiences to follow. But even in this genre of film, the audience must have a rooting interest in the protagonist and a reason to despise the antagonist. At a minimum, we need to know whose side we are on and why.

BACK STORIES

When we learn things about characters that happened to them before the story of the movie actually begins, we are obtaining the back story. Unless the film begins with the birth of a character and ends with his or her death, there will always be some sort of a back story or a front story. In *Citizen Kane* we meet Charles Foster Kane when he is nine or ten years old and quickly learn that his mother wants to get him away from his father so that he can become a proper gentleman. The father is presented as a roughneck and it is suggested that he might be physically abusive to his son. This is not much of a back story but it is important to know why Kane's mother would give him over to a man like Thatcher. In *The Godfather* we learn that Michael has a back story of being a college graduate and a hero during World War II and that he has been earmarked by the family to go into a legitimate enterprise rather than organized crime. We learn through Michael's introduction of his family to Kay in the opening wedding scene that Don Vito may appear to be a lovable head of family but he is also a man capable of extreme violence when the matter calls for it. At the end of *The Godfather* we know that in many ways this is just the beginning for Don Michael Corleone. He will move to Nevada and the story will continue. When Francis Ford Coppola and Mario Puzo wrote *The Godfather, Part II*, they chose to tell Don Vito's back story and Michael's front story.

ELEMENTS OF CHARACTER

APPEARANCE

In *The Godfather* we first see Michael dressed in his Army uniform. This tells us that he is an officer and has won medals for valor. It reinforces his otherness within the extended Corleone family as does the fact that his girlfriend, Kay, is decidedly not Italian. Next we see Michael dressed as an Ivy Leaguer in a corduroy sports coat with leather patches on the elbows. When he meets with Sollazzo, he is wearing a dark silk

suit similar to the styles of the other younger members of the family. When the location shifts to Italy, Michael has adopted the native manner of dress and is clearly discovering his inner Sicilian.

DIALOGUE

The way a character speaks tells us a great deal. It can tell us where he was raised, if she is educated or not, if the person is funny or serious, devious or plain spoken. In *Gran Torino* (2008) Clint Eastwood plays Walt Kowalski, an alienated seventy-something Korean War veteran and retired auto worker. Even though most of his neighbors are Asian, he uses racial slurs when speaking of them or to them. This serves to demonstrate his sense of exclusion which extends to his sons who are too busy to take much interest. But there are hints that this rock hard exterior might hide something more compassionate underneath. When he is befriended by and befriends the Hmong family next door, we hear the same gruff language but with a different, more open, connotation.

Since dialogue is also used as a comedy delivery system, some characters are almost completely defined by their way of talking. In the Coen brothers' 1998 film, *The Big Lebowski*, the antagonist (Jeff Bridges as "The Dude") has a laid back, stoner way of talking. Not only are the things he says funny, but when contrasted with other characters who are either more conventional, even up-tight, The Dude's words become funnier. In *Blood Diamond* (2006) the antagonist, Danny Archer (Leonardo DiCaprio), plays an Afrikaner from Zimbabwe. His Dutch-influenced English accent makes his soldier-of-fortune and diamond-smuggler character more realistic and the film more believable.

EXTERNAL AND INTERNAL ACTION

Films are more about what actions characters take and what behaviors they show than about what they think or who they are down deep. This is most true of action films. Protagonists generally do what they think is the right thing to do. Some films are about protagonists who take action reluctantly. This is certainly true of the *Harry Potter* films. Potter's character is basically peace loving. He is interested in the secrets of magic more out of curiosity than out of a desire to gain power over others. He attempts to side step conflict rather than invite it. By contrast, the protagonist of the *Indiana Jones* films sees conflict and danger as mere by-products of his ongoing search for the ancient treasures and mysteries of the world. In either case, as in most action films, the hero takes action and risks life and limb because someone is in danger and must be protected or the protagonist is defending himself.

Internal action is usually associated with the character-driven film, the point of which is to see what is ticking under the surface of a person who behaves in unpredictable and unusual ways. In the film *LA Confidential* (1997) several of the characters reveal themselves to be different from what they appear to be. Bud White (Russell Crowe) plays a police officer who specializes in beating up whoever his boss Captain

Dudley Smith (James Cromwell) assigns to him. Over time we discover that his brutishness is a cover for being tortured by his father and having witnessed his mother's murder by his father. Underneath, he is more interested in protecting people, especially women, than in being a savage cop. Guy Pierce plays Ed Exley a politically ambitious young policeman who is willing to step over any of his colleagues to advance through the ranks of the department. He does not seem to mind being hated. We later discover he is trying to live up to the legend of his father, one of the heroes of Los Angeles police lore. When the cards are down, he does the right thing. In the final act of the film we learn the true nature of wise old Captain Smith. He is not the steadfast, tradition-bound career policeman he makes himself out to be. In *Crazy Heart* (2009) the central issue is can the protagonist, country singer Bad Blake (Jeff Bridges) overcome decades of alcoholism and thoughtlessness to become a decent human being and will it happen in time for him to live a conventional life. The changes in Bridges' character come slowly and are often expressed in his music as much as his behavior.

STOCK CHARACTERS

Almost all films contain many minor characters who are important to furthering the story but the story is not about them. We call these stock characters (characters who are extremely predictable but perform important dramatic purposes) and stereotypes (characters who have more of a story, maybe even a back story but time limits prevent exploring them in depth).

Examples of stock characters would be the kindly old doctor, the ramrod military officer, the dumb jock, or even the villain who has no motivation for evil, he is just bad. Stereotypes can be much more important to the story without requiring us to know much about them such as the sidekick or best friend, the influential teacher or mentor, the good or the bad boss, or the colorful villain in films such as the *Batman* franchise.

ELEMENTS OF FILM: ART DIRECTION AND DESIGN

Two different titles are used in describing the person whose responsibility it is to create the overall visual look of a film, production designer and art director. Especially in big-budget filmmaking, a production designer creates the drawings and designs for the look of the film and the art director executes them. But the terms are also used interchangeably. Production design includes sets, if any, locations, props, and wardrobe. Typically the designer commences work early in the production cycle, collaborating closely with the director and the cinematographer to determine the overall "look" of the film. Issues such as color palette, the type of film stock to be used, the aspect ratio of the screen format, the time frame, setting, and location are discussed at length. The designer usually prepares sketches or, more modernly, computer-based illustrations that serve as an inexpensive way to change and massage a design until the creative team reaches agreement.

Most films involve some location shooting. Canada, New Zealand, and Australia which offer financial incentives for production on their soil are often chosen for that reason. Then the challenge often becomes to find locations that can stand in for other places. For instance, Toronto is often used as a substitute for shooting in New York City where the cost of production is very high. Under the supervision of the line producer and the designer, location scouts begin the process of finding the perfect place to shoot. In the film *Bonnie and Clyde* (1967), the challenge was to recreate 1931 depression era Middle America. The decision was made to shoot in a thirty-mile radius around Dallas where the production would be headquartered. Using that as a point of departure, the scouts were charged with the task of finding the small towns, farm houses, and motor courts that would provide the setting for the film. This meant that backgrounds could not contain modern visual symbols such as TV antennas, fast food restaurants, and signage.

Once contracts have been made for the exact locations, the set and property departments are called upon to begin the process of painting and construction and dressing the locations to look authentic. In a film like *Bonnie and Clyde* cars become an important element. The prop master usually arranges with one or more car rental companies that specialize in vintage automobiles to supply the production. Not all cars need to be capable of running, especially those that are parked on downtown streets. During pre-production the costume designer also begins to submit sketches for wardrobe. For films that are set in the past, historical accuracy is as important as designing costumes that will flatter the star's looks. For films set in the imagination, such as *The Ring Trilogy* or science fiction, costume design should adhere to the overall look of the film. Once the designs are agreed upon, the wardrobe is fitted to the actors and usually camera tested before production begins. For modern dress films, selecting wardrobe is more a matter of shopping than design. It is not unusual for a film to have a commercial tie-in with a retailer such as the Gap Stores which will usually provide much of the wardrobe, particularly for background actors, in return for credit in the film.

Dean Tavoularis is one of the great production designers in recent movie history. *Bonnie and Clyde* was one of his earliest films. Thereafter, he did the designs for *The Godfather* which presented many of the same challenges. Tavoularis became Francis Ford Coppola's go-to designer for the next two-plus decades with his last collaboration with the great director being the Robin Williams film, *Jack* (1996). On *The Godfather* the problems associated with locations were compounded. Paramount's Astoria Studios, located in the Queens Borough of New York City on Long Island, served as the geographic center for production. Most of the interior sets were built on the studio's stages. The Corleone family compound was located on Staten Island; Manhattan was used for many exterior locations, as were Riverdale in the Bronx and Jersey City in New Jersey. Several scenes were shot in California, including Beverly Hills, Los Angeles, and Ross, California which provided the location for Kay Adams' New England school scene. The production team also spent time in Sicily as well. Wardrobe, props, and automobiles were also important parts of the design.

ELEMENTS OF FILM: CINEMATOGRAPHY AND VISUAL EFFECTS

Some films are conceived as epic in nature. Cinematically they strive to create grand vistas that capture the sweep and energy of stirring and breathtaking events. Other films are conceived as closely observed character stories where the behavior, emotions, and interaction of the actors is uppermost. Great cinematographers throughout movie history have had the ability to work in both styles depending on the director's vision for the film. One of the first decisions that the director and the photographer must make is the film's point of view.

OBJECTIVE POINT OF VIEW

The most common approach is to employ an objective point of view. It entails using the camera as a window on the world. It directs the viewer's attention by creating the frame within which the action will occur. Francis Ford Coppola was highly influenced by the great John Ford in this respect. In *The Godfather* the camera can assume a very intimate point of view such as the opening scene between Don Vito and Bona Serra the undertaker or the scene in which Michael is meeting with Sollazzo. At other times the camera pulls back to take in some grand spectacle or scenery as in the wedding scene or many of the scenes shot in Sicily. But in either circumstance there is a general feeling that the director and cinematographer, Gordon Willis, are carefully arranging the action so that it is balanced and framed in an almost classical style. In early movies the camera shot was organized to contain all of the action in a scene. As the art progressed using the camera to lead the audience through the story by controlling what the lens sees became part of visual story telling.

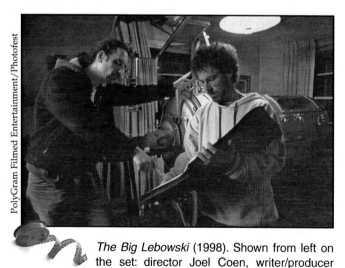

PolyGram Filmed Entertainment/Photofest

The Big Lebowski (1998). Shown from left on the set: director Joel Coen, writer/producer Ethan Coen.

SUBJECTIVE POINT OF VIEW

A technique that puts the audience in the place of one of the characters in the scene is called a subjective point of view. Hitchcock was very fond of this approach. In the last act of *North by Northwest* (1959) he places the camera in the same position as one of the characters in the scene. We see the action between Van Dam (James Mason) and Leonard (Martin Landau) from Roger Thornhill's point of view on the balcony

outside the residence. When Van Dam punches Leonard, we see the punch from each person's point of view. When Thornhill is in Eve Kendall's room on the second floor, we see the action from his point of view in the stair landing. All of this is intended to and does serve the purpose of allowing the audience to witness all of the intrigue with logic that is easy to follow.

In *Chinatown* (1974), director Roman Polanski and cinematographer John Alonzo used a subjective point of view extensively. The action is often seen from over the shoulder of the protagonist, Detective Jake Geddes (Jack Nicholson). This technique served to underscore the voyeuristic nature of the private detective's profession. In the film Geddes spends a great deal of time following and observing the target of his investigation, always with the detective in the foreground and his prey visible at a distance. In one particularly intimate scene Polanski hand holds the cumbersome Panavision camera himself to capture action which takes place within the confines of a tiny bathroom.

CINEMATIC COMPOSITION

This refers to the organization of the elements within the camera's frame. Therefore, if a film is shot in the relatively vertical aspect ratio of basic thirty-five millimeter film (four units wide to three units high) or the 9 by sixteen ratio of widescreen cinema, the approach to composition will be different. One of the primary objectives is to balance out the composition. In the four by three format, organizing objects into a triangular composition with the apex of the form at top center gives a sense of stability. In widescreen formats there is much more space to fill. Putting everything in the center leaves the edges empty and putting objects on the sides of the frame can leave the center empty. Often the problem is solved by stacking objects across the frame from front to back, from one side to the other. This uses the entire frame and results in complex compositions that hold the audience's interest.

Another element of composition is the use of focus. In deep focus photography all of the elements in the frame are in focus. This naturally draws the eye deep into the frame and makes it possible for actors to move around the frame without fear of moving out of focus. Shallow focus photography allows the director and cinematographer to draw attention to one specific object or person within the frame. Even though there may be much else visible in the frame, we tend to only look at what is in focus. Another technique is to change the focus during a scene. This is called rack focus. In one memorable scene from *Bonnie and Clyde*, the camera is focused on the two lovers in bed at night. Bonnie is clearly interested in Clyde's physical companionship but he is seen snoring away. Next the focus changes to reveal that C.W. Moss is also in the room, suggesting that he might be playing some role in Bonnie's sex life. Finally, the focus changes back to Clyde's face and we discover that he is only pretending to snore in order to avoid another sexual disappointment with Bonnie.

CAMERA FRAMING

There are standard methods for composing camera shots. Some are based on the way people are organized for dialog scenes and some are determined by the way we perceive specific image qualities.

Neutral Camera Angle The neutral camera angle places the camera at exact eye-level with the person being photographed. Regardless of the height of the actor this seems normal and balanced to the audience.

High Camera Angle Any time the camera is above eye line it begins to change the audience's perception of the subject. With the camera six inches to two feet above the actor, the forehead is emphasized and the subject needs to look upward for the eyes to be seen and, therefore, begins to appear slightly diminutive in stature, like a child looking up at an adult.

Low Camera Angle A low camera angle makes the subject appear larger than normal. This emphasizes the chin line and makes the subject appear to be larger than normal. Very low camera angles can make the actor seem heroic as in *Citizen Kane* or they can emphasize a large stomach for comedic effect as is the case with the character, Gutman, in *The Maltese Falcon* (1941). In either case a very low camera angle might necessitate the very expensive addition of ceilings to set designs. Both high and low camera angles are often associated with classic expressionist cinema. With the advent of the hand held "Steadicam" in the 1970's and the resulting tendency to work very close to action sequences, the effect of the high and low camera angles became somewhat diminished.

Close-Up and Extreme Close-Up Shots These refer to dialog shots where a single individual is in the frame. The close-up is the same as a head shot with a little room in the frame above the top of the head and the bottom of the frame composed on the top of the shoulders. Any shot that is closer, especially those that crop off part of the head or chin or both are extreme close-ups. The function of the shot is to focus attention on the actor's face and dialog. This framing is also used for reaction shots. The director or script supervisor feeds the actor their counterpart's lines and their reactions to the words are filmed.

Two Shot or Medium Shot Such shots are generally framed to accommodate two people for dialog. The actors are given a little head room and are generally cut off at the waist. Usually the actors are slightly "cheated" toward the camera so that, even though they are speaking to each other, their faces are clearly visible and not in complete profile.

Three Shot The three shot is designed to accommodate three people in a dialog scene. It differs from the two shot in that the framing is wider and the actors are generally cut off at the knees.

POV (Point of View) Shot The POV shot is a two person dialog shot designed for one actor to be facing the camera with the other actor's back turned to the camera with the camera placed over that actor's shoulder. The purpose of this type of shot is to vary the look of dialog scenes and to be able to complete half a dialog scene when only the actor's stand-in is available to shoot the scene.

The Master Shot In classic Hollywood directing style, most scenes were initially shot as a master shot which included everyone's entrances and exits and the dialog in a scene. In the master shot every actor had their own mark which not only determined where their optimum pool of light was located but where their assigned microphone would be. Once the master shot was completed, the basic dialog groupings would be shot next until the scene was completely covered.

The Establishing Shot Often times a wide angle exterior shot would be inserted ahead of a master shot to indicate the location where the scene is taking place. Masters of the establishing shot like John Ford used the immensity of the natural surroundings to create a sense of how small the scale of human beings were in the pioneer West. This gave an emotional context to the establishing shot and underscored the fragility of mankind in a hostile environment.

LIGHTING

Lighting is the cinematographer's most creative tool. The standard technique for lighting actors is called three point lighting. The key light is the main source of illumination on the actor's face. It is usually positioned forty-five degrees above the eye height and forty-five degrees off center depending upon which side of the actor's face is the most photogenic. The intensity of the light is 100% as determined by the exposure or foot candle meter. The fill light is also forty-five degrees above eye height and forty-five degrees in the opposite direction of the key light. The intensity of the fill light is 75% of the key light or less. The back light is placed directly behind the actor at one hundred twenty degrees above eye height. Its intensity is 120 percent of the key and should result in a pleasing halo effect around the top of the head and shoulders. In high key lighting the position of the key is usually greater than forty-five degrees above eye level and the intensity is usually greater or the intensity of the fill light is lowered or both. For any accomplished cinematographer, this is second nature. It is the other little tricks used both for lighting the actors and the backgrounds that makes for great lighting.

 The Godfather is a great example of a lighting approach that breaks most of the rules. In the opening scene in Don Vito's office there is barely enough light to make out Bona Serra, the undertaker. Both his and Don Vito's eyes are hidden in the shadows. Normally a cinematographer would put a small light on the camera to give life to the eyes. Here, Gordon Willis and Francis Ford Coppola want the eyes, windows into the soul, to remain hidden and mysterious. In a later scene Don Vito meets in a

hotel conference room with all of the heads of the organized crime families. Even though the room is lit to a fairly normal overall intensity not a single one of the actor's eyes can be seen. Willis was a master at this expressionistic style of lighting.

CAMERA MOVEMENT

Almost all movement of objects on the screen requires some corresponding camera movement. It might be as simple as following a character as the director's blocking instructions call for them to move from one position within the frame to another. Movement might be as complicated as following an actor through an elaborate tracking shot as is common in the films of Martin Scorsese or through an intricate action sequence involving many other characters and a change of locations.

Pan and Tilt The basic camera moves are the pan and tilt. With a pan or panoramic shot, the camera moves left to right or right to left across the horizon either to follow or to reveal the action or character. The tilt motion consists of moving the camera up and down on its hinged camera mount, again to follow or reveal action. Of course combinations of these two basic movements are also natural.

The Tracking Shot The tracking shot consists of following something, usually a character through a complicated motion. In a studio setting track is often laid on the floor and a special camera platform is used to make the camera motion precise. In *Raging Bull* (1980) Martin Scorsese's cinematographer, Michael Chapman, follows the protagonist, Jake LaMotta (Robert DeNiro), from his dressing room under the stadium, through the tunnels out into the stadium, and down the stairs to the boxing ring in one continuous, unbroken shot. The result is operatic. It completely amplifies the drama of the moment. There are many such equally impressive tracking shots in Scorsese's films.

Crane Shots and Boom Shots Using devices that are capable of changing the height of the camera dramatically as it is rolling are labeled crane shots and boom shots. Most often these techniques are used to move the camera from an intimate point of view to a grand wide angle point of view or the opposite. In either case, the purpose is to reveal something dramatically. In *Gone with the Wind* (1939) director

MGM/UA/Photofest

Manhattan (1979). Directed by Woody Allen. Shown on the set: Gordon Willis (Cinematographer).

Victor Fleming wanted to show Scarlett O'Hara at the Atlanta Railroad Station searching among the thousands of the assembled wounded and dying for her lover. A special crane was borrowed from the Long Beach Harbor that allowed the camera to be raised ten stories in the air in a single shot to underscore the terrible price in humanity paid by the South for its rebellion. The shot begins at ground level with Scarlett searching from victim to victim and gradually pulls back to reveal the thousands on the ground and, eventually, a tattered Confederate flag.

Slow and Fast Motion Slow and fast motion cinematography is accomplished by running the film through the camera at different speeds. Since the introduction of sound, the normal speed for a thirty-five millimeter camera is twenty-four frames per second. When the film is run through the camera faster and projected at normal speed, the result is slow motion. When the film is run slower than normal, the result is fast motion. There are any number of motivations for using these camera techniques including comedy (with fast motion) or to show great physical exertion (with slow motion).

VISUAL EFFECTS

Dating back to 1902 and George Méliès' film, *A Trip to the Moon,* in which he used stop action photography to create several different illusions. In modern times the computer has had a profound effect on visual effects photography. Two basic approaches are currently employed in many action style films, green screen photography and motion capture.

Green Screen Photography This technique consists of filming actors and some other foreground objects against a green screen. Careful attention must be taken in lighting the actors to be sure that there is maximum contrast between their figures and the green background. In post production computers remove the green background and leave a new canvas upon which new visual and action elements may be computer generated. The majestic backgrounds as well as many of the action elements in films such as the Lord of the Rings Trilogy were created by mixing film with computer illustrations and animation.

Motion Capture A part of the production process for some time, motion capture has been used in films such as *The Polar Express* (2004), *Beowolf* (2007), and *A Christmas Carol* (2009), all created by Robert Zemeckis, have used motion capture technology. It consists of dressing the actors in motion capture suits that contain hundreds of digital sensors that capture the three dimensional movements of the actors, including dialog. Next a computer generated skin and costumes are applied to the actors and they are placed into the three dimensional matrices of the virtual realities of the backgrounds and actions that have been created for the film. Therefore, live actors are able to interact with imaginary artificial realities. It approaches the "if you can imagine it, it can be done" goal of all great fantasy movies. One of the shortcomings of this technology has always been what purists call the "dead eye" look of the live elements in the films. It is nearly impossible to capture the intricate and subtle expressions of the human face.

In 2009 James Cameron created the next generation of motion capture films, *Avatar*. The so-called "dead eye" problem has been addressed by a combination of better computer software and more and more accurate facial sensors. The result is both humanoid and fantasy creatures that have an enhanced quality of realism. Cameron combined this innovation with the best possible new three dimensional technology in generations. One critic made the historical comparison between Cameron's new 3-D and the advent of practical sound with *The Jazz Singer* in 1927. Clearly movies are in the process of making a great leap forward. Many of these technologies have already been successfully incorporated into the world of gaming. What is next for the motion picture industry is open to the imagination of filmmakers.

EDITING

The earliest story telling films used editing simply as a means for connecting the scenes they shot. Each scene was complete unto itself and only needed to be glued to the preceding scene to form the finished story. Since it was usually the camera operator who did this work or maybe even someone from the laboratory, the idea of using editing as a tool for enhancing the story and action had not occurred to anyone yet. Most credit D.W. Griffith and his cameraman, Billy Bitzer, for being the first to realize the potential power of the cleverly edited film. As an art form there are many things about film that make it a plastic art but none so much as the ability to use the bits of raw film to assemble something that is truly greater than the sum of the parts.

One of Griffith's and Bitzer's early discoveries was breaking the scene into smaller parts. Using different points of view, such as close-ups and reaction shots, served not only to comment on the action but also to create the feeling of the action being sped up through this method of deconstruction and reconstruction. Later they learned that the chase scene, a staple of early filmmaking, could be made much more exciting through editing. They perfected the art of parallel editing by cutting back and forth between shots of the rescuers in their frantic chase to save the victims and shots of the victims as the danger they face becomes more intense with each passing moment. Audiences had never before been brought to such heights of anxiety and anticipation.

The Soviets added greatly to the language of editing. Using Griffith as their point of departure, they experimented endlessly with new ways of assembling film. The concept of artificial space was one of their first discoveries. If an audience is first shown a standard establishing shot of the exterior of a building, followed by a shot of an interior space, they will always assume they are seeing what is inside the building they were shown initially. Another technique is the idea of juxtaposition. If an audience is shown a frightened actor, followed by a sword slashing through the air, it will always assume that the actor is reacting to the threat of the sword. If the shot of the sword is followed by an image of blood spattered on the wall or floor, the audience will naturally assume that it is the blood of the victim that was shown in the first shot. This method of leading the audience to reach its

own conclusions based on the suggestion of the images is the basis of some of the greatest scenes in movie history including the famous "shower scene" in Alfred Hitchcock's *Psycho* (1960).

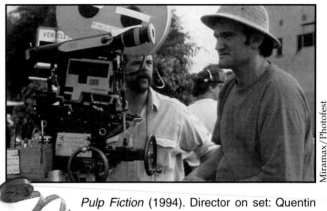

During the studio era, editing was departmentalized and separate from the direction and filming process. Directors were taught to shoot their films using a basic formula. They would shoot the master shots first, the

Pulp Fiction (1994). Director on set: Quentin Tarantino.

dialog groupings next, then reaction shots and finally POV shots. The second unit would shoot exteriors and establishing shots and the film would be shipped to the editing department for assembly. On the one hand this provided a form of quality control by forcing the directors and actors to focus on their performances rather than attempting to create some cleaver editing effect. On the other hand, this type of editing could become too predictable and formulaic. Great directors like Hitchcock, Ford, and Hawks became quite skilled at editing in their heads so that the film would fit together only one way, the way they wanted. Over time the studios began to recognize the value of giving their star directors more creative control over their films. Eventually, the Director's Guild of America was successful in winning the right for every director to have first cut of their own films.

Over the history of motion picture editing a number of standard transitions have been identified. They are as follows:

Fade Up. Beginning with a black frame the image is gradually given greater exposure until it is at full light value. This transition is often used at the beginning of a film to suggest we just entered the reality of the movie. It can also be used to suggest the passage of time.

Cut To. The cut is the simplest form of transition. Interior to a scene it is used to focus the audience's attention on what the director/editor wants them to see. In parallel editing, two simultaneous actions are established and the editor cuts back and forth to follow the progress of both actions as they generally are headed to some form of intersection. Cutting from one scene to the next is the basic method of tying scenes together. The abruptness of the cut technique is often perceived as linking the two scenes closely together in time.

Match Cut. This variation on the cut is based on the idea of linking scenes by using the same or a similar image to end one scene and begin the next. For instance a simple example of a match cut would be to use a framing device such as a door or a window to enclose the action at the end of one scene and repeat

the use of a similar looking aperture to begin the action in the following scene. Objects like telephones are also often used to create match cuts.

Dissolve To. The dissolve consists of slowly fading one image out while fading the following image up. This was a common form of transition in the early days of movie production. It was accomplished by slowly closing the lens iris at the end of a scene, winding the film back through the camera an appropriate number of frames and beginning the next scene by slowly opening the iris. This transition is not only smoother than the cut but it is usually perceived by the audience as suggesting some passage of time between the scenes.

Match Dissolve. The match dissolve is identical to the match cut except the transition is accomplished by dissolve, therefore suggesting a passage of time and a linkage between images. In *The Godfather,* Francis Ford Coppola used the match dissolve to comment on the fate of Don Vito. As the Don lies dead where he has fallen in the tomato garden, the camera pulls back to reveal him amidst the greenery with a white muslin canopy shading his corpse. It is a scene of peaceful repose. Gradually the scene dissolves to a shot of the exterior of the foreboding wrought iron gates of the cemetery where his burial will take place. The transition suggests the sinister nature of the cemetery and hints that the Don's fate is likely not an eternity in heaven.

Freeze Frame. A freeze frame is simply a transition or an ending in which the last image is left frozen as a still picture on the screen. It can be used to end a film or a scene. When the freeze frame is used to connect scenes, the following scene will usually begin with a frozen frame and gradually thaw into normal action. This is a rarely used linking device. When the freeze frame is used at the end of a film, it is done to suggest an uncompleted action. For instance at the end of Francois Truffaut's *400 Blows* (1959) the protagonist, Antoine Doinel, is walking through the shallow surf at the ocean's edge when the camera zooms into a close-up of his face and freezes. At that moment Doinel has just achieved his physical freedom from the reform school where he was incarcerated. The freeze frame is used to suggest that there is much more to come for this troubled young man. Another film that employs the freeze frame is *Butch Cassidy and the Sundance Kid* (1967). At the end of the film Butch and Sundance are surrounded and out-numbered by a detachment of soldiers. As they attempt one last desperate escape, the frame freezes while they are still alive and only the gunshots are heard to remind the audience of their probable fate.

Fade to Black. The fade to black is a common way of ending a film. It is like turning the last page in a book. The story is over. When the fade to black is used as a scene to scene transition, it is usually followed by a fade up onto the next scene. This type of transition is sometimes referred to as a cross-fade and almost always connotes the passage of time.

These basic transitions are only a part of the editor's language. Digital effects have added an open ended quantity of new ways to transport the movie from one scene or place to another. Morphing is only one example of what digital production makes possible. However, even with all of this new technology at the editor's disposal, a few basic rules should apply. First the internal scene should have an editorial logic. Basic rules like maintaining consistent screen direction in action scenes still apply. The editing should not get in the way of the actors' performances. To the extent the editing is rhythmic, there should be a consistency to the beat of the cutting. The ultimate goal of the editor is to be sure that the story makes it to the screen.

ACTING

In the earliest days of film history most movie actors were stage actors who were supplementing their income by working in the daytime for the motion picture companies so they could follow their true calling on stage. There was very little rehearsing on movie sets and very little attention was paid to the quality of the performances as long as the actors roughly approximated the characters their roles demanded. The cameraman was the person in charge of the set. Most early cinematographers were too focused on the technological side of making movies to care much about actors. This led to the practice of naming one of the actors (usually someone who evidenced a little maturity) as the director of the actors' performances. The idea was initially to relieve the camera operators of a nuisance. Some directors, like Griffith and DeMille, began to take the acting and performance part of filmmaking more seriously. Likewise, early comedians such as Chaplin and Keaton wanted their performances to be better, funnier, and more vivid. Once audiences began to single out individual performers as having some special quality, and the star system began to develop, acting became an important part of the filmmaking process.

Physical Acting

During the silent movie era, actors had to learn to communicate with their audiences through pantomime and gesture. Griffith was once asked his definition of what a director does. His answer was, "Finding the perfect gesture that communicates what the character is feeling." Comedians borrowed from circus clowning and vaudeville to create the rich language of slapstick. When talking pictures arrived, many silent film actors were discarded as old fashioned and replaced by stage actors. But within a two or three year period, most of the old stars were back in speaking roles, still using many of the skills they had learned during the silent days. Today, good screen actors understand many of the basic principles that have served screen acting for generations.

Act Small

The camera lens and the big screen amplify everything. When an actor is filmed in close-up their head becomes twenty feet tall on the screen. The smallest gesture or

change of expression becomes discernable to the audience. Whereas stage actors are taught to project their performances to the back rows of the theater, screen actors must contain themselves or risk appearing ridiculous.

KNOW WHERE THE CAMERA IS

Stage actors are taught to fill the stage area with their performances. Natural movement that engages the audience is one of the stage actor's tools. The screen actor plays to the camera which is dictating the audience's point of view. What the camera does not see, the audience does not see.

ACT NATURALLY

Particularly when involved in dialog scenes, the screen actor must learn how to work to the microphone as well as the lens. Stage actors must speak with clarity of elocution in order to be understood by the entire audience. The microphone does for dialog what the lens does for physical movement, it amplifies. In many respects, this frees the screen actor to perform in a more intimate manner than the stage actor. A whisper that could never be heard in a theater can easily be picked up by the microphone.

ACTING STYLES

Studio Style Also known as iconographic acting, studio style grew out of the economic realities of the star system. Audiences were and still are motivated to see a specific film because their favorite star is in it. The studios were careful to choose roles for their stars that fit the audiences' preconceived notions of what they would see when they went to the movies. For instance, MGM's biggest male star in the thirties was Clark Gable. He had a kind of rough-edged virility and a "one of the guys" down to earth style. He was particularly good at performing dialog that employed the slang of the day. As a result he was often cast as a man of action in his films. There were plenty of romantic sub-plots in his films but he always "got the girl" in the end if she was worth getting. When Gable took on roles that required some depth of character as with Rhett Butler in *Gone with the Wind* (1939), great care was taken to be sure that the mannerisms he adopted for the role fit with what the audience wanted and expected from his performances. Male stars were most often identified as iconographic, but some women also received this treatment. Marilyn Monroe almost never deviated from the hyper-sexualized "blonde bombshell" type the studios and their publicity departments created.

Character Actors Parts for villains, sidekicks, and best friends were usually relegated to a group of actors the studios identified as being well suited for character parts. In most cases there was no need to protect the actors from playing unbecoming

roles. Therefore, a good, tough, villain could suddenly become a sniveling coward. Likewise, the hero would only rarely be allowed to die in battle, but the sidekick could easily be killed off to underscore the presence of danger. Actors like Walter Brennan and John Carradine made long and successful careers playing these colorful character roles.

Method Acting In the thirties the Broadway stage experienced a revolution in acting technique. A new style of acting, known as the Stanislavski Method or simply "The Method" swept through the world of international theater. The basic approach was to replace the mannered iconographic style of acting with an emotionally realistic style. Using a combination of techniques including sense memory and psychoanalysis, a new generation of actors were achieving dramatically powerful and truthful performances. In Hollywood the "Method" movement coincided with the introduction of a new generation of post war actors that began to arrive in the late forties. Many of the male actors had taken advantage of the free education offered by the GI Bill of Rights to attend method acting schools such as The Actors Studio. Marlon Brando, Montgomery Clift, and James Dean were early proponents of the Method. They were soon followed by the next wave of actors including Warren Beatty, Lee Grant, Faye Dunaway, Gene Hackman, John Cassavetes, and Dustin Hoffman.

Actors Who Become the Character Some actors have the ability to become the character they are portraying so completely that their off screen identity is complete hidden in the performance. Daniel Day Lewis and Johnny Depp are two examples of this style of acting. It is almost the complete opposite of studio style acting in that the audience never knows from one role to another who their favorite star will be. Other actors like Robert Di Niro and Jack Nicholson can point to performances in which they have exhibited this chameleon quality and to other performances in which they were clearly playing themselves playing a character.

CASTING

For all actors technique is an important element in their role preparation. However, there are other important considerations as well. Do the actor and the role fit each other? Does the actor have the right look, the right physical presence, and the right voice for a part? If a role calls for a woman to be a great beauty, it does not make much sense to begin with an actress who requires a make-up miracle to achieve the proper look. If a role calls for an athletic actor that can do some stunts, it does not make sense to cast a non-athlete in the part. At the outset of production, who will play the major roles is almost always known. It then becomes the casting director's job to find a supporting cast that will blend with and enhance the central performances.

ENSEMBLES

Many films call for a large cast of actors who can work well as a unit. Robert Altman was particularly interested in working with acting ensembles as is evidenced by his films, *M*A*S*H* (1970) and *Nashville* (1976) in which there are easily over twenty different speaking parts. A more recent example of an ensemble cast is Martin Scorsese's film, *The Departed* (2007). One of the attributes of the ensemble approach is that actors begin to feed off of one another. In the hands of directors like Altman and Scorsese, the cast members are encouraged to suggest improvisations that can add to the richness of the film and the performances.

DIRECTION

Historically, the director's job was to supervise the actors' performances. To a large extent this was true through the studio years when production involved many individuals working in carefully defined roles to make a large quantity of films using an assembly line manufacturing approach. As the influence of the studios declined in the post World War II era, star directors began to fill the void. The French "auteur theory" which held that the director should be the author of the film and should retain control over as many creative elements as possible took root and became institutionalized in the movie industry. Today the art department, the writer, the cinematographer, the music composer, and the editor are generally subservient to the director or director/producer. The upside of this approach is the unity of vision that can be obtained. The downside is that everything has to flow through one person, creating a natural bottleneck in the production process. One of the responses to the bottleneck problem is for directors to work with many of the same people over several productions. A shorthand form of communicating evolves as does the ability to trust the work of veteran colleagues. When evaluating the overall success or failure of a film today we begin by evaluating what the director did.

DIRECTORS AND THE SUBJECTS THEY EXPLORE

Many directors are drawn to stories with similar themes over and over. Hitchcock was fascinated with how people react when caught up in a web of intrigue, especially when their involvement is unwitting. The Coen brothers are interested in moral dilemmas and how people respond to them. Wes Anderson is interested in stories that have a sense of irony and feature quirky characters. James Cameron is interested in creating the ultimate cinematic thrill. Spike Lee investigates the intersection of African-American and American culture. Given the freedom to do so, most directors chose a kind of story that intrigues them.

Many directors began as screenwriters or see themselves as writers first and directors second. Cameron Crowe, Billy Wilder, Quentin Tarantino, and Francis Ford Coppola are all examples of writer/directors. It is fair to expect that a director so intimately involved with the telling of the story on the page will bring story coherence to the screen. On the

other hand, directors like David Lynch and Howard Hawks use the story as a point of departure for exploring the possibilities of the individual scenes contained in the story.

VISUAL TREATMENT

John Ford was generally interested in epic stories that gave him the opportunity to do things on a big scale and explore the source of courage and heroism in human nature. He was particularly taken by the vastness of the Old West and the insignificance of the intrepid pioneers who attempted to settle it. His films are full of dramatic vistas and an appreciation of the power of nature over man. Many of Martin Scorsese's films deal with the violent nature of humans. His movies are filled with bloody scenes, enhanced by his use of saturated colors. Being a tailor's son, he usually pays a great deal of attention to wardrobe as an element of character. Scorsese got his first break in the business as an editor, working with his partner, Thelma Schoonmaker. He still works with her and his films still contain a focus on editing.

Some filmmakers have a personal relationship with the camera. Many of these who came from the European new wave movements operated their own cameras while directing. On the set of *Chinatown* (1974) it was common for Roman Polanski to grab the camera himself to shoot a particular scene. Steven Soderbergh is another director who likes to pick up a camera, as he did in his 2000 film, *Traffic*. Stanley Kubrick began as a magazine photographer and never lost his interest in getting behind the lens. With modern video assist technology, the director sees what the camera sees and hears what the microphone hears. Therefore it is fair to assume that, on some level, the director is always responsible for the look of a film.

ACTOR'S PERFORMANCES

Many directors have experience as actors before moving behind the camera. Clint Eastwood, John Cassavetes, and Woody Allen worked on both sides of the camera. It should be fair to assume that these directors would be especially skilled in communicating with actors and helping them achieve excellent performances. This is often true. In the later part of his career, Eastwood became an excellent director capable of drawing nuanced and satisfying performances out of his actors. John Cassavetes spent his opportunities as a director creating an American cinema verité. His work could be uneven. In some films in which he cast his close friends, Ben Gazzara and Peter Faulk, there is a sense that things have gotten out of control. But in other films he achieves an emotional power commercial filmmaking would have never allowed. Woody Allen has become a prolific director of small films that form an impressive body of work. Overall, there is no rule that great actors make great directors of actors. Great actors often have a difficult time teaching their process or they expect things from their cast members that are beyond their abilities. Conversely, many great directors had very little or no experience acting, yet their films are consistently known for great acting performances. Nonetheless, the director's first job is to achieve the best his actors have to give and to blend their performances naturally.

DIRECTOR'S STYLE

Since style encompasses everything a director does, the concept may seem elusive. One way to approach analyzing style is to set up a matrix of opposites. Choose the description that best fits this director in this film and the result will be some sort of a description of style.

Laid back	or	Intense
Talkative	or	Stoic
Grand Imagery	or	Close-ups
Realism	or	Fantasy
Action	or	Observation
Emotion	or	Objectivity
Logical	or	Irrational
Comedic	or	Serious
Spiritual	or	Nihilistic
Complex	or	Simple
Optimistic	or	Cynical

The matrix above could consist of dozens, if not hundreds, of other possibilities. When analyzing a film the writer should attempt to create his or her own matrix while thinking about what qualities the film contained. A director's style is one of the more elusive and most rewarding elements of film analysis. Researching the director will also give clues to style.

AVATAR (2009): THE BEGINNING OF A TECHNOLOGICAL AND ARTISTIC TRANSITION

After he completed production and marketing on *Titanic* in 1997, director James Cameron began work on a project that would push the limits of digital production exponentially. He wrote a screenplay titled *Avatar* that would require vast improvements in 3-D (three dimensional) and motion capture technologies. Because of his ownership of and daily involvement in his own special effects company, Digital Domain, Cameron was confident that he could realize his vision for the film. But as the details of the budget came into focus, it became clear that the film could not be made for less than $400 million. Neither Fox nor Paramount, the companies that had bankrolled *Titanic*, would agree to such an expensive project, despite the fact that *Titanic* was the all-time top grossing motion picture. Boasting a box office total of $1.8 billion in ticket sales and untold hundreds of millions more in DVD sales and merchandising, the success of *Titanic* was not enough to overcome the enormous risk that *Avatar* represented. Cameron decided to bide his time.

The breakthrough came in 2002 when Cameron saw a screening of Peter Jackson's *Lord of the Rings: The Two Towers*. The quality of a motion capture/computer

generated character, Gollum (played by Andy Serkis), was so good that there was a debate within the Motion Picture Academy if a computer generated performance was eligible for a supporting actor nomination. This convinced Cameron that his vision for *Avatar* was within reach. He convinced Fox to finance the project and began work on the technology he needed to develop.

By far the greatest challenge was to improve the motion capture process to give the actors the ability to be more expressive. Cameron chose a production

Avatar (2009). Writer-director James Cameron (front, center) reviews a scene with actors (from left) Sigourney Weaver, Joel David Moore and Sam Worthington.

stage in Playa Del Rey, California known as "the volume" which had been used for motion capture previously by Peter Jackson and Steven Spielberg. It is a space that is rigged with 120 fixed video cameras that can pick up the motions of the actors in three dimensions. Special performance capture suits were developed for the actors that made it possible to record body movements, as was the case with earlier iterations of the technology. The suits were enhanced to record facial expressions through sensors on the masks and small video cameras mounted approximately three inches in front of the actors' faces. New software was developed to add the dimension of facial expression to actors' performances. Cameron also developed new software that would allow him to have immediate playback of the actors' performances combined with low resolution versions of the computer generated finished film. The playback technology allowed the director and the actors to see their performances on the stage and do retakes as would be the case with a non-digital film. The result is a seamless blending of live action and computer generated acting.

A less complicated but equally important technology was the creation of a new process for digital 3-D photography. Film-based 3-D had been around since the 1950's but had never been accepted in the industry as anything more than a passing fad. One of the problems with this particular film process is that it is expensive and much of the screen is out of focus because of the special lenses used. Cameron's new digital 3-D process eliminates the focus problem, giving the screen a true sense of depth and eliminating the need to "gimmick" the film with objects flying at the audience to stress the effect. *Avatar* is about forty percent live-action and sixty percent computer generated. Technology for computer 3-D has been available for over a decade.

With all of the basic technical hurdles conquered, Cameron proceeded to put together the biggest special effects team in movie history. George Lucas' Industrial Light

and Magic Company in the San Francisco Bay area joined forces with Peter Jackson's WETA (New Zealand), Framestore (Great Britain), and Cameron's Digital Domain. Two thousand people worked for two years on the finished production including a University of Southern California linguist, Dr. Paul Frommer, who created the Na'vi language. A special team of music composers was put together to create Na'vi music and songs.

The film's story deals with a corporate mining company prospecting for a rare mineral, unobtanium, on the garden planet/moon, Pandora. The natives are ten-foot tall blue humanoids called Na'vi that have an intimate relationship with the abundant flora and fauna that surrounds them. The mining company has created hybrid human-Na'vi creatures through DNA blending. Humans can occupy their Na'vi counterparts by entering sleeping pods that connect their conscious minds to their Na'vi bodies. Sam Worthington plays Jake Sully, a former Marine who has been recruited to take his dead brother's place as an Avatar (they share the same human DNA). A veteran of Cameron's *Alien* films, Sigourney Weaver, plays the scientist/avatar, Dr. Grace Augustine, who works for the mining company but believes she can save Na'vi culture from her employer's rapacious tendencies. Zoe Saldana plays Neytiri, a Na'vi princess who becomes Sully's eventual love interest.

Cameron succeeds in creating a ground breaking work of visual art. Some critics complain that the story is trite, that it was lifted from Pocahontas. But the story is not the centerpiece of the film. Cameron's ability to bring the Na'vi characters to life and to imagine a garden planet unlike anything ever put on a movie screen is the real point of the film. It proves that technology has brought the film world to the threshold of a new era in which if it can be imagined, it can become a movie. Like Griffith's seminal works, *Birth of a Nation* and *Intolerance*, no doubt *Avatar* will inspire a new generation of filmmakers to strive to surpass the mundane and create something that changes the way we look at movies.

Avatar passed the billion dollar mark in ticket sales faster than any film in movie history (seventeen days). In January 2010 at the Consumer Electronics Show in Las Vegas, a new generation of 3-D digital televisions was introduced. *Avatar: The Game* has been very successful and there is no question that performance capture will lead to more vivid interactive games and to consumers rushing to buy 3-D TVs, knowing what is to come. In the final analysis, perhaps the most important development that will result from *Avatar* is that the question of whether a computer generated film can be nominated for the Best Picture and Best Director Oscar has been answered. The answer is yes.

20th Century Fox/Photofest

Avatar (2009). Directed by James Cameron. Shown: Zoe Saldana.

Index

NOTE: Page references in *italics* refer to photos.